On This Day In
CONNECTICUT
HISTORY

GREGG MANGAN

THE
History
PRESS

Published by The History Press
Charleston, SC 29403
www.historypress.net

Copyright © 2015 by Gregg Mangan
All rights reserved

First published 2015

Manufactured in the United States

ISBN 978.1.62619.665.0

Library of Congress Control Number: 2014958075

CONTENTS

ACKNOWLEDGEMENTS

At its core, my affinity for history comes from the brilliant minds found in the public history departments at Central Connecticut State University and Arizona State University. I owe everyone affiliated with these two programs a tremendous debt of gratitude for reigniting my passion for history and guiding me down my chosen career path. My experiences attending these two schools were literally life changing.

In addition, it is important that I thank Doug Fisher, Stuart Parnes, Brett Thompson and everyone at Connecticut Humanities for all their generosity and support over the years and for providing much of the inspiration for this book. I cannot imagine working on a more rewarding project than ConnecticutHistory.org and recommend it to anyone with an interest in state and local history. My experience working on the project, and in expanding my knowledge of Connecticut's history, was greatly enhanced by the time I spent working at Connecticut Humanities alongside such talented writers and historians as Anne Farrow, Shirley Wajda and Clarissa Ceglio. Also, I would like to extend a special thank-you to Amy Gagnon and Kim Sheridan for always going out of their way to keep me involved in the project and for sharing all their knowledge with me over the past four years.

A critically important aspect of this project are the many attention-grabbing photographs that detail the chronicled events better than the chosen words that accompany them. For this, I am grateful for all the efforts and exertions of Elena Filios and Brenda Miller at the Hartford History Center, Jeff Hakner and Mike Schreiber at the Shore Line Trolley Museum, Louisa Watrous at Mystic Seaport and Kate Igoe at the Smithsonian's National Air and Space Museum. Of equal skill and dedication was all the work put forth by Betsy Pittman and Laura Smith

at the Thomas J. Dodd Research Center, Christine Pittsley and Allen Ramsey at the Connecticut State Library and William Caughlin at the AT&T Archives and History Center.

Significantly enhancing the quality of this project was an unofficial research team of family and friends who, upon learning of the book's premise, voluntarily forwarded me useful materials whenever they came across them. These supportive contributors included Don and Meredith Wendell, Eph and Judy Mangan, Frank and Jane Polubinski, Barbara Kuhn, Gracemary Comstock and Pamela Trotto. Thank you all!

I would be remiss if I did not acknowledge all the contributions made to this project's success by Tabitha Dulla at The History Press as well. Her patience, understanding and advocacy guided this book to completion in the most professional and efficient manner possible.

I also need to express my gratitude to my stepdaughter, Jaime Adanuncio, for framing me for any number of household crimes and then threatening to tell on me unless her name appeared somewhere in this book. She also gets credit for taking the author photograph. Anything substandard found in that photo comes solely from the aesthetic limitations inherent in her subject, not in her skill as a photographer.

Lastly, an enormous amount of credit goes to my amazing wife, Kari Mangan. Her love, support and understanding not only allowed me to finish my education and to write this book, but she also proved to be the most innovative and determined researcher I ever encountered. Every dead end I ran up against she met with a creative solution relentlessly pursued to its conclusion. It was incredible to watch and just one more addition to the infinite list of reasons why she is the love of my life and my whole world.

INTRODUCTION

For such a small state, Connecticut's history is amazingly robust and complex. Its founding as an English colony came not so much from the romantic promise of fertile soil or newfound freedoms but largely from a desire to push Dutch traders out of the Connecticut River Valley. Subsequent relations with indigenous peoples living in the area facilitated an array of complex treaties and conflicts that not only determined local settlement patterns but also later helped dictate national policies incorporating ever-greater applications of force in Native American relations.

Connecticut's history is steeped in colonial pride as home to some of the most recognizable heroes of the American Revolution, such as Jonathan Trumbull and Roger Sherman, but it is also home to its greatest villain, Benedict Arnold. The same dichotomy holds true of other episodes in its history. During the Civil War, for example, Connecticut soldiers, both white and black, sacrificed as much as those of any state in the fight to maintain the Union and end slavery in the South, but the state was also among the least progressive to fight on the Union side, earning it the nickname the "Georgia of the North." While going to great lengths to promote its agricultural past, it actually made even greater contributions to national growth as a leader in industry through its production of automobiles, bicycles, firearms, textiles, submarines, helicopters, brass, silver and iron. It is a state of well-known inventors, artists, entertainers, athletes, politicians and criminals.

To complicate matters, Connecticut is a state with a well-publicized identity crisis. Situated between Boston and New York, the influences of these two major metropolitan areas often seem to split Connecticut in half, with a greater New York–style identity found in its western counties and a distinct Bostonian flavor in its east. To forge its own identity, Connecticut goes to

great lengths to promote some of the most cherished and recognizable icons of its past. These include such celebrated cultural treasures as the Charter Oak (found in the name of innumerable institutions in Connecticut, as well as on the back of its state quarter), its constitutional history (found in the state's nickname and on its license plates) and its prominent role in both maritime trade and the American Revolution (promoted in its tourism campaigns and at a significant portion of its heritage sites).

While these recurring fixtures of Connecticut scholarship promote comfort and continuity within the state's historical narrative, the primary motivation behind authoring this book was to shed light on the perhaps lesser-known facets of what it means to be a "Connecticuter." This work is a compilation of short, concise essays that mixes both the familiar and the traditional with the more complex and ambiguous. Many stories are celebratory in nature. Others are more critical. All, it is hoped, provide greater understanding of the diverse components that make up Connecticut's identity and encourage the reader to explore topics of interest in greater detail.

In addition to uncovering more about Connecticut than I previously experienced in nearly four decades of life here, the research that went into this book brought with it cognizance of joy, anger, curiosity, pride, resentment and confusion within me. It forced me to reevaluate my identity as a Connecticut resident—sometimes for the worse and other times for the better. It is my hope that the reader has a similar experience and finishes this work wanting to learn more.

JANUARY

January 1

The "Red Spy Queen"

Elizabeth Bentley was born in New Milford, Connecticut, on January 1, 1908. A graduate of Vassar College, Bentley attended graduate school at Columbia University, where her exposure to a wide range of worldly ideologies fostered a growing desire to join the Communist Party.

In 1938, Bentley took a job serving as a secretary for Jacob Golos, a Russian immigrant and spy with whom Bentley allegedly became romantically involved. Bentley went on numerous missions for Golos, usually acting as a courier. When Golos died in 1943, Bentley took on a leadership role in the spy ring.

While a valuable resource to the Russians, Bentley often

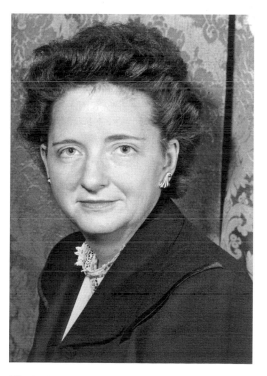

Elizabeth Bentley shortly after turning herself in to the FBI. *Library of Congress, Prints and Photographs Division, Miscellaneous Items in High Demand Collection.*

succumbed to bouts of depression and alcoholism, and the Russians began to characterize her work as "sloppy." In 1945, fearing for her safety, she renounced Communism and turned herself in to the FBI in New Haven. Her subsequent testimony before Congress revealed the identities of numerous Russian spies in America and helped usher in the paranoid era of McCarthyism.

January 2

The Opening of I-95

Motivated by opportunities for economic development, as well as by concerns for national security, President Dwight D. Eisenhower promoted the passage of the Federal Aid Highway Act in 1956. The bill approved increases in federal aid for the construction of multi-lane access routes between major metropolitan and industrial centers. Included in the plan was a stretch of highway running along the southern Connecticut coast connecting the borders of New York and Rhode Island. By later that year, Connecticut had forty-five individual projects underway focused on completing construction of the Connecticut Turnpike.

At 9:30 a.m. on January 2, 1958, the widow of former governor James McConaughly cut a ribbon in Greenwich that sent an official motorcade traveling along the 129-mile route of the new I-95 to Killingly. There, former governor John H. Trumbull cut the ribbon that opened the new highway to its connection with Route 6 and Providence, Rhode Island. Officials granted public access to the highway at 2:30 that afternoon.

Though the product of years of labor, costing taxpayers $464 million, I-95 was far from complete when it opened in early 1958. Several lanes and exit ramps remained inoperable, and the crews still needed to finish the eight toll stations along the route. In addition, the highway became a dead end in Greenwich, with no bridge available to cross the Byram River into New York. Officials redirected traffic there through Stamford and Greenwich and up on to the Merrit Parkway until New York completed its sections of the new highway.

January 3

Closing Out the Lieberman Era

A career encapsulating over forty years of public service came to a conclusion on January 3, 2013, with the retirement of Joe Lieberman from politics. Having served eighteen years at the state level and another twenty-four at the national level, Lieberman left politics and returned to his legal practice before joining a Chicago-based private equity firm.

Born in Stamford in 1942, Lieberman attended Stamford public schools before graduating from Yale in 1964 and Yale Law School in 1967. His political career began with an election to the state senate in 1970. He later served as the state's attorney general before defeating Lowell Weicker in 1988 to win election to the U.S. Senate. While in Washington, he served on the Committee of Governmental Affairs and became a vocal leader in advocating the creation of the Department of Homeland Security.

Lieberman's most recognized political endeavor came in 2000 when he joined Al Gore's presidential campaign and became the first Jewish American to seek the office of the vice presidency. After the loss in 2000, Lieberman launched an unsuccessful presidential campaign of his own in 2004. Two years later, he lost the primary for his senate seat, due largely to his support of the war in Iraq, forcing him to abandon the Democratic Party and run (successfully) as an independent. He represented Connecticut for an additional six years before finally retiring.

January 4

Connecticut's First Female Pilot

Born in Hartford in 1907, Mary Goodrich Jenson received an education in Verona, Italy, before attending the Katharine Gibbs School and then Columbia University. Her education helped kindle a passion for the written word, and Goodrich pursued a career in journalism.

She eventually took a job with the *Hartford Courant*, capitalizing on the burgeoning age of flight by becoming the newspaper's first aviation editor. While writing for the paper, she began taking flying lessons at Hartford's

Brainard Field, where she became widely known as "the girl pilot." In 1927, at the age of twenty, she became the first licensed female pilot in Connecticut.

In 1929, Goodrich joined Amelia Earhart and ninety-seven other female pioneers in forming the women's aviation support organization, the Ninety-Nines. Connecticut residents regularly witnessed Goodrich flying her Fairchild KR-21 throughout the state, and in 1936, when the German airship *Hindenburg* flew over Hartford, Mary Goodrich was its only female passenger. Later, she became the first woman to fly solo to the island of Cuba.

After briefly relocating to California, where she met her husband, Carl Jenson, and working for Walt Disney Productions, she returned to Connecticut in 1941. There, she supported the war effort through the promotion of the Women Flyers of America, who freed male pilots for military service by transporting supplies domestically.

Mary Goodrich Jenson spent most of her remaining years in Wethersfield. She died in Hartford Hospital on January 4, 2004, at the age of ninety-six.

January 5

Revolutionizing a Seemingly Simple Task

In 1810, British merchant Peter Durand forever changed the preservation and distribution of food by placing it in a sealed wrought-iron can made with a tin lining. The only drawback to Durand's design was that no easy way existed for consumers to get at the food once merchants sealed it inside. For decades, the prevailing practice called for cutting open cans with a hammer and chisel.

On January 5, 1858, Ezra Warner, a native of Waterbury, Connecticut, patented the first can opener in American history. His bayonet and sickle design required users to jab the bayonet into the top of the can and then use the sickle blade like a saw to cut it off.

The device was very popular with the U.S. Army during the Civil War but still proved quite difficult to operate. The more user-friendly version of the can opener—one with a cutting wheel—did not become available until 1870.

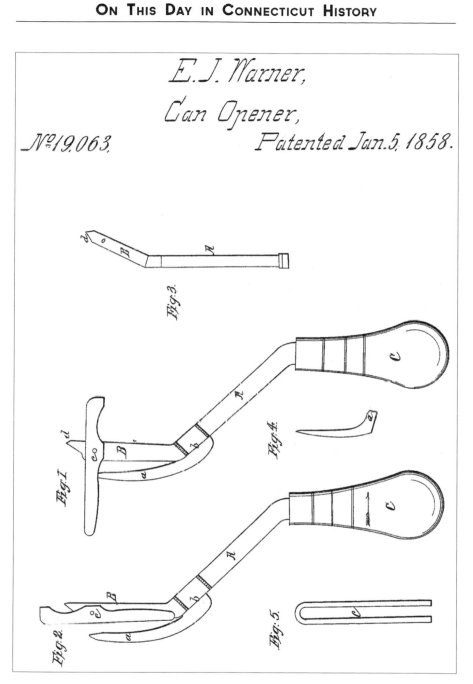

Ezra Warner's can opener patent. *United States Patent Office.*

January 6

The $40 Billion Woman

When Denise Nappier began her new job as Connecticut's state treasurer on January 6, 1998, she not only took over an office at the center of a high-profile corruption scandal but also became an unlikely pioneer of political office the likes of which the state had never seen. On that January day, Denise Nappier simultaneously became the first woman elected state treasurer in Connecticut's history, the first African American woman elected to any statewide office in Connecticut and the first African American woman elected state treasurer in the entire United States.

Born in Hartford in 1951, she served as Hartford's city treasurer for ten years (starting in 1989) before winning a tight election contest to become the state's treasurer in 1998. Nappier not only took on the challenge of managing $40 billion in state assets but also in revamping the image of her office. Her predecessor, Paul Silvester, pleaded guilty to accepting bribes and kickbacks from a $500 million investment of state pension funds he authorized while in office.

Nappier worked hard to bring new transparency to state operations, in part, through the passing of the state's Treasury Reform Act. She also played a fundamental role in expanding the Connecticut Higher Education Trust (CHET) and even co-chaired a 2005 United Nations summit on the financial implications of global climate change.

January 7

Hiram Bingham Resigns as Governor after Just One Day

Hiram Bingham III's career took him all over the world, as well as into the annals of Connecticut political history. Born the son of Connecticut missionaries in Hawaii, he attended Yale and then Harvard, where he developed an interest in Latin American history. In 1911, while serving as an adjunct professor at Yale, he led an expedition into the Peruvian Andes, where he "discovered" the famed Incan city of Machu Picchu—though he was not truly the first to uncover its existence.

After training pilots in France during World War I, he entered Connecticut politics, becoming the state's lieutenant governor in 1922 and then winning election as governor in 1924. Shortly after his election, however, Connecticut senator Frank Brandegee (amid failing health and growing debts) committed suicide, opening up a senate seat coveted by Bingham. Hiram Bingham won a special election to replace Brandegee, and so, on January 7, 1925, Bingham took the oath of office as Connecticut's governor, attended his inaugural ball that evening and then promptly resigned his position to go serve in Washington.

Bingham served as a Connecticut senator until 1933. His post-political career included banking, lecturing at naval training schools during World War II and authoring a highly successful book entitled *Lost City of the Incas*. He died on June 6, 1956, and received a burial at Arlington National Cemetery.

January 8

Eli Whitney: More Than Just the Cotton Gin

Born in Westboro, Massachusetts, in 1765, Eli Whitney graduated from Yale in 1792 and headed south to become a teacher. While tutoring the children of deceased Revolutionary War general Nathanael Greene in Savannah, Georgia, Whitney learned much about the production of cotton. A man possessing great mechanical aptitude, Whitney set about inventing a machine to rapidly clean the seeds from cotton fibers. The result was the cotton gin—a machine capable of producing fifty pounds of clean cotton per day (as opposed to the one pound per day produced when performing the process by hand).

Whitney returned to New Haven and opened a factory for producing cotton gins. Unfortunately, the factory burned in March 1795, and with the machines still in high demand, many farmers began utilizing Whitney's simplistic design to build cotton gins of their own. The patent infringement lawsuits that followed consumed much of Whitney's time over the next several years.

Tired of battling in the courts, Whitney changed career paths when he accepted a government contract to produce firearms in 1798. Without a factory, workmen or any knowledge of gun manufacturing, Whitney opened

an armory and went to work. He delivered the first five hundred guns in 1801 (three years late) and the last in 1809 (nearly nine years late). Though Whitney delivered the guns late and over budget, he helped design a system using interchangeable parts that later became the basis for mass production during the Industrial Revolution. This contribution to the growth of American industry, perhaps more than any other, became his legacy after his passing on January 8, 1825.

January 9

Connecticut Becomes a State

On May 25, 1787, delegates from twelve of the thirteen states (all but Rhode Island) met at the Constitutional Convention in Philadelphia. Their goal was to draw up plans for a new system of government to replace the relatively ineffectual Articles of Confederation passed in 1781.

The most contentious issue debated at the convention surrounded the size of each state's representation in the new government. Larger states argued for representation commensurate with the size of a state's population, while smaller states lobbied for equal representation for all states. In the end, Connecticut delegates Roger Sherman and Oliver Ellsworth designed a plan later deemed "the Connecticut Compromise," which created a bicameral legislature incorporating both systems—equal votes in the Senate with population size dictating the number of votes each state received in the House of Representatives.

After delegates signed off on the compromise, it fell to votes in each individual state to actually ratify the Constitution. Nine out of the thirteen states needed to vote in favor of this new form of government for it to take effect and so conventional delegates set to work rallying support in their home states.

On January 9, 1788, at the state convention in Hartford, Connecticut ratified the Constitution by a vote of 128–40, thus becoming the fifth state to enter the Union (after Delaware, Pennsylvania, New Jersey and Georgia). New Hampshire became the necessary ninth state on June 21 of that year, and the new U.S. Constitution took effect on March 4, 1789.

January 10

A Fighter for Independence from Independence

Revolutionary War hero Ethan Allen was born in the Connecticut village of Litchfield on January 10, 1738. He spent his youth working on the family farm, which he took over after his father's death in 1755. He then moved to Salisbury, where he operated an iron forge.

Service with the Litchfield County militia during the Seven Years' War took him up to the Hampshire Grants (modern-day Vermont), where he eventually bought property. There, he became head of a local militia known as the Green Mountain Boys, who fought to keep New Yorkers from claiming land in the Grants for themselves.

With the outbreak of the Revolutionary War, Allen turned his attention to fighting the British and, in 1775, led an expedition (along with Benedict Arnold) to capture Fort Ticonderoga in upstate New York. The cannon and other supplies he captured there later proved vital in forcing British troops to evacuate the city of Boston.

In the midst of the American war for independence, Allen helped Vermont launch its claim to independence from both Great Britain as well as the thirteen colonies. In 1777, Vermont declared itself an independent republic. Allen continued to fight for Vermont's independence right up until his death in 1789. Two years later, Vermont joined the Union as the nation's fourteenth state.

January 11

Professional Hockey Finds a Home at the Civic Center

The professional hockey franchise known as the New England Whalers emerged in November 1971 from an agreement between the World Hockey Association (WHA) and a group of New England businesses. Less than one year later, the team played its first professional game, defeating the Philadelphia Blazers 4–3 in front of fourteen thousand fans at Boston Garden.

The Whalers spent their first two years playing in Boston before making their debut in Springfield, Massachusetts, in 1974. The following year, the Whalers found a permanent home.

On January 11, 1975, the New England Whalers opened a new hockey facility at the Hartford Civic Center. Playing in front of a sell-out crowd of 10,507, the Whalers defeated the San Diego Mariners 4–3 in overtime and ignited a burgeoning love affair between a city and its new sports franchise.

Only three years after moving to the civic center, however, the roof of the building collapsed, forcing the Whalers to move their home games back to Springfield. The Whalers did not return to the civic center until February 6, 1980. By that time, they were a new expansion franchise in the National Hockey League (NHL) and had changed their name to the Hartford Whalers.

Unfortunately, the Whalers met with little success in Hartford. They won only one division title and accrued an overwhelming list of debts. Whalers ownership then announced their intention to move the team to Raleigh, North Carolina. On April 13, 1997, the Whalers played their last game in Hartford (a 2–1 victory over the Tampa Bay Lightning).

January 12

Mary Townsend Seymour

In 1917, the NAACP held an anti-lynching rally in Connecticut meant to further the cause of civil rights and bring an end to the persecution of African Americans in the United States. Moved by the groundswell of support demonstrated at the rally, several attendees began to discuss forming a much-needed local chapter of the fledgling civil rights organization. Shortly after, one of the rally's attendees, Mary Townsend Seymour, did just that, helping found the Hartford chapter of the NAACP.

Though headed by James Wheldon Johnson, Mary Seymour worked diligently to organize NAACP meetings that included such renowned civil rights leaders as Wheldon Johnson and W.E.B. DuBois, as well as female suffragists such as Mary Bulkeley and Katherine Beach Day. When Johnson joined the military during World War I, Mary stepped in and assumed the role of spokesperson for the organization.

In addition to her work with the NAACP, she joined the American Red Cross and worked with numerous charities that helped returning World War I veterans. She continued to lobby for a woman's right to vote and also

volunteered with the Colored Women's League of Hartford to teach women how to sew, cook and do laundry.

In 1920, she became the first African American woman in the country to run for state office when she campaigned for a spot in the General Assembly on the Farmer-Labor Party ticket. Although unsuccessful in her campaign, she remained active in African American political affairs right up until her death on January 12, 1957, at the age of eighty-four.

January 13

Furthering the "Power of Community" through Theater

The Reverend Horace Bushnell was not just a controversial theologian who challenged many of the sacred religious doctrines of his time—he was also a leader of the social purity movement and believed in the power of community to solve societal ills. Among the many contributions he made to the area in and around Hartford was the establishment of Bushnell Park. His death in 1876 inspired his youngest daughter, Dotha, to carry on his legacy through the establishment of yet another iconic Hartford institution.

In 1879, Dotha Bushnell married philanthropist Appleton Robbins Hillyer and began making plans to open a theater in memory of her father. She invested $800,000 in securities, which grew to over $2.5 million throughout the 1920s, and whether by sound planning or good fortune, removed the money from the market just prior to the 1929 stock market crash.

Dotha Bushnell Hillyer then hired the architectural firm of Corbett, Harrison and MacMurray (the men who designed Radio City Music Hall) to build her theater. On January 13, 1930, Horace Bushnell Memorial Hall (now the Bushnell Theater for the Performing Arts) opened to the public and has since gone on to provide theater, music and other forms of entertainment to over twenty-five million patrons.

January 14

The Hazardville Gunpowder Explosion

In 1837, Colonel Augustus George Hazard purchased a one-quarter interest in Loomis, Denslow and Company, a gunpowder manufacturer in Enfield, Connecticut. Born in 1802 in South Kensington, Rhode Island, Hazard worked as a house painter in Connecticut during his teenage years before moving to Georgia and then New York, where he became a very successful merchandising agent.

In the mid-nineteenth century, gunpowder manufacturing was a thriving business. Hazard became principal owner of a new corporate entity (the Hazard Powder Company) in 1843 and rapidly grew his business supplying the powder America needed to fight a war with Mexico, mine for gold and clear a path for new railway lines. In fact, over 40 percent of all the gunpowder used by the Union army during the Civil War came from the section of Enfield renamed "Hazardville."

Unfortunately, explosions set off during the manufacture of gunpowder were a common occurrence. In Hazardville, employees worked in mills sectioned off by large stone blast walls to minimize the damage from individual explosions. The company prohibited the use of iron or steel tools (that might create a spark) and made employees work on one-legged stools to keep them from falling asleep. Still, over eight decades in Harzardville, sixty-seven employees lost their lives in explosions. On January 14, 1913, the largest of all the explosions in the company's history killed two workers and virtually leveled the mill. The damage proved so extensive that the company decided not to rebuild and instead relocated any surviving machinery to a mill in Valley Falls, New York.

January 15

Train Wreck at Tariffville

On January 15, 1878, the Connecticut Western Railroad brought passengers to Hartford to attend a sermon by famous evangelist preacher Dwight L. Moody. Just after 9:00 p.m., the train left on its sixty-nine-mile

return trip back through western Connecticut on its way to New York's Hudson Valley.

Shortly after 10:00 p.m., the train crossed the bridge over the Farmington River at Tariffville. Just as the two locomotives pulling the train made it to the far side of the river, the bridge gave way. The force of the collapse flipped the first locomotive, and it landed upside down in the muddy riverbank. While the second locomotive and baggage car came down upright, the first passenger car fell into the river and sank. The second passenger car came halfway off the bridge, with its front end smashing the submerged roof of the first. The third also ended half on and half off the bridge, while all remaining cars remarkably stayed on the track.

In the end, thirteen people lost their lives in the Tariffville wreck—some were thrown from the cars, while others died in the icy water. Service to Tariffville resumed with the construction of a new bridge, but the New Haven Railroad soon purchased the line and discontinued its use.

January 16

The Yale "Grade Strike"

On December 7, 1995, members of the union representing roughly 650 graduate students at Yale University voted to go on strike—refusing to issue grades for undergraduate classes. Because the students received compensation for teaching, they wanted the university to recognize them as employees. Yale administrators responded by claiming that the teaching performed by graduate students was a part of their education and failed to qualify them as employees.

The strike intensified after the January 2 deadline for turning in grades passed without a resolution. On January 10, students (and some professors) held a noon rally attended by supporters from as far away as New York and Massachusetts. The rally resulted in the peaceful arrests of 138 protestors.

Yale University then increased the pressure on its graduate students by threatening to take away their teaching jobs for the spring semester. On January 16, 1996, the *Hartford Courant* reported an end to the strike. Rather than lose their jobs and tuition reimbursement, graduate students decided to return to work.

Yale graduate students were not the first graduate students to organize. At the time of their strike, graduate-student unions existed at eleven other schools. They did, however, bring renewed attention to the increasingly unsustainable model of graduate school education—that of universities producing PhDs in ever-greater numbers while simultaneously decreasing the job opportunities available to them due to university policies encouraging the hiring of cheaper, non-tenured faculty.

January 17

The Arrival of a Forty-Five-Ton Behemoth

At the start of the twentieth century, the expansion of prosperous Connecticut industries brought with it substantial new demands on the state's resources. Among the most pressing challenges was finding a way to produce enough electricity to support these companies and the growing populations they drew to industrial areas in the state. One solution, employed by the Hartford Electric Light Company, made history in 1901.

On January 17, 1901, a specially designed railcar of the New York, New Haven and Hartford Railroad stopped on Asylum Street in Hartford. It carried on its back a ninety-thousand-pound steam turbine–driven generator. Engineers carefully loaded the gigantic machine onto rollers and inched it along Asylum, Ford and Pearl Streets on its way to the electric company's powerhouse.

Built by the Westinghouse Machine Company of Pittsburgh, Pennsylvania, the generator was the first of its kind—capable of generating three thousand horsepower. Unfortunately for the Hartford Electric Light Company, engineers calculated that the water supply needed to power the turbine potentially required the entire capacity of the Connecticut River, so the company erected three cooling towers designed to capture the steam exhaust and condense it back into usable water. This allowed Hartford Electric to reuse the same water supply for almost an entire year.

Ten months after its arrival, workmen finally completed assembly of the generator. On October 5, 1901, the machine roared to life, and the Hartford Electric Light Company became the first public utility in America to utilize a steam turbine–driven power generator.

January 18

The Civic Center Roof Collapses

At 4:19 a.m. on the morning of January 18, 1978, a prolonged rumble heard throughout downtown Hartford signified the collapse of the Hartford Civic Center's roof. The previous evening, thousands of fans had packed the stadium to witness a basketball game between the UConn Huskies and the UMass Minutemen, but all vacated without incident hours earlier. Also, thanks to consecutive nights of basketball games played at the civic center that week, no crews remained inside after the game to change the floor over for the next event.

Investigators determined that the roof collapsed due to a number of factors that included mistakes made in its innovative, cost-saving "space truss" design. In addition, ten straight days of snow and ice accumulation on the 1,400-ton roof ultimately caused its supports to fail. The civic center reopened in 1980 sporting a new roof with a stronger railroad bridge truss design.

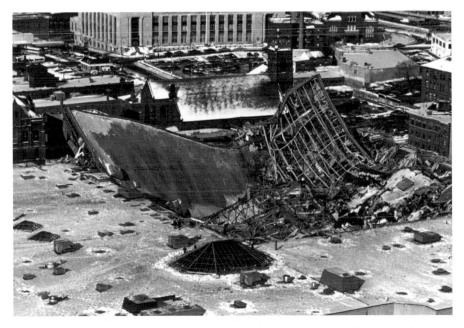

The collapsed roof of the Hartford Civic Center (1978). *Hartford History Center, Hartford Public Library.*

January 19

"Miss James"

Born on January 19, 1886, Anna Louise James had a father who served as a slave in Virginia before escaping to Hartford at age sixteen. Anna attended Arseneal Elementary School in Harford and, after moving to Old Saybrook, graduated from high school there in 1905. She then graduated from the Brooklyn College of Pharmacy three years later as the only woman in her class.

In 1909, James became the first female African American pharmacist in Connecticut when she chose to operate a drugstore in Hartford. Two years later, she moved to Old Saybrook to join a pharmacy owned by her brother-in-law, Peter Lane. Shortly after Lane left the business in 1917, James took over and changed its name to James Pharmacy.

For the better part of the next five decades, James operated her pharmacy on Pennywise Lane, living in the apartment above the business. She became a regular part of community life in Old Saybrook, known to local residents as "Miss James," a compassionate, thoughtful woman who cared for the sick and engaged in friendly conversation from behind her wildly popular soda fountain.

Miss James closed her business and retired in 1967 but continued to live in her upstairs apartment. Much to the consternation of town residents, Anna Louise James passed away on December 12, 1977.

January 20

A Tragedy at Windsor Locks Army Air Base

In early 1941, with war raging in Europe, the United States military actively sought locations for military bases along the East Coast. In response, Connecticut governor Robert A. Hurley petitioned the state assembly to acquire 1,700 acres of land used largely for tobacco farming in Windsor Locks. The state legislature approved his request, and the United States Army went to work building a new air base. They had it operational in a matter of months.

That summer, on August 18, 1941, members of the Sixty-fourth Squadron of the Fifty-seventh Pursuit Group arrived for training. Among them was twenty-four-year-old pilot Eugene M. Bradley. Bradley was a native of Oklahoma who had earned his pilot's wings just three months before coming to Windsor Locks. Accompanying Bradley on the trip was his wife, whom he had married just a few weeks earlier.

Three days after his arrival, Bradley participated in a routine training exercise at the airfield. Engaged in a mock dogfight at roughly two thousand feet, Bradley put his Curtiss P-40 Warhawk into a dive from which he could not recover. The plane crashed into the nearby woods, and Eugene Bradley became the first fatality suffered at the new airfield.

Nearly five months later, on January 20, 1942, the United States War Department announced it was changing the name of Windsor Locks Army Air Base to "Army Air Base, Bradley Field, Connecticut." While known informally as Bradley Field for the remainder of the war, Connecticut residents recognize the airfield today as Bradley International Airport.

January 21

The Navy Goes Nuclear

In July 1951, the United States Congress authorized the construction of the world's first nuclear-powered submarine, the USS *Nautilus*. After President Harry Truman attended the keel laying in Groton, Connecticut, in June 1952, completion of the revolutionary craft took approximately one and a half years.

First Lady Mamie Eisenhower took center stage at the Electric Boat Division of General Dynamics in Groton on January 21, 1954, and officially launched the submarine corps into the nuclear age. The boat slipped gingerly into the water of the Thames River at 10:57 a.m.

The *Nautilus* cast off on its first voyage one year later. Thanks to its nuclear propulsion system, the ship traveled farther and faster than any sub in history. In August 1958, it became the first ship to cross the North Pole, and roughly eight years later, it broke a naval record when it logged its 300,000th mile in service.

The final voyage of the *Nautilus* took place in 1979, and the navy decommissioned the ship on December 3, 1980. After nearly eighteen

months in retirement, the ship received a designation as a National Historic Landmark, and a year later, Connecticut named the *Nautilus* its official state ship.

January 22

Waterbury's "Mad Bomber"

It was on November 16, 1940, that New York police first encountered the workings of a new serial bomber. An undetonated bomb found on the windowsill of the Consolidated Edison Company (Con Ed), along with a threatening note, alerted them to his presence. Police found a second undetonated bomb nearby roughly a year later. It was not until the 1950s, however, that the bombs began exploding.

Bombs detonated at high-profile New York locations like Radio City Music Hall and the Grand Central Terminal rattled the nerves of New Yorkers but injured very few. After the planting of thirty-two bombs over a sixteen-year period, police released a public profile of the "Mad Bomber." Shortly after, the *Journal-American* newspaper published correspondence it received from the suspect, and an employee at Con Ed recognized the handwriting.

On January 22, 1957, police arrested former Con Ed employee George Metesky at his home in Waterbury, Connecticut. Metesky, fifty-four, was single, the son of Lithuanian immigrants and living in a house with his two sisters. Injured in a boiler explosion at Con Ed in 1931, he sought revenge against the company for denying his disability claims.

Authorities diagnosed Metesky with paranoid schizophrenia and, after he refused legal counsel, sentenced him to seventeen years in a state mental health facility. Upon his release in 1973, he returned to his Waterbury home but ultimately moved to Torrington, where he passed away in May 1994. Authorities later converted his home into a treatment facility for the mentally ill.

January 23

The Pluto Platter

When the machines at the Wham-O toy company fired up on January 23, 1957, they began making large quantities of plastic discs called "Pluto Platters." It was a toy that made the company millions of dollars and may have actually traced its origins back nearly one hundred years to a small bakery in Bridgeport, Connecticut.

In 1871, baker William Frisbie opened the Frisbie Pie Company in his new hometown of Bridgeport. Shortly after (as one version of the story goes), university students began taking the tins in which Frisbie sold his pies and turning them into toys. They threw them back and forth, yelling "Frisbie" every time they let one go.

Decades later, inventors Walter Frederick Morrison and Warren Franscioni decided to make a plastic version of the flying pie tin; they called it the "Flying Saucer." After Morrison split with Franscioni, Morrison updated the design and sold it to Wham-O as the "Pluto Platter."

It took roughly a year for Wham-O to change the name from "Pluto Platter" to "Frisbee" (supposedly upon hearing the story about the Bridgeport bakery). After the name change and some small tweaks to the design, the company sold over 100 million Frisbees in the next twenty years. The Mattel Toy Company bought the design from Wham-O in 1994, and today dozens of companies continue to produce a variety of different versions of the Frisbie pie tin.

January 24

Connecticut's Hall of Fame

In order to educate residents about some of the state's most accomplished scientists, athletes, politicians, entertainers and business leaders, on January 24, 2005, legislators announced the creation of the Connecticut Hall of Fame. Funded by individuals, grants and private corporations, the hall of fame resides on the second floor of the Legislative Office Building in Hartford.

Every year, hall of fame committee members review nominations received from the Connecticut Historical Society, the State Library and other organizations—as well as from individuals—and award enshrinement to those who distinguished themselves in their chosen pursuits and professions. The committee announced the first class of inductees on February 21, 2007. It included such renowned figures as Katharine Hepburn, Mark Twain and Igor Sikorsky. Honored annually at "Connecticut Hall of Fame Day" with their names emblazoned in bold brass letters along the wall, subsequent inductees include Jackie Robinson, Harriet Beecher Stowe, Roger Sherman, Noah Webster, Paul Newman and Geno Auriemma.

January 25

Mohegan Nation of Connecticut Land Settlement Claims Act

The history of the indigenous Mohegan tribe in Connecticut is one of early peaceful coexistence with English settlers. Most famously, the Mohegan people teamed up with the English, as well as with the Niantic and Narragansett tribes, to raid the settlements of the more hostile Pequot tribe and push them out of the area in the seventeenth century.

In recognition of their service, Connecticut's leaders granted 2,700 acres of land to the Mohegan people. By the end of the nineteenth century, however, the state had managed to reclaim all of this land and did so without approval from the federal government.

After applying for federal recognition in 1978, the Mohegan tribe filed a lawsuit in 1981 to regain its Connecticut lands. The issue finally came to a head shortly after the second session of the 103rd Congress began on January 25, 1994. Members of this congressional session finally acted on the issue by approving the Mohegan Nation of Connecticut Land Settlement Claims Act, which designated 240 acres of land in southeastern Connecticut as a Mohegan reservation. Today, this land is home to the Mohegan Sun casino.

While maybe the most well-known Native American settlement act in Connecticut, the 1994 act was not the first of its kind. In 1983, the Mashantucket Pequots won federal recognition and, nine years later, opened Foxwoods casino. Despite the success of the Mashantucket Pequots and

the Mohegans in reclaiming some of their territorial holdings, dozens of other tribes, such as the Schaghticoke, Paugussetts and Paucatuck Eastern Pequots, have yet to meet with equal success.

January 26

Banning African Americans from Carrying the Mail

Gideon Granger was a Connecticut lawyer born in Suffield in 1767. He served ten years in the state legislature before Thomas Jefferson appointed him the nation's fourth postmaster general.

Granger took office on January 26, 1802, and served under both Jefferson and James Madison before resigning from his position in 1814. Among his most recognized accomplishments was the effective manner in which he managed the expansion of postal service after the Louisiana Purchase.

Granger took office, however, shortly after a slave uprising in St. Domingue (modern-day Haiti) manifested itself in heightened fear and paranoia among slaveholders in the American South. While Granger's predecessors either tolerated or supported the use of slaves in carrying the mail, Granger felt the practice too dangerous and lobbied to terminate it.

Congress listened and, on May 3, 1802, passed a law allowing only "free whites" to deliver mail. It then expanded the ban in 1828 by requiring white supervision over the loading and unloading of all mail carriages. It was not until 1862 that Congress finally lifted the ban on African Americans delivering mail.

January 27

Father of the Connecticut National Guard

Stephen Wright Kellogg was a farmer from Shelburne, Massachusetts, who attended Amherst College and Yale University before settling in Waterbury, Connecticut, in 1854. He opened a legal practice there before involving himself in state politics. He served in the state senate in 1853 and the statehouse of representatives in 1856.

At the outbreak of the Civil War, Kellogg organized the Connecticut "National Guard," being the first to utilize the term that would become popular with states across the nation. He served as colonel of the Second Regiment of the guard from 1863 until 1866, when he rose to brigadier general.

He served as Waterbury's city attorney for three years—playing an instrumental role in bringing water and sewer systems to the city—before, in 1869, becoming the first Waterbury resident elected to Congress. He served three terms in Congress, where, among his many achievements, he helped design the system of power succession utilized in the event that a president of the United States dies in office.

After six years in Congress, he returned to Connecticut to practice law. He died in his Waterbury home on January 27, 1904.

January 28

The First Commercial Telephone Exchange

Inside New Haven's Boardman building on January 28, 1878, three men (George W. Coy, Herrick P. Frost and Walter Lewis) launched the District Telephone Company of New Haven—the world's first commercial telephone exchange. In the three years since Alexander Graham Bell's invention of the telephone, existing technology limited telephone use to those willing to lease two phones and hire someone to run a single line between them. The telephone exchange was a switchboard that allowed a person to purchase a single phone and call anyone else with phone service.

George Coy designed the switchboard after attending a lecture by Alexander Graham Bell at the Skiff Opera House in New Haven on April 27, 1877. Using some makeshift electronics equipment, $600 of borrowed capital and some old empty boxes for office furniture, Coy, Frost and Lewis initially provided service to just twenty-one subscribers for a fee of $1.50 per month. Though the company maintained eight lines, the equipment proved capable of handling only two conversations at any given time.

The service proved wildly successful, and the company rapidly expanded its customer base. By 1882, the District Telephone Company had become a part of the new Southern New England Telephone (operated by former

Connecticut governor Marshall Jewell). The Boardman building where Coy, Frost and Lewis made history received a designation as a National Historic Landmark in 1964, but authorities revoked its designation in 1973, when urban renewal plans brought about the building's demolition.

January 29

Plymouth Hollow Runs Like Clockwork

Seth Thomas, born in Wolcott, Connecticut, in 1785, was a man of very little formal education. Consequently, he made a living by apprenticing himself to a carpenter to build houses and barns. His skill caught the eye of clockmaker Eli Terry, who hired Thomas in 1807 to fabricate the many intricate wooden gears used in clock making.

In 1813, Thomas opened his own clock-making shop in Plymouth Hollow. He purchased the rights to Terry's revolutionary clock shelf—revolutionary because it was small enough to fit on a shelf. Rolling his own brass

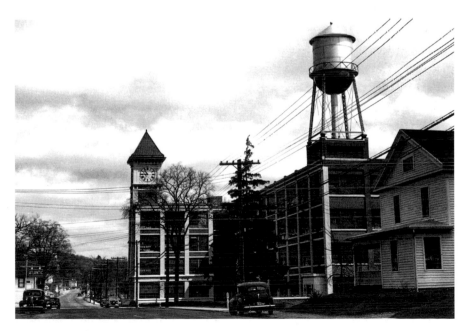

Seth Thomas Clock Factory, Thomaston (1949). *Archives and Special Collections of the University of Connecticut Libraries and AT&T.*

components and standardizing the fabrication process, Thomas made some of the most popular clocks of the early nineteenth century.

Forty years after striking out on his own, Thomas reorganized his operation into the Seth Thomas Clock Company. His operation proved so successful that two years after his death, the state incorporated the area around his factory as the new town of Thomaston.

January 30

The Great Raid

In the early Pacific Theater battles of World War II, the Japanese military moved swiftly across the Asian continent. By the time U.S. general Douglas MacArthur abandoned the Philippines, the Japanese held tens of thousands of American prisoners. These men faced disease, starvation and brutal physical abuse. In one three-day forced march, known later as the Bataan Death March, Japanese soldiers shot or stabbed more than fifteen thousand prisoners.

As word of Japanese atrocities made it back to the United States, American officials designed a plan to rescue soldiers at one particularly brutal camp near the city of Cabanatuan in the Philippines. The man they chose to lead what became known as the "Great Raid" was a thirty-three-year-old West Point graduate from Bridgeport, Connecticut, named Henry Mucci.

Mucci, a survivor of the attack on Pearl Harbor and a trainer of elite fighting units, launched his raid on January 30, 1945. With four hundred army rangers and Filipino guerrillas, Mucci snuck his way thirty miles behind Japanese lines and rescued the 511 prisoners who remained out of an original population of over 10,000. He returned home as one of Connecticut's most celebrated war heroes.

After the war, Mucci made an unsuccessful bid for public office before going to work in the Far East as a representative of a Canadian oil company—though many speculated he was secretly working for the CIA. He retired to Florida, where he died in 1997 at the age of eighty-eight.

January 31

The Kohanza Dam Bursts

In the middle of the nineteenth century, the rapid growth of the hat industry in Danbury necessitated the construction of reservoir dams to provide a reliable source of power and water to the surrounding area. Engineers completed a 336-foot-long dam along the lower Kohanza reservoir in 1860, followed by a second along the upper reservoir in 1865. In the years that followed, the dams helped provide for both the expansion of industry and the growth of local populations.

Around 7:00 p.m. on the night of January 31, 1869, however, a large build-up of ice in the upper reservoir contributed to the collapse of the upper dam. The sudden rush of water downstream washed away the lower dam, adding another forty million gallons of water to the flow headed toward Danbury. After destroying the recently reconstructed Flint's dam, the deluge of water, carrying with it trees, chunks of ice and boulders, roared into town.

The flood took out bridges at Main Street, White Street and Balmforth Avenue and lifted buildings right off their foundations. In the end, eleven people perished in the flood, including an entire family belonging to a Mr. A. Clark living in the north end, when the flood carried away their home with all its occupants still inside.

FEBRUARY

February 1

A Harvard President Saves the Country's National Treasures

Born on May 10, 1789, in Willington, Connecticut, Jared Sparks was one of nine children brought up in a family of modest means. In order to relieve his parents of some financial burden, Sparks lived with an aunt and uncle in New York before finding work as a carpenter and schoolteacher and then entering Harvard.

After graduation, he became a minister in Baltimore, Maryland, and then served as a chaplain for the United States Congress but resigned shortly after to pursue literary interests. He returned to Massachusetts and founded the *North American Review*—soon to be one of the most respected literary journals in the country.

A belief in the importance of preserving history for future generations drove Sparks to begin collecting the papers of the nation's founding fathers. In 1827, he began researching the life of George Washington and published a twelve-volume biography of the country's first president. He published other works as well, such as a biography of Benjamin Franklin and a compilation of diplomatic correspondence of the American Revolution. He also used his journal as a platform to call on the nation to archive and preserve historical manuscripts and other artifacts.

In 1838, he became a history professor at Harvard—a position he held for ten years. Then, on February 1, 1849, he accepted an appointment as president of the university. He served as president for four years before a distaste for administrative duties motivated him to resign. He spent his remaining years in Cambridge collecting and preserving the nation's early historical records.

February 2

The World's First Two-Sided Building

The Phoenix Mutual Life Insurance Company unveiled plans on February 2, 1961, for one of the most remarkable architectural landmarks in Connecticut. The plans called for the company's new Hartford office to be housed in a sleek, fourteen-story building consisting of only two sides.

The company hired Max Abramovitz—one of the country's leading architects—to provide a uniquely modern yet functional workspace. The result was the two-sided Phoenix Mutual Life Insurance Building, a structure that reminded so many of the conning tower of a submarine that it quickly earned the nickname "the boat building."

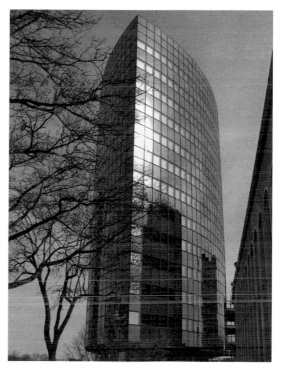

The Phoenix Mutual Life Insurance Building in Hartford. Public domain image.

The structure proved so popular that over twelve thousand visitors toured the building in the first year after its opening. It not only earned a place on the National Register of Historic Places but also, and more importantly, helped keep the Phoenix Mutual Life Insurance Company in Hartford—its home since 1851.

February 3

America's First Mass Murder

In the late fall of 1779, New Milford flax farmers Caleb and Jane Mallory hired a down-on-his-luck farmhand named Nicholas Davenport. Davenport was from a local family of mill owners and went right to work in the Mallory's fields, using his large wooden swingle to harvest flax for linen.

What the Mallorys did not know was that the man they knew as Nicholas Davenport was really nineteen-year-old Barnett Davenport, Nicholas's older brother, a horse thief, robber and army deserter. Around midnight on February 3, 1780, Barnett Davenport snuck through the Mallorys' house, stealing anything he found of value. He then proceeded up to the Mallorys' bedroom with his swingle and bludgeoned the Mallorys and their young granddaughter in their beds.

Startled by the noise, the Mallorys' other two grandchildren inquired about its source, and Davenport reassured them everything was fine and put them back to bed. Groans from the master bedroom brought Davenport back in, this time swinging a musket to replace the swingle he had shattered in his first attack. Davenport then proceeded to change out of his bloody clothes before grabbing some cash and additional loot. On his way out, he set the house on fire, killing anyone left alive.

Thanks to the mistaken identity, authorities originally arrested Nicholas Davenport before catching up with Barnett in Cornwall six days later. Barnett Davenport received forty lashes for his crime, and then authorities brought him up to Litchfield and, on May 8, 1780, hanged him.

February 4

The Colt Armory Burns

Workers at the Colt Armory in Hartford arrived at work on February 4, 1864, like they did on any other day. They started their shift around 7:00 a.m., but just over an hour later, someone noticed smoke coming from the attic over the polishing room. A steam gong sounded, raising the alarm, and workers grabbed a fire hose and rushed toward the attic, only to find the

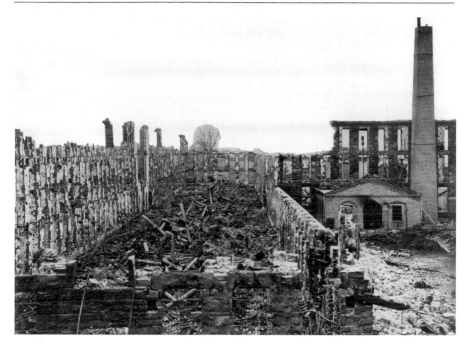

Remains of the Colt Armory after the fire. *Armory Fire, PG 460, Colt Patent Firearms Manufacturing Company, State Archives, Connecticut State Library.*

hose had no water pressure. They evacuated, saving whatever machinery they could.

By 9:00 a.m., the fire had consumed the entire building, even reaching across a covered bridge to engulf the business office. The disaster caused approximately $2 million in damages and one death. While Samuel Colt never bothered to insure his building, luckily after his death two years earlier, his widow, Elizabeth Colt, did. Consequently, she decided to have the factory rebuilt. Contractors finished the new brick building three years later.

February 5

A Dog of War

In the summer of 1917, the army's 102nd Infantry of the Twenty-sixth Yankee Division trained for battle in World War I on the fields of Yale University. One day, a stray brindle puppy with a short tail wandered

into camp, and Private J. Robert Conroy adopted him—giving him the name "Stubby."

When the 102nd shipped off for France, Conroy smuggled the dog aboard ship. Upon arriving in Europe, Stubby received special orders that allowed him to travel to the front. He arrived there on February 5, 1918.

A German gas attack soon sent Stubby to the hospital, but he made a full recovery and returned to the lines able to bark a warning to troops at the presence of even trace amounts of gas. He also proved valuable in finding wounded soldiers and even once caught a German spy mapping out the Allied trenches. For this he received a promotion to sergeant and became the first dog ever given a rank in the U.S. Army.

In April 1918, the Germans retreated from the town of Schieprey, lobbing grenades at the advancing Allies. Standing on top of a trench, Stubby took shrapnel in the chest and leg. Again in the hospital, once he recovered, he spent his time walking around and visiting wounded soldiers.

After the war, Stubby, a veteran of seventeen battles, received visits from Presidents Wilson, Harding and Coolidge. He then accompanied Robert Conroy to Georgetown Law School, where he became the Hoyas' mascot.

February 6

The American Revolution on Canvas

The artist John Trumbull was born the son of Connecticut governor Jonathan Trumbull on June 6, 1756. He attended Harvard and served briefly as George Washington's aide-de-camp during the Revolutionary War before heading to London to study art under renowned painter Benjamin West. In 1784, at West's suggestion and with the encouragement of Thomas Jefferson, Trumbull began creating a series of historical paintings focusing on the American Revolution.

His work caught the eye of important national figures in Washington, and on February 6, 1817, Congress authorized President James Madison to commission four works from Trumbull for hanging in the capitol rotunda. Trumbull completed the works in 1824, which included *Washington Resigning His Commission*, *The Surrender of Cornwallis*, *The Surrender of Burgoyne* and, perhaps most famously, *Declaration of Independence*.

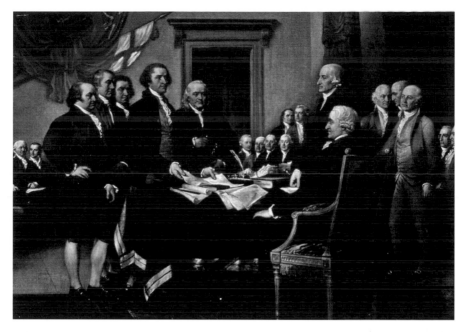

U.S. Capitol painting, *Declaration of Independence*, by John Trumbull. *Library of Congress, Prints and Photographs Division, Horydczak Collection.*

February 7

The Birth of Electric Boat

In 1888, John P. Holland won a U.S. Navy competition for his design of the first modern submarine. He formed the Holland Torpedo Boat Company with Elihu B. Frost in 1893 and went to work building boats for the navy. Their *Holland VI* submarine made its first dive in March 1898 and became the company's first sub purchased by the government.

Complaints about sluggish performance, however, prompted Holland to make expensive renovations to the design. The money came from Isaac Rice (a man who controlled the Electric Launch Company and the Electro-Dynamic Company), and Rice and Frost incorporated the business as the Electric Boat Company on February 7, 1899.

The company made six more subs for the U.S. government before seeking out overseas customers. By the start of World War I, the company possessed over one hundred orders for new submarines from governments all over the world.

Though the superiority of German U-boats in World War I strained the company's relationship with the U.S. Navy, the company continued to produce boats for foreign customers, including four subs for the government of Peru that became the first four boats built at Electric Boat's own shipyard in Groton.

After repairing relationships with the U.S. government in time to build submarines for use in the Second World War, Electric Boat helped the U.S. Navy enter the nuclear age with the launching of the world's first nuclear submarine in 1954 and, in 2003, acquired the largest submarine order in U.S. history—an $8.7 billion order for six Virginia-class subs.

February 8

Protecting Ohio

A Connecticut blacksmith born in 1747, Elijah Wadsworth took up arms against the British after the battles at Lexington and Concord. He served as captain of the Second Continental Light Dragoons and later guarded British major John André after his capture for helping Benedict Arnold commit treason.

After the war, Wadsworth became one of the first members of the Connecticut Land Company—a private corporation that purchased Connecticut's Western Reserve (modern-day northeastern Ohio) from the State of Connecticut in 1795. He spent the summers of 1799, 1801 and 1802 on the reserve before packing up his family and resettling there in the fall of 1802.

On February 8, 1803, following Ohio's admission to the Union, Wadsworth became sheriff of Trumbull County, Ohio, and later placed at the head of the militia charged with protecting one-quarter of the state. During the War of 1812, he once again took up arms against the British, this time as a general, fighting to protect Cleveland, Akron and other sites of strategic importance along Ohio's western frontier.

Service in the war took a tremendous toll on Wadsworth's health, and he suffered a stroke that left him paralyzed on his left side. He died just a few years later on December 30, 1817.

February 9

A Polarizing Pioneer

Born on February 9, 1953, in Waterbury, Connecticut, Gary Franks became a polarizing figure in American politics. He was a graduate of Yale who worked for three Fortune 500 companies and became a successful real estate mogul before, in 1990, becoming the first African American elected to Congress from Connecticut and the first black Republican elected from any state in over fifty years.

Franks became a divisive figure for a number of reasons. He arrived in Congress amid allegations that he owed tens of thousands of dollars in personal loans resulting from past real estate transactions. Once in office, he created a divide in the Republican Party by supporting affirmative action but upset many in the African American community with his conservative approaches to other political issues, including his support of conservative Supreme Court judge Clarence Thomas. He won reelection to the House in 1994 despite opposition from the NAACP and his exclusion from meetings of the Congressional Black Caucus.

While a rising figure in the Republican Party, Franks published his autobiography in 1996. Already criticized for making himself unavailable to his constituency, the book tour associated with his autobiography only made Connecticut voters feel more neglected. Franks ultimately lost the 1996 election. His political career came to an end two years later with a failed challenge to win the Senate seat held by Democrat Chris Dodd.

February 10

Tom Thumb Gets Married

Charles Sherwood Stratton was just a young boy when the famous showman P.T. Barnum discovered him in Bridgeport, Connecticut. Barnum saw a marketing opportunity in Stratton's diminutive size—he only grew to be thirty-six inches tall—and by age eleven, Stratton toured the world as "General Tom Thumb."

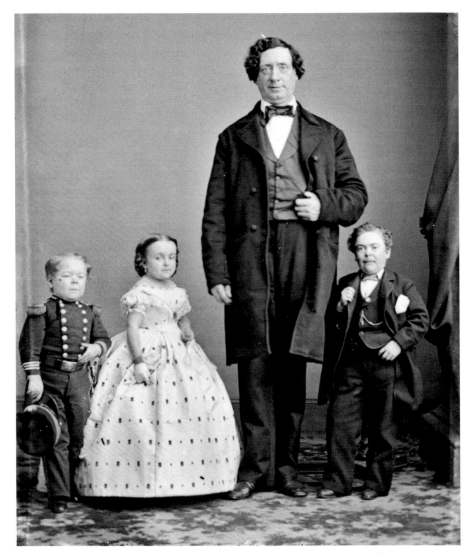

Charles Stratton (far right) with Lavinia Warren (second from left). *Library of Congress, Prints and Photographs Division, Brady-Handy Collection.*

Stratton was an international celebrity by the time he met and fell in love with another of Barnum's discoveries, Miss Lavinia Warren—herself between thirty and thirty-two inches tall. The two married on February 10, 1863, at Grace Episcopal Church in Manhattan, to great fanfare. While Barnum did not sell tickets to the wedding, he did sell tickets to the reception (at the Metropolitan Hotel) for seventy-five dollars apiece.

Stratton and Warren honeymooned at the White House—thanks to an invitation from Abraham and Mary Todd Lincoln—before touring the world as husband and wife. They remained married until Charles's death from a stroke in 1883.

February 11

A Visit from Charles Dickens

In the early months of 1842, celebrated author Charles Dickens began a tour of the United States that lasted nearly six months. He began his tour in Boston before moving on to Worcester, Massachusetts. From there, he took a railroad car to Springfield and then hopped on a small steamboat and traveled down the Connecticut River to Hartford.

He arrived in Harford on the afternoon of February 7. While there, he visited the statehouse and a mental hospital and attended a reception for seventy guests at the City Hotel. After four days in Hartford, Dickens headed by rail to New Haven.

Due to the short duration of his stay in their city, New Haven leaders feared being greatly outshined by the fanfare afforded Dickens in Hartford. The city's residents soon allayed those fears, however. Within an hour of Dickens's arrival in New Haven on the evening of February 11, 1842, throngs of fans and curious residents of all classes clogged the streets outside the Tontine hotel where the author stayed.

Admirers then packed the hotel lobby, encouraging the Tontine's leadership to request Dickens come out of his room for a reception. After an escort to a reception room, Dickens spent the next several hours greeting his fans. To prevent a crushing stampede, security personnel blocked the stairwell to the reception room, allowing admirers to meet Dickens only in small groups. The festivities lasted until 11:00 p.m., with Dickens finally making it back to his room around midnight. He left for New York the next day.

February 12

Connecticut Pays Tribute to Sherlock Holmes

William Gillette was an actor, producer and playwright born in Hartford on July 24, 1853. The son of a U.S. senator and a descendant of Connecticut founder Thomas Hooker, Gillette became perhaps the most popular stage actor of his era after assuming the role of the famous fictional detective Sherlock Holmes.

Gillette made his first appearance on stage in 1875, but it was his 1899 stage adaptation of Sir Arthur Conan Doyle's Sherlock Holmes stories that catapulted Gillette into international stardom. Casting himself in the lead role, Gillette wowed audiences in New York and then in England. The success of the play even landed Gillette his only motion picture role, starring in the 1916 feature *Sherlock Holmes*.

On February 12, 1930, Gillette reprised the role that made him famous for two days of performances at the Parsons Theatre in Hartford. To acknowledge his contributions to the arts, various civic organizations met in the office of Howard Bradstreet, the director of adult education at the Old State House, and planned a celebratory luncheon at the Hartford Club on the first day of Gillette's performance. Four hundred ticketholders attended the event, while scores of others listened to it live on the WTIC radio broadcast.

William Gillette died on April 29, 1937. The provisions he made in his will directed its executor to ensure Gillette's 1919 stone castle home he built in East Haddam did not fall into the hands of some "blithering saphead." Consequently, the state purchased the land in 1943 and turned it into Gillette Castle State Park.

February 13

Bicentennial Gold

It was at the age of eight that Dorothy Hamill, living in Greenwich, Connecticut, received her first pair of ice skates. The following year, she entered her first competition and by the age of fifteen devoted nearly all her free time to training.

In 1976, Hamill won both the U.S. National Championship and the World Championship prior to heading to the Olympics in Innsbruck, Austria. On February 13, 1976, the nineteen-year-old Hamill won the Olympic gold medal for her freestyle performance—scoring nothing lower than a 5.8 out of 6.0 for her technical skating and all 5.9s for the artistic portion of her program.

After the Olympics, the contract offers poured in, including a lucrative offer from the Ice Capades that helped make Hamill the first athlete to earn more than $2 million in each of her first two years as a professional. In addition, her "wedge" haircut became one of the most popular style trends of the 1970s.

Hamill was the last figure skater to win an Olympic gold medal without attempting a triple jump. She received induction into the U.S. Olympic Hall of Fame in 1991, the World Figure Skating Hall of Fame in 2000 and the Connecticut Women's Hall of Fame in 2007.

February 14

A Blast from East Canaan's Past

Dormant for nearly one hundred years, the Beckley blast furnace quietly resides in the hills of East Canaan. The forty-foot-high stone structure acts as a stoic reminder of a time when northwestern Connecticut hosted a thriving iron industry. The pig iron that once came out of the Salisbury Iron District helped drive the expansion of industry throughout the United States.

Built in 1847 by John Beckley, the furnace originally measured thirty-two feet high and thirty feet square at its base. The Barnum and Richardson Company purchased the furnace in 1858 and used it to forge iron of exceptional quality used primarily in railway car wheels in Connecticut and Chicago.

Horses originally brought iron ore to the forge from a nearby mine, and Beckley's operators took advantage of local forests for supplies of charcoal and the swift-moving Blackberry River for power. As operations moved into the twentieth century, however, depleted forests required the import of charcoal from other sources, and ore deposits became increasingly difficult to find.

In the winter of 1918–19, furnace operations came to an end at Beckley. This came partly from a decreased demand for iron caused by the end of World War I and by the expansion of the steel industry in western Pennsylvania. The Beckley site fell into disrepair until civil engineer Charles Rufus Harte successfully lobbied for its preservation as a state park in 1946. Thirty-two years later, on February 14, 1978, the Beckley furnace earned a listing on the National Register of Historic Places.

February 15

A Physical Altercation on the Floor of Congress

Prior to Roger Griswold serving as governor of Connecticut, he served ten years in the U.S. House of Representatives. Three years into that term, in the early months of 1798, Vermont representative—and anti-Federalist—Matthew Lyon accused Connecticut representatives (including

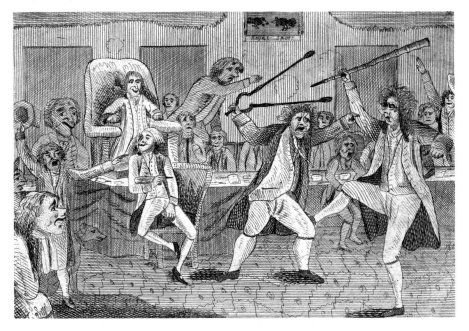

Artist depiction of the Roger Griswold attack (1798). *Library of Congress, Prints and Photographs Division, Cartoon Prints, American.*

Federalist Roger Griswold) of ignoring the needs of their constituents. Griswold responded by calling Lyon a coward for the manner in which the Continental army dishonorably discharged him (albeit temporarily). Lyon responded by spitting tobacco juice in Griswold's face.

On February 15, 1798, after two weeks of debate, a vote regarding whether or not to expel Lyon from the House fell several votes short of requiring his dismissal. Griswold promptly walked over to Lyon and began assaulting him with a hickory walking stick. Lyon defended himself with a pair of fireplace tongs, and congressional members jumped in to pull the two apart as they began landing fists on each other.

February 16

Roger Sherman

In addition to being New Haven's first mayor, Roger Sherman was one of the most important statesmen in early U.S. history. Born in Newton, Massachusetts, in 1721, Sherman moved to New Milford, Connecticut, after the death of his father in 1741. There, he taught himself surveying and then studied law and became the justice of the peace for Litchfield County in 1755.

After the death of his wife in 1760, Sherman moved to New Haven and, soon after, won election to the state's General Assembly. His service to the state earned him a position in the Continental Congress, where Sherman served on both the committees that drew up the Declaration of Independence and the Articles of Confederation.

Shortly after his return from years in Congress, on February 16, 1784, Sherman won election as the first mayor of the newly incorporated city of New Haven. It was a position he maintained for only a short period, however, as the country needed his service to help draw up a new constitution in 1787.

Sherman then served in the House and the Senate until returning to New Haven due to ill health. He died of typhoid fever on July 23, 1793, as the only man to sign all four of the most significant political documents in the country's early history—the Continental Association from the first Continental Congress, the Declaration of Independence, the Articles of Confederation and the United States Constitution.

February 17

The End of County Government

When Connecticut governor Abraham Ribicoff addressed the state legislature on February 17, 1959, it was to detail his plan for eliminating county governments in Connecticut. County government was a system utilized since the mid-1600s that provided an extra layer of regional authority. By the middle of the twentieth century, however, improvements to transportation and communication networks allowed towns greater access to officials at the state level, eliminating the need for county middlemen. The move aimed to lessen the $2.5 million annual burden paid to county officials by towns and the state.

The elimination of county government meant the end to county commissioners and treasurers, as well as the position of the county sealer of weights and measures. The state took over these functions, as well as administration of all county buildings. In addition, the bill evicted eight county sheriffs from their homes attached to county jails and turned these facilities over to the state.

The new laws took effect on October 1, 1959. To allow county workers to find work, as well as to scrub all state statutes of any reference to county governments, the abolition of county government did not officially take place until a year later.

February 18

Playing Baseball with Cosmetic Cases

David N. Mullany lived in Fairfield, Connecticut. He played baseball at the University of Connecticut before accepting a position at a pharmaceutical company. Upon losing his job in the 1950s, Mullany cashed in his life insurance policy and started looking for work. One day, he watched his son play baseball with a stick and a tennis ball (so as not to damage the neighbor's house). Mullany came up with the idea of making the ball out of plastic.

Mullany made a baseball out of two plastic half spheres used in cosmetic cases. He glued them together, and then, to make the ball curve, he added

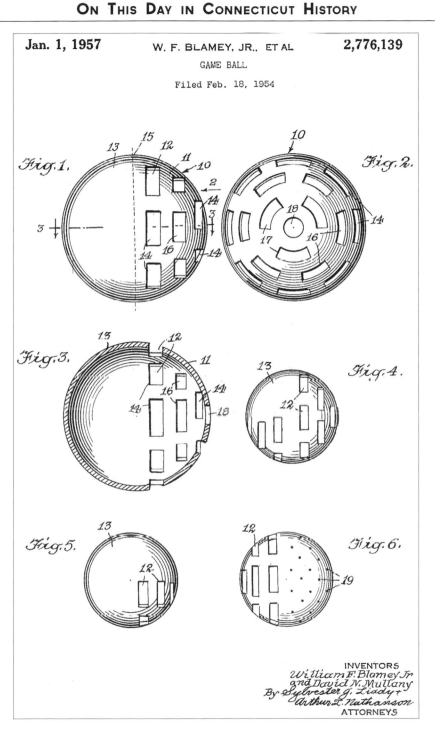

Jan. 1, 1957 W. F. BLAMEY, JR., ET AL **2,776,139**

GAME BALL

Filed Feb. 18, 1954

Fig.1. *Fig.2.* *Fig.3.* *Fig.4.* *Fig.5.* *Fig.6.*

INVENTORS
William F. Blamey Jr
and David N. Mullany
By Sylvester J. Liady &
Arthur L. Nathanson
ATTORNEYS

Mullany's patented design for the Wiffle ball. *United States Patent Office.*

weight to one side and cut holes in the ball. After witnessing the fun his children had playing with it, he took out a second mortgage on his house and founded Wiffle Ball, Inc. He filed the patent for his invention on February 18, 1954.

February 19

An Amistad Lawyer Turned Governor

Roger Sherman Baldwin was a Connecticut governor who served in one of the most important legal cases in U.S. history. Born in New Haven in 1793, his parents named him after his famous grandfather, Roger Sherman. He studied law at Tapping Reeve's school in Litchfield and passed the bar in 1814.

Baldwin took the often-unpopular position of opposing slavery in Connecticut in the early nineteenth century and served as counsel on a number of racially charged cases. His most famous case was his defense of the Mende slaves who revolted aboard the Spanish ship *Amistad*. Teaming up with former president John Quincy Adams, Baldwin fought his case for two years, eventually winning freedom for his clients in 1841.

A regular in the Connecticut General Assembly, Baldwin became the state's governor in 1841. While in office, he tried unsuccessfully to pass a law banning slavery in Connecticut. Among the goals he did achieve, however, were a series of measures enacted to reform the state's educational system. Baldwin created the office of State Superintendent of Schools to help standardize curricula and improve attendance at schools across Connecticut.

After serving the state, he served the country as a member of Congress from 1847 to 1851 and became a delegate to the National Peace Conference in 1861—established to try to stave off the impending war with the South. After a long political and legal career, Baldwin passed away on February 19, 1863. He received a burial at New Haven's famous Grove Street Cemetery.

February 20

Connecticut Daughters of the American Revolution

Founded in 1890, the Daughters of the American Revolution (DAR) is a national volunteer organization focused on promoting historic preservation and education through the celebration of patriotic culture. A product of the revival in colonial history after the country's centennial, the DAR helped women gain a voice in the public sphere. By taking their culturally accepted domestic responsibilities (such as childcare and taking care of the home) and extending them into the civic arena, women gained new access to avenues of social and political influence.

The DAR offers membership to any woman over the age of eighteen who can prove her lineage back to a patriot of the American Revolution. Its membership listings include nearly one million members since the organization's inception.

The women of Connecticut founded their first state chapter of the DAR on February 20, 1892. The number of chapters in the state eventually expanded to over forty, and they maintain such historic properties as the Oliver Ellsworth Homestead in Windsor and the Governor Jonathan Trumbull House in Lebanon.

February 21

The First Phone Book

Mercly weeks after New Haven became the site of the first commercial telephone exchange, it claimed its place in communications history yet again on February 21, 1878, with its production of the first telephone directory. Printed by the District Telephone Company, the directory consisted of only one page listing fifty individuals and businesses.

The company printed just over 150 copies of the directory in the form of a modern-day flier. Included on the list were residents, physicians, dentists, the post office, the police department and numerous businesses, such as the New Haven Flour Company and the American Tea Company.

Just months later, with the explosion in popularity of the telephone, directories became multiple pages in length—more closely resembling the modern telephone book.

February 22

The 1898 Ice Storm

February 22, 1898, brought an end to a three-day ice storm that paralyzed a large portion of northwestern Connecticut. In some places, the storm brought as much as seven inches of ice that knocked out electricity, telephone and telegraph service and halted trolley service.

The oaks and elms that lined town streets cracked and popped with a frequency that reminded residents of fireworks on the Fourth of July. Worse yet, the storm did irreparable damage to fruit trees and other crops. Power lines not pulled down by broken branches or uprooted trees snapped and fell to the ground from the sheer weight of the ice alone. The slippery road conditions combined with the tangle of live wires and falling debris made travel extremely hazardous. Most residents chose to ride out the storm indoors.

With roads nearly impassible and communication lines snapped, some communities found themselves almost completely isolated from the outside world. Residents got most of their news about the damage to surrounding towns and the cleanup efforts underway from resilient milkmen or from travelers who made it through on heavily delayed rail lines. Extra police patrolled darkened neighborhoods while utility crews worked throughout the storm and its aftermath to restore service to customers. While utilities and safe modes of transportation returned to the area in the coming weeks, much of the area's natural surroundings took years to recover.

February 23

Unconstitutional Embargo

Throughout the Napoleonic Wars, Britain and France enforced a variety of trade restrictions meant to cripple each other's economies. While the

United States struggled to remain neutral, these trade restrictions weakened the American economy as well. To make matters worse, the British navy looked to reclaim deserters by seizing and searching American ships and impressing American citizens into service. In response, Thomas Jefferson's administration passed the Embargo Act on December 21, 1807—effectively outlawing much of America's trade with Europe.

Among the hardest hit by this new legislation were the New England states that relied on trade with Europe for their livelihood. On February 23, 1809, Connecticut governor Jonathan Trumbull spoke before a special session of the state legislature and called on lawmakers to openly defy Jefferson's embargo. Trumbull accused the federal government of exceeding its Constitutional powers and pleaded with other state governments to step in and act as a "shield" to protect the rights of their citizens.

In support of Governor Trumbull, Connecticut legislators determined that the only way "to preserve the Union" was to defy the Jefferson administration. They labeled the embargo unconstitutional and asked all citizens to abstain from cooperating in its enforcement.

In the end, Jefferson's embargo proved largely ineffective. Smugglers worked their way around the law, and after seeing an initial spike in the price of consumer goods, Britain began acquiring products from other sources, such as South America. The economy of the United States perhaps suffered the most, and Congress eventually had little choice but to repeal the embargo.

February 24

The Amazing Adventures of John Ledyard

Born the son of a ship's captain in Groton in 1751, as a young man, John Ledyard enrolled at Dartmouth College but found his desire for adventure too difficult to overcome. After spending a considerable amount of his time in the New Hampshire woods learning from local indigenous peoples, Ledyard bade farewell to Dartmouth one day by hopping in a canoe and traveling down the Connecticut River from Hanover, New Hampshire, to Old Saybrook, Connecticut.

At the start of the Revolutionary War, Ledyard enlisted in the British navy and, in 1776, joined the crew of the HMS *Resolution* in sailing halfway

around the world under the famous explorer Captain James Cook. The journey took Ledyard around the Cape of Good Hope to New Zealand, the Polynesian islands and to modern-day Alaska.

After deserting the British navy in 1783, Ledyard returned to Connecticut and wrote a wildly popular book about his adventures. It did not take long, however, for him to devise his next plan. In 1786, after a return to Europe, Ledyard intended to travel through Europe and Asia, across the Pacific Ocean, and then walk across North America.

On February 24, 1788, however, Russian authorities under Catherine the Great arrested Ledyard for spying on their fur-trading operations. Escorted out of Russia, Ledyard returned to England before devising a new plan to explore the interior of Africa. After arriving in Cairo, Ledyard passed away suddenly—it is believed from an overdose of an acidic medicine used to treat intestinal illnesses.

February 25

Colt's Revolver

Perhaps the most famous handgun in American history, the Colt revolver has its origins in the failed navigational career of Samuel Colt. After Amherst Academy in Massachusetts expelled the young inventor from school, Colt's father sent him on a yearlong sailing voyage to study navigation. While at sea, Colt studied the turning and locking mechanisms of the ship's wheel and came up with the idea for a gun with a revolving chamber that spins and locks into place.

Colt patented his revolving chamber design on February 25, 1836. The gun allowed operators to fire off six shots in rapid succession without reloading. By way of contrast, single-shot weapons of the era took as long as twenty seconds to reload.

After initial sales proved sluggish, Colt closed his company in 1842, but soon, westward expansion created new demand and the U.S. Army eventually ordered one thousand Colt revolvers for use in the growing war with Mexico. Colt's use of interchangeable parts and organized assembly lines produced the weapons both efficiently and reliably. Marketed using romantic images of the western frontier, the Colt brand soon became synonymous with revolving-chambered handguns.

In 1855, Colt built a new factory in Hartford that became the largest independently owned firearms manufacturing plant in the world. Colt died in 1862 as one of the wealthiest men in the country.

February 26

The Largest Silk Works in the Country

In 1838, the Cheney Brothers silk mill began operations in Manchester, Connecticut. Officially taking the name Cheney Brothers Silk Manufacturing Company in 1854, the operation took raw silk from silkworm cocoons and turned it into suitable material for sewing. Though unable to raise its own silkworms, the company imported raw silk from China, Japan, Italy and France and soon became the largest silk manufacturer in the country.

The Cheney Brothers company was part of a wave of textile manufacturing that prospered in New England during the nineteenth and early twentieth centuries. Workers from all over the world filled the extensive mill facilities Cheney Brothers constructed between 1872 and 1917. By the early 1920s, a population one-quarter the size of Manchester worked in the company's mills.

The arrival of new synthetic fabrics in the 1920s, combined with the elimination of protective tariffs, began a period of steady decline in the silk industry, however. The Great Depression only exacerbated the new economic challenges, and despite a brief boost to production during World War II, the company continued to see its revenues decrease.

On February 26, 1955, news broke of an offer to buy Cheney Brothers made by the synthetic textile company J.P. Stevens & Company. Stevens offered to pay nearly $5 million for all of Cheney Brothers stock—80 percent of which the Cheney family owned. Company executives finalized the deal a month later, and despite assurances from J.P. Stevens that it intended little change, the company soon eliminated or sold off much of its newly acquired operations.

February 27

Reinventing Consumer Advocacy

Ralph Nader, the son of Lebanese immigrants, was born in Winsted, Connecticut, on February 27, 1934. In the latter half of the twentieth century, Nader redefined consumer advocacy through his approach to research, political lobbying and the formation of numerous professional advocacy organizations.

He graduated from Princeton and an earned a law degree from Harvard before teaching history and government at the University of Hartford from 1961 to 1963. Shortly after, he began researching design flaws in American automobiles and published the best-selling book *Unsafe at Any Speed*, which helped pass the National Traffic and Motor Vehicle Safety Act in 1966—a law that allowed the federal government to set safety standards for all cars sold in the United States.

Capitalizing on this momentum, Nader went on to establish organizations dedicated to monitoring nuclear safety, the use of insecticides and fair trade and banking practices. He parlayed his extensive government lobbying efforts into four presidential campaigns (1996, 2000, 2004 and 2008) but never garnered more than 3 percent of the vote. His presence did have a significant impact on the 2000 election, however, when he won key votes, especially in Florida, that might otherwise have allowed Al Gore to defeat George W. Bush.

After his political runs, both for the Green Party and as an independent, Nader refocused his energies on advocacy once again. Among the organizations operating under his control are the Center for Auto Safety, the Clean Water Action Project, the Disability Rights Center and the Public Interest Research Group (PIRG).

February 28

The Treaty of Ghent

American and British agents in Belgium signed the Treaty of Ghent on December 24, 1814, effectively bringing the War of 1812 to a close. While

the treaty did little to address the underlying causes of the war (chiefly the harassment of neutral American ships during the Napoleonic Wars and the impressment of U.S. sailors), it did settle the boundary with Canada and open up the Great Lakes to westward expansion. More importantly, it brought an end to a war that witnessed brutal fighting in America's western frontier, the burning of the White House by British soldiers, the lingering threat of invasion from British Canada and unrelenting disruptions to trade on the sea.

When word of the treaty finally reached Hartford on Sunday, February 19, 1815, the city broke into immediate celebration. Bells began ringing, and cannons discharged to announce the joyous news. The next day, legislators shelved their political differences during a meeting at the statehouse to plan a celebration. On Tuesday, the twenty-first, banks, stores and public offices closed early for a parade at 2:00 p.m. and fireworks in the evening. The news rapidly spread throughout the rest of the state and was met with equal celebration in the streets.

All that remained to make the celebration complete was for Congress to ratify the treaty. On February 28, 1815, the *Connecticut Courant* printed President Madison's announcement of the ratification in its entirety, letting Connecticut residents know the war had officially ended.

MARCH

March 1

Samuel Huntington: The First President of the United States

Scotland Parish, a small area in the town of Windham, Connecticut, became the birthplace of Samuel Huntington in 1731. Huntington was the son of a prosperous farmer. While several of his brothers went off to college, Huntington remained on the farm. He did, however, develop an interest in the law and through his own independent studies earned admittance to the bar in 1754.

After opening a legal practice in Norwich, he served in the state legislature and then as a member of the Continental Congress. He survived a bout with smallpox upon arriving in Philadelphia and returned to duty in time to sign the Declaration of Independence.

In the fall of 1779, with John Jay's departure to serve as minister to Spain, Congress needed a new president. It chose Samuel Huntington. A second term as Congress's president began in September 1780. The following spring, Maryland (the last state to hold out) ratified the Articles of Confederation. On March 1, 1781, these articles became the nation's official constitution, making the president of Congress, Samuel Huntington, America's highest-ranking politician—a de facto president of the United States.

Three months after Maryland's ratification, Huntington resigned his position to return to Connecticut. There, he became the state's chief justice of the superior court and wrote the nation's first copyright law. He

served as lieutenant governor in 1784 and 1785, and in 1786, with no gubernatorial candidate winning the majority of votes required for election, the state General Assembly stepped in and chose Huntington to serve as Connecticut's new governor.

March 2

Lincoln's Secretary of the Navy

Gideon Welles arrived in Washington, D.C., on March 2, 1861, via a special train from Baltimore. The city was abuzz with talk of new president Abraham Lincoln's political appointees, and Welles, a native of Glastonbury, Connecticut, and founder of the pro-Republican newspaper the *Hartford Evening Press*, came to Washington to serve as Lincoln's secretary of the navy.

While not an ardent abolitionist, Welles opposed slavery and worked to give protection to runaway slaves wishing to join the navy. He also proved instrumental in promoting the plans of John

Gideon Welles during his time as secretary of the navy. *Library of Congress, Prints and Photographs Division, Civil War Glass Negatives and Related Prints.*

Ericson for the construction of the famous ironclad ship the *Monitor*. It was the first in a series of moves that modernized the navy, bringing its ships into the industrial age of iron and steam.

March 3

A Centennial Exhibition

In the years following the Civil War, America prepared for the 100th anniversary of the signing of the Declaration of Independence. John L. Campbell, a professor at Wabash College in Indiana, developed a plan to reunite the country in a celebration of patriotism and progress by hosting a world's fair. After four years of preparation, a presentation made before Congress led to the approval of what became the International Exhibition of Arts, Manufacturers, and Products of the Soil and Mine.

Congress approved the creation of a Centennial Commission on March 3, 1871, to oversee the fair's preparations. The commission consisted of one representative from each state and territory in the United States. President Ulysses S. Grant appointed Connecticut's Joseph Hawley as the commission's president, making him the first American president of an international exhibition. Hawley was a veteran of thirteen Civil War battles and the former military governor of Wilmington, North Carolina. He also served as governor of Connecticut in 1866 and then as a state representative in Congress.

More than ten thousand visitors attended the opening ceremonies of the exhibition on May 10, 1876. Patrons strolled through 285 acres of Fairmount Park in Philadelphia, sampling the wares of over thirty thousand national and international companies. By the time the fair closed in November, visitors from all over the world had witnessed the practical applications of new inventions such as the telephone, typewriter and electric light. The exhibition also introduced a variety of new and popular foods to the American diet, including ice cream sodas and popcorn.

March 4

The First Crossword Puzzle Championships

The Marriott Hotel in Stamford, Connecticut, hosted what is believed to be the country's first annual crossword puzzle tournament on March 4, 1978. Over one hundred contestants ranging in age from fifteen to sixty-nine filled

the hotel's ballroom over the course of the two-day event. A twenty-dollar fee covered entry into the contest, a Sunday luncheon and a discounted room in the hotel.

Contestants completed four puzzles on Saturday, starting around 3:00 p.m., and then finished a fifth the following morning. Sectioned off at partitioned tables, the ballroom soon filled with cigarette smoke, leaving the hotel staff scrambling to find enough ashtrays.

Judges spent most of Saturday night and Sunday morning poring over the hundreds of puzzles—awarding points for every correct letter, as well as points for correctly completed sections and bonus points for finishing ahead of the allotted time. After the completion of the contest, participants socialized at a luncheon while waiting for the results. In the end, judges declared Nancy Shuster (a homemaker from Queens, New York) the winner. Second place went to Eleanor Cassidy of Fairfield, Connecticut. The prizes the two women took home for their weekend of work were $125 and $50, respectively.

March 5

Abraham Lincoln in Connecticut

In February 1860, Abraham Lincoln arrived in New York as a senator and presidential hopeful from Illinois. With the country on the verge of civil war, Republicans involved in a number of hotly contested political contests sought personal appearances by Lincoln to boost their campaigns. After giving his "Cooper Union Address" in New York City, Connecticut Republicans approached Lincoln about giving a speech in Hartford to aid incumbent governor William Buckingham, and Lincoln accepted.

He arrived in Hartford by train on the afternoon of March 5, 1860. Shortly afterward, officials ushered Lincoln to a Republican rally at an overcrowded city hall. There, Lincoln spoke for more than two hours. The focus of his address, not surprisingly, was slavery, an institution he labeled "a great evil."

The response to Lincoln's speech proved overwhelming. With great fanfare, supporters cheered Lincoln all along his route to the house of Hartford mayor Timothy Allyn. Among his escorts were the Hartford Cornet Band and a recently organized militant Republican organization

called the "Hartford Wide Awakes"—founders of a national grassroots movement that grew to a membership of hundreds of thousands in just a few months.

With requests for appearances pouring in throughout his trip to the Northeast, Lincoln rarely stayed in one city very long. He left for New Haven on March 6. Later that year, William Buckingham won reelection as Connecticut's governor, and Abraham Lincoln carried Connecticut and all of the Northeast on his way to becoming the sixteenth president of the United States.

March 6

A Twelve-Foot Wall of Water

It was a rainy Wednesday on March 6, 1963, when the director of the State Water Resources Commission lobbied the legislature for $12,000 to hire external consultants to aid in the inspection of Connecticut's dams. The commission had just one employee, who devoted only part of his time to inspections, and the director feared the potential consequences of his inadequate program.

At around 6:00 that evening, the director of public works in Norwich drove to Spaulding Pond Dam in Mohegan Park to check the rain's impact on the dam. Harold Walz noticed a small trickle coming from the base of the 110-year-old dam, but that was hardly an uncommon occurrence. A return inspection three hours later, however, uncovered something much more alarming—a large breach at the base of the damn. At 9:20 p.m., Walz hurriedly notified police of the potential danger; at 9:37 p.m., the damn gave way.

The millions of gallons of water stored in Spaulding Pond's eighteen acres formed a twelve-foot-high wall of water that crashed into Norwich. The water toppled buildings, washed away cars from a nearby sales lot and blocked streets. In all, the flood claimed six lives. One was Mrs. Margaret Moody—washed away as she, her husband and their three small sons scrambled from their overturned car to a nearby tree. The other five fatalities were employees at the Turner-Scranton Twine Mill, killed as the water destroyed the front end of the factory and sent heavy machinery crashing down on them.

March 7

Whalley and Goffe Flee Charges of Regicide

William Goffe and his father-in-law, Edward Whalley, served as members of the "High Court of Justice" in England after Oliver Cromwell overthrew the monarchy of King Charles I during the English Civil War. As part of their service under Cromwell, they ordered Charles I beheaded in 1649. In 1660, however, Charles II (the son of Charles I) regained the throne and ordered the arrests of anyone who took part in executing his father. Goffe and Whalley quickly fled to New England.

They arrived in the Massachusetts Bay Colony and settled in Cambridge until orders for their arrest arrived. They then traveled to Springfield and Hartford before arriving in the New Haven Colony on March 7, 1661. New Haven was one of the more hostile colonies to the Crown, and its authorities did their best to frustrate the English search (without appearing to openly defy the king). Shortly after, perhaps in retribution for New Haven's defiance, Charles II ordered all powers stripped from the New Haven Colony and that it be placed under the control of its northern neighbors, the Connecticut Colony.

Whalley and Goffe spent the rest of their lives on the run. A renewed effort to capture them in 1664 forced them to leave New Haven for the remote town of Hadley, Massachusetts. There, Whalley suffered a stroke and died. Goffe remained in Hadley for twelve years. When authorities eventually closed in, however, he moved to Hartford, where he remained safe for only another four years before fleeing again. He died in 1679, most likely somewhere in Massachusetts.

March 8

The Jewett City Vampire Panic

In the middle of the nineteenth century, Jewett City (now a borough of Griswold, Connecticut) became the setting for one of the state's most famous brushes with the supernatural. The Ray family, consisting of Henry and Lucy and their children, Henry Nelson, Lemuel, James, Elisha

and Adaline, began dying of consumption. Known today as tuberculosis, the disease causes the body to waste away, growing steadily paler and thinner as blood fills the lungs and ultimately suffocates its victims. In nineteenth-century Connecticut, residents attributed the onset of the condition to attacks by vampires.

The first of the Ray family to die was Lemuel on March 8, 1845. The following years brought the deaths of father, Henry, and his son Elisha. When Henry Nelson contracted the disease, the family determined that brothers Lemuel and Elisha had returned in the night to drink Henry Nelson's blood. This belief in vampires preying on family members was a common occurrence throughout rural New England during this period as tuberculosis often spread among close-knit, isolated families.

In 1854, the people of Jewett City exhumed the bodies of Lemuel and Elisha to burn them. Burning was just one of a variety of practices used in New England to prevent the dead from returning and feasting on the living. Other practices called for binding their feet with thorns before burial or decapitating them and placing their leg bones in an "X" pattern across their chests. In Connecticut, a common technique was to burn the heart of the recently deceased and inhale the smoke as a cure for the disease.

March 9

Isaac Hull and the USS Constitution

Derby's Isaac Hull first put to sea as a fourteen-year-old cabin boy aboard a merchant ship. He took readily to life aboard ship and, in 1793, earned command of a West Indian trading ship. Five years later, on his twenty-fifth birthday (March 9, 1798), Hull joined the navy and received a commission as fourth lieutenant aboard the USS *Constitution*.

The next several years brought Hull numerous assignments commanding different ships for the navy until, in 1810, his career came full circle and Hull took command of the *Constitution*. He commanded the ship throughout the War of 1812, fighting in numerous battles. One particularly intense engagement came on August 19, 1812, when Hull's men sunk the HMS *Guerriere*. During the battle, one of Hull's crew noticed a shot from the

The USS *Constitution. Library of Congress, Prints and Photographs Division, Detroit Publishing Company.*

Guerriere bounce off the hull of the *Constitution* after inflicting only minimal damage. From that day forward, the crew affectionately referred to the *Constitution* as "Old Ironsides."

March 10

Editor, Playwright and Connecticut Representative

Claire Booth Luce, born on March 10, 1903, grew up in New York City and married millionaire George Brokaw at age twenty-three. The marriage ended in divorce six years later, and Booth took a job at *Vanity Fair* magazine, eventually rising to the position of managing editor.

In 1934, she changed careers and began writing plays. Critics panned her first Broadway production, *Abide with Me*, but her 1936 play, *The Women*, earned her over $2 million. It was during this time that she married Henry

Luce, the publisher of such popular periodicals as *Time*, *Life* and *Sports Illustrated*. With the outbreak of World War II, she accepted an assignment to cover the war in Europe for *Life* magazine.

She returned to her home in Greenwich, Connecticut, shortly after and ran for political office. In 1942, she became the first woman to represent Connecticut in the U.S. House of Representatives. She earned a reputation as a hardline anti-communist who criticized FDR's handling of the war and lobbied for an end to racial discrimination in the military.

After the death of her daughter in an automobile accident, Luce opted not to seek reelection in 1946. She became a popular figure in the Republican Party, however, and served as ambassador to Italy under President Dwight Eisenhower.

Retirement witnessed moves to Phoenix and Honolulu before moving into an apartment in the Watergate complex in Washington, D.C. Always active in politics, President Ronald Reagan awarded her the Presidential Medal of Freedom in 1983, just four years before her death.

March 11

G. Fox & Co.

Once America's largest privately owned department store, G. Fox & Co. began as the fancy goods store of Isaac and Gershon Fox in downtown Hartford in 1847. Gershon, who arrived from Germany in the 1830s, took over the company in 1848 and named it G. Fox & Co. after his brother Isaac moved to New York. Gershon's son, Moses, quit school at age thirteen to work at the store full time and took over as company president when Gershon died in 1880.

Moses had a daughter, Beatrice (born in 1887), who married Utah department store operator George Auerbach. They both moved from Utah to Hartford after the G. Fox building burned in 1917. Beatrice took over as secretary of the company after her husband's death in 1927 and then as president when Moses died in 1938. A bill creating the charitable Beatrice Fox Auerbach Foundation passed three years later, on March 11, 1941.

Beatrice modernized the G. Fox store and enhanced the company's focus on customer service. She offered foreign-language interpreters

and personal shoppers to customers and provided beauty salons, postal service, a travel bureau, fashion shows and a restaurant in order to turn shopping into an all-day social experience. The home delivery service that started with a fleet of wheelbarrows in 1847 and moved to one-horse wagons in 1907 offered home delivery by helicopter as part of the store's 100th anniversary celebration.

The era of G. Fox came to an end in the early 1990s, however. The steady decline of downtown stores forced the closing of G. Fox's Hartford location in 1993. The Filene's department store chain then bought all of G. Fox's remaining branch stores.

March 12

The Great White Hurricane

On the morning of March 12, 1888, a storm moved into Connecticut that caught most of the East Coast by surprise. Very rapidly, winds picked up to seventy miles an hour, and the storm dumped up to two feet of snow on Connecticut residents in a matter of hours. Schools and businesses shut down, but many people remained trapped at their places of employment due to the impassible roads. While some who ventured out on foot became the subject of miraculous rescue stories, others did not survive the plunging temperatures. One such report came from authorities in Bridgeport who, two days after the storm, found the bodies of two women huddled together not far from their place of employment.

Two low-pressure systems blocked the storm's exit until March 14. By then, Middletown reported a snowfall nearing fifty inches. The whipping winds created monstrous snowdrifts—such as the thirty-eight-foot-tall drift recorded in Cheshire—and forced many people to exit their homes through second-story windows. Those able to venture out found both food and fuel in short supply.

When it was all over, the storm had claimed four hundred lives, sunk more than two hundred ships in the Atlantic and caused more than $20 million in property damage. Major cities along the East Coast remained closed for a week until horse- and oxen-driven plows cleared the roads, assisted eventually by the return of milder March temperatures.

March 13

The New Haven Black Panther Trials

In 1969, members of the New Haven chapter of the Black Panthers, suspecting nineteen-year-old Alex Rackley of being an FBI informant, kidnapped Rackley and took him to their headquarters on Orchard Street in New Haven. There, Panthers spent days beating Rackley with sticks and dousing him with boiling water until he confessed. Leaders then promptly drove him to Middlefield, shot him and dumped his body in the Coginchaug River.

While authorities arrested several members of the New Haven Black Panthers for Rackely's murder, New Haven state's attorney Arnold Markle charged Panther national chairman Bobby Seale with ordering the crime. On March 13, 1970, Seale arrived in Connecticut to face the charges. Arriving via a chartered jet to Bradley International Airport, authorities promptly escorted Seale to the Connecticut Correctional Center in Montville while he awaited trial.

Anti-government protestors soon swarmed the New Haven Green, claiming that a racially biased judicial system offered Seale little hope of acquittal. Seale's trial began in November with New Haven Black Panther founder Ericka Huggins claiming Seale ordered the killing. The testimony of Huggins and others proved unconvincing, however, and the jury came back deadlocked, leading Judge Harold Mulvey to declare a mistrial. Rather than retry Seale, Mulvey decided that due to the publicity surrounding the case it would be impossible for Seale to receive a fair trial, so he dismissed all charges. While other Black Panthers left the courtroom as free men and women, Seale returned to prison in Illinois, where he was serving time on a contempt of court charge.

March 14

Connecticut's World War I Flying Ace

Born in France on March 14, 1885, Raoul Lufbery came to Wallingford, Connecticut, at age twenty and worked in a silver plant. After enlisting in the army, he went to work in India for a railroad company. While in India,

Raoul Lufbery during his service in World War I. *Library of Congress, Prints and Photographs Division, Miscellaneous Items in High Demand Collection.*

he learned to fly and volunteered for the French Foreign Legion before joining the air service to fight in World War I. Lufbery met with tremendous success in the skies over France, becoming America's first flying ace. Over a very short career, he racked up eighteen confirmed kills and received the Legion of Honor, the King George Medal, the French Military Cross and fourteen citations for bravery.

On May 19, 1918, a German triplane shot Lufbery out of the sky. With his aircraft on fire and no parachute, Lufbery ultimately jumped to his death. While originally buried in France, authorities exhumed his body in 1921 and buried him near his home in Wallingford.

March 15

Connecticut v. Massachusetts

The case of *Connecticut v. Massachusetts* was a water diversion case fought in the United States Supreme Court from 1927 to 1931. Connecticut filed the suit to prevent the state of Massachusetts from diverting water away from the Connecticut River watershed.

In 1895, the Massachusetts State Board of Health submitted a report suggesting that the growing population around the city of Boston required a supplemental water supply from the Connecticut River. By the mid-1920s, water supplies in eastern Massachusetts had hit record lows, so the state passed a plan to divert the Connecticut River's resources toward Boston and away from Connecticut. Representatives from Connecticut denounced the plan as damaging to Connecticut's manufacturing and transportation industries.

Filed in the Supreme Court by the State of Connecticut, the case of *Connecticut v. Massachusetts* began on December 22, 1927. The court heard testimony from both sides, and events quickly turned in Massachusetts's favor. On March 15, 1928, Secretary of War Dwight Davis announced the War Department would not interfere with the Massachusetts plan but balked at issuing a permit until the Supreme Court finalized its decision on the case.

The decision finally came on January 5 and 6, with the Supreme Court ruling against granting Connecticut an injunction prohibiting the diversion of water from the state. The court did, however, rule that Connecticut had the

right to resume legal action if the quantity of water diverted ever exceeded the agreed-upon limits. The flow of diverted water into Massachusetts's Quabbin Reservoir officially began on August 14, 1939.

March 16

"Yankee Doodle"

In the spring of 1978, Connecticut lawmakers took time out from their usual round of activities to determine a state song for Connecticut. The front-runner was the Revolutionary War anthem "Yankee Doodle," but the song failed to make it out of a vote in the Government Administration and Policy Committee, thus denying it a chance for consideration in the General Assembly. When one of the song's strongest proponents, House Democratic majority leader (and future governor) William O'Neill agreed to remove the sexist term "gals" from the last line of the chorus and replace it with "folks," the patriotic anthem reemerged as the favorite.

Many opposed "Yankee Doodle" as the state song for a variety of reasons. Among them was that both terms, "yankee" and "doodle," carried negative connotations in England at the time of the war and that the British played the song in a derogatory fashion as way of portraying Americans as simpletons. Other opponents felt the state needed a song more specific to Connecticut.

On March 9, 1978, after a two-hour debate that included Representative Dorothy Osler of Greenwich performing an entry written by two of her constituents and Neal Hanlon of Naugatuck calling the whole affair a waste of the government's time, the state house of representatives voted in favor of "Yankee Doodle." One week later, on March 16, after voting down Senator Joe Lieberman's suggestion of adding lines from the Yale fight song, "Boola, Boola," to the lyrics, the Senate approved "Yankee Doodle" as the official state song.

March 17

Spring Training Baseball

Every year, sports fans recognize the arrival of professional baseball players to training camps throughout Florida and Arizona as the unofficial start of spring. During the Second World War, however, travel restrictions limited the destinations available to teams for practice. For teams based in the Northeast, cold weather limited their options even further.

In 1943, Boston Braves executive Bob Quinn coveted the indoor batting cages and practice fields available at the Choate School in Wallingford, Connecticut. Choate was one of the country's most exclusive preparatory schools and offered professional-quality practice facilities. After successful negotiations with the school's headmaster, the Reverend George St. John, the Braves arrived in Wallingford in March 1943.

The Braves used the facilities every day from 9:00 a.m. until 2:30 p.m. and, in return, offered instruction to players of Choate's varsity baseball team. Spring training lasted only thirty-one days that year (three weeks less than normal) before manager Casey Stengle deemed his team ready for the start of the professional season.

On March 17, 1944, the Braves returned to Wallingford to start the 1944 season. Major Leaguers like Tom Holmes and Phil Masi matched up against minor-league teams from Hartford and the varsity squad from Yale in exhibition games intended to generate revenue for the American Red Cross.

March 18

Civil Rights Flight

The day after the events of "Bloody Sunday" unfolded in Selma, Alabama, Reverend Richard Battles led a group of Connecticut clergymen flying south to join Dr. Martin Luther King Jr. on his march to the Alabama state capital. Battles was the Connecticut chairman of the Southern Christian Leadership Conference and a personal friend of Dr. King's.

Upon returning from Alabama, Battles organized an even larger party of Connecticut activists to join the march to Montgomery. Battles and

approximately ninety other Connecticut residents boarded a flight at Bradley Airport on March 18, 1965, and headed to Alabama.

After a day of protest in Selma, a number of these Connecticut residents experienced the terror faced by blacks in the South firsthand. Lacking buses to bring them back to the airport, a fleet of cars and station wagons shuttled protestors to the airport. After sunset, one car, carrying eight Connecticut residents, stopped for gas and noticed three white men glaring at them from the gas station door. Once back on the Jefferson Davis Highway, the three men appeared in a pickup truck alongside the car. The truck alternated between driving alongside the car, swerving in front of it and slowing down to tailgate behind it. Real fear began to set in among the passengers as the lights of Selma faded and the highway became dark, but after harassing the protestors for five miles, the pickup finally turned back toward Selma. One week later, however, Klansmen shot and killed activist and Michigan housewife Viola Liuzzo on that same stretch of highway.

March 19

The New Primary Law

January 1, 1956, brought the most significant change to Connecticut's election law in the state's history. Approved and signed the previous August, the law allowed candidates for political office who did not receive their party's nomination to challenge their party's candidate in a primary election. The primary law affected the election of candidates for governor, senator and justice of the peace, all the way down to town and local offices. It was a way to give average citizens a greater say in who represented them in government.

Connecticut was the last state to pass a primary law and required primary candidates to obtain five thousand signatures to get on the ballot—two thousand if it were a congressional nomination. The state also required potential candidates to make a financial deposit of 5 percent of the annual salary of the office they sought. The state returned this deposit if the candidate received 15 percent or more of the primary vote. If not, the state kept the money and deposited it into its general fund.

In early January, the town of Wethersfield announced its intention to hold the first election under the new law on March 19, 1956. The eyes of citizens across the state focused on Wethersfield to see just how the new law affected the election process. When the big day finally arrived, it turned out that party nominations in the election went unchallenged and no opposition candidates chose to run.

March 20

The First International Figure Skating Championships

The "international style" of figure skating is the style most Americans think of when they think of figure skating today. Invented in the 1860s by New York–born skater Jackson Haines, it combined technical skating prowess with ballet and other forms of dance. Americans did not take to its provocative style right away, however, and despite winning the 1863 and 1864 Championships of America, Haines soon took his talents overseas.

At the start of the twentieth century, Americans became more accepting of the international style, and the many informal skating clubs that practiced it began to organize. George H. Browne, who studied skating in Switzerland, formed the International Skating Union of America (a precursor to U.S. Figure Skating) and organized the first-ever international-style skating competition held in the United States.

The event took place at the New Haven Arena ice rink, and officials opened the competition to all amateur skaters in the United States; this included foreign skaters on tour in the United States. The competition began on Friday morning, March 20, 1914, and carried over into the following day. While the men's winner was Norman Scott, a native of Montreal, the women's championship went to an American—a Mrs. T. Weld of the Skating Club of Boston.

March 21

AIG Fallout

On March 20, 2009, twenty state attorneys announced an investigation into the operations of the American International Group (AIG). Connecticut attorney general Richard Blumenthal was among those who subpoenaed CEO Edward Liddy and eleven others to explain why the company paid over $200 million in bonuses to executives after receiving $200 billion in taxpayer-funded financial bailouts.

The following day, a tour bus charted by the Connecticut Working Families Party picked up forty passengers in Hartford and Bridgeport and headed for the Fairfield County homes of many AIG executives. Among their targets were officers such as James Haas and Doug Poling (an executive vice-president who received a $6.4 million bonus). The bus, followed by nearly fifty members of the national and international media, stopped in the neighborhoods of wealthy AIG employees to allow passengers to deliver letters expressing their outrage. After security stopped protestors from entering any of the properties, the bus went on to visit AIG's financial products division in Wilton.

The backlash against AIG prompted the company to issue warnings to its employees to avoid displaying the company logo in public and to call 911 at the slightest sign of any danger. A tour of the wealthy neighborhoods that housed AIG's executives only incensed many residents further. As a result, many of the bonus recipients voluntarily returned their checks rather than subject themselves to further harassment.

March 22

A Master of "Luminism"

Engraver and native of Cheshire, Connecticut, John Frederick Kensett was born on March 22, 1816. At age twenty-four, he set off for Europe to study landscape painting. Years of study and fine-tuning his craft earned him a reputation in artistic circles as a master of "luminism," a style of painting using nearly invisible brush strokes to capture the subtle effects of atmospheric light.

John Frederick Kensett's *Beacon Rock, Newport Harbor* (1857). *Courtesy National Gallery of Art, Washington.*

Kensett's favorite subjects were the coastline areas of New England and landscapes of upper New York. In 1867, he purchased a small piece of land off the coast of Darien, Connecticut, and named it "Contentment Island." There, he spent most of the next five years before contracting pneumonia in 1872 after diving into Long Island Sound in a failed attempt to save a friend's drowning wife. Kensett promptly relocated to his New York studio and died there a month later.

March 23

The "Mad Dog" Killings

On March 23, 1950, Hartford resident Joseph Taborsky decided to celebrate his twenty-fifth birthday by taking his younger brother, Albert, out to "get some money." Albert drove Joseph to a West Hartford liquor store, where Joseph promptly shot and killed its owner, forty-year-old Louis Wolfson, before robbing the store.

Police failed to generate any leads in the case until the boys' mother called the police and informed them that Albert wanted to confess. A jury convicted both men on June 7, 1951, and sentenced Joseph to die. After more than four years on death row, authorities released Taborsky, however, because officials declared Albert insane and his testimony inadmissible.

About one year after his release, during a December 15 ice storm, Taborsky walked into a Hartford shop and shot a tailor in the head and neck. He then proceeded to a New Britain gas station, where he murdered an attendant and a customer. On January 5, 1957, Taborsky entered a shoe store, bought a pair of size-twelve shoes, pistol-whipped the owner and shot customers Bernard and Ruth Speyer in the head. The following month, Taborsky shot and killed pharmacist Jack Rosenthal.

The press labeled the unknown murderer "the Mad Dog" because of the brutal nature of the attacks. Many Hartford-area residents stayed indoors, and shops began closing early out of fear until police traced the size-twelve shoes to Taborsky. After a nine-week trial, a jury once again sentenced him to die. Authorities carried out the sentence on May 17, 1960.

March 24

Former President William Howard Taft Joins the Connecticut Home Guard

After a falling out between President William Howard Taft and former president Teddy Roosevelt split the Republican Party during the election of 1912 and gave the White House to Democrat Woodrow Wilson, William Howard Taft accepted a position as dean of Yale Law School and moved to New Haven. Taft had family in Connecticut and had lived in the state prior to becoming president. Once in New Haven, he stayed at the family-owned Taft Hotel before finally finding a permanent residence on Prospect Street near the university.

Taft spent the better part of the next ten years in Connecticut lecturing at Yale and avoiding requests to run for state and local political offices. As the politics of the First World War drew America ever closer to joining the conflict in Europe, Taft toured throughout the state as the president of the League to Enforce Peace—a hawkish organization that believed in the use of military force to prevent actions from aggressive nations from deteriorating into war.

Once America mobilized the National Guard in preparation for entry into the war, Taft backed up his words by enlisting in the Connecticut Home Guard on March 24, 1917. He left Connecticut four years later to become chief justice of the United States Supreme Court.

Design drawing for a stained-glass window depicting Bishop Samuel Seabury (far right) in Long Island. *Library of Congress, Prints and Photographs Division, Lamb Studios Archive Collection.*

March 25

The First American Bishop

At a meeting held in Woodbury on March 25, 1783, ten clergymen concerned with providing for the future of the Episcopal Church named Samuel Seabury the first American bishop. Without an Anglican bishop in America to perform the consecration, however, Seabury (born to a New London minister in what is now the town of Ledyard) headed for England.

After Seabury's arrival in London, the Church of England determined that it could not consecrate an American citizen, as the ceremony required taking an oath of allegiance to King George III. Seabury then turned to the Scottish Episcopal Church, which, failing to recognize the authority of King George, performed the ceremony on November 14, 1784. A return to Connecticut then facilitated his recognition as the bishop of Connecticut in a ceremony held in Middletown.

March 26

The Fight to Increase the Minimum Wage

Central Connecticut State University hosted President Barack Obama for a rally on March 5, 2014. The purpose of the rally was to push for legislation

raising the federal minimum wage to $10.10 per hour. Joined by Connecticut governor Dannel Malloy and the governors from Massachusetts, Rhode Island and Vermont, the president encouraged rally attendees to pressure Washington for greater income equality in the United States.

In response to President Obama's request, on March 26, 2014, Connecticut lawmakers became the first in the country to push their state's minimum wage over the ten-dollar mark. The bill passed in the Senate by a vote of twenty-one to fourteen and in the House by a margin of eighty-seven to fifty-four.

The plan, affecting more than seventy thousand minimum-wage workers in the state, called for increases up to $9.15 in 2015, $9.60 in 2016 and $10.10 by 2017. Prior to the vote, Connecticut's minimum wage (pushed to $8.70 by Malloy for 2014) was the fourth highest in the nation behind Washington, Oregon and Vermont.

March 27

The Mickey Mouse Watch

The Waterbury Clock Company started out as a division of the Benedict & Burnham Manufacturing Company—a firm that specialized in the production of rolled brass. On March 27, 1857, it became its own company and, seizing on the popularity of Eli Terry's shelf clock, began to make timepieces in smaller, more convenient casings.

In 1922, after purchasing the bankrupt firm of Robert H. Ingersoll & Bro., the company began producing large quantities of clock movements small enough to fit on a person's wrist. Eleven years later, to improve the marketing of their wristwatches, the Ingersoll-Waterbury Clock Company obtained a license for a design that utilized a picture of Mickey Mouse on the face with his arms pointed to the hour and minute increments. The watch became an instant success.

After attaching a price tag of $2.98, Ingersoll-Waterbury sold over two million Mickey Mouse watches in the first two years. One promotion held at a Macy's department store sold over eleven thousand in a single day. To keep up with the demand, Ingersoll-Waterbury increased its staff from 200 to 3,100 in just two years.

In the 1950s, the company took the watch off the market to offer a wider range of products to its consumers. One of these products was the reliable and inexpensive watch they called the "Timex"—a product so popular the company changed its name to Timex a decade later. Still, the surprising persistence of consumer demand for the Mickey Mouse watch brought the piece back into production in 1968.

March 28

Oyster Farming

In 1928, the U.S Bureau of Commercial Fisheries assigned Dr. H.F. Prytherch to study oysters off the coast of Milford, Connecticut. Milford was both centrally located along the Long Island coast, as well as home to some of the most productive commercial shellfish beds in the area.

Four years later, Dr. Victor Loosanoff arrived to take over for Prytherch, and Congress approved $65,000 for a permanent laboratory on the site. Loosanoff not only conducted experiments but also used his knowledge of oysters to assist local fishermen in maximizing their catches through sustainable practices. Oystermen helped plant young oysters in Connecticut waters, and then as the oysters grew, fishermen pulled them up and dropped them out into deeper water. Studies showed that oysters grew large rapidly in Connecticut waters, but they lacked the flavor of oysters cultivated off Long Island, so once Connecticut oysters grew big enough, oystermen pulled them up again and planted them in the waters of Long Island.

Studying oyster farming on the roughly forty-seven thousand acres of sea beds the state leased to fishermen required being on the water almost every day. Consequently, in 1949, the Senate Appropriations Committee approved funds for the construction of a state-of-the-art research vessel. Authorities launched the forty-seven-foot R/V *Shang Wheeler* (named after the general manager of the Connecticut Oyster Farm Company) at the West Haven Shipyard on March 28, 1951. It served the state, and the nation, until 2001, helping ensure the quality of oysters along the entire Atlantic seaboard.

March 29

The Tammany Influence

The extremely close-run 1871 Connecticut gubernatorial election pitted Democratic governor James E. English against former Republican governor Marshall Jewell and came at a time of scarce funding for the state's Democratic Party. On March 29, 1871, Governor English penned a letter to New York's William M. "Boss" Tweed that read, in part, "Do not disappoint us. Nothing could be more disastrous."

At the time of English's correspondence, Boss Tweed was the head of Tammany Hall, the corrupt executive committee of New York's Democratic Party. Over the course of their careers, Tweed and his ring of political appointees stole as much as $200 million from the people of New York through a system of bribes, kickbacks and overpaid contractors.

When English's letter became public, the governor faced charges of placing the State of Connecticut under the influence of Tammany. English took the confusing approach of claiming the letter referred to a request for advice, not money, but then also deemed the letter a forgery and offered a $500 reward for capturing its author.

When officials finally tallied the vote, English beat Jewell by a vote of 47,474 to 47,473. The vote did not give English the majority he needed to win. A story soon emerged, however, of voter fraud in New Haven. After a legislative committee took testimony from all the voters in New Haven's Fourth District, it determined that someone had opened the ballot box and withdrawn one hundred votes cast for Marshall Jewell. It was Jewell who became the state's next governor.

March 30

Igor Sikorsky

The Stratford-based Sikorsky Aircraft Corporation is the prime contractor for the U.S. Army's aviation program and a world leader in military and commercial helicopter production. A division of United Technologies Corporation, Sikorsky's focus on safety and innovation helped extend the company's service into all five branches of the armed forces. Its most recognized and versatile

helicopter is the UH:60 Black Hawk. Variations of the Black Hawk serve in the militaries of over twenty countries across the globe.

The company's founder, Igor Sikorsky, was born in Russia and studied aviation from an early age. The first successful flight of a Sikorsky-designed aircraft came on May 17, 1911, and Sikorsky later earned recognition from Tsar Nicholas II for his design of a four-engine plane used by the Russians in World War I.

With the coming of the Bolshevik Revolution, Sikorsky fled Russia. He arrived in America on March 30, 1919, and continued designing aircraft. In 1923, he founded the Sikorsky Aero Engineering Corporation on the farm of a fellow Russian émigré in New York. There, Sikorsky designed sea planes, and meeting with much success, he relocated to a larger property in Stratford, Connecticut, in 1929. Thirteen years later, on January 14, 1942, Sikorsky piloted the first successful helicopter flight in America.

March 31

An Aerial View of Connecticut

Among the first aerial photographs taken of Connecticut were those by John Doughty, taken in the fall of 1885 while a passenger in the balloon of Alfred E. Moore. Though the operation met with some success, in 1934, Governor Wilbur Cross requested the completion of an aerial survey of the entire state. It was a resource he deemed vital for planning the state's future.

The state hired Fairchild Aerial Surveys, Inc., of New York City to complete the survey. The company utilized three of its own planes and one from the Connecticut National Guard to fly in geometric patterns over the state in March and April 1934. The planes flew at one hundred miles an hour and kept a steady altitude of 11,400 feet to keep all of the photos to scale. The planes remained aloft for a total of 153 hours, taking photos nearly every 25 seconds on rolls of film reaching 75 feet long.

Employees of the Connecticut National Guard and the State Highway Department then took on the momentous task of piecing together the ten thousand overlapping photographs to form one giant mosaic. On March 31, 1935, the *Hartford Courant* announced the completion of the first-ever government-sponsored aerial survey of an entire state. The final product was thirty-one feet high by forty-two feet long and came at a cost of approximately $25,000.

APRIL

April 1

Uncle Tom's Cabin

In the years leading up to the Civil War, antislavery writings proved a powerful catalyst in the growth of the abolition movement. Slave narratives and other works of literature provided Northerners a glimpse of slave life and prompted a sympathetic public to take organized action. Of all the literature written during this period, few works reached a wider audience or matched the impact of Harriet Beecher Stowe's novel *Uncle Tom's Cabin*.

Born in Litchfield, Connecticut, on June 14, 1811, Harriet Beecher Stowe was the daughter of influential minister Lyman Beecher. As a young woman, her family moved to Cincinnati on the western frontier, and Beecher witnessed the horrors of slavery firsthand in the neighboring state of Kentucky. Stowe became so outraged when Congress passed the Compromise of 1850 (which, among other things, led to the capture and enslavement of free black men living in the North) that she put pen to paper. The story she wrote, *Uncle Tom's Cabin*, appeared in serial format in the weekly *National Era* newspaper. Printed in a total of forty installments, the story first appeared on June 5, 1851, and ended with the last installment on April 1, 1852.

Later in 1852, Stowe published the story as a two-volume book. The first printing of 5,000 copies sold out in two days. In all, 300,000 copies sold in America that first year. Critics acknowledge Stowe's sympathetic portrayal of slaves as a watershed moment in the expansion of abolitionism and her critical portrayal of slave owners as creating such outrage in the South that it potentially hastened the outbreak of the Civil War.

April 2

Connecticut SAR

Founders of the Connecticut Society of the Sons of the American Revolution (CTSSAR) formed their organization on April 2, 1889. In an era rich in patriotic fervor, the Connecticut society became a part of the national Sons of the American Revolution, a private nonprofit organization focused on preserving the nation's colonial past. Participants adopted a constitution and bylaws in a September 1889 meeting in the governor's room at the state capitol and the organization grew rapidly to nearly one thousand members in its first six years.

The CTSSAR expanded to nine chapters throughout Connecticut, performing services such as the maintenance of genealogical records and the formation of the CTSSAR Color Guard for use in ceremonial parades. The CTSSAR is also the only state chapter of the organization that maintains historic properties. In addition to preserving schools in New London and East Haddam taught at by Revolutionary War hero Nathan Hale, the society operates the Lebanon War Office, where the Council of Safety met throughout the Revolution. The office also hosted such prestigious figures as Israel Putnam, Henry Knox and the Marquis de Lafayette.

April 3

The Bushnell Park Carousel

In early 1974, Meyer's Amusement Park in Canton, Ohio, offered to sell its early twentieth-century carousel to the Knox Foundation of Hartford. Made in Brooklyn, New York, in 1912, the carousel came with colored horses, a Wurlitzer organ and a $55,000 price tag. The City of Hartford and the Retail Trade Commission approved a plan to bring the carousel to Hartford as a way of attracting people to the city's downtown area.

Plans called for the carousel to be installed in Hartford's Bushnell Park and operational by the fall of 1974. While workers painted the carousel for the grand opening, the horses went on display in the windows of Hartford's G. Fox & Co. department store. Unfortunately, the plans hit a snag when

Hartford's fine arts commission objected to the carousel's placement in Bushnell Park, preferring instead to locate the attraction in a renewed section of the city near Asylum and Main Streets.

After workers completed the renovations and authorities straightened out all the legal wrangling surrounding the location, the carousel finally opened in Bushnell Park in the spring of 1977. It proved so popular that on only its third day of operation, April 3, 1977, operators needed to shut it down due to the tremendous crowds it attracted. With tickets costing only ten cents, numerous customers stockpiled tickets and rode the horses continuously, creating a substantial backup of patrons awaiting their turn. Capable of handling five hundred customers per hour, operators sold over five thousand tickets for that Sunday for rides between 11:00 a.m. and 5:00 p.m.

April 4

The Upper Brass

Abel and Levi Porter came to Waterbury to manufacture metal buttons—a goal they accomplished with the establishment of Abel Porter & Company in 1802. After the business passed into the hands of Frederick Leavenworth, David Hayden and James M.L. Scovill, Scovill's brother, William, bought

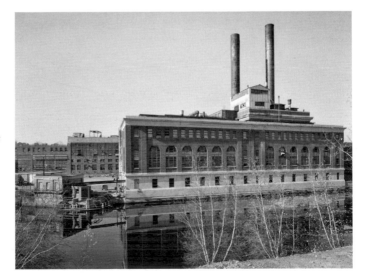

Southwest view of Scovill Manufacturing Company in Waterbury. *Library of Congress, Prints and Photographs Division, Historic American Buildings Survey/ Historic American Engineering Record/Historic American Landscapes Survey.*

out Hayden and Leavenworth on April 4, 1827, and the two brothers established what became the Scovill Manufacturing Company—a world leader in brass production for more than one hundred years.

Scovill produced brass buttons, pins and housewares, along with ammunition casings vital to Allied victories in World War I and World War II. Their success drew other brass manufacturers to the area and earned Waterbury the nickname of the "Brass City." It was only in the late twentieth century that the arrival of plastic and aluminum brought an end to Scovill's reign as one of the premier brass goods producers in the world.

April 5

Mayor P.T. Barnum

The great American showman Phineas Taylor Barnum was born in Bethel, Connecticut, on July 5, 1810. Known for his love of practical jokes and aversion to physical labor, Barnum went to work at a grocery outside Bethel at the age of twenty-five. There, he met a customer selling the rights to the performances of Joice Heth, a woman alleged to be 161 years old. Barnum bought the rights to the act and toured with Heth throughout the Northeast.

In 1841, Barnum purchased Scudder's American Museum in New York City. Reopened as Barnum's American Museum, it contained a variety of oddities meant to draw audiences through the doors, including a working model of Niagara Falls and the body of a preserved "mermaid." During a stopover in Bridgeport, Connecticut, the following year, he discovered Charles Stratton. Standing less than three feet tall, Stratton took the name "General Tom Thumb" and toured the world with Barnum, making both men very wealthy.

An interest in politics helped Barnum win election to the state legislature from the town of Fairfield in 1865. Ten years later, on April 5, 1875, Barnum won the mayoral election for the city of Bridgeport. He served as mayor for just one year and focused on lowering utility rates, improving water supplies and cracking down on rampant prostitution.

Shortly after leaving political life, Barnum merged his Great Roman Hippodrome show with James A. Bailey's International Allied Shows. The merger ultimately produced the world-famous Barnum & Bailey circus.

April 6

U-C-O-N-N

The victory by the University of Connecticut women's basketball team on April 6, 2004, in New Orleans made UConn the proverbial center of the college basketball world. It had nothing to do with the victory giving the team its fifth national championship (and third in a row), UConn's impressive 31–4 record or Connecticut guard Diana Taurasi being named the NCAA tournament's Most Outstanding Player. Thanks to a victory by the university's men's program the night before, the women's victory meant that, for the first time in NCAA history, one school had won both the men's and women's Division I national basketball championships in the same year.

The victory by the men took place in San Antonio, Texas, and represented the second national championship for the men's program—the first having occurred in 1999. Both the men's and women's programs had coaching hires made in the mid-1980s to thank for their success. In 1985, UConn hired University of Virginia assistant women's basketball coach Geno Auriemma to run the women's program in Storrs, and the following year, it hired Jim Calhoun away from Northeastern University to coach the men. Both coaches took their programs from relative obscurity to national dominance in a matter of years.

The dual championships helped give the state a new sports identity—one lost with the departure of the Hartford Whalers (the state's only major professional sports franchise). Since 2004, the remarkable dual championship feat has been accomplished only one other time, and that was also by UConn, in 2014.

April 7

A Patriotic Mass Meeting

Although the First World War began in 1914, the United States did not enter the conflict until three years later. Initial resistance to intervening in European affairs quickly changed when the Germans opted to form a naval blockade around Great Britain—America's closest trading partner—and

chose to enforce that blockade by sinking arriving U.S. ships. On April 2, 1917, President Wilson went before Congress to declare war on Germany. The Senate approved the resolution two days later, and the House followed suit on April 6, making America's entry into the war official.

The next day, the bells of the Old State House in Hartford summoned throngs of Connecticut residents to a "patriotic mass meeting" on the plaza between the Municipal Building and the Morgan Memorial. At three o'clock that afternoon, patriotic citizens stood shoulder to shoulder to hear a speech by Governor Marcus Holcomb, listen to patriotic music and make a pledge in support of the American war effort.

Two days after the rally, Hartford mayor Frank Hagarty sent the following message to President Wilson: "Acting under authority of the people of Hartford, assembled in mass meeting in this city on Saturday afternoon, April 7, I have the honor to transmit to you herewith a resolution adopted by the unanimous vote of said meeting, pledging to the President and Congress their loyalty, devotion and support to bring the war to a successful termination."

April 8

The Constitution State

Throughout Connecticut's history, residents afforded the state numerous nicknames, both formally and informally, in hopes of capturing its unique identity through proper phrasing. Perhaps the most famous moniker attached to Connecticut is the "Nutmeg State." This name came from the stories of Yankee peddlers traveling throughout the South selling phony wooden nutmegs to unsuspecting consumers who then attempted to season pies and breads with hunks of nutmeg-shaped wood. (Though some attribute these stories to southerners who, unfamiliar with using nutmegs, attempted to crack them open rather than grind them and, being unable to do so, thought they had been swindled.)

During the American Revolution, Connecticut earned the reputation as the "Provisions State," thanks to the frequency with which Governor Trumbull regularly fulfilled General Washington's pleas for supplies. Other nicknames attributed to Connecticut through the years have been

the "Freestone State" (due to the abundance of Connecticut brownstone in national construction projects) and the "Land of Steady Habits" (which refers to the strict Puritan values that have dominated Connecticut throughout its history).

In 1959, the Connecticut legislature decided it was time to choose an official nickname for the state. It approved the name the "Constitution State" on April 8 of that year. The nickname comes from the belief that Connecticut's Fundamental Orders of 1638–39 represent the very first written constitution in the history of the Americas.

April 9

Commissary to the Continental Army

Jeremiah Wadsworth was only four years old in 1747 when his father died, forcing him to move to Middletown and live with his uncle Matthew Talcott. His uncle was a ship owner (and son of Connecticut governor Joseph Talcott) and taught Jeremiah to be a sailor.

When hostilities broke out between Great Britain and its American colonies, Wadsworth began work as the supply commissary for Connecticut's military. It required the type of management and attention to detail he learned performing similar tasks aboard ship, and Wadsworth excelled at his new position. As a result, the Continental Congress appointed him deputy commissary general of purchases in June 1777, serving under Joseph Trumbull.

When Trumbull resigned the following year, Wadsworth became commissary general, in charge of all purchases for the Continental army. Wadsworth took the position over on April 9, 1778, and held it through December of the following year. It was then that he began serving in the same position for French troops stationed in America.

After the war, Wadsworth traveled to France, as well as England and Ireland. He purchased large quantities of goods that he brought back to America and sold for a substantial profit. In this manner, he became the wealthiest man in Connecticut. Prior to his death in 1804, he also served as one of the founders of the Bank of North America, an executive at the Bank of New York and a member of Congress.

April 10

Spanish Merino Sheep

David Humphreys was a poet, soldier, diplomat and agricultural innovator who rose to the highest ranks of early American society. A native of Derby, Connecticut, he served as aide-de-camp to both Israel Putnam and George Washington during the Revolutionary War. Humphreys, held in high esteem by colonial leadership, later joined the likes of John Adams, Benjamin Franklin and Thomas Jefferson in helping negotiate treaties with European powers after the war.

In 1796, Humphreys began a five-year term as minister to Spain. While there, he took an interest in local wool production facilitated by the breeding of Merino sheep. Sensing their potential value in America, Humphreys acquired one hundred sheep for export to America. Three shepherds and a small force of Portuguese soldiers guided the highly prized animals across the Portuguese countryside on their way to Lisbon. Once there, the twenty-five rams and seventy-five ewes departed for America on April 10, 1802.

Upon their arrival, Humphreys brought most of the animals to his farm in Derby. He then sold them for $100 apiece. Local farmers crossbred them with their stock and produced wool of a quality equal to that of the finest European cloth. The sheep so completely revolutionized cloth manufacturing in the United States that they soon sold for as much as $1,500 apiece. Humphreys took advantage of his new acquisitions and opened a successful wool mill in Seymour. He spent the rest of his life engaging in agricultural pursuits, taking time out only to accept the numerous awards and accolades heaped upon him by his peers.

April 11

Home of the Submarine Force

The home of America's submarine force is the Naval Submarine Base New London—the navy's first submarine base. Despite its official name, the military actually located the base along the Thames River in the town of Groton, not New London.

The base got its start as a naval yard and storage depot on April 11, 1868. The State of Connecticut, along with numerous southern Connecticut towns and cities, donated land along the Thames for the establishment of the base, which the navy first used for storing inactive ships. Despite adding a refueling station for ships sailing in New England waters, the navy initially used the base sparingly and nearly closed it in 1912.

With the onset of World War I, however, submarines began arriving in Groton, and in 1916, the land along the Thames housed a newly designated sub base and submarine training school. The First World War expanded the fleet to twenty submarines and 1,400 men, while the Second World War facilitated the expansion of the grounds from 112 to 497 acres. In 1954, it became the home of the first nuclear-powered submarine, the USS *Nautilus*.

Occupying more than 680 acres and home to fifteen nuclear submarines, the Naval Submarine Base New London is the heart of the navy's submarine service. A desire to serve aboard an American submarine will inevitably draw any submariner to train in Groton.

April 12

A Different Type of Invention

Approximately twenty years after the typewriter became an essential part of business life in America, George Blickensderfer of Stamford, Connecticut, thought of a way to make it better and easier to use. Using a revolving type

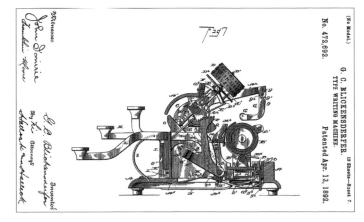

The patent drawing for Blickensderfer's portable typewriter. *United States Patent Office.*

wheel that decreased the number of parts needed to make the machine (thus significantly lowering its weight and improving its reliability), Blickensderfer designed the first truly portable typewriter. He patented his design on April 12, 1892.

Blickensderfer started working out of a small workshop behind his home but, in 1896, moved to a large factory on Atlantic Street and made it the headquarters of the Blickensderfer Manufacturing Company. Orders for the devices poured in, and Blickensderfer Manufacturing soon became one of the world's largest typewriter manufacturers. Blickensderfer died in 1917, and three years later, the L.R. Roberts Typewriter Company of Stamford took over his operations.

April 13

The King Tut Scam

Roughly fifty years after the discovery of King Tut's tomb in 1922, artifacts from the young Egyptian ruler's grave embarked on a four-year tour of the United States, lasting from 1976 through 1979. Its arrival at New York City's Metropolitan Museum of Art attracted 1.3 million people interested in viewing the artifacts of the "Boy King," and Connecticut residents arrived in New York by the busload.

On Saturday, April 7, 1979, the Met denied admittance to twenty-four Connecticut museumgoers who arrived as part of a tour arranged by the Dattco bus company of New Britain. The museum claimed the tickets these patrons possessed were counterfeit. Dattco spokesperson Joanne Perloff appeared flabbergasted but refused to comment on where Dattco obtained the tickets.

Nearly a week later, on April 13, 1979, the *Hartford Courant* broke the story of the King Tut ticket scam in its entirety. By then, hundreds of Connecticut residents held fraudulent tickets. According to the *Courant*, an unnamed perpetrator stole hundreds of blank tickets from a Ticketron outlet in Hartford and sold them.

On the morning of Tuesday, April 10, police attempted to pull over a speeding car on I-684, and a chase ensued. Eventually stopping the suspect, they found the driver to be Dattco's Joanne Perloff. In her car, they found 2,700 tickets to the exhibit she intended to distribute by hurriedly arriving

at the Met before a busload of tourists. Though the Dattco company apologized and offered refunds, those in possession of fraudulent tickets failed to gain admittance to the exhibit, which closed the following week.

April 14

Mourning FDR

The thirty-second president of the United States, Franklin Delano Roosevelt, died of a massive cerebral hemorrhage on April 12, 1945, at his retreat in Warm Springs, Georgia. The news came as a tremendous shock to most Americans, who, having relied on FDR to get the country out of the Great Depression and through the travails of the Second World War, elected him to an unprecedented four terms in office.

The day after FDR's death, Connecticut governor Raymond Baldwin addressed a joint convention of the state's General Assembly as he prepared to leave for Washington to attend the former president's funeral. He declared Saturday, April 14, 1945, an official day of mourning throughout Connecticut.

In response to the governor's decree, nonessential war businesses closed at noon. Bars, movie theaters and museums closed for the entire day. Dances, sporting events (except for a bowling match benefiting the Red Cross) and other forms of amusements were canceled. The governor asked Connecticut residents to attend their places of worship at 4:00 p.m. (the time of FDR's funeral) for prayers and memorial services and asked workers laboring in vital war industries to observe a moment of silent prayer that afternoon. Connecticut, along with the rest of the nation, mourned the loss of the president for weeks on end, not raising its flags above half-staff for a full thirty days.

April 15

The American School for the Deaf

Thomas Hopkins Gallaudet was a Congregationalist minister who traveled throughout the Northeast spreading the word of God in the early nineteenth

century. During one visit to Connecticut, Gallaudet became acquainted with Dr. Mason Cogswell, whose nine-year-old daughter, Alice, was deaf and did not speak. Dr. Cogswell, having listened to Gallaudet describe experiments in Europe where educators developed a series of signs to help the deaf and the mute communicate, asked Gallaudet to travel overseas and learn these techniques.

While in Europe, Gallaudet studied under Laurent Clerc, a deaf priest developing a form of manual communication. Clerc returned with Gallaudet to America, and the two traveled extensively in New England, tutoring and raising money for the creation of a school for teaching the deaf.

After considerable effort, Cogswell, Gallaudet and Clerc succeeded in acquiring a charter for the school from the Connecticut General Assembly. The school officially opened on April 15, 1817, as the Connecticut Asylum for the Education and Instruction of Deaf and Dumb Persons. The first class to enter the school consisted of seven students, including Alice Cogswell. Later, a grant of three acres of land from the United States Congress prompted a move from Hartford to West Hartford, and the institution changed its name to the American School for the Deaf.

April 16

The Grange

While farming began in the United States as a necessary practice—one needed to ensure individual survival—by the country's 100th birthday, farming was entering the realm of "big business." To keep farmers informed about the latest changes to industry practices, as well as to provide a forum for professionals to gather and exchange ideas, forward-thinking agriculturalists formed the National Grange of Patrons and Husbandry.

After two days of meetings at the Old Taylor Opera House in Danbury that ended on April 16, 1875, Connecticut organized its first state grange—becoming the thirty-third state to do so. Unfortunately for the twenty local granges that made up this organization, a series of poorly defined rules and a lack of adequate funding slowly brought about the demise of Connecticut's first state grange.

A second attempt to organize came ten years later and met with much greater success. Sixteen subordinate organizations formed the new state grange

in South Glastonbury in June 1885. By the end of the year, the grange even had its own meeting hall in Lebanon. In addition to ensuring the viability of Connecticut farming over the next century and beyond, the Connecticut State Grange played a vital role in the state's history by facilitating the establishment of the Connecticut Agricultural Experiment Station—the nation's oldest such facility—and promoting the success of the Storrs Agricultural School (which eventually became the University of Connecticut).

April 17

The Face of American Capitalism

Born in Hartford on April 17, 1837, John Pierpont Morgan spent years working in the financial industry. In 1871, he became a partner in the New York firm of Drexel, Morgan and Company, which he reorganized as J.P. Morgan and Company in 1895. It eventually grew into the most powerful bank in the world.

Morgan's accomplishments did not stop there, however. He fostered the growth of American industry by reorganizing the nation's numerous railroads, largely through consolidation. Additionally, he bolstered the national treasury during the Great Depression by supplying the government with gold, and in 1891, he merged Edison General Electric with the

J.P. Morgan stepping off the yacht he used to travel to work from his summer home in Greenwich (circa 1914). *Library of Congress, Prints and Photographs Division, Miscellaneous Items in High Demand Collection.*

Thomson-Houston Electric Company to form the General Electric Company (GE). Seven years later, he financed the establishment of the Federal Steel Company and merged it with the Carnegie Steel Company and others to form the United States Steel Company—the world's first billion-dollar company.

April 18

Referee and Opponent Arrested in Death of a Boxer

Turn Hall in Waterbury hosted a boxing match between two local men, Joseph Clancy and William Luke, on April 17, 1911. The fight came to an end one minute and fifty-two seconds into the fourth round when Clancy knocked out William Luke. After the fight, Luke returned to his dressing room and quickly fell unconscious. He died at nine o'clock the following morning (April 18, 1911), leaving behind a wife and four children.

The coroner began an investigation into the incident by interviewing those in attendance, including Waterbury mayor William Hotchkiss. During the investigation, police arrested Luke's opponent, Joseph Clancy, and the man who refereed the match, Daniel Bulkley, and charged them both with manslaughter.

The coroner later determined that Luke died of a brain hemorrhage and that he also suffered from diseased kidneys compromised long before the fight took place. Authorities discharged Clancy and Buckley the following day.

April 19

Connecticut Ratifies the U.S. Bill of Rights (150 Years Late)

One of the most contentious issues surrounding the creation of the U.S. Constitution was its ability (or inability) to protect individual liberties from a potentially tyrannical central government. Consequently, on September 25, 1789, members of the first U.S. Congress proposed twelve amendments to the Constitution. The first two (concerning representation of the states and compensation for congressmen) failed to pass, but Congress did pass the remaining ten amendments. These became known as the Bill of Rights.

The proposed amendments went back to the individual states for ratification, and one by one, states voted in the affirmative until Congress had the necessary support to sign the amendments into law. Connecticut, however, failed to ratify the amendments due to a procedural snafu in which both houses of the state General Assembly voted for ratification but failed to do so in a consistent manner.

Connecticut's failure to officially ratify the Bill of Rights garnered little attention in the state over the next 150 years, thanks largely to the state passing its own bill of rights as part of the Fundamental Orders of 1650. The 150th anniversary of the passing of the Bill of Rights finally created the political pressure required to move legislators to action, however. On April 19, 1939, without speeches or great fanfare, a unanimous vote by the General Assembly made Connecticut the last state in the Union to ratify the Bill of Rights.

April 20

Norwalk for Sale

The first recorded observation of the land comprising modern-day Norwalk, Connecticut, came from the Dutch navigator Adrian Block during his passage through the Long Island Sound in 1614. Just over twenty-five years later, Captain Daniel Partrick acquired the land from local indigenous tribes.

Partrick was a Loyalist and one of the first settlers of Watertown, Massachusetts. He fought in Connecticut during the Pequot War, where he earned the title of captain. He and Roger Ludlowe pursued the Pequot as far west as Fairfield before the war ended.

Recognizing an opportunity for expansion and the opening of new trade routes, Partrick negotiated for the purchase of land from the Norwalk River to Darien—a tract that included half of modern Norwalk. (Roger Ludlowe negotiated the purchase of the other half). On April 20, 1640, leaders from the Norwake and Makentouh tribes deeded the land to Partrick in return for three hatchets, three hoes, six glasses, twelve tobacco pipes, three knives, ten drills, ten needles and ten fathoms (a particular measurement of strung beads that varied in length) of wampum.

Less than three months later, Partrick negotiated the purchase of the area around Greenwich and soon met his demise there. It took the

better part of ten years for settlers to finally move into the Norwalk lands he purchased and until 1701 for the first of Partrick's descendants to relocate to Norwalk.

April 21

A Civil War Orphanage Turned State University

In the middle of the nineteenth century, Edwin Whitney of Mansfield, Connecticut, made plans to establish a new school for boys in the state, but when he heard about a proposal to open a home in Cornwall for orphans of the Civil War, Whitney offered his school building and fifty acres of land in place of the smaller facilities. The orphanage he established operated out of Mansfield from 1866 until 1875—when the last of the orphans reached adulthood and moved away.

After Edwin Whitney died, his widow sold the property to Augustus Storrs in 1878. Three years later, Augustus Storrs and his brother, Charles, included the property in a gift he made to the state to establish the Storrs Agricultural School. The state General Assembly approved the founding of the school on April 21, 1881.

In all, the agricultural school consisted of 170 acres, the orphanage building and several barns. After a delay caused by the death of American president James Garfield, the school opened on September 28, 1881, with a total of three faculty members and seven students. Founded as a two-year vocational school, it produced its first six graduates in 1883. Ten years later, the school opened its doors to women and changed its name to the Storrs Agricultural College. It then became the Connecticut Agricultural College in 1899, the Connecticut State College in 1933 and, finally, the University of Connecticut in 1939.

April 22

The Powder House Keys

On the morning of April 19, 1775, British forces under General Thomas Gage left Boston, Massachusetts, to march on the towns of Lexington

and Concord, where they planned to arrest Patriots Sam Adams and John Hancock and seize a stockpile of colonial munitions. The British encountered a group of colonial militia (minutemen) on the Lexington Green, and the two sides exchanged fire, leaving seven minutemen dead.

News of the conflict reached New Haven, Connecticut, two days later. On April 22, 1775, the Second Company of the Governor's Foot Guard responded by organizing on the New Haven Green in order to march on the British in Boston. Short on ammunition, the guard, under commander Benedict Arnold, confronted town leaders meeting at a local tavern and requested the needed supplies. With New Haven's leadership reluctant to act, Arnold threatened violence if he did not immediately receive the keys to the local powder house. Ultimately successful in his quest, Arnold armed his men, headed out on the three-day march to Cambridge and entered Connecticut into the Revolutionary War.

April 23

L'Ambiance Plaza

It was on the afternoon of April 23, 1987, that construction workers lifted concrete slabs into place at L'Ambiance Plaza—a $17 million apartment complex under construction in Bridgeport, Connecticut. Having just secured the concrete in the east building, workers were using cranes to lift slabs into place in the west building when, just after 1:30 p.m., the west building collapsed. Giant hunks of concrete crashed down on top of one another, destroying the entire structure and killing twenty-eight workers. It was the worst construction disaster in Connecticut's history.

An investigation into the accident revealed several possible causes for the collapse but no definitive answers. Some blamed welding failures on the upper floors, while others hypothesized that faulty wedges used to temporarily hold the slabs in place prior to welding were the cause. Still other sources blamed the collapse on a loss of support for a lifting jack. The accident led to a moratorium on "lift-slab" construction until 1994, when the government issued new federal safety regulations that, among other provisions, forbid work on lower floors during the securing of slabs above. Authorities never filed any criminal charges in the case,

but lawsuits resulting from the collapse paid families of the victims approximately $41 million.

April 24

Settling New Haven

John Davenport was a preacher at St. Stephen's Church in London in the early seventeenth century. Controversial due to his growing adherence to the principles of Puritanism, Davenport, along with his friend Theophilus Eaton and a group of Puritan supporters, boarded two ships in May 1637 and headed to Massachusetts, largely in search of religious freedom. After arriving, they looked for a place to settle in Massachusetts but found none to their liking. In addition to seeking out land suitable for construction and agriculture, a faction of Puritan merchants in the group desired a home with a harbor nearby for shipping.

In August 1637, Eaton traveled with a small group to inspect an area along the southern coast of modern-day Connecticut. The explorers returned with favorable reports, and the following spring, approximately five hundred English Puritans sailed for what eventually became the city of New Haven. They arrived there on April 24, 1638.

Met by a friendly tribe of indigenous Quinnipiacks, the settlers purchased land stretching from Milford to Guilford from them. They then divided the area into a traditional nine-square grid—the center grid becoming the New Haven Green. With the abundant resources of Long Island Sound at their disposal, settlers prospered and grew into a community of eight hundred residents in just three years.

April 25

Winchester Arms

In 1856, Oliver Winchester, vice-president of the bankrupt Volcanic Repeating Arms Company, purchased two thousand rifles, three lathes and a number of other company assets in order to organize a new firearms

Women making Browning machine guns at Winchester Repeating Arms Company during World War I. *Library of Congress, Prints and Photographs Division, Miscellaneous Items in High Demand Collection.*

business. This business became the New Haven Arms Company on April 25, 1857. Winchester grew the business into a national leader, thanks to the popularity of the company's Henry rifle—a firearm designed by B. Tyler Henry and praised for its power, accuracy and speed of loading.

Capitalizing on the popularity of the Henry rifle, Winchester renamed the company the Henry Repeating Arms Company before giving his enterprise its more famous moniker, the Winchester Repeating Arms Company, in 1866. Winchester's company, which operated out of both New Haven and Bridgeport, went on to produce a variety of other iconic firearms, including the M1 Carbine, the standard thirty-caliber weapon issued to Allied forces during World War II.

April 26

Tryon's Raid

During the American Revolution, the town of Danbury served as a vital supply depot for colonial troops in New York and New England. The town's location, at a break in the mountain ridges separating Connecticut from New York, meant that much of the supplies used by the Continental army during battles in the Hudson Valley came through Danbury.

In the spring of 1777, William Tryon, the royal governor of New York, landed near Westport with 1,800 British troops intent on disrupting colonial supply lines. Tryon's men arrived in Danbury on April 26, 1777; took whatever supplies they could carry back with them; and then burned much of the town, including twenty-two homes. That night, residents in the surrounding area spread news of the attack. Among them was sixteen-year-old Sybil Ludington from nearby Patterson, New York, who rode over forty miles through the rainy night to sound the alarm.

The next day, British troops made their way back to their boats through the town of Ridgefield. There, they skirmished with militiamen commanded by David Wooster, Benedict Arnold and Benjamin Silliman. Despite a blockade on Main Street manned by Arnold and Silliman and an attack launched on the British rear guard by Wooster, the British managed to arrive back in Westport by the twenty-eighth. After the British attack, Israel Putnam stationed a force of men in Danbury to discourage any future raids.

April 27

The Pope of Litchfield County

The Reverend Joseph Bellamy was a preacher, author and educator born in 1719. He earned his license to preach in 1737 and, three years later, became a minister in Bethlehem, Connecticut. He spent much of the early 1740s traveling throughout the state, speaking on as many as 450 occasions over a two-year period, helping to earn him the unofficial nickname of "the Pope of Litchfield County."

On April 27, 1744, Bellamy purchased property in Bethlehem and built a home that also served as the first theological school in the country. He took to writing and published twenty-two books in his lifetime—the most famous being 1750's *True Religion Delineated.*

After Bellamy's death in 1790, the house in Bethlehem served as a working farm and remained in the Bellamy family until 1860. In 1912, Henry McKeen Ferriday purchased the property as a summer home for his family. Ferriday's daughter, Caroline, took a special interest in preserving it after her parents' passing. She filled it with European and American antiques that reflected the tastes of the era, while also working to preserve the legacy of the home's original owner, Joseph Bellamy. She left the home to the Antiquarian and Landmarks Society (now Connecticut Landmarks) in 1990. It currently operates as a historic house museum.

April 28

The Great Merritt Parkway Land Grab

As Connecticut prepared to open the first stretch of the soon to-be-iconic Merritt Parkway in 1938, rumors circulated of corruption in various state departments that facilitated fraudulent land purchases along the highway's planned route. For the first time in Connecticut's history, the state convened a grand jury to investigate the operations of one of its major departments.

The grand jury issued its final report on April 28, 1938, after a three-month investigation. The five-thousand-word report detailed how certain government employees leaked information to real estate brokers about the proposed path of the parkway. The brokers then helped clients purchase the land along this path and sell it to the state at several times its assessed value.

Most of the blame, according to the report, belonged to the State Highway Department commissioner, John A. McDonald, whose alleged lax security and mismanagement of key processes created the opportunity for price gouging and profiteering. Among other things, the grand jury blamed McDonald for employing G. Leroy Kemp as the land agent for purchasing highway properties. (Kemp shared offices with a New York real estate broker who sold land to speculators.) The report also recommended McDonald resign, which he did the following day.

April 29

Designer of the Supreme Court

Born on April 29, 1745, in Windsor, Connecticut, Oliver Ellsworth studied law and passed the bar in 1771. He became Connecticut's state attorney for Hartford County in 1777, the same year he went to serve in the Continental Congress. He spent six years there before returning to Philadelphia as a representative to the Constitutional Convention, where he helped author the Connecticut Compromise and served on the committee that prepared the first draft of the U.S. Constitution.

Ellsworth went on to serve as a senator in the new federal government from 1789 until 1796. Prophetically enough, one of his most celebrated achievements was as the principal author of the Judiciary Act of 1789, which defined the organization and operation of the Supreme Court. Seven years later, on March 3, 1796, President George Washington nominated Ellsworth for the position of chief justice of the Supreme Court. The Senate confirmed the nomination the next day.

A diplomatic appointment as commissioner to France ended Ellsworth's service on the Supreme Court in 1799. He retired from public life two years later and returned to his home in Windsor, where he passed away on November 26, 1807.

April 30

How the NFL Almost Came to Connecticut

In 1998, Robert Kraft, owner of the National Football League's (NFL) New England Patriots, wanted a new stadium for his team. Kraft purchased the team in 1994 and deemed its home stadium in Foxboro, Massachusetts, inadequate for generating the type of revenue he desired. After a proposal to build a new facility in South Boston failed in 1995 and negotiations with Foxwoods casino and the State of Rhode Island fell through in 1997, Kraft looked to move the team to Hartford.

In December 1998, the Connecticut legislature approved the construction of a $375 million stadium along the Connecticut River to lure the Patriots to

Hartford. The deal offered Kraft revenues from 150 luxury suites, as well as most of the remaining game-day revenues and the income from selling the stadium's naming rights.

In the months that followed, preparations began for the Patriots' move. The team and the state signed a team relocation and a stadium development agreement in February. In the middle of April, the Patriots filed their preliminary budget for the project, prepared to move their offices to Constitution Plaza and filed a relocation application with the NFL. Then suddenly, on April 30, 1999, Robert Kraft announced he was pulling out of the deal. Citing concerns about potential environmental and infrastructure problems that might delay construction, Kraft decided to build a new stadium in Foxboro with help from the NFL and the State of Massachusetts, leaving Connecticut, once again, without a major professional sports franchise to call its own.

MAY

May 1

The Pequot War

Years of increasingly violent confrontations between European colonists and warring factions of indigenous tribes resulted in the colonies of Massachusetts, Plymouth and Connecticut (as well as warriors of the

Drawing of the attack on the Pequot (1638). *Library of Congress, Prints and Photographs Division, Miscellaneous Items in High Demand Collection.*

Narragansett and Mohegan tribes) declaring war on the Pequot people on May 1, 1637. One of the most violent episodes in Connecticut's history occurred just weeks later when Connecticut militia leader John Mason led a raid on the Pequot in modern-day Mystic, Connecticut. With most of the Pequot warriors away, Mason set fire to the Pequot village, killing as many as seven hundred women, children and elderly members of the tribe. It was an act so appalling that many Native Americans, including the Narragansett, withdrew their support for the English.

The brutal nature of the raids on the Pequot forced their leader, Sassacus, to eventually seek refuge with the Mohawk, but the Mohawk feared English retaliation and slaughtered Sassacus and his warriors. In September 1638, the two warring sides signed the Treaty of Hartford.

May 2

Pediatrician to the World

Perhaps the world's most famous pediatrician, Benjamin Spock was born in New Haven, Connecticut, on May 2, 1903. The product of a strict upbringing in New Haven, he received his medical degree from Columbia University in 1929. Ten years after the birth of his first child, Spock began writing a book on childcare that emphasized a relaxed, commonsense approach to parenting. Spurred by the postwar baby boom, sales of *Dr. Spock's Baby and Child Care* (later renamed *The Common Sense Book of Baby and Child Care*) reached more than four million copies in the book's first six years.

Despite the success, Spock drew criticism from women's groups for the sexist tone of his literature, and in the 1960s, Americans began blaming Spock's liberal parenting style for the disorderly behavior of its youth. Spock, who became a socialist, joined the tide of rebellious behavior by protesting the draft and America's presence in Vietnam. Authorities arrested him in 1968 for directing young men to avoid the draft—though the U.S. Court of Appeals overturned his conviction the following year due to a lack of sufficient evidence.

In 1972, Spock ran unsuccessfully for president of the United States on the People's Party ticket, which promoted free medical care, legalized marijuana and the immediate withdrawal of all troops overseas. He then

took to protesting the development of nuclear weapons and, by the mid-1980s, had been arrested a dozen times. Continuing his advocacy for peace well into his older years, Spock passed away in San Diego, California, in 1998 at the age of ninety-four.

May 3

The First Purple Hearts Awarded

As the Revolutionary War came to a close, General George Washington looked for a way to recognize the meritorious service of enlisted men and noncommissioned officers. In August 1782, he designed the "Badge of Military Merit." The award consisted of a heart-shaped piece of purple silk or cloth with decorative trim and was designed for recipients to wear on their coats above their left breast to enable them to walk unchallenged past guards and sentinels.

On May 3, 1783, at his headquarters in Newburgh, New York, Washington awarded these badges for the first time. The first badge went to Elijah Churchill of Enfield, Connecticut, for his bravery at Fort St. George in 1780 and Tarrytown, New York, in 1781. The other badge awarded that day went to William Brown of Stamford, Connecticut, who served throughout the war and, it is believed, took part in the siege of Yorktown. Washington awarded the badge only one more time—on June 10, 1783, to Daniel Bissell Jr. of East Windsor, Connecticut. Bissell had posed as a Continental army deserter to gather information from the British in New York from 1781 to 1782.

In January 1931, General Douglas MacArthur looked to revitalize interest in the badge to commemorate the bicentennial of George Washington's birth. The War Department announced a new design for the award in February 1932 that included an enameled purple heart with bronze trim and a bronze profile of George Washington. The newly redesigned medal went by its new name, the "Purple Heart."

May 4

The Connecticut National Guard Enters the Spanish-American War

At the outbreak of the American war with Spain in 1898, the United States maintained an army of only modest size. Consequently, military officials deemed it necessary to raise fifty thousand volunteers from National Guard regiments across the country. Connecticut's quota required the state to produce one entire regiment for service. The regiment Governor Cooke chose was the Connecticut National Guard's First Regiment—one of the oldest military units in the country. On May 4, 1898, 100,000 citizens turned out to watch the First Regiment march through Hartford on its way to Niantic, where Connecticut forces departed for combat.

The mustering in of troops began on May 17, 1898, with Company F (the first company mustered in for the Civil War as well). The entire process took several months. Throughout the process, parents sent word to Niantic that their children falsified their ages to qualify for service and the army needed to identify these young enlistees and send them back home. Other soldiers refused to sign the muster roll and found themselves placed under arrest, while dozens of others failed to pass the required medical exams. By the time officials finished mustering in all the Connecticut troops, the brief military conflict was nearly at an end.

May 5

The First Woman to Receive a U.S. Patent

The Patent Act of 1790 allowed both men and women to legally protect their ideas and inventions by applying for patents, but state laws of the era typically did not allow women to own property independent of their husbands, which discouraged women from participating in the patent process. Mary Kies of South Killingly, Connecticut, changed all that.

When President James Madison issued Mary Kies a patent on May 5, 1809, she became the first woman to ever receive a U.S. patent. Her patent covered a new method for braiding straw with silk and other materials used

to make women's bonnets. The concept so delighted President Madison's wife, Dolly, that she sent a complimentary note to Mary Kies upon her receipt of the patent.

Mary Kies was born the daughter of an Irish immigrant farmer in 1752. Like many New England women of the early nineteenth century, Kies made her livelihood weaving straw hats. While her patent seemed to have significant ramifications for the hat industry at the time she applied for it, shortly after, changing fashion trends rendered her invention obsolete. After the death of her husband in 1813, Kies moved into the home of her son, Daniel, where she lived for the rest of her life. She died in relative poverty at the age of eighty-five.

May 6

A Pulitzer Prize for Public Service

In the 1930s, the *Waterbury Republican* and *Waterbury American* newspapers were in the midst of a campaign against corruption. The publisher of both papers (William Pape) became suspicious of sudden increases in voter registration in the city and asked his reporters to investigate. What they found were lists of active voters who were either deceased or no longer living in Waterbury. Their research resulted in the termination of Waterbury's Democratic and Republican registrars of voters.

Years later, Pape launched a similar investigation of Waterbury mayor T. Frank Hayes. Serving simultaneously as the city's mayor and the state's lieutenant governor, Hayes made little progress in erasing Waterbury's debts despite maintaining a high tax rate. In 1937, city comptroller Sherwood Rowland (grandfather of future governor John Rowland) began sending information to Pape about millions of dollars in funds illegally transferred to Hayes and his partners. The subsequent newspaper reports about the unfolding scandal helped a grand jury indict twenty-seven men on conspiracy and fraud charges the following year.

The stories Pape ran in his newspapers about the various scandals in Waterbury drew national attention to corruption in Connecticut. Consequently, on May 6, 1940, the *Waterbury Republican* and *American* won the Pulitzer Prize for Meritorious Public Service.

May 7

Two State Capitals

From the time of their founding until the middle of the seventeenth century, the Connecticut Colony (around Hartford) and the New Haven Colony operated independently of each other. It was in 1662 that King Charles II united them. For the better part of two centuries, Connecticut contained two capitals, one in Hartford and the other in New Haven. Each capital administered different functions of the government.

The two-capital system became increasingly cumbersome to administer throughout the nineteenth century, however, and Connecticut residents expressed little interest in funding the construction and maintenance of two statehouses. In 1866, the General Assembly appointed a committee to investigate consolidating the two capitals into one, and the idea steadily gained momentum in the years that followed. On May 7, 1873, a vote of the General Assembly held in New Haven passed a resolution proposing an amendment to the state constitution, designating Hartford as Connecticut's sole capital city. The resolution passed by a narrow margin, and New Haven ceased to act as Connecticut's capital shortly afterward.

May 8

Maurice Sendak

A longtime resident of Ridgefield, Connecticut, celebrated author Maurice Sendak died in Danbury Hospital on May 8, 2012. One of the most influential children's authors and illustrators of the twentieth century, Sendak wrote such acclaimed works as 1970's *In the Night Kitchen*, 1981's *Outside Over There* and, most famously, his 1963 work, *Where the Wild Things Are*. By breaking from the well-behaved, polished heroes of traditional children's literature, Sendak pioneered a darker form of the craft that both alarmed and delighted readers throughout the late twentieth century.

Born in Brooklyn, New York, in 1928, Sendak was the sickly son of Polish Jewish immigrants. He spent much of his childhood in bed, where he learned to draw. Among his first jobs was filling in backgrounds for comic books

and designing illustrations for textbooks. In 1948, he took a job designing window displays for F.A.O. Schwarz, and there he met Ursula Nordstrom, the editor of children's books for Harper & Row. He spent the better part of the next decade illustrating over fifty books before writing one of his own.

Later in life, Sendak designed stage sets, adapted many of his works for the theater and produced operas and ballets for television. Among the many accolades he received were the 1964 American Library Association's Caldecott Medal, the Hans Christian Anderson Award, the Laura Ingalls Wilder Award and, in 1996, the National Medal of the Arts.

May 9

A "Black-Hearted Villain" Fights to Abolish Slavery

A passionate abolitionist, John Brown believed in using extreme measures to stop the spread of slavery in the middle of the nineteenth century. He was born in Torrington, Connecticut, on May 9, 1800, and moved to Ohio as a child before opting to raise his own family in North Elba, New York. While there, he learned of the violence taking place in Kansas as proslavery and antislavery forces violently battled for control of the area.

Brown arrived in Kansas outraged at the brutality used by proslavery forces to spread their influence. In May 1856, he retaliated by leading four of his sons and three other men on a raid of

Portrait of John Brown (1859). *Library of Congress, Prints and Photographs Division, PH Filing Series Photographs.*

proslavery settlers along Pottawatomie Creek. Brown's party dragged five men out of their homes in the middle of the night and murdered them. Three years later, Brown led his famous raid on the armory at Harpers Ferry, Virginia—intent on inciting a slave insurrection. Labeled "a damned black-hearted villain" by slaveholding Southerners, Brown escalated the tensions between Northern and Southern interests and ultimately contributed to the outbreak of the Civil War.

May 10

The Wells Fargo Heist

On May 10, 2011, authorities arrested Norberto Gonzalez Claudio in the mountains of Puerto Rico. Over twenty-five years earlier, Gonzalez Claudio had masterminded one of the largest cash robberies in American history. It happened on September 12, 1983, when Wells Fargo employee Victor Gerena drugged two co-workers at an armored car depot in West Hartford and made off with $7 million in cash. Gerena and Gonzalez Claudio belonged to a terrorist organization called Los Macheteros, which, with support from Cuban leader Fidel Castro, fought for Puerto Rican independence from America throughout the 1970s and '80s.

Leaders of Los Macheteros quickly hid the money in Mexico and moved Gerena to Cuba. The FBI spent the next three decades chasing Gonzalez Claudio and his other accomplices around Puerto Rico, Mexico, Panama and Cuba before finally catching up with the ringleader in 2011. On November 14, 2012, the sixty-seven-year-old Gonzalez Claudio received a ninety-seven-month prison sentence.

In all, American authorities charged nineteen men in the 1983 Wells Fargo robbery (including two of Gonzalez Claudio's brothers). They proved unable to capture Victor Gerena, however, and never recovered the stolen money.

May 11

The New Old State House

In 1792, the Connecticut General Assembly ordered the construction of a new statehouse in Hartford to replace the tiny, antiquated building housing its operations during the previous seventy years. They hired noted architect Charles Bulfinch to design the three-story building, and the construction lasted from 1793 until 1796 (with a temporary halt in 1794 due to a lack of funds). With furniture purchases by Jeremiah Halsey and the first circular stair rail ever made in New England furnished by Asher Benjamin, the statehouse hosted its first legislative session on May 11, 1796.

The building hosted state government operations until 1879, when it came under the ownership of the City of Hartford. It then served as Hartford City Hall until 1920. The following year, it opened as a public museum, and in 1961, the U.S. Department of the Interior designated Connecticut's Old State House a National Historic Landmark.

Interior hall and stairs of Connecticut's Old State House. *Library of Congress, Prints and Photographs Division, Historic American Buildings Survey/Historic American Engineering Record/Historic American Landscapes Survey.*

May 12

Katharine Hepburn

A Hartford physician (Thomas Norval Hepburn) and his wife (Katharine Houghton Hepburn) welcomed the birth of a daughter on May 12, 1907. Thomas was a respected surgeon who pioneered the fight against venereal disease, while his wife, a women's rights activist, fought for female suffrage and for greater public access to birth control. Their daughter, Katharine, grew up to be one of the most famous actresses in motion picture, television and theater history.

After leading a privileged childhood and graduating from Bryn Mawr College in 1928, Katharine Hepburn launched her acting career by taking parts in small theater productions. She earned her first film role (as John Barrymore's daughter) in 1932's *A Bill of Divorcement*. The following year, Hepburn won her first Academy Award for her portrayal of Eva Lovelace in *Morning Glory*. She went on to win three more Oscars over the course of her career for her performances in *Guess Who's Coming to Dinner*, *The Lion of Winter* and *On Golden Pond*.

In her films, Hepburn worked with such powerful leading men as Humphrey Bogart, Warren Beatty, Jimmy Stuart, John Wayne, Henry Fonda and Cary Grant. In 1942, she starred alongside Spencer Tracy in *Woman of the Year*, and the two began a celebrated romance that lasted until Tracy's death in 1967.

When not filming movies, Hepburn split her free time between homes she owned in the Turtle Bay section of Manhattan and the Fenwick section of Old Saybrook, Connecticut. She passed away at her home in Fenwick on June 28, 2003.

May 13

The Columbia Motor Carriage

As the rain came down in Hartford on May 13, 1897, a group of businessmen and reporters sat down to an elegant lunch at the Pope Manufacturing Company awaiting a presentation from their host, Albert

Augustus Pope. Pope was a Civil War veteran who, after seeing his first bicycle at the 1876 Centennial Exposition in Philadelphia, acquired the American rights to the bicycle and began producing them in Hartford. He ultimately turned Hartford into the largest producer of bicycles in the United States.

A decade later, Pope created an automotive division of his Pope Manufacturing Company, but rather than relying on gasoline, Pope believed in the future of cars that ran on electricity. He focused on their production when he founded the Columbia Electric Vehicle Company in 1896. On that rainy May day in 1897, Pope unveiled his vehicle to public.

The Columbia Motor Carriage thrilled onlookers as it effortlessly traveled through the mud and up steep inclines along Laurel Street. Hitting maximum speeds of fifteen miles an hour, the 1,800-pound carriage ran on four sets of batteries charged using a standard 110-volt outlet. Reporters at major publications across the country experienced the future of transportation as Pope offered rides in three of his motor carriages throughout the afternoon.

Unfortunately for Albert Pope, the heavy batteries used to power his carriages were no match for the abundant supplies of petroleum available at the end of the nineteenth century. Cheaper sources of raw materials ultimately moved auto production to the Midwest, and Pope died largely insolvent in August 1909.

May 14

Heroism Aboard a Crippled Plane

The night of February 24, 1969, found Airman First Class John Levitow aboard an AC-47 gunship flying over Vietnam. Levitow, a native of Connecticut, removed magnesium flares from a rack, set their controls and passed them to a gunner who pulled the safety pin and threw the flares out the cargo door. Once in the air, the flares ignited and illuminated the enemy's positions for gunners both on the ground and in the air.

Five hours into the mission, a Vietcong mortar struck the right wing of Levitow's plane and exploded, ripping a two-foot hole in the wing and punching 3,500 holes into the fuselage. The entire crew suffered serious

injuries. Stunned, Levitow moved to assist one of his fellow injured crewmen when he noticed a smoking flare rolling among thousands of rounds of explosive ammunition.

Despite bleeding from more than forty shrapnel wounds, Levitow attempted to grab the flare, but the wildly rocking plane made it impossible. As a last resort, Airman Levitow threw himself upon the lit flare. Having corralled it, and with just two seconds left before the flare separated and ignited, he managed to throw it out the back of the plane.

For his bravery and for saving the lives of his crew, John Levitow received the Congressional Medal of Honor from President Richard Nixon on May 14, 1970. He was the lowest-ranking member of the Air Force ever to receive the honor.

May 15

The Queen of Mean

New York hotel tycoon and real estate developer Leona Helmsley, known as the "Queen of Mean," went to work for her future husband, real estate magnate Harry Helmsley, in 1968. The couple married four years later and built a real estate empire that included such iconic locales as the Park Lane Hotel and the Empire State Building.

Trouble began for Helmsley in 1986, when an investigation uncovered that she failed to pay sales tax on $485,000 worth of jewelry purchases made in New York City. Helmsley managed to avoid indictment by seeking immunity in a case that ultimately charged two jewelry store officials with tax fraud. The following year, however, a disgruntled ex-employee charged that Helmsley evaded more than $4 million in income tax payments by charging her businesses with upgrades to her twenty-eight-room mansion in Greenwich, Connecticut. It was during testimony in Helmsley's trial that a former employee credited Helmsley with once uttering the famous line, "We don't pay taxes. Only the little people pay taxes."

A jury found Helmsley guilty of evading taxes, and a judge sentenced her to pay a $7.1 million fine and spend four years in prison. After receiving medical tests at a facility in Kentucky, the seventy-one-year-old Helmsley arrived at the federal prison in Danbury, Connecticut, on May 15, 1992.

She served eighteen months there before ultimately obtaining her release. She died of heart failure at her Greenwich home in 2007 and left behind an estate valued at $5.4 billion.

May 16

The Largest Earthquake in Connecticut History

Scientists estimate that fault lines found deep underground in Connecticut formed between 250 million and 400 million years ago. These geological configurations resemble those found in more active seismic states but do not shift with the frequency and intensity of those found in areas more traditionally associated with earthquakes. That all changed one night in 1791 in the village of Moodus, however.

Moodus is in the town of East Haddam and lies along the Connecticut River. It derives its name from a Native American word meaning "the place of many noises." For centuries, residents in the area claimed to hear moaning and grinding noises coming from deep inside the earth.

According to an account documented by a local pastor, at approximately eight o'clock on the night of May 16, 1791, the largest earthquake in Connecticut's history hit the village of Moodus. Two large shocks in quick succession crumbled stone walls and chimneys, threw open latched doors and opened a fissure in the ground several yards long. A captain aboard a ship anchored in Clinton claimed to see fish suddenly jumping out of the water in all directions at the time of quake. Thirty smaller shocks followed the initial two, and hundreds of others carried on through the night and the following days. Residents as far away as New York City and Boston felt what modern scientists estimate to have been a 4.3-magnitude earthquake.

May 17

The Vietnam Memorial

In 2001, students at the Captain Nathan Hale Middle School in Coventry, Connecticut, began a project focused on documenting the lives of

Connecticut military personnel who died in the Vietnam War. A year and a half of research that included interviewing war veterans and their families resulted in a book identifying all 612 Connecticut residents who lost their lives in Vietnam during the war.

Robert Tillquist, 1 of the 612, was a combat medic killed in November 1965. His sister, Jean Risley, was a resident of Coventry and, moved by the project, formed the Connecticut Vietnam Veterans Memorial Committee in 2006. Her goal was to raise enough money for a permanent memorial to all of those identified in the book.

Through a variety of fundraisers and donations from individuals and local businesses, the committee raised enough money to cover the costs of the $40,000 memorial. The town of Coventry donated a plot of land in Patriots Park, and officials broke ground on the project in August 2007.

The dedication of the memorial took place on May 17, 2008. Approximately five hundred attendees from around the state descended on Patriots Park to watch the unveiling of the black granite memorial. Measuring fourteen feet long and seven feet high, surrounded by a cobblestone patio and granite benches, the memorial is the first to honor all the Connecticut servicemen who lost their lives in Vietnam.

May 18

The Oldest Man Executed in Connecticut

Gershon Marx was a Russian Jewish immigrant who purchased a farm in Colchester, Connecticut, in 1897. After moving to the farm four years later, he hired a man named Pavol Rodecki to work as a farmhand. At one point, owing Rodecki six months' worth of wages, Marx opted to murder Rodecki rather than pay him. Marx then cut up Rodecki's body, sewed it into a sack and buried it in a cellar.

Once police finally discovered Rodecki's body, the seventy-three-year-old Marx fled Colchester for a Jewish settlement on the east side of Hartford. After several days there, he headed for New York City. While on the boat to New York, however, a Mrs. Samuel Rodinsky recognized Marx and had heard the stories about his part in Rodecki's murder. She told her husband, who passed the story on to some neighbors, and the news eventually reached

the ears of New London sheriff George Jackson. The sheriff set off in pursuit and captured Marx in New York.

After a ten-day trial in New London, it took jurors only four hours to find Marx guilty of first-degree murder. On May 18, 1905, Gershon Marx became the oldest man, and first member of the Jewish faith, executed by the state of Connecticut when authorities hanged him at the state prison in Wethersfield. Three years later, police discovered the body of Samuel Rodinsky, murdered for betraying one of his fellow countrymen (Marx) to the police.

May 19

The Dark Day

A passing thunderstorm seemed of little consequence to residents of Connecticut on the morning of May 19, 1780. After the storm passed, the skies cleared but then slowly turned an eerie shade of yellow. By ten o'clock in the morning, darkness had fallen, and it only got worse. Yale president Ezra Stiles recorded that by noon, the day was as dark as night, and residents needed to light candles in order to read.

Many feared for their lives. They thought either something extinguished the sun or that Judgment Day had finally arrived. The birds stopped singing, and all animal life seemed to disappear. People began to pray, and legislators of the Connecticut General Assembly debated whether to adjourn and return to their homes.

The sky appeared to lighten a little around two o'clock but darkened again just as quickly. It was not until after three o'clock that the darkness finally began to move on.

The cause of the Dark Day remained a mystery for centuries. Recently, however, scientists at the University of Missouri determined that the cause of the darkness was likely large forest fires in Canada that produced enormous, slow-moving clouds of black smoke capable of blotting out the sun in much of New England.

May 20

A Disastrous Battle at Cold Harbor

In the summer of 1862, due, in part, to the defeat at the Battle of Bull Run the previous year, the Union army looked to recruit new units in its fight against the South. Among these new units was the Nineteenth Connecticut Volunteer Infantry consisting of 815 men (primarily from Litchfield County) and placed under the command of Major Elisha Kellogg of Derby. The new recruits arrived at the front on May 20, 1864.

Union commander Ulysses S. Grant's recently adopted plan to destroy the Confederate capital of Richmond, Virginia, first required a move against Confederate positions at Cold Harbor (ten miles north of Richmond). Around noon on June 1, after a twelve-hour march, the Nineteenth Volunteers (now a part of the Second Connecticut Volunteer Heavy Artillery) received word of their part in a charge on the entrenched enemy position scheduled for 5:00 p.m.

At the designated time, Grant ordered a full frontal assault—an order he later acknowledged was a terrible mistake. The men of the Nineteenth charged across open ground toward the felled trees and other obstacles shielding the Confederate army. The Confederates poured a hail of fire on to the advancing troops, killing 118 men in a matter of minutes. Bleeding from a wound to the arm, Kellogg ordered a retreat just as a bullet slammed into his head. Many of the men then scattered into the woods and became prisoners or were never heard from again. In all, 323 of the Connecticut volunteers died or received wounds at Cold Harbor—the single largest loss by any Connecticut regiment in a single battle.

May 21

America's First Speed Limit Law

Connecticut became the first state in the nation to legislate the speed of automobiles when it passed An Act Regulating the Speed of Motor Vehicles on May 21, 1901. The law limited motor vehicle speeds to twelve miles per hour within city limits and fifteen miles per hour outside them and was

a variation of a bill introduced by Representative Robert Woodruff that proposed limits at eight miles per hour and twelve miles per hour, respectively. The bill also required vehicles to reduce speeds at intersections and, when encountering horse-drawn carriages, to slow down or, if the horse appeared frightened, to come to a complete stop. Fines for breaking the law reached as high as $200 per infraction.

Other states followed Connecticut's example and rapidly implemented similar laws of their own. The process occurred without much uniformity, however, and by the 1930s, as many as a dozen states still lacked enforceable restrictions on vehicle speeds. It was not until January 1974 that President Richard Nixon signed a bill creating a national speed limit of fifty-five miles per hour.

May 22

Washington and Rochambeau

In July 1780, French forces under the command of General Comte de Rochambeau arrived in Newport, Rhode Island, to assist the American colonies in their fight for independence from Great Britain. The French saw little action, however, until the following spring, when word arrived of France's intention to send a fleet of ships to the southeastern coast of America. Seizing on this opportunity, Rochambeau contacted General

The Joseph Webb house, Wethersfield, where Washington and Rochambeau met. *Public domain image.*

George Washington at his headquarters in New York to request a meeting between the two leaders in order to develop a new military strategy.

Washington suggested meeting in Wethersfield, Connecticut. Two days of meetings between Washington and Rochambeau held at the house of Joseph Webb in Wethersfield concluded on May 22, 1781. The plan devised by the two generals ultimately led to the surrender of British general Charles Cornwallis during an attack on Yorktown, Virginia—the final major battle of the American Revolution.

May 23

Choate Rosemary Hall

Mary Atwater Choate founded the Rosemary Hall prep school for girls in Wallingford, Connecticut, back in 1890. Six years later, her husband, Judge William Gardiner Choate, founded the Choate prep school for boys on the same grounds as Rosemary Hall. The schools soon earned an enviable reputation for sending large numbers of graduates (such as John F. Kennedy) on to study at Ivy League colleges and universities.

Rosemary Hall moved to the town of Greenwich in 1900 but returned to Wallingford seventy-one years later. On May 23, 1971, Rosemary Hall and Choate announced plans to merge, which they did in 1974. A private co-ed prep school for grades nine through twelve, Choate Rosemary Hall remains one of the most prestigious prep schools in the country.

May 24

The First Steam-Powered Transatlantic Voyage

The SS *Savannah* was a sailing packet built in New York in 1818. Moses Rogers, a sea captain from New London, Connecticut, convinced the boat's owners that, after some modifications, he could sail the ship across the Atlantic under steam power—a feat never before accomplished.

Rogers oversaw the installation of a steam engine aboard the *Savannah*, while his brother-in-law, Stevens Rogers, oversaw the construction of the

hull and riggings, turning the *Savannah* into a hybrid. The ship then headed to Savannah, Georgia, for its historic voyage.

Unable to convince merchants and passengers about the safety of steam power, the crew embarked on their historic voyage aboard an empty ship at 5:00 a.m. on May 24, 1819. They arrived safely in Liverpool, England, on June 20, 1819, after twenty-nine days at sea. Despite the successful operation of the steam engine, the ship only operated under steam power for less than ninety hours, traveling by sail for the rest of the trip.

Questions surrounding the safety of steam power out on the ocean kept passengers away from transatlantic steam travel, however, and forced the owners of the *Savannah* to convert the boat back into a sailing ship. It ran aground and broke up off the coast of Long Island in November 1821. It was nearly thirty years before another American steamship attempted to cross the Atlantic.

May 25

Connecticut's New State Library

At the start of the twentieth century, Connecticut's capitol building also housed its state library—a function it acquired in 1878. But with the space too small to manage the thousands of new objects acquired by the library every year, and the facilities inadequate to provide the protection needed for the various books, documents and portraits under the library's care, the state formed the Commission to Make Repairs on the Capitol and to Procure a Site for a New Building for State Officials. This ultimately led the state to purchase land for a new library and Supreme Court building directly across from the capitol.

The groundbreaking took place on July 29, 1908, and for the better part of a year, workers utilized horse-drawn wagons to clear the site for construction. On May 25, 1909, Governor Frank Weeks and a host of state officials attended the laying of the library's cornerstone facing Lafayette Street.

The day began at 2:00 p.m. with a concert by the Colt Armory Band on the lawn outside the capitol. After listening to a variety of speakers, at 3:30 p.m., the crowd proceeded to the construction site, where the Connecticut Grand Lodge of Masons lowered the cornerstone into place. Inside the cornerstone, officials placed U.S. flags, coins, photographs, Hartford

newspapers and a piece of the Charter Oak. Workers largely finished the construction of the building and the relocation of the library's resources by the end of the following year.

May 26

The First Execution of a Suspected Witch

Although not as well publicized as those of Salem, Massachusetts, witch trials in Connecticut actually began almost fifty years earlier than their more famous counterparts. Guided by passages from the Bible, Connecticut's colonial government made witchcraft one of twelve capital crimes punishable by death in 1642. Five years later, magistrates of the Hartford Colony found Alse (Alice) Young of Windsor guilty of the crime and sentenced her to hang at Hartford's Meeting House Square (now the site of the Old State House). On May 26, 1647, Alse Young became the first person executed for witchcraft in America.

Throughout the 1600s, numerous other Connecticut residents met with Young's fate. Authorities executed Mary Johnson in 1648 for entering into a compact with the devil. Rebecca Greensmith met her sanctioned demise in Hartford after a local woman accused Greensmith of causing her to have strange fits. In all, eleven people died in Connecticut as a result of witchcraft allegations throughout the seventeenth century.

Although the last witchcraft execution was the hanging of Mary Barnes on January 25, 1663, formal accusations of witchcraft practice carried into the eighteenth century. The last listing of witchcraft as a capital crime in Connecticut came in 1715 but disappeared with a subsequent revision to Connecticut's laws in 1750.

May 27

New England's Oldest Continually Operating Volunteer Fire Department

Among the many threats faced by Connecticut's earliest European settlers, the danger of catastrophic fires was one of the most significant. Buildings

consisting mostly of wood and packed closely together proved susceptible to large-scale fires that demolished entire towns in very short periods of time.

The Town of Wethersfield took measures to improve fire control in the late seventeenth century by purchasing a supply of ladders and leather buckets and storing them at the local church. Throughout the eighteenth century, the town inspected private homes monthly for fire hazards and hired night watchmen to roam the streets and raise the alarm. Any call of "fire" required the ringing of the church bell, which summoned local men to the scene, where they used buckets of water to douse the flames and often tore down adjoining buildings to prevent the fire from spreading.

Recognizing the need for more organized responses to local conflagrations, Wethersfield petitioned the General Assembly for a charter to start a fire company. The approval of the petition came on May 27, 1803, and created what became the Wethersfield Volunteer Fire Department— the oldest continually operating volunteer fire department in New England. Consisting of sixteen men and two pumps at the time of its formation, the Wethersfield volunteers fought fires without much assistance during the early part of the nineteenth century. Then, in 1834, after Wethersfield suffered two catastrophic fires in three years, the town bolstered its firefighting efforts through a special act of the state legislature that incorporated the more formally trained Wethersfield Fire Company.

May 28

Schoolmaster of the Republic

After graduating from Yale in 1778 and working as a teacher, West Hartford–born Noah Webster thought it was time Americans had a language that reflected their own unique identity. He published a spelling book in 1783 that taught Americans reading, spelling and pronunciation. It outsold every book except the Bible during the nineteenth century.

In 1801, he began defining words used by Americans and differentiating them from their British counterparts (e.g. "color" instead of "colour"). He also compiled a list of uniquely American words not found in the British vocabulary, such as "squash," "moose" and "prairie." He published these among thirty-seven thousand words he included in his first edition of *A*

Noah Webster, the "Schoolmaster of the Republic." *Library of Congress, Prints and Photographs Division, Popular Graphics Arts Collection.*

Compendious Dictionary of the English Language. Twenty-two years later, in 1828, Webster published his sixty-five-thousand-word *American Dictionary of the English Language.* He spent the last twenty-two years of his life a resident of New Haven, until his passing on May 28, 1843.

May 29

The Law and Order League of Connecticut

In 1884, Connecticut residents fed up with the state's lax approach to enforcing liquor and gambling laws formed their own security force, the Law and Order League of Connecticut. They received backing from the state thirteen years later when Connecticut governors began appointing agents to join the league. The perception of the group as do-gooders interfering in police business undermined their authority, however, and the group disbanded in 1903.

The end of the Law and Order League of Connecticut came thanks to the signing of House Bill #247 by Governor Abiram Chamberlain. Signed on May 29, 1903, the bill authorized the creation of the Connecticut State Police. Five commissioners set about designing the structure and organization of the department and hired Thomas Egan as the first superintendent of the state police. Working out of an office at the Connecticut State Capitol, Egan selected five men to make up the state's first police force. Each officer received three dollars per day to crack down on violations of the state's vice laws. The years that followed witnessed the enforcement of laws against burglary and assault. The exploding popularity of automobiles in the early twentieth century expanded upon the responsibilities of the state police once again and brought about the regular highway patrols that provide state law enforcement with its most visible presence.

May 30

Separating the Wheat from the Chaff

An eccentric inventor by the name of Benjamin Dutton Beecher lived in an eight-sided house he designed in Prospect, Connecticut, during the early nineteenth century. A millwright and machinist by trade, Beecher enjoyed tinkering and designed numerous inventions (such as an automatic button maker and an automatic water feeder for steam boilers) that rarely earned him more than the money he invested in their creation. On May 30, 1816, however, he patented a fanning mill that proved quite successful.

Prior to the arrival of the fanning mill, farmers separated grains from their stalks by dragging sledges over them or allowing horses or other animals to trample them. The farmers then placed the grain and chaff in winnowing pans and tossed the mixture in the air to allow the wind to blow away the unwanted chaff. Beecher's device used a fan to provide a steady source of wind for this process. It proved very effective for farmers looking to prepare wheat, oats and barley for market by faster and more efficient means.

In addition to his grain-winnowing machine, Beecher's other noteworthy invention was a screw propeller for steamboats. After testing it on nearby Juggernaut Pond, Beecher used a team of oxen to drag his boat over to the Farmington Canal in Cheshire. There, he took an adventurous lot of

passengers downstream as far as Hamden before his invention failed and forced everyone to return to Cheshire on foot. Though the screw propeller proved unsuccessful, future inventors capitalized on Beecher's design to later revolutionize seaborne transportation.

May 31

Free Government

Thomas Hooker was a prominent pastor in England and Holland before he joined the Puritan migration to Massachusetts in 1633. Three years later, he and a group of followers left for new lands to the south and established what eventually became the colony of Connecticut. Hooker was Connecticut's leading public figure during its first years of European settlement.

On May 31, 1638, Hooker delivered one of the most influential sermons in early colonial history. In it, he advocated rule through the "free consent of the people." Whether Hooker delivered the address to truly encourage civic reform is a matter of debate, but any sermon that inspired calls for popular control of government was at the very least a radical concept in an era dominated by the rule of European monarchies.

The concept of free government played an important role in shaping Connecticut's Fundamental Orders in January of the following year. The orders not only brought together Windsor, Hartford and Wethersfield under one centralized system of elected government but also represented what may be the first written constitution in the history of the Americas.

JUNE

June 1

America's Oldest Public Art Museum

Daniel Wadsworth was one of Connecticut's wealthiest men and an early American patron of the arts. A direct descendant of Connecticut's first European settlers, he aspired to establish an art museum in the state, but others persuaded him to instead open an atheneum—a nineteenth-century

The Wadsworth Atheneum (1900). *Hartford History Center, Hartford Public Library.*

term for an institution housing literary, historical and scientific artifacts, as well as art.

Governor Chauncey Cleveland signed an act incorporating the Wadsworth Atheneum on June 1, 1842—making it the nation's oldest public art museum. While its collections initially consisted largely of painted portraits and landscapes, they grew to include such culturally significant pieces as Greek and Roman antiques, Wallace Nutting furniture and a collection of Colt firearms.

June 2

The Minister's Baby?

Sarah Maria Cornell, born in 1802, was the granddaughter of Christopher Leffingwell, a resident of Norwich and patriarch of one of the most respected families in Connecticut. Cornell grew up in modest surroundings, however, after Leffingwell left Sarah and her mother out of his will.

After living with an aunt in Norwich, at fifteen, she worked as a tailor and rejoined her mother at a house in Bozrah. She spent her twenties traveling throughout New England finding work in factories and earning a reputation for petty theft and promiscuity. At thirty, Sarah Cornell was a factory worker in the town of Falls River, Massachusetts, and a member of the Methodist church.

On the morning of December 21, 1832, a farmer in Tiverton, Rhode Island, found Cornell's partially frozen and pregnant body hanging from a haystack post. Authorities originally recorded her death as a suicide, but notes Cornell left behind directed them to question Ephraim Avery, a local Methodist minister. Cornell was a member of Avery's church until he expelled her for lying and promiscuous behavior. Rumors spread that the married minister had fathered Cornell's child and then murdered Cornell to keep her quiet. Authorities arrested Avery and charged him with murder.

The sensational trial of Ephraim Avery lasted nearly a month. On June 2, 1833, a jury found him innocent of murder due to a lack of convincing evidence. Though a free man, Avery encountered public outrage everywhere he went. He eventually moved to Ohio and took up farming to escape the scorn of an angry public.

June 3

The Seventy-eighth Coast Guard Academy Commencement

The Coast Guard Academy's seventy-eighth commencement ceremony took place in New London on June 3, 1964. At eleven o'clock that morning, a helicopter carrying the ceremony's commencement speaker, President Lyndon Johnson, touched down nearby. He arrived at the academy to a twenty-one-gun salute and accompanied by Connecticut governor John Dempsey and Senators Thomas Dodd and Abraham Ribicoff.

Under a cloudless sky, Johnson took his place at the podium in the center of the football field, sheltered by a blue-and-white canopy. Addressing the 109 graduates, he became the first president of the United States ever to speak at a Coast Guard graduation ceremony. As part of his speech, Johnson thanked the graduates for their service before lauding America's position of superiority over the Soviet Union in the contentious nuclear arms race. After addressing the graduates, Johnson administered the officers' oath and handed out commissions. The Coast Guard then made him an honorary member of the class of 1964.

Johnson left the ceremony by car to attend the keel laying of the attack submarine *Pargo* in Groton. His motorcade stopped along the way in Hodges Square in New London, where Johnson got out to shake hands with some of the thirty thousand admirers packing the streets. He repeated this gesture (once across the Thames River) at Plaza Square in Groton before addressing eight thousand workers at General Dynamics and then re-boarding his helicopter.

June 4

The Lemon Law

Connecticut lawmakers approved a milestone in consumer protection legislation on June 4, 1982, when they passed the nation's first "lemon law." The bill, supported by state representative John Woodcock III from South Windsor, came at a time when no fewer than twelve states debated the benefits of similar laws—despite vocal opposition from the automobile industry. It took effect in Connecticut on October 1.

The law held automobile manufacturers responsible for irreparable defects found in new cars sold in Connecticut. Owners of any car that required numerous repairs for the same problem within two years or twenty-four thousand miles of the vehicle's purchase became eligible for a refund on their purchase or a replacement of their vehicle. Prior to the passing of the "lemon law," the only recourse available to consumers of poorly made cars was to register a complaint with the state's motor vehicle department or undertake a costly legal battle with the manufacturer.

The first successful application of the lemon law came the following year. Within one week of purchasing a new Ford station wagon on December 29, 1982, a retired East Hartford couple found their new car incapable of traveling in reverse. After their car spent forty-three consecutive days in the repair shop, Chester and Ann Sobolewski looked for help from their state representative, who referred them to John Woodcock III. Woodcock took the case for free and ultimately forced the Ford Motor Company to provide the Sobolewskis with a new car.

June 5

Race Riots

Like many urban areas in 1960s, Hartford was home to a number of racially charged riots stemming from frustrations over discrimination, poverty and substandard employment and housing. Angered by a lack of equality and crowded into ghettos in Hartford's North End, groups of largely African American teenagers and young adults took to the streets in 1967, throwing rocks and bottles and destroying property before police disbursed the riots with tear gas.

The underlying causes of the North End riots remained largely unaddressed by city officials for the next two years, however, and on June 4, 1969, a block dance sponsored by the Inner City Exchange ended in violence. Shortly after 7:00 p.m., a number of fights drew police to the dance, where angry youths greeted them with rocks, bottles and chunks of cement. The rioters tossed barricades at passing police cruisers and, on more than one occasion, fired on officers attempting to restore the peace.

The violence carried into the following day (June 5), with reports of police brutality only escalating hostilities. At one point during the riots, crowds reached as many as 250 people, causing police to run out of tear gas. A number of suspicious fires added to the unrest, ultimately forcing Mayor Ann Uccello to declare a state of emergency on June 6. In all, the June riots (some of the worst in Hartford's history) lasted for the better part of four days and drew in over 100 state police to help maintain order.

June 6

A Mom Packs Something More Important Than Her Son's Lunch

Robert C. Hillman ran cross-country and played football for Manchester High School in the early 1940s. After graduating in June 1942, he joined the military. He trained to become a paratrooper and headed off to Europe in November 1943 to enter the Second World War.

On June 6, 1944, Hillman took part in the Allied invasion of France meant to break through Adolf Hitler's "Atlantic Wall." As Hillman flew over the English Channel on his way to Normandy, a routine check of his equipment uncovered an interesting and reassuring coincidence. The Pioneer Parachute Company, located in Hillman's hometown of Manchester, Connecticut, had manufactured his parachute. As it turned out, the final quality check of parachutes leaving the Pioneer facility in Manchester fell to a Mrs. Ronald C. Hillman, Private Hillman's mother.

June 7

Griswold v. Connecticut

The federal Comstock Law of 1873 outlawed the sale or distribution of materials that promoted the termination of pregnancy or encouraged the use of contraceptives. In the years that followed, numerous states passed their own versions of the Comstock Law to enforce more localized standards of morality. Connecticut's came in 1879 with the passing of An Act to Amend

an Act Concerning Offenses against Decency, Morality and Humanity—a law that punished any persons using birth control, or counseling others in the use of the birth control, with a minimum forty-dollar fine or no fewer than sixty days in jail.

In 1961, authorities arrested Estelle Griswold, the executive director of the Planned Parenthood League of Connecticut, and Dr. C. Lee Buxton, a physician and professor at Yale Medical School, for providing contraceptive counseling to married couples. Each received a $100 fine. Griswold and Buxton appealed to the Connecticut Supreme Court, but the court upheld their conviction. Eventually, Connecticut attorney Catherine Roraback took their case to the U.S. Supreme Court.

On June 7, 1965, the Supreme Court ruled in the case of *Griswold v. Connecticut*, deciding by a margin of 7–2 that the spirit of the Bill of Rights guaranteed a certain right to privacy and that Connecticut's ban on contraceptives violated a couple's right to that privacy. This decision paved the way for the landmark case of *Roe v. Wade*, in which the Supreme Court determined that the right to privacy carried over into decisions regarding whether to terminate a pregnancy.

June 8

The World's First Aviation Law

From Charles Ritchel's dirigible flight in 1878 to Gustave Whitehead's place in history alongside the Wright brothers, Connecticut residents pioneered many advances in early aviation history. As aviation enthusiasts took to the skies in greater numbers, concerns over safety and liability prompted calls for the regulation of air travel over the state.

In a speech to Connecticut's legislature in 1911, Governor Simeon Baldwin asked lawmakers to pass an aviation law to protect people and property from the hazards associated with early flight. The legislature acquiesced and, on June 8, 1911, passed the world's first aviation law. The law standardized important aviation terms and required aviators to obtain licenses for operation. It also forced the state's pilots to register their aircraft and clearly mark them with state-assigned registration numbers. Lastly, it held pilots personally responsible for any damages from injuries during

flight and expanded that liability to include companies when the flights were commercially operated.

Enforcement of Connecticut's new law fell to the secretary of state before authorities transferred it under the commissioner of motor vehicles. In 1927, with amateur aviators filling Connecticut's skies, the state created a separate Department of Aviation to monitor this burgeoning form of transportation.

June 9

William Howard Taft Opens a Connecticut Landmark

Thomas Lee, a man of wealth and influence in Sussex, England, boarded a ship with his wife, in-laws and three children and headed for the Saybrook Colony in 1641. During the voyage, both Lee and his mother-in-law died of smallpox. The remaining family members recuperated from the long voyage in Boston before arriving in what today is the town of East Lyme, Connecticut, and building a one-room home.

The Lees lived in the house for only two years before Mrs. Lee remarried and moved her family to Norwich. Twenty years later, however, Thomas Lee II returned to his temporary childhood home and went about making extensive renovations to accommodate his wife and fifteen children.

The home stayed in the family for nearly two hundred years until they sold it to a local farmer, who allowed the property to fall into disrepair. Recognizing the importance of the historic structure—the oldest standing timber structure in Connecticut—the East Lyme Historical Society purchased the property in 1914 and began an extensive restoration.

On June 9, 1915, the historical society opened the doors of the newly restored Lee House to the public. Former U.S. president William Howard Taft—a Lee descendant—spoke at the ceremony and attended a luncheon and an exhibition of spinning and weaving provided as part of the day's festivities. The Lee House became the headquarters of the East Lyme Historical Society and earned a listing on the National Register of Historic Places in 1970.

June 10

The Matlock Paper

Wesleyan University in Middletown, Connecticut, held its 119th commencement on June 10, 1951. Among its many promising graduates that day was aspiring actor and producer Robert Ludlum.

Almost immediately after graduation, Ludlum married his fellow Wesleyan classmate Mary Ryducha, and the two set about establishing their respective acting careers. Ludlum appeared in small roles both on television and Broadway in the 1950s and opened the Playhouse-on-the-Mall in Paramus, New Jersey, in 1960.

Ludlum took more to writing, however, and in 1971, he published his first book, *The Scarlatti Inheritance*. The book became a best seller and the first of twenty novels written by Ludlum (including *The Bourne Identity* and *The Matarese Circle*) to sell a combined 110 million copies.

The third in this series of successful novels was a book titled *The Matlock Paper*. The story follows the clandestine adventures of James Matlock, a Vietnam veteran and college professor. The backdrop for the story is a small, fictitious college in Connecticut modeled after Wesleyan University.

June 11

The First Hospice

In 1965, Dr. Cicely Saunders, medical director of St. Christopher's hospice in London, accepted an invitation to speak at Yale University about end-of-life medical care for patients. Among the attendees at the lecture was Florence Wald, associate professor and dean of the Mental Health and Psychiatric Nursing Program at Yale. The two formed a friendship. Three years later, Wald resigned her deanship and dedicated herself to studying care for the terminally ill in Great Britain. With the help of Saunders, Wald went on to found the hospice movement in America.

Hospice in the United States became a reality when, on June 11, 1974, the Connecticut Commission on Hospitals and Health Care approved the construction of a hospice facility in Branford—the first of its kind in the

country. The proposal called for a $2.6 million facility offering forty-four beds to all patients, regardless of economic status.

Initially just offering home care, the Connecticut Hospice became the first teaching hospice in the United States with the opening of the John D. Thompson Hospice Institute for Education, Training and Research in 1978. In 1980, the institute opened a new inpatient facility and, five years later, expanded its services to offer care for persons with AIDS. Eight years after that, it opened a cottage facility dedicated exclusively to treating AIDS patients who had no other care available to them.

June 12

The Jumping Frog of Hartford County

The Mark Twain Memorial Commission and the Children's Museum of Hartford sponsored the first modern frog-jumping contest in Connecticut on June 12, 1955. Inspired by the Mark Twain story *The Celebrated Jumping Frog of Calaveras County*, the festivities took place on the grounds of Mark Twain's former residence on Farmington Avenue in Hartford and included a tour of Twain's home.

Officials opened the contest to children aged six to sixteen and limited entries to frog varieties found in the Hartford area. Children seeking to participate brought their entries to the Children's Museum, where experts examined the frogs both to identify their species and to disqualify any frogs displaying signs of inhumane treatment. A week before the contest, local frog specialists even offered a free clinic on how to properly capture and care for frogs.

On the day of the event, thirty-two frogs took their turn on a cardboard platform and, after receiving one initial tickle with a feather, had the length of three jumps combined into one total score. The winner was Louis DiCapua of Shelton, a student at the American School for the Deaf in West Hartford, who captured his winning entry, "Lulu," in the pond behind the school. Among the prizes handed out were honorary membership in the Mark Twain Memorial Commission, a trip to the Bronx Zoo and numerous copies of stories written by Mark Twain.

June 13

Thomas Dodd Censured

In January 1966 a series of newspaper articles emerged that accused Connecticut senator Thomas Dodd of inappropriately expending campaign funds for personal use. A Senate committee began a formal investigation three months later, and after Dodd refused to disclose information on his personal finances, the committee began public hearings in March 1967.

Thomas Dodd (the father of future Connecticut senator Christopher Dodd) once served as an agent in the FBI and later became executive trial counsel during the Nuremberg trials in Germany before becoming a member of Congress in 1953. At question during his Senate hearings were funds Dodd acquired from political fundraisers held between 1961 and 1965 and the transfer of portions of those funds to Dodd's personal bank accounts.

A final committee report issued in April 1967 officially charged Dodd with transferring $116,083 of the $450,273 he raised into his personal accounts and using those funds to pay taxes, fund home improvements and distribute cash to members of his family. On June 13, 1967, the Senate began review of a motion to censure Dodd, which it did ten days later by a vote of 92 5.

After Dodd's censure, the Democratic Party refused to nominate him for reelection in 1970. Dodd chose to run as an independent that year but ultimately lost to Lowell Weicker. He died of a heart attack the following year.

June 14

The Bazooka

June 14, 1942, was the day Bridgeport's General Electric Company completed work on a weapon Dwight Eisenhower labeled as an essential tool in producing the Allied victory in World War II. The weapon was a handheld rocket launcher nicknamed the "bazooka." It consisted of a five-foot steel tube that opened at both ends. It fired a roughly three-and-a-

A soldier holding a bazooka during World War II. *Library of Congress, Prints and Photographs Division, Miscellaneous Items in High Demand Collection.*

half-pound rocket armed with eight ounces of explosive pentolite capable of penetrating five inches of armor plating. The weapon allowed an infantryman to single-handedly destroy a tank.

By the time of the Korean War, the army had begun utilizing a bazooka made of aluminum and capable of firing a nine-pound rocket carrying two pounds of explosives. The weight and limited range of the bazooka, however, led to the army abandoning its use for more sophisticated anti-tank weapons by the start of the Vietnam War.

June 15

Vulcanized Rubber

Charles Goodyear was born in New Haven in 1800 and grew up in Naugatuck. Raised in a family of limited means, he took to inventing at the

age of thirty-three following the failure of his family's hardware business. Goodyear recognized the growing importance of rubber for use in industry and dedicated himself to overcoming the challenges faced by rubber goods—mainly that they cracked when exposed to extreme cold and melted under intense heat.

The next several years witnessed Goodyear accumulate substantial debts in his pursuit of more stable and reliable rubber derivatives. He moved numerous times to locations throughout the Northeast and even spent time in debtor's prison. Finally, in 1841, he developed a process of combining rubber with sulfur that provided the stability he envisioned. He named his process "vulcanization" and received a patent for it on June 15, 1844.

Vulcanized rubber went into shoes, hats, umbrellas and other commercial goods in need of waterproofing, as well as played a vital role in the evolution of heavy industry. Goodyear opened a factory in Naugatuck and attracted numerous competitors to the area looking to replicate his success. He spent the better part of his remaining years engaged in a series of patent-infringement lawsuits that brought about his financial ruin. It was not until well after Goodyear's death in 1860 that the industry adapted vulcanized rubber for its most celebrated use—as a critical component of automobile tires.

June 16

The Liberty Bell

On June 15, 1903, a train carried the Liberty Bell from Philadelphia toward Boston to celebrate the 128th anniversary of the Battle of Bunker Hill. After brief stops at Princeton and Newark, New Jersey, the train arrived in Stamford, Connecticut, at 6:10 p.m. It remained in the city for only ten minutes before moving on to Bridgeport and New Haven. At each stop along the way, nearly ten thousand people braved the pouring rain for a chance to see the iconic symbol of American freedom up close.

At 8:00 a.m. on June 16, 1903, the train left New Haven for Hartford. Once in the capital city, between ten and twelve thousand people braved mud-covered streets (treated with straw and sawdust) to catch a glimpse.

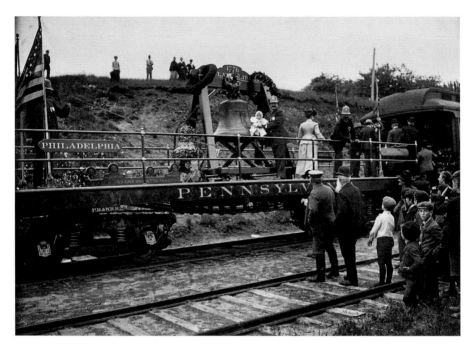

The Liberty Bell at its stop in Plainfield (1903). *Liberty Bell in Plainfield, PG180, Mills Photograph Collection, State Archives, Connecticut State Library.*

Thirty-five policemen kept order as people climbed up on the flat car to see and touch the bell. From Hartford, it headed east, through Plainfield, on its way to Boston.

June 17

The Murder Factory

Amy Archer Gilligan took care of those who could not care for themselves. After moving into the Newington, Connecticut home of John Seymour to assist in his care, thirty-four-year-old Archer and her husband, James, opened the Archer Home for Aged People in Winsted in 1907. There, she provided care in return for residents signing over their life insurance policies to her.

Over the course of the next decade, however, over sixty residents of Archer's facility (along with husbands James Archer and Michael Gilligan)

passed away. The death of one resident, Franklin Andrews, appeared very suspicious, and relatives soon uncovered paperwork linking Andrews to a $500 loan made to Amy Archer Gilligan. A subsequent investigation discovered that the bodies of more than two dozen former Archer Home residents contained high levels of arsenic. In 1916, authorities arrested Gilligan for operating what the press dubbed a "murder factory."

A jury convicted Gilligan and sentenced her to hang in the summer of 1917, but a technicality allowed her to appeal her conviction. A second trial sent her to Wethersfield State Prison and eventually on to a state mental institution. She died there in 1962. Shortly after Gilligan's conviction, however, New York playwright Joseph Kesselring caught wind of the story and turned it into a comedic play he named *Arsenic and Old Lace*. The play was a smash hit on Broadway and throughout tours across the country. On June 17, 1944, the last of 1,444 New York performances took place at the Hudson Theater.

June 18

Connecticut's Declaration of Independence

In the summer of 1776, prior to the signing of the Declaration of Independence, the American colonies were well on their way to formally separating from the kingdom of Great Britain. The eruption of hostilities at Lexington and Concord and the Battle of Bunker Hill were already a year old, and the quartering of British troops in the colonies and King George's rejection of the Olive Branch Petition set the opposing sides on a course for war.

Prior to the celebrated July 4th signing of the Declaration of Independence in Philadelphia, however, Connecticut governor Jonathan Trumbull issued his colony's own independence declaration. In front of the General Assembly on June 18, 1776, Trumbull proclaimed that King George "laid upon us Burdens too heavy and grievous to be born," and he encouraged his fellow colonists to take up arms in defense of their freedom. Three days later, the Connecticut legislature passed a resolution instructing its delegates at the Continental Congress to lobby for consideration of the American colonies as free and independent from English rule—a sentiment already made popular by delegates from Virginia and several other colonies.

June 19

Mobilizing for World War I

On June 17, 1916, with the United States on the verge of entering World War I, President Woodrow Wilson called a meeting with Major General H.L. Scott (chief of staff of the war department) and other advisors to discuss the security of America's borders, particularly the border with Mexico. The following day, President Wilson called on militia organizations from every state to prepare for service on the Mexican border. Word of Wilson's call to arms reached Hartford at 11:45 p.m. that night.

The next morning, June 19, 1916, Governor Marcus Holcomb mobilized the First Connecticut Infantry of the National Guard. The state armory received a flood of new recruits that day, and by June 22, Troop B was already parading through Hartford on its way to Niantic to depart for service. The last of the Connecticut troops arrived in Niantic two days later and, on June 26, prepared to board trains for the Mexican border, but mass confusion during the boarding process kept the men standing around all night. The first train finally left at 8:55 a.m. the next morning.

Transportation by rail lasted approximately a week and took the men through Buffalo and Chicago and then south through Kansas City and El Paso before finally arriving in Nogales, Arizona. There, Connecticut guardsmen stood watch for ten weeks before beginning a three-week assignment at Fort Huachuca keeping alert to any signs of aggression from a proposed Mexican-German alliance. After completing thirteen weeks of hot, dusty and exhausting duty, the men finally boarded trains and headed back to Hartford.

June 20

Helen Keller

Born in Tuscumbia, Alabama, in 1880, Helen Keller survived a life-threatening fever that left her blind and deaf at just nineteen months old. Under the tutelage of Perkins School for the Deaf graduate Anne Sullivan, however, Keller learned to read and write. She attended Radcliffe College at age twenty and graduated *cum laude* in 1904.

By the time of her graduation, Keller was already a published author and soon took to lecturing and political and social activism. She traveled the world lobbying for greater recognition of the needs of the blind, supported woman suffrage and became one of the founding members of the American Civil Liberties Union.

In 1936, Keller moved to a home in Easton, Connecticut, that she named Arcan Ridge. She lived there for more than thirty years. On June 20, 1963, just months before his assassination, President John F. Kennedy wrote a letter to Keller acknowledging her achievements as "legendary" and congratulating her on earning "a permanent place in the history of human progress." Less than five years later, Helen Keller passed away at her Easton home at the age of eighty-eight.

June 21

John Rowland Resigns

John Rowland was once a rising star in the Republican Party. A native of Waterbury and a graduate of Villanova University, Rowland won election to the Connecticut legislature at age twenty-three, became a member of Congress at twenty-seven and, in 1995, became the nation's youngest governor. After nearly ten years as Connecticut's governor, and facing a possible impeachment vote, Rowland stood on the back lawn of the Governor's Mansion and announced his resignation on June 21, 2004.

Most of the trouble for Rowland started in the spring of 2003, when his chief of staff, Lawrence Alibozek, pleaded guilty to federal charges that he awarded state contracts in return for payments of cash and gold. A subsequent investigation into the Rowland administration discovered that Governor Rowland had accepted numerous illegal gifts (including cars, discounted vacations and renovations to a lakeside cottage) from employees and friends holding state contracts. Rowland went on to serve ten months in federal prison as a result of the investigation.

After prison, John Rowland involved himself in economic development in his hometown of Waterbury and even hosted his own radio talk show, but this did not keep him from encountering more trouble with the law. In 2014, authorities charged Rowland with seven counts of falsifying records and

concealing his participation in the congressional campaign of Lisa Wilson-Foley by accepting payments through a nursing home operated by Wilson-Foley's husband.

June 22

A Voice of the Cherokee

Elias Boudinot was a Cherokee leader born in Georgia who came to Cornwall, Connecticut, to study at the Foreign Mission School in the early nineteenth century. The Foreign Mission School came into existence in 1817 when proponents of the Christian Revival movement sought institutions willing to recruit men of indigenous cultures, convert them to Christianity and train them to become preachers.

In 1825, Boudinot fell in love with a young Cornwall woman named Harriet Gold. Their engagement heightened fears of miscegenation held by local residents and created such outrage that Boudinot and Gold needed to flee to Gold's parents' house at one point to avoid an angry mob. The mob, which included Gold's brother, even burned an effigy of Gold on the town green. Despite the protests, Boudinot and Gold married in 1826 and soon headed for Cherokee territory in Georgia.

Boudinot then became editor of the *Cherokee Phoenix*, a newspaper with a national circulation meant to counter portrayals of Native Americans in the white media. In addition, Boudinot used the paper to advocate for Cherokee rights, and he soon became a leader in the Cherokee community.

With President Andrew Jackson aiming to remove the Cherokee from Georgia by force, Boudinot and a small minority of Cherokee signed the Treaty of Echota in 1835, which advocated the relocation of the tribe to modern-day Oklahoma. Feeling betrayed, a group of Cherokee intent on remaining on their lands ambushed and murdered Boudinot on June 22, 1839.

June 23

Redefining Eminent Domain

In 1998, pharmaceutical giant Pfizer, Inc., built a plant in the Fort Trumbull area of New London, Connecticut. Shortly after, the city of New London authored a plan to boost its struggling economy. Through the New London Development Corporation (NLDC), the city sought to seize the homes of over one hundred residents by eminent domain and use the land to build a hotel, shops, condominiums and expanded facilities for Pfizer. While the NLDC managed to acquire the majority of the properties in the proposed ninety-acre area, a handful of residents held out and took the city to court.

The Connecticut Supreme Court ruled (in 2004) that New London's economic development plan did not violate the constitution of the state or the United States, forcing residents to take their case to the United States Supreme Court. On June 23, 2005, the Supreme Court handed down its landmark decision. By a vote of 5–4, the Supreme Court ruled that economic development constituted a form of public use and thereby did not violate the Fifth Amendment allowing the government to seize private land for public use.

The decision in *Kelo v. City of New London* sent shockwaves throughout the country, and states scrambled to pass legislation bolstering their private property laws. Despite the court's ruling in 2005 and millions of dollars spent by the city of New London, the property remained vacant and undeveloped at the time Pfizer announced (in 2009) its intention to leave New London and relocate to Groton.

June 24

Henry Ward Beecher

Henry Ward Beecher was one of the most popular and influential preachers of the nineteenth century. Born in Litchfield, Connecticut, on June 24, 1813, Beecher became famous for his boisterous nature and sense of humor and for the manner in which he tailored his sermons to focus on the love of Christ and the evidence of God found throughout nature. Beecher's

Henry Ward Beecher, from a photo taken around 1871. *Library of Congress, Prints and Photographs Division, Popular Graphics Arts Collection.*

demeanor changed dramatically, however, when it came to addressing the issue of slavery.

Following the passage of the Kansas-Nebraska Act, Beecher campaigned vociferously to end slavery. He lectured around the country and raised money for the abolitionist cause. The money he raised often went toward the purchase of rifles that those in Kansas affectionately referred to as "Beecher's Bibles." Like his sister, Harriet Beecher Stowe, he was also a supporter of woman suffrage and wrote numerous published articles praising Victorian morals. In the midst of writing his autobiography, Beecher succumbed to a stroke in 1887.

June 25

Marilyn Monroe Takes to Life on the Farm

In the summer of 1956, members of the press and curious onlookers descended on the town of Roxbury, Connecticut, in anticipation of the upcoming wedding between Arthur Miller and Marilyn Monroe. The two celebrities holed up in Miller's home on the corner of Old Tophet Road and Gold Mine Road, while eager newspaper and magazine reporters kept a vigil outside, waiting for any official word about the upcoming nuptials. On June 25, 1956, Miller addressed the crowd.

Miller came out of his house shortly after 7:00 p.m. and attempted to give the press what they desired. After some brief discussions, Monroe joined him out on the lawn, and the two posed for pictures. They married in New York four days later.

The day before the wedding, however, on their way to a press conference, a car driven by a New York resident named Ira Slade fatally injured a French magazine correspondent following Miller and Monroe. The Roxbury Superior Court summoned Monroe and Miller to testify in the case just as Monroe made plans to leave for England to film *The Prince and the Showgirl* with Sir Laurence Olivier.

Despite the tragedy, life for the Millers was a quiet one in Roxbury. Local residents noted encountering Monroe in local shops and watching her plant flowers and ride along when Miller drove his tractor around their farm, and they said they always considered her a courteous and polite neighbor. The Miller-Monroe marriage did not last long, however, and in 1961, the two divorced. Monroe died of an overdose the following year.

June 26

JFK's First Choice for Attorney General

A native of New Britain, Connecticut, Abraham Ribicoff became a member of Congress in 1949. In 1952, he lost a bid for a vacant Connecticut Senate seat to Prescott Bush (father of future president George H.W. Bush), but

two years later, on June 26, 1954, Connecticut Democrats nominated him to become the state's governor.

Ribicoff won the gubernatorial election by fewer than three thousand votes and became the first Jewish governor in Connecticut's history. He earned a reputation as a proponent of safe highways and integrated schools. He served as governor from 1955 until he resigned in 1961 to take a position in John F. Kennedy's administration.

Kennedy and Ribicoff became friends as congressmen in the 1940s, and Kennedy credited Ribicoff with helping him win the presidential election of 1960. Kennedy thanked Ribicoff by offering him the position of attorney general, but Ribicoff turned it down, suggesting Kennedy offer the position to his brother, Robert. Instead, Ribicoff became the secretary of the Department of Health, Education and Welfare—Kennedy's first presidential cabinet appointment.

Just over a year later, Ribicoff won election to the U.S. Senate from Connecticut and served there for nearly two decades. Most famously, he took the podium at the 1968 Democratic National Convention in Chicago and openly confronted Mayor Richard J. Daley about his use of "Gestapo tactics" to subdue antiwar demonstrators outside the convention. Ribicoff retired in 1981 and returned to his private law practice and a home in Cornwall Bridge, Connecticut, before passing away in 1998.

June 27

Arrested For Teaching

Prudence Crandall opened a private school for girls in Canterbury, Connecticut, in 1831 to offer women a rare opportunity to pursue an education. It soon became one of the most acclaimed educational institutions in the state. This changed two years later, however, with the admission of Sarah Harris.

Sarah Harris was a young African American girl with dreams of becoming a teacher. After Crandall admitted her to the Canterbury Female Boarding School, town leaders violently protested. Crandall responded by opening a new school founded explicitly for the education of African American girls, both from Connecticut and elsewhere. The

REPORT, &c.

STATE OF CONNECTICUT, Windham County, ss. Brooklyn. Supreme Court of Errors, July Term, A. D. 1834.
Present,

Hon. DAVID DAGGETT, *Chief Justice.*
Hon. THOMAS S. WILLIAMS,
Hon. CLARK BISSELL, } *Associate Judges.*
Hon. SAMUEL CHURCH,

PRUDENCE CRANDALL, plaintiff in error, *vs.* STATE OF CONNECTICUT. Counsel for Miss Crandall, Hon. CALVIN GODDARD, and Hon. WILLIAM W. ELLSWORTH ; for the State, ANDREW T. JUDSON, Esq., and CHAUNCEY F. CLEVELAND, Esq.

Argument of WM. W. ELLSWORTH, in the case of the State of Connecticut *vs.* PRUDENCE CRANDALL. Delivered before the Supreme Court of Errors of the State of Connecticut, July, 1834.

May it please the Court :—The statute on which this prosecution is founded, prohibits the *setting* up a school for persons of color, not inhabitants of this state—teaching them in *any* school, or boarding and harboring them, to attend a school, without first obtaining the consent, in writing, of the civil authority and selectmen of the town where said school is situated.

The record finds, that the pupils in this case were born in the states of Pennsylvania, New-York, and Rhode Island respectively, of free parents, and have recently come into Connecticut, to attend Miss Crandall's school, where they are taught the common and essential branches of knowledge.

The principle asserted in this law, and indeed such is its very language, is, that it is a crime for any individual to entertain a person of color, not having a legal settlement in any town in this state, (though he was born and has ever lived in these states,) having come here to pursue the acquisition of learning, in a manner *open, common,* and *lawful* to *all our* population, white or *colored.* The condition imposed by the law will be found not to alter the character of the law, as I have now asserted it to be. A power to license, implies a power to refuse—what one holds by *permission,* he does not hold by *right.* And if the Legislature can delegate the power to license, it can exercise it, itself; and hence, may impose conditions tantamount to exclusion or total denial. This statute, stripped of its appendages, makes the *place of birth* the criterion of the rights of citizens of these states ; it is not a question of *color,* so much as of state *supremacy ;* if a state may exclude a colored citizen of another state, it may exclude a white 'citizen.'

The defence of Miss Crandall will be rested upon the unconstitutionality of this statute law of Connecticut, and may be embraced under these two heads.

1. These pupils are *citizens* of their respective states.

2. As *citizens,* the constitution of the United States secures to them the right of *residing* in Connecticut, and pursuing the acquisition of knowledge, as people of color may do, who are settled here.

I would first remark, that if the constitution of the United States does indeed secure to these pupils this most valued right, it

Report on Prudence Crandall's arrest (1834). *Library of Congress, Slaves and the Courts, 1740–1860, American Memory Collection.*

state then passed a law forbidding the education of African American students from out of state and, on June 27, 1833, arrested Crandall for breaking that law. After watching protestors break the school's windows,

smash its furniture and throw eggs, rocks and manure at its students, Crandall closed the school out of fear for the safety of her students. She promptly moved out of Connecticut and never returned.

June 28

The Mianus River Bridge Disaster

At 1:30 a.m. on June 28, 1983, two cars and two tractor trailers traveling north on Interstate 95 in Greenwich, Connecticut, began crossing the Mianus River Bridge when a one-hundred-foot span of the bridge collapsed. The span fell (intact) seventy feet down into the river, claiming the lives of three motorists and seriously injuring three others.

For the better part of the following month, authorities directed the nearly ninety thousand vehicles that crossed the bridge every day down on to Route 1 while they investigated the cause of the accident. In July, after $12 million in repairs, the state reopened the bridge to cars. A month later, on September 10, officials allowed busses and trucks to resume use of the bridge.

A federal investigation ultimately blamed the accident on the delay of critical repairs to the bridge due to a lack of state funding. An inspection of the bridge eight months earlier had uncovered needed repairs but nothing reported as critical in nature. In the weeks leading up to collapse, however, residents living near the bridge complained of louder-than-normal vibration noises coming from the structure and of large pieces of concrete falling nearby.

The structural failure had begun approximately ten years earlier, when road crews paved over storm drains on the bridge. In the years that followed, water began collecting in different areas of the structure and eventually caused large pins holding the bridge section in place to rust and snap.

June 29

The Merritt Parkway Opens

On June 29, 1938, Connecticut governor Wilbur Cross presided over ceremonies that officially opened the Merritt Parkway. The governor

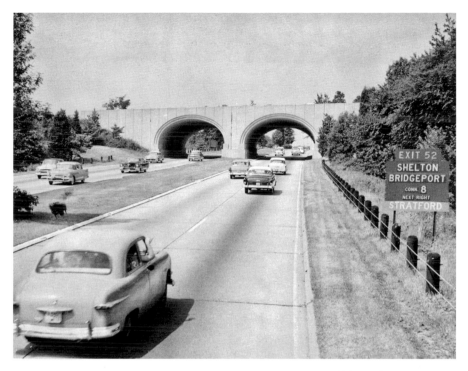

The Merritt Parkway winding through Trumbull. *Library of Congress, Prints and Photographs Division, Historic American Buildings Survey/Historic American Engineering Record/Historic American Landscapes Survey.*

used a pair of golden scissors to shear a ceremonial ribbon in Norwalk and then hopped into the first car of a one-hundred-car processional that traveled over the seventeen and a half miles of completed roadway. The governor then stopped for similar ceremonies in New Canaan, Stamford and Greenwich.

The parkway—the largest public works project of its time in Connecticut—offered drivers an alternative to travel on the congested Boston Post Road, provided greater access to the state's southwestern suburbs and fostered economic development in Fairfield County. Its scenic landscaping and bridge designs earned it a place on the National Register of Historic Places in 1991.

June 30

Charting America's Course through the Cold War

Dean Acheson, perhaps the most influential voice in American foreign policy during the Cold War, grew up in Middletown, Connecticut, before attending the Groton School, Yale University and Harvard Law School. He entered the Department of State in 1941 and became its undersecretary in 1945—proving instrumental in gaining the United States membership in the United Nations.

Among the most significant challenges facing the United States during this period was the spread of Soviet influence over the war-torn nations of Europe and Asia. Acheson reshaped American Cold War policy by contributing to the development of the Truman Doctrine and the Marshall Plan to provide aid to these struggling countries. In recognition of his service, President Harry Truman awarded Acheson the Medal of Merit at a White House ceremony on June 30, 1947.

A year and a half later, Truman appointed Acheson his secretary of state. Under Truman, Acheson oversaw the rebuilding of Japan as an American ally and the nonrecognition of China after communists ousted its Nationalist government under Chiang Kai-shek. He also played an important role in the formation of the North Atlantic Treaty Organization (NATO).

After leaving office, Acheson resumed his private law practice but continued to advise U.S. presidents on foreign policy decisions. President John Kennedy consulted with Acheson during the Cuban Missile Crisis, and Lyndon Johnson likewise sought Acheson's counsel on the American withdrawal from Vietnam.

JULY

July 1

The State Department of Corrections

While Connecticut's prison system evolved over the course of two centuries to meet the changing needs of reformers, prisoners and administrators, by the 1960s, the system still consisted of a series of independently operated institutions. Each facility maintained its own board of directors, and each operated under the auspices of its own policies regarding the training, education and rehabilitation of inmates. Calls for the creation of one centralized authority to manage the state's prison system became louder and more consistent as the decade progressed.

Finally, on July 1, 1968, after numerous delays caused by prison administrators and board directors, the Connecticut General Assembly created the State Department of Corrections. Run by a commissioner appointed by the governor the first commissioner being Ellis MacDougall—the department oversaw the operation of both jails used to house criminals awaiting trial and the prisons that held them after sentencing. Connecticut became the first state in the country to bring all of its youth, adult and parole functions under the authority of one central agency.

July 2

Connecticut's Governor Refuses a Federal Order for Troops

War between England and France in the early nineteenth century significantly reduced trade between the United States and Europe. In response to raids on American shipping, President Thomas Jefferson exacerbated an economic crisis in the New England states by announcing an embargo on international trade. Consequently, when America entered the War of 1812, it was a country divided. Many New England leaders opposed the war due to the disproportionate share of economic hardship born by the states that depended on trade with Europe. One of these leaders was Roger Griswold.

Griswold, a former member of the U.S. House of Representatives, became Connecticut's lieutenant governor in 1809 and then governor two years later. He won a second term in 1812, in part, through staunch opposition to war with Great Britain. His opposition manifested itself in outright hostility toward President James Madison's administration, and on July 2, 1812, Griswold openly defied Madison's order to place the Connecticut militia under federal control.

Griswold fought the federal order right up until his death in October 1812. The case ended up in the U.S. Supreme Court, which ultimately sided with President Madison. This did not stop opposition to the war at the state level, however. In December 1814, representatives from the New England states actually met in Hartford purportedly to discuss secession. The Treaty of Ghent, ending the War of 1812, ultimately put those discussions to rest.

July 3

Charlotte Perkins Gilman

Charlotte Perkins Gilman was an author, lecturer, feminist and reformer born in Hartford on July 3, 1860. Abandoned by her father, Gilman grew up under the influence of her famous great aunts from the Beecher family: Harriet Beecher Stowe, education reformer Catharine Beecher and suffragist Isabella Beecher. A suffragist who believed in a woman's need for economic independence, Perkins made the difficult decision to set her career

aside and marry Charles Walter Stetson in 1884. The marriage resulted in the birth of a daughter the following year.

The lack of stimulation she encountered in domestic life soon set Perkins into a deep depression, however. Her doctor prescribed lots of bed rest and the minimizing of intellectual activity. While the treatment proved ineffective, it provided the inspiration for Perkins's most famous work, a short story entitled "The Yellow Wallpaper." The story followed the descent into madness of a woman confined to her room by a controlling husband.

With her first marriage ending in divorce, Perkins opted to move to California, where she wrote numerous books and magazine articles promoting a woman's right to work outside the home and be free from paternalistic influences. In 1900, she married her first cousin George Gilman, who proved very supportive of his wife's need to promote her "radical" feminist agenda.

The couple moved to Norwich, Connecticut, in 1922, but George Gilman's sudden death in 1934 prompted Charlotte Perkins Gilman's move back to California. There, suffering from inoperable breast cancer, she took her own life in 1935.

July 4

The Farmington Canal

Citizens from seventeen towns came together in January 1822 to discuss the construction of a canal connecting the St. Lawrence River to Long Island Sound. Residents of Connecticut desperately sought a way to rapidly move produce and other marketable goods from the interior parts of the state to the port of New Haven for commercial trade with New York City and other metropolitan areas.

In May 1822, the privately funded Farmington Canal Company formed as one of several canal projects envisioned for the state in the 1820s. The groundbreaking ceremony took place on July 4, 1825, with Governor Oliver Wolcott addressing over two thousand enthusiastic onlookers. Over the next three years, farmers and large groups of Irish immigrants excavated the twenty-foot-wide and four-foot-deep canal using little more than shovels, wheelbarrows and horse-drawn wagons. The first section of the canal,

reaching from New Haven to Farmington, opened in 1828 and eventually reached as far as Northampton, Massachusetts, by 1835.

In the end, the canal project proved to be a financial disaster. Toll revenues rarely offset the maintenance costs inflicted by floods and landslides along the canal route and failed to cover the tremendous debts the company incurred during the canal's construction. Ultimately, the company suspended canal operations in 1847 and instead focused on expanding railroad transportation through the area.

July 5

Town's House a Statehouse

When New Haven became co-capital of Connecticut in 1701, it housed no public buildings except for a meetinghouse. After voting to provide a statehouse in Hartford in 1717, the General Assembly approved construction of a similar structure on the public green in New Haven the following year. A new brick statehouse replaced this building in 1763, but by the start of the nineteenth century, it proved inadequate for the needs of the town, county and state government.

In 1827, the General Assembly approved the construction of a new statehouse in New Haven. On July 5, 1827, New Haven county judges and representatives approved the plan. Its design fell to renowned Connecticut architect Ithiel Town.

Town was a native of Thompson, Connecticut, and one of the first professional architects in the United States. Among his accomplishments were designs for the Wadsworth Atheneum, the Trinity Church in New Haven, the U.S. Customs House in New York City and the state capitol building in North Carolina. Together with partner Andrew Jackson Davis, Town designed a stone building with a marble basement that housed the legislature halls in the upper story and the governor's parlor, courtrooms and committee rooms below.

Officials first took occupancy of the building in 1830 and tended to state business there for over forty years—until shortly after the vote to make Hartford Connecticut's sole capital in 1873. The building then fell to the care of the New Haven people, who, having let it fall into disrepair, razed the structure in the summer of 1890.

July 6

The Hartford Circus Fire

July 6, 1944, was a sweltering hot day that witnessed nearly six thousand people crowd into a field on Barbour Street in Hartford to witness a matinee performance of the Ringling Brothers Barnum & Bailey Circus. After a display of animal training by French lion tamer Alfred Court, the Great Wallendas began their acrobatic routine—then someone shouted, "Fire!"

Officials later theorized that a carelessly tossed cigarette had ignited the canvas of the five-hundred-foot-long big top. The tent, waterproofed with a mixture of paraffin thinned with gasoline, soon began dropping giant patches of burning canvas onto patrons below. Exits blocked by animal cages from the previous act trapped much of the crowd inside. It took only ten minutes for the nineteen-ton big top to completely succumb to the fire and crash down on the remaining patrons. In the end, over 160 people died in the fire—many of them trampled to death in the panic to escape.

July 7

Punishing Fairfield

Throughout the years encompassing the Revolutionary War, the town of Fairfield, Connecticut, was a busy commercial center, thanks, in part, to the maritime trade coming through Black Rock Harbor. While much of Connecticut remained loyal to the British Crown, bands of privateers and spies operating out of Fairfield drew the ire of British commanders. In 1779, the British decided the time had come to seek retribution.

On the morning of July 7, 1779, residents of Fairfield awoke to find a British fleet anchored off their beaches. The lifting of fog that afternoon brought nearly two thousand British troops ashore. Many local residents gathered their valuables and fled, while others chose to stay and fight. But those who remained rapidly found themselves overwhelmed. The British looted homes and destroyed the possessions of Loyalist and Patriot alike before slowly and deliberately setting a number of houses on fire.

The worst of the destruction came the following day, however, when the German mercenaries covering the British withdrawal set fire to most of the town. In the end, forty-eight stores, sixty-seven barns and nearly one hundred homes burned along with schools, meetinghouses and a courthouse. The fires devastated the local economy and took decades from which to recover. Rather than rebuild, many residents chose to move to Connecticut's Western Reserve in what today is northeastern Ohio.

July 8

In the Hands of an Angry God

One of the most influential theologians of his time and a leader of New England's First Great Awakening, Jonathan Edwards was the only son among Reverend Timothy Edwards's eleven children. Jonathan enrolled at Yale at thirteen and became a pastor in Bolton, Connecticut, and a tutor at Yale before agreeing to move to Northampton, Massachusetts, to assist his grandfather the Reverend Solomon Stoddard.

Stoddard died three years after the move, and Edwards became the senior minister at Northampton. It was during this time, at the height of the Great Awakening, that Edwards accepted an invitation to preach in Enfield (then a part of Massachusetts). On July 8, 1741, he delivered a sermon entitled "Sinners in the Hands of an Angry God." While delivered earlier to his own congregation with little effect, Edwards's sermon in Enfield became one of the most celebrated in American history. Emphasizing the Puritan belief in hell and in living life in fear of the potential sudden and unexpected wrath of a vengeful God, Edwards's warning to sinners spread throughout New England.

After leaving Northampton, Edwards ended up on the western frontier of Massachusetts working as a missionary with local indigenous tribes. Eight years later, he accepted an offer to become president of what became Princeton University but died of smallpox shortly afterward. His words carried on, however, through the work of many of his disciples, who transformed much of Edwards's work into the fundamental argument for the abolition of slavery (despite the fact that Edwards was a slaveholder and defended slavery during his lifetime).

July 9

A Volcanic Summer Frost

On April 4, 1815, what scientists believe was the loudest noise ever recorded rocked the Dutch East Indies (modern-day Indonesia) with the eruption of Mount Tambora. The powerful explosion killed more than twelve thousand people living nearby. It ripped the top four thousand feet off the mountain and sent more than twenty-five cubic miles of rock and ash into the atmosphere. The cloud of debris proved so dense it actually blocked out sunlight as it spread across the globe.

One year later, in Connecticut, farmers welcomed the arrival of spring. After a long winter, temperatures finally rose in early June, but a pattern of cold weather moved in and began threatening crops. The drop in temperature came from the clouds of volcanic debris from Mount Tambora finally reaching New England. On July 9, 1816, a killer frost pushed overnight temperatures down into the twenties. Crops died, and with vital canal networks packed with ice, a food shortage ensued. The cold temperatures led many Connecticut residents to believe a second ice age was upon them, and the state witnessed a period of massive migration to warmer climates. The effects of the ash in the atmosphere and the resulting shortened growing season took years for the state to overcome.

July 10

Connecticut's Worst Tornado Outbreak

It was the afternoon of July 10, 1989, when a supercell thunderstorm that developed near Albany, New York, moved into western Connecticut. Shortly before 5:00 p.m., the storm spawned a tornado that touched down in Cornwall. Sporting 150-mile-per-hour winds, the tornado destroyed homes, uprooted trees and leveled much of the Mohawk Mountain ski resort as it made its way along a 10-mile path.

Another tornado touched down in Watertown as the storm moved south and east. At Black Rock State Park, it dropped a tree limb on the tent of four camping Girl Scouts, taking the life of a twelve-year-old Stratford girl.

Hamden bore the brunt of the storm around 5:45 p.m. There, an F-4 tornado brought green skies and winds in excess of two hundred miles per hour that tore the roof off the local middle school and injured hundreds. The F-4 remains one of only two such storms to ever touch down in Connecticut.

By the time the storm finally lifted, there were nearly six hundred reported injuries to go along with the one fatality and damage to almost one thousand homes. In addition, the storm wiped out power to more than seventy-five thousand homes. Large portions of New Haven and Litchfield received "disaster area" designations and required millions of dollars to restore.

July 11

Savin Rock Amusement Park Raided

Savin Rock Amusement Park was the brainchild of Civil War veteran George Kelsey in the late nineteenth century. After building a pier out into Long Island Sound in modern-day West Haven and investing in local transportation interests, Kelsey sought a way to attract visitors to the area. He started by building a hotel and a park overlooking Long Island Sound. He then added attractions such as gardens, a zoo and a dance hall. He also went on to build a "white city" inspired by the wildly popular buildings of the 1893 Columbian Exposition in Chicago.

By the early twentieth century, Savin Rock was bringing in visitors from all across the Northeast. The games offered along the boardwalk, however, became a matter of increasing concern for law enforcement authorities. Offering money to winners instead of prizes, many covert (and not so covert) gambling operations took over and increasingly attracted a criminal element to the park.

In early 1959, the Connecticut State Police created a new department to focus on, among other things, enforcing the state's ban on gambling. The "racket squad" led its first organized raid on July 11, 1959. On that Saturday night, one hundred officers (some in plain clothes) quietly arrested fifty persons at Savin Rock Park and charged them with gambling. The raid resulted in the closing of a bingo parlor and more than twenty-five other attractions.

July 12

Dymaxion

The Dymaxion was a three-wheeled car designed by Buckminster Fuller in the early twentieth century. Designed to carry eleven passengers at speeds up to 120 miles per hour, the Dymaxion got its name from Fuller's combining of the words "dynamic," "maximum" and "ion."

Fuller set up production for his car in Bridgeport, Connecticut, in March 1933. While his original design called for inflatable wings to allow the car to fly when reaching high speeds, the final specifications for the car instead called for a teardrop design with two wheels in the front and one in the back. Consisting of a steel chassis and a body made of aluminum-covered wood, the first Dymaxion emerged from the factory on July 12, 1933. Three months later, however, a demonstration of the Dymaxion led to a crash that killed the driver, and investors promptly pulled funding from the project.

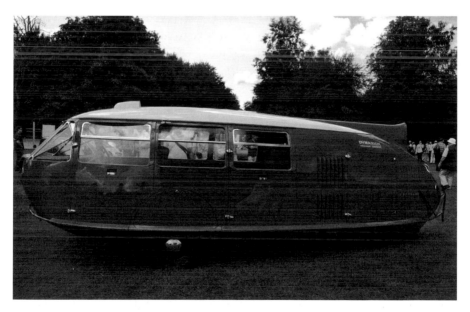

The Dymaxion. *Supermac 1961 from Chafford Hundred, England, http://www.flickr.com/people/72752141@N00 Supermac1961].*

July 13

Suffragists Appeal to President Wilson

Suffragists took to the streets of Hartford and Simsbury on July 12, 1918, fighting to get women the right to vote. Frustrated by the opposition to woman suffrage displayed by Connecticut senators George McLean and Frank Brandegee, throngs of suffragists took their appeal directly to President Woodrow Wilson.

President Wilson seemed largely indifferent to the plight of woman suffragists until demonstrations outside the White House and a number of hunger strikes threatened to tarnish his administration's accomplishments. He agreed to support a woman suffrage amendment in January 1918.

By the summer of that year, however, proponents of the amendment had become disillusioned by a lack of progress in Congress. Suffragists in Connecticut opted to appeal publicly to Wilson to intervene. They likened their cause to that of the fight for democracy in World War I and documented the progress made by women in all the other Allied countries that exceeded that found in America.

In addition to the numerous rallies held in the state, suffragists drafted a telegram to the White House meant to pressure Wilson into action. On July 13, 1918, the *Hartford Courant* published the telegram, which asked President Wilson to address the United States Senate and demand the immediate passage of a suffrage amendment. The required action finally came the following summer with congressional approval of the Nineteenth Amendment to the Constitution.

July 14

Silas Deane Recalled from France

One of America's most accomplished diplomats, Silas Deane, was born in Groton, Connecticut, on December 24, 1737. After studying law and opening a legal practice in Wethersfield, he became a member of the Connecticut Colonial Assembly in 1768 and served as secretary of the Connecticut Committee of Correspondence. He then represented the state

at the First Continental Congress in Philadelphia, where he served on forty different committees. At the end of his second term, Congress asked Deane to travel to France and secure military supplies for use against the English in the Revolutionary War.

Deane served as part of a three-person team that included Arthur Lee and Benjamin Franklin. While in France, Deane purchased supplies for the American colonies but also conducted private business transactions as well. Poor accounting records led to charges that Deane used government money for his own personal gain. Congress recalled Deane to answer these charges, and on July 14, 1778, Deane arrived back in Philadelphia.

Unable to produce the records Congress demanded to clear his name, Deane returned to France in July 1780 to gather documents for his defense. There, his reputation in the colonies declined further after news arrived that Deane, frustrated by inaction in Congress, publicly questioned the viability of democratic government, moved to London in 1783 and even met with American traitor Benedict Arnold. In 1789, in poor physical and financial health, Deane decided to move back to Connecticut, but only four hours after boarding a ship bound for America, he passed away.

July 15

Candlewood Lake

A lawyer named J. Henry Roraback saw the potential to expand development in southern Connecticut through the use of hydroelectric power and, consequently, began purchasing potential dam sights along the Housatonic and Connecticut Rivers in 1907. He then set about purchasing the stock of the Housatonic Power Company and renaming his enterprise Connecticut Light and Power.

One of Roraback's more auspicious plans called for pumping water from the Housatonic River into a giant reservoir and then down to a power plant along the Rocky River in New Milford. On July 15, 1926, the board of directors at Connecticut Light and Power approved construction of the reservoir—what today is Candlewood Lake.

Over a roughly two-year period, authorities cleared more than five thousand acres of farm and forestland in Brookfield, Danbury, New Milford,

Sherman and New Fairfield. The project displaced dozens of families and demolished homes, churches, cemeteries and barns and wiped out the entire village of Jerusalem.

Water began flowing into the lake in February 1928, and in December of that year, the Rocky River hydroelectric plant began operating. The construction of Candlewood Lake ultimately cost builders about $5 million but provided benefits in excess of reliable electric power. Connecticut Light and Power made the lake available for recreational use, and boaters, fishermen and real estate developers helped fuel demand for the construction of numerous successful lakefront resort communities.

July 16

The Connecticut Compromise

The stifling hot summer of 1787 in Philadelphia witnessed delegates from throughout the newly independent United States arriving to Independence Hall to debate the structure and operation of their new government. The interests of the country's original states varied considerably, and the world watched the proceedings carefully to see if a democratic system of government was truly capable of holding a tenuous union of states together.

One of the most significant challenges faced by the delegates to the Constitutional Convention was the issue of representation. Future president James Madison authored the Virginia Plan, which called for the size of a state's representation in the federal government to be proportionate to the state's population. The smaller states rejected this plan and backed the New Jersey Plan, which called for representation from each state to be equal. The stalemate that ensued threatened to bring the American experiment to a swift end.

Connecticut representative Roger Sherman, assisted by fellow Connecticut representative Oliver Ellsworth, authored a plan aimed at compromise. Sherman's plan called for a bicameral legislature with equal representation in the Senate but proportional representation in the House of Representatives. Adopted on July 16, 1787, by a narrow vote, Sherman's plan became known as the Connecticut Compromise and played an essential part not only in forming America's modern system of government but also in holding the country together at a particularly fragile time during its early development.

July 17

The First Nutmeg Games

The largest amateur multisport event in Connecticut started out with a mere three hundred athletes gathering on the fields of Canton on July 17, 1986. There, the first Nutmeg Games lasted four days and began a state tradition that grew steadily in popularity over the next several decades. Promoting sportsmanship, teamwork and physical fitness, the original games consisted of competitions held in such sports as basketball, soccer, swimming, tennis, volleyball, field hockey and softball. Organizers divided competitors into three groups: those fourteen years of age and younger, those fifteen to nineteen and an older "corporate" division (meant to promote greater corporate interest in supporting youth sports).

Despite incurring a $400 loss on the original games in 1986, organizers decided to make the competition an annual event, though slightly modified. They postponed the second games in 1987 while they sought sanctioning from the United States Olympic Committee (USOC). The USOC required a minimum of ten Olympic sports be represented at each games, a mandate Nutmeg Games organizers complied with by offering competitions in gymnastics and wrestling, as well as other Olympic events. The games resumed in 1988, albeit at a new location (Eastern Connecticut State University) and not only received sanctioning from the USOC but eventually from the National Collegiate Athletic Association (NCAA) as well.

July 18

A Place for Digging Holes

Connecticut's largest shoreline park, Hammonasset Beach State Park, is one of the state's most popular summer tourist destinations—hosting over one million visitors annually. Those who choose to meander the boardwalk or play in the sand and surf might be unaware that the area around Hammonasset has a rich history.

Located in the town of Madison, today's Hammonasset Park originally provided fertile agricultural lands for local indigenous tribes. The name

Hammonasset loosely translates to "a place for digging holes in the ground." Indigenous people planted corn and beans and took advantage of ample stocks of fish.

Radical change to the area came in the late nineteenth century when the Winchester Repeating Arms Company purchased the land and turned it into a firing range. Weapons testers piled into boats in Long Island Sound and fired rifles into the sandy shoreline. It was not until July 18, 1920, that Hammonasset first opened as a public beach and park. It met with immediate success, attracting over seventy-five thousand visitors in its first year.

During World War II, officials actually closed the area to the public and lent it to the federal government for use as an army reserve base. The area out by Meigs Point even served as an aircraft range, allowing military aircraft to fly over and fire at targets along the point. After the war, the park reopened, and its popularity skyrocketed, spawning numerous renovations, as well as the opening of additional state parks to alleviate congestion at the site.

July 19

Growing Inspiration

Julian Alden Weir came from a family of artists and was himself an aspiring painter. He enrolled at the National Academy of Design at seventeen and

Weir Farm in Ridgefield. *Library of Congress, Prints and Photographs Division, Highsmith (Carol M.) Archive Collection.*

then studied art in Europe for four years, largely at the Ecole Des Beaux-Arts in Paris.

Upon returning to America in 1877, he settled in New York and became a portrait and still-life painter, instructor and art buyer. In 1882, Erwin Davis offered Weir a 153-acre farm in Branchville, Connecticut, in return for ten dollars and a painting Weir had acquired in Europe. Weir agreed to the deal on July 19, 1882.

Weir ultimately lived on the farm for thirty-six years. He built a studio there and, by the 1890s, was one of America's most famous Impressionists. The farm became a retreat for new and established painters, who drew inspiration from its picturesque surroundings. It became a National Historic Site in 1990.

July 20

Sun Myung Moon

Korean evangelist Sun Myung Moon founded the Unification Church in 1954 and built a financial empire using businesses in Japan and South Korea to fund his nonprofit enterprises. He moved to the United States in 1972 and settled in New York. Part of a wave of new religious movements to prosper in the West during the 1960s and '70s, Moon's controversial Unification Church was characterized by a devotion to mass weddings and intricate ties to commercial interests.

After arriving in America, Moon busied himself in commercial fishing enterprises, construction and real estate speculation. His religious influence spread throughout the next two decades, but ceremonies such as the mass wedding of 2,075 couples at New York's Madison Square Garden in 1982 led increasingly to allegations that the Unification Church was nothing more than a thinly disguised and dangerous cult.

In October 1981, federal authorities indicted Moon on twelve counts of tax evasion for failing to report over $100,000 in income between 1973 and 1975. After his conviction, Moon surrendered to authorities in Danbury, Connecticut, on July 20, 1984. He ultimately served thirteen months of an eighteen-month prison sentence.

After obtaining his release, Moon remained in America but witnessed a steady decline in his fortunes. Despite ties to a $110 million investment in

the University of Bridgeport, Moon's personal finances endured a series of setbacks, and interest in his church steadily declined. In the late 1990s, he became increasingly anti-American in his rhetoric and ultimately returned to South Korea, where he died in 2012.

July 21

Testing the Turtle

An inventor who studied ways to make gunpowder ignite underwater, Saybrook's David Bushnell first saw the need for a submersible boat in the years leading up to the Revolutionary War. He built a wooden ship, complete with snorkels to provide air, a screw propeller and ballast tanks for controlling the sub's depth. He named it the *Turtle* because he thought the boat resembled two turtle shells fixed together.

After the British landed their massive fleet in New York Harbor in 1776, Bushnell decided to use the *Turtle* to sneak under the flagship HMS *Eagle* and attach an explosive charge. On July 21, 1776, navigational training for the *Turtle* took place off Charles Island in Milford, Connecticut. Roughly two months later, Ezra Lee piloted the *Turtle* through exhausting tides in New York Harbor and submerged under the *Eagle* but found the hull too difficult to penetrate and was unable to attach the mine.

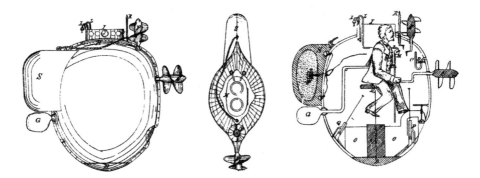

Drawing of Bushnell's *Turtle* design. *Library of Congress, Prints and Photographs Division, Miscellaneous Items in High Demand Collection.*

July 22

A Native American Missionary Unintentionally Helps Found Dartmouth College

Samsom Occom was a Native American born into the Mohegan tribe around Montville, Connecticut, in 1723. He became enamored of religion during the Great Awakening and converted to Christianity in 1741. Occom trained to be a missionary under Eleazar Wheelock in Lebanon and, after briefly teaching school in New London in 1748, served as a minister to members of the Montauk tribe living on Long Island. He was ordained as a Presbyterian minister in 1758.

Nearly a decade later, Eleazar Wheelock asked Occom to travel to England to raise money for the construction of a Native American school. Starting in February 1766, Occom preached over three hundred sermons and raised twelve thousand British pounds to fund the school. He ended his tour on July 22, 1767.

Upon returning to Connecticut, Occom parted ways with Wheelock after Wheelock used the money Occom raised to found (what became) Dartmouth College rather than to build the promised Native American school. In the 1770s, Occom moved to New York (near present-day Utica) and established a settlement of Brotherton Indians composed of Native Americans from several different New England tribes. Occom died there in 1792, and nearly thirty years later, the Brothertons relinquished their lands to the State of New York, moved west and established the town of Brotherton, Wisconsin.

July 23

A Close Shave

Born in Iowa and raised in New Mexico, Jacob Schick served in the Philippines during the Spanish-American War. After the war, the army stationed Schick in the Philippines and then Alaska, where Schick set about prospecting for gold. A serious injury, however, sidelined his efforts but inspired two of Schick's greatest inventions.

Finding it difficult to safely change the blades in his shaving razor using one arm, Schick imagined a system that allowed him to replace old blades

with new ones at the push of a button. Modeling his design after ammunition clips he saw in the army, Schick patented a "magazine repeating safety razor" that ejected old razors and moved new ones into place by depressing a plunger. He formed the Magazine Repeating Razor Company in 1925. The years that followed witnessed Schick make various improvements to his design, and on July 23, 1929, Schick (now operating out of Stamford, Connecticut) received a patent for a razor with a protective plate meant to rest against the face and house a slightly recessed blade underneath it that allowed for improved comfort and safety.

By that time, however, the second of Schick's greatest inventions preoccupied most of his time. He actually sold the assets of his previous company to fund the development of an electric razor. He opened a new factory in Stamford and patented a shaver that operated with power supplied from an external motor. Before fully realizing the potential of his new invention, Schick moved to Canada fleeing charges of income tax evasion. He soon caught pneumonia and died.

July 24

Bringing Down Nixon

Questions surrounding the break-in at the Watergate offices of the Democratic National Committee in June 1972 prompted Senator Edward Kennedy to call for an investigation of President Richard Nixon's campaign practices. The Senate unanimously approved the formation of the Select Committee on Presidential Campaign Activities—headed by Sam Ervin of South Carolina—on February 7, 1973.

One of the committee's most outspoken members was an inexperienced senator from Connecticut, Lowell Weicker (elected to his first term in 1970). Through the media, Weicker publicly questioned the president about why he failed to turn important information over to law authorities and called on Nixon to explain how his actions did not constitute a felony obstruction of justice. Weicker also released his own 146-page report on the investigation that cited 170 abuses of power by the Nixon White House and called for a ban on domestic wiretapping and for Supreme Court jurisdiction over disputes between the president and Congress.

Meanwhile, the Select Committee repeatedly requested access to secret recordings Nixon made of White House conversations—requests Nixon denied on the grounds of "executive privilege." On July 24, 1974, however, the Supreme Court ordered Nixon to surrender the tape-recorded conversations. The tapes ultimately led to the House Judiciary Committee adopting three articles of impeachment against the president, forcing Nixon to resign in August 1974.

The publicity Weicker received as part of the Select Committee helped him win reelection to the Senate for the next fifteen years. He then became Connecticut's eighty-fifth governor on January 9, 1991.

July 25

Why Do Birds Suddenly Appear?

Richard Carpenter was somewhat of a musical prodigy. Born in New Haven, Connecticut, in 1956, he spent large portions of his childhood listening to records and familiarizing himself with music theory. He studied classical piano at Yale University before his parents relocated their family to California in 1963.

Once there, Richard formed a three-person band that included his sister Karen on the drums. Though signed by RCA, the group met with little commercial success and eventually broke up. In 1969, after hearing a demo tape, Herb Alpert signed Richard and Karen Carpenter to a deal with A&M Records. That November, they released an album entitled *Offering* that underperformed until they changed the name to *Ticket to Ride* to promote their cover of the song made popular by the Beatles.

The following year, the Carpenters released their second album, *Close to You*, and their popularity exploded. The album sold over one million copies, and on July 25, 1970, the title track reached number one on the Billboard charts and stayed there for nearly a month.

Over the course of the 1970s, the Carpenters toured the world, won three Grammy Awards, performed at the White House and even had their own short-lived television series. Their popularity waned toward the end of the decade, however, and Karen's career came to a tragic end on February 4, 1983, when she died from cardiac arrest brought on by years of struggle with anorexia nervosa.

July 26

The Wide Awakes

Groups of young Republican militants flooded the streets of America in the summer of 1860. Marching with military precision, carrying torches and dressed in military hats and black enameled capes (to protect their clothes from the torch oil), these mysterious activists did not seek violent confrontation but instead wished to win votes for presidential candidate Abraham Lincoln. Consisting primarily of men in their teens, twenties and thirties, these "Wide Awakes," as they called themselves, focused on connecting with disillusioned younger voters.

The Wide Awake movement actually started in Hartford, Connecticut, in March 1860. There, a handful of dry goods clerks and rifle makers took an active interest in the hotly contested gubernatorial contest between Republican William Buckingham and Democrat Thomas Seymour. Seeing the Connecticut election as a precursor to the national presidential election, these grassroots political activists took to providing armed escorts for Republican speakers traveling through the heavily Democratic capital city.

On July 26, 1860, the Hartford Wide Awakes hosted a banquet attended by visitors from across Connecticut, New York and Massachusetts and a large contingent of Wide Awakes from Newark, New Jersey. Greeting their arriving guests at Chapin's Wharf and escorting them to city hall, the group of between three and five thousand militants organized a torchlight parade through the streets of Hartford the following night.

By November 1860, the Wide Awakes numbered in the hundreds of thousands across the country, filling cities such as Philadelphia, Chicago, Cleveland and San Francisco. They not only helped William Buckingham win election as governor of Connecticut but also played an important part in Abraham Lincoln's ascent to the presidency.

July 27

Forty Years Later, the Russians Execute a Waterbury War Criminal

Feodor Fedorenko was a thirty-three-year-old soldier in the Soviet Red Army at the time the Nazis invaded the Ukraine in 1941. Within a matter of weeks, Fedorenko agreed to change sides and became a member of the German SS. The Germans sent him to work at the Treblinka death camp in Poland.

Fedorenko served as a guard at Treblinka throughout 1942 and '43 and took part in the execution of thousands of Jewish prisoners. Accounts recorded Fedorenko stealing the possessions of the condemned and beating them on their way into the gas chambers—work for which he received two promotions.

Shortly after the conclusion of World War II, Fedorenko fled to America. He entered the United States in 1949 and moved to Waterbury, Connecticut. There, he worked for numerous years at the Scovill Manufacturing Company before retiring to Florida and then Pennsylvania.

In 1981, the United States stripped Fedorenko of his citizenship after an investigation uncovered his role in numerous Nazi war crimes. In 1984, having lost a long legal battle to remain in the States, Fedorenko became the first person ever extradited to the Soviet Union from the United States. He lived there for a year before his arrest, conviction for murder and treason and eventual execution by firing squad on July 27, 1987.

July 28

The Most Famous Sandwich in America

It was July 28, 1900, when Louis Lassen (proprietor of New Haven's Louis' Lunch restaurant) waited on a customer who was in a tremendous hurry. The customer wanted a hot meal but needed something he could eat on the run. Louis cooked some ground steak trimmings and placed the meat between two pieces of toast. What he unwittingly invented was the hamburger.

The idea for the "Hamburg steak" was actually a dish familiar to immigrants from Hamburg, Germany. They found it the perfect meal to eat while standing up or walking through the streets of New York City. Consequently, much debate

exists about who actually invented the hamburger. While many Connecticut residents credit the achievement to Louis Lassen and many German immigrants point to the national origins of the sandwich, others claim it was "Hamburger Charlie" Nagreen, who placed meatballs between two pieces of bread at a Wisconsin fair in 1885, or Frank and Charles Menches, who sold ground beef sandwiches in Hamburg, New York, that same year. In 1995, the governor of Oklahoma proclaimed that Tulsa resident Oscar Weber Bilby was the first to sell a burger on a bun in 1891.

While the hamburger did not catch on immediately with the American public, the growth of the country's automobile culture helped spread the popularity of foods eaten on the run. Several restaurants catered to this new breed of consumer in the early twentieth century, but it was Ray Kroc's opening of the first McDonald's restaurant in 1955 that helped launch hamburgers into mainstream American culture.

July 29

Eleven Inches of Rain in Seventeen Hours

Late on the night of July 29, 1905, heavy rains moved into southern Connecticut. Areas in and around Easton, Connecticut, endured a deluge of nearly seven inches in a matter of hours. At 2:00 a.m. on July 30, Easton's Ward's Mill dam burst, setting off a chain of dam failures that poured water into Trumbull and Bridgeport.

In Bridgeport, 11.32 inches of rain fell over a seventeen-hour period. The rain filled city sewers and shut down transportation and communication networks. But the devastating flood of the Pequonnock and rupture of the Ward's Mill dam did the greatest damage. As the floodwaters surged into Bridgeport, they broke the home of John Lescoe loose from its foundation and carried the family inside for over a mile before leaving them largely unharmed. Local resident Michael Moran was not so lucky, however, and the flood smashed his home against the Berkshire Bridge, drowning him inside.

In addition, the water poured onto Barnum Avenue just as William Kowzeski and John Starkin drove their ice wagon over the bridge. Starkin managed to swim to shore, but the waters carried away Kowzeski, the wagon and its horses. The destruction reached its crescendo when the schooner

Hope Hayes broke loose from its moorings in the harbor and crashed into the Congress Street Bridge, tearing down electrical wires that touched off an explosion from a nearby gas main break.

The floodwaters ultimately claimed only two lives, however, thanks to the rescue of forty-one people by local police and fire personnel. The property damage exceeded $250,000 in 1905, a figure roughly equivalent to $6 million today.

July 30

Connecticut's Biggest Rock Concert That Never Was

Lou and Herman Zemel opened the Powder Ridge ski resort in 1960. Located on Beseck Mountain on the Middlefield-Meriden border, the facility offered a Swiss-style lodge and luxurious amenities, drawing sizeable crowds to central Connecticut. The brothers later increased business by offering live musical acts at the resort.

In 1970, with the country still abuzz about Woodstock, a New York promotional group called Middleton Arts International approached the Zemels about hosting a music festival at their resort. Organizers lined up twenty-five acts, including Janis Joplin, the Allman Brothers, Joe Cocker, Grand Funk Railroad and Fleetwood Mac, to play the Powder Ridge Rock Festival from July 31 to August 2, 1970.

Almost immediately after the announcement, the lawsuits began. Local residents took the organizers to court, and just days before the festival opened, a superior court judge issued an order barring the event. This did not stop people from coming, however. Despite police blockading the roads and the town shutting off electricity to the area, nearly thirty thousand people walked and hiked onto the festival grounds. On July 30, 1970, police arrested Louis and Herman Zemel for defying the court order.

Despite the cancelation of the concert, most of the ticketholders opted to stay and camp on the site for the weekend. When they tried to obtain refunds, however, the promoters were nowhere to be found. An investigation into Middleton Arts International found numerous members with prison records and ties to organized crime. Most of the money taken in from the ticket sales simply disappeared.

July 31

Branford Gets on the Trolley

In the middle of the nineteenth century, with industrial growth drawing workers and consumers into New England cities, systems of mass transportation emerged that relied on horses to draw large numbers of people through the streets on coaches and omnibuses. Streetcars placed on rails eventually proved more efficient, but concerns about sanitary conditions along the lines brought about mechanically powered cable cars and then electric trolleys. These systems provided fast and reliable ways to move people through the city.

The oldest continuously operated trolley line ran along the Connecticut shoreline. The Branford Electric Railway, an extension of service begun years earlier in East Haven, started transporting passengers on July 31, 1900. While clean, efficient transportation into and out of cities helped spread the growth of suburbia, this growth eventually spread beyond the reach of trolley lines. The Branford Electric Railway succumbed to these realities and discontinued service on March 8, 1947.

The Shore Line #12 heads east toward Guilford from Stony Creek, while the #434 heads west for New Haven (between 1911 and 1919). *Shore Line Trolley Museum Collections.*

AUGUST

August 1

A Connecticut Yankee in the British Royal Air Force

Born with a highly developed sense of adventure, Andrew Mamedoff, a native of Thomson, Connecticut, attended Bryant College in the 1930s, where a penchant for fast cars and reckless behavior got him kicked out of school on numerous occasions. After finally graduating from Bryant in 1932, Mamedoff took to the skies, learning to fly in a small plane he purchased. It was not long before he made a living performing dangerous stunts at air shows.

Seeking out greater adventure, Mamedoff headed for Finland to fight in the Russo-Finnish War but arrived just as the war ended. Rather than return to United States, Mamedoff chose to defy American neutrality laws at the start of World War II and join the French air force. He got bounced around from station to station but never saw any combat. As France fell, Mamedoff escaped across the English Channel.

Once in England, Mamedoff talked his way into the Royal Air Force (RAF). In September 1940, he and two of his friends were among the first pilots assigned to the newly formed No. 71 Eagle Squadron. Less than a year later, on August 1, 1941, the RAF made Mamedoff a flight commander for the elite No. 133 Eagle Squadron. Only two months after receiving his promotion, however, Mamedoff took to the skies on a routine flight from England to Northern Ireland but never arrived at his destination. The onset of bad weather most likely caused Mamedoff to crash near the Isle of Man, where authorities eventually recovered his body and the remnants of his plane.

August 2

The Last Public Hanging in Connecticut

On the night of March 22, 1829, Oliver Watkins of Sterling, Connecticut, snuck up on his wife, Roxana, while she slept and strangled her to death. The motivation for this heinous crime came from a budding association Watkins formed with the widowed "temptress" Waity Preston. Though Watkins vehemently denied involvement in his wife's death, authorities felt there existed enough evidence against Watkins to sentence him to death by hanging.

Public hangings were originally used as a criminal deterrent in Connecticut, as elsewhere in the United States. Lawmakers believed that witnessing the morbid spectacles might encourage criminals to think twice about committing illegal acts. What public hangings evolved into, however, were macabre, drunken entertainment spectacles.

The case of Oliver Watkins proved no exception. A gallows erected between Brooklyn and Danielsonville drew throngs of spectators on the morning of August 2, 1831. Entire families clogged the streets on their way to Watkins's hanging, and local tavern keepers hired their own special guards to watch over Watkins to make sure he did not escape or commit suicide before the liquor sales began. After a brief prayer and Watkins's execution, a party erupted that consumed essentially all the food and drink to be had in the immediate vicinity.

Finding public hangings to be of little deterrent to criminals in the early nineteenth century, and with changing ideas about human rights and the social versus religious nature of criminal activity, Connecticut soon restructured its penal code. The execution of Oliver Watkins was the last public hanging held in the state.

August 3

The First Continental Congress

In 1774, a history of colonial defiance to new taxes led the British Parliament to pass a series of laws known as the Intolerable Acts. In response, radical elements in the American colonies called for a boycott of British goods, but

many merchants proved reluctant to join a boycott without assurances of unified action on behalf of all the colonies. As a result, colonial legislatures authorized the formation of a continental congress to decide on a course of action.

It was in July 1774 that a committee of the Connecticut General Assembly met to appoint a delegation to represent the colony at the congress. Of the five men selected, three declined to attend. It was not until August 3, 1774, that Connecticut finalized its delegate selection, choosing Eliphalet Dyer, Roger Sherman and Silas Deane.

The First Continental Congress convened at Carpenter's Hall (later known as Independence Hall) in Philadelphia on September 5, 1774. All of the colonies except Georgia sent representation. Despite initial uncertainty about their objectives, members of the Congress agreed on a nonimportation pact, effective December 1, 1774, unless Parliament rescinded the Intolerable Acts. They also sent a list of grievances to King George III and agreed to meet again the following year if their grievances remained unaddressed. The following year, however, shots fired at Lexington and Concord forced the Second Continental Congress to focus on preparing for war.

August 4

Connecticut Radio Bans the Beatles

It was a March 4, 1966 interview between columnist Maureen Cleave and Beatles member John Lennon that started all the controversy. As Cleave asked questions attempting to ascertain the events that comprise the daily life of a rock star, Lennon ventured off on a discussion about the waning influence of organized religion on the lives of Britain's younger generation. At one point, Lennon argued that Christianity was on its way out and, as evidence, referred to the Beatles when he claimed, "We're more popular than Jesus now."

The interview garnered little attention in Great Britain, but four months later, a firestorm of controversy erupted after the American teen magazine *Datebook* published excerpts from the interview. Immediately radio stations like KLUE in Longview, Texas, and WAQY in Birmingham, Alabama, called for boycotts and the destruction of Beatles records.

On August 4, 1966, several Connecticut radio stations joined in the frenzy. Stations WFIF in Milford, WSTC in Stamford and WINY in Putnam agreed to remove the Beatles from their airwaves. The same was true of WLIS in Old Saybrook, and WINF in Manchester even went so far as to form a "Beatles Are Bad Business" club.

Though many Connecticut stations succumbed to public pressure to join the boycott, the state's more popular rock stations, like WPOP in Hartford, chose not to ban the Beatles. Instead, they asked listeners to actually contemplate why the issue caused so much controversy. Later that month, on August 29, at Candlestick Park in San Francisco, the Beatles gave their very last performance.

August 5

The Cornerstone of the Statue of Liberty

A large vein of unusual pink granite runs beneath the Connecticut shoreline in the area of Branford and Guilford. Beginning in 1858, industrious quarrymen began mining the granite using black powder explosions to extricate it from the ground. This high-quality granite went into such iconic commemorations as Grant's Tomb and the Battle Monument at West Point.

Later in the century, the expansion of railroad transportation helped the industry attract more quarrying operations to the area. One of these operations was the Beattie Quarry, begun by Scottish immigrant John Beattie after his purchase of four hundred acres of land in Guilford.

It was the Beattie Quarry that came to the forefront of plans to celebrate the friendship forged by the United States and France during the American Revolution. When France offered to build what became the Statue of Liberty and give it to the United States, the United States offered to build a giant granite pedestal on which to rest the statue. A six-ton block of granite from the Beattie Quarry became the cornerstone of the statue's pedestal on August 5, 1884.

Funding for the remainder of the pedestal, however, proved slow in materializing. Despite charity art exhibitions and theater performances, Americans seemed reluctant to part with the necessary funds. That is when Joseph Pulitzer (for whom the Pulitzer Prize is named) used editorials placed

in his newspaper, the *World*, to essentially shame Americans into being more philanthropic. Organizers reached the necessary funding threshold in August 1885, allowing workers to complete work on the pedestal the following April.

August 6

The Intimidator

Stafford Motor Speedway in Stafford Springs, Connecticut, originally opened as an agricultural park in 1870. Meant to celebrate the state's farming heritage, the park offered sporting enthusiasts a half-mile track on which to race horses. The track continued catering to equine-based competitions until the end of World War II, when track officials offered visitors more speed through automobile racing. The following decade, ownership in Stafford Springs entered into an agreement with NASCAR (the National Association for Stock Car Auto Racing) to offer weekly NASCAR-sanctioned events.

NASCAR modifieds (with open wheels) raced on dirt until owners paved the speedway in 1967. Two years later, racing legend Jack Arute Sr. purchased the track and revitalized its popularity by investing in new grandstands and press facilities and making additional improvements to the track.

On August 6, 1985, the 1979 NASCAR Rookie of the Year and 1980 NASCAR Winston Cup Champion, Dale Earnhardt, made his first appearance at Stafford Motor Speedway. Coming off of three short-track wins in New Hampshire the previous weekend, Earnhardt left his mark on Stafford Springs by winning both of the two Showdown of Champions 25-Lap Pro Stock races that day.

Earnhardt (nicknamed "the Intimidator") went on to win six more NASCAR Winston Cup Championships in his career, becoming one of the most successful drivers of all time and a 2010 inductee into the NASCAR Hall of Fame. Tragically, however, Earnhardt's life was cut short when a crash on the last lap of the 2001 Daytona 500 claimed his life.

August 7

The Longest Episcopalian Pastorate in the United States

Born in New Haven in 1724, Richard Mansfield became interested in the Episcopalian religion while studying at Yale. After graduating in 1741, he wished to become an Episcopalian minister, but the American colonies lacked anyone capable of ordaining him, so Mansfield headed to England. On August 7, 1748, the archbishop of Canterbury ordained Mansfield a deacon and a priest.

Upon returning to America, Mansfield became the first Episcopal minister in the town of Derby. At the outbreak of the Revolutionary War, however, Mansfield's loyalty to the Crown led to a mob of Patriots chasing him out of town. Mansfield settled in Loyalist New York, leaving behind a wife and daughter who died in Derby before his return at the end of the war.

Mansfield then became a pastor at the St. James church in Derby and preached there right up until his death in 1820. His service to the town spanned seventy-two years, the longest Episcopalian pastorate in U.S. history. His home, built in 1700 and purchased for him by the church in 1747, still remains standing in town after more than three hundred years.

August 8

The Shoe Box Murder

As Joseph Samsom, Edward Terrill and Joseph Terrill walked through farm country in the borough of Wallingford on the morning of August 8, 1886, they discovered a shoe box that appeared to have fallen off the cart of some commercial enterprise. Measuring just thirty inches long and twelve inches wide, the men and their dog discovered it along their path resting under some low bushes. When they opened the box, to their great horror, they discovered the headless, limbless torso of a man wrapped in tar paper.

Authorities determined that the torso belonged to a man in his thirties or forties who had died five to ten days earlier. Large quantities of arsenic found in the man's stomach pointed to foul play. The following month, police recovered two arms and two legs wrapped in a similar style of paper

as the torso, but without any additional evidence, identifying the victim and the murderer proved extremely difficult.

While locals originally thought the remains belonged to an Albert Cooley of Durham (a Wallingford slaughterhouse worker who had taken home a $1,500 pension the previous week), Cooley later turned up alive. A string of recent fires in Wallingford prompted some to theorize that the man in the box was an arsonist murdered by his accomplices. In 1888, a woman named Mabel Gage informed police she knew the whole story behind the murder but then refused to tell the story in court and later committed suicide. The identities of both the murderer and the victim remain a mystery to this day.

August 9

The Wallingford Disaster

The worst tornado in New England history touched down in Wallingford on August 9, 1878. It cut a path half a mile wide and two miles long, destroying homes, barns, orchards and forests. Among the hardest hit were laborers living in flimsy wooden structures by the local railroad lines. The

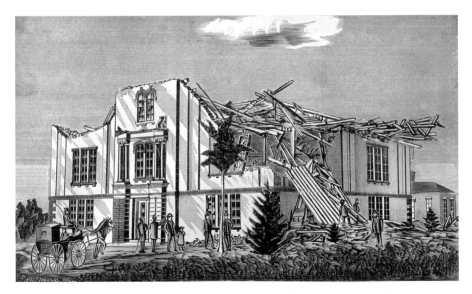

Artist's rendition of the grade-school building in Wallingford after the 1878 tornado. *National Oceanic and Atmospheric Administration, photo library, public domain image.*

tornado destroyed forty homes and countless other structures, including the top floors of the new schoolhouse.

In all, thirty-four people died, and the storm left more than one hundred injured, many with broken backs and broken limbs. Local clergymen immediately set to fundraising to help those suffering the greatest losses, and aid came by rail as Connecticut physicians boarded trains and headed to Wallingford. Unfortunately, the trains also brought more than fifteen thousand curious onlookers from New Haven, New Britain, Hartford, Middletown and Meriden, who hampered local relief efforts as they perused the devastation.

August 10

The First Union General to Die in the Civil War

From a very early age, Nathaniel Lyon knew he wanted a career in the military. After growing up on his family farm in Ashford, Connecticut, Lyon entered the military academy at West Point in 1837. He possessed a violent temper, and during a campaign of the Second Seminole War in Florida, the army suspended Lyon for gagging and beating a private he thought acted insolently.

Lyon received a wound during the war with Mexico in the 1840s, and the army transferred him to California, where reports indicate he took part in the massacre of untold numbers of indigenous peoples. After a transfer to Kansas, Lyon created more controversy when he took charge of the arsenal in St. Louis, Missouri, at the outbreak of the Civil War.

After Lyon successfully shipped weapons from the St. Louis arsenal to the safety of Illinois, the governor of Missouri sent the Missouri State Guard to St. Louis. Lyon took many of the state guardsmen prisoner and paraded them through the streets of St. Louis. Local residents began rioting at this audacious display, causing Lyon to order his men to fire on a mob of civilians, killing twenty-eight of them.

The state guardsmen then headed to the Missouri capital of Jefferson City with Lyon's men on their heels. On the morning of August 10, 1861, a battle erupted at nearby Wilson's Creek. At approximately 9:30 a.m., forces of the Missouri State Guard shot and killed Nathaniel Lyon, making him the first Union general to die in the Civil War.

August 11

Tired of Paying High Rates for Insurance?

At the end of the nineteenth century, large fires in major metropolitan areas such as Chicago and Boston drove insurance rates oppressively high for many inner-city businesses. Buildings packed closely together, built of wood and other flammable materials and engaged in or surrounded by heavy industry made it possible for entire city blocks to rapidly succumb to large conflagrations.

In New Haven, Connecticut, one business owner, Henry S. Parmalee of the Mathusek Piano Works, looked for a way to lower his premiums. His solution was to develop the country's first fire sprinkler system. Patented on August 11, 1874, Parmalee's invention was a system of elaborate pipes, valves and perforated heads subjected to substantial water pressure. The only mechanisms keeping the water from spraying out were heavy springs holding the valves shut. "Two eyes" made of materials compromised when exposed to high heat held the springs in place so that in the case of a fire, the eyes fused, allowing the springs to open the valves. The device proved so popular that between 1878 and 1882, approximately 200,000 Parmalee systems found their way into busy New England mills and factories.

August 12

Gidget Goes Hawaiian

On August 12, 1941, Ice Capades skaters and choreographers Nathan and Edith Walley gave birth to a daughter, Deborah, in Bridgeport, Connecticut. Deborah took to performing on the ice with her parents at the age of three but longed for an acting career and ended up attending New York's Academy of Dramatic Arts. She made her stage debut at age fourteen.

What followed were roles in fifteen feature films, including 1961's *Gidget Goes Hawaiian*, in which she played the title character made famous by Sandra Dee two years earlier. That same year, she was named *Photoplay* magazine's Most Popular Actress of 1961. She went on to star in such popular films as *Beach Blanket Bingo* with Frankie Avalon and Annette Funnicello, *Spinout* with

Elvis Presley and the 1974 smash *Benji*. Interspersed with her film roles were television appearances on *Gomer Pyle U.S.M.C.*, *The Hardy Boys* and the 1967 Desi Arnaz production, *The Mothers-in-Law*.

In 1991, Walley left Connecticut to raise her three sons in Sedona, Arizona. There, she founded Pied Piper Productions and the Sedona Children's Theater. She also took an interest in indigenous cultures—founding the Swiftwind Theater Company and producing award-winning short films featuring Native American stories. Walley died of esophageal cancer at her home in Sedona in 2001.

August 13

A Deserter or a Spy?

Daniel Bissell was a native of East Windsor who enlisted in the Continental army at the outbreak of the Revolutionary War. He served with bravery and distinction at the Battles of White Plains, Trenton and Monmouth, so it was with a great deal of agitation that the colonials met the news of Bissell's slipping away from the American lines on August 13, 1781, to join the British army in New York.

What many did not know, however, was that George Washington had requested Bissell go to New York in the guise of a defector to spy on the British. To make the ruse more convincing, the plotters took every precaution to make Bissell's betrayal look authentic.

After safely entering New York, however, Bissell contracted a terrible fever and enlisted in the British army for the purposes of seeking medical care. He remained hospitalized in deplorable conditions (with little food or bedding and forced to wear the same lice-ridden clothes for three months) until the following May. At that time, Bissell, in a fit of delirium, unwittingly disclosed his plans to a physician. When the physician later hinted to Bissell about his disclosure, Bissell decided to escape back to the colonial lines.

After noting his absence, the British pursued Bissell through New York, forcing him to hide for hours up to his neck in a swamp and spend a night perched precariously in a tree. He finally returned to Washington's camp on September 29, 1782.

August 14

Beating the Wright Brothers to the Punch

Gustave Whitehead, a German native who came to America around 1894, claimed to have made the first powered flight of a heavier-than-air machine. A newspaper report in the *Bridgeport Sunday Herald* on August 18, 1901, claimed that on the morning of August 14, Whitehead took off from a predetermined sight in Fairfield and traveled half a mile in his aircraft at an altitude of fifty feet. Whitehead claimed to make another flight, along Long Island Sound in Bridgeport, in January 1902 that lasted seven miles.

Despite "eyewitness accounts" of the inaugural flight, there are many skeptics who doubt Whitehead's claims. Investigators never uncovered any concrete evidence that the flights took place, and Whitehead never attempted to fly his machines again. Still, in July 2013, Connecticut governor Dannel Malloy signed an act creating Powered Flight Day in Connecticut to honor Whitehead's controversial achievement.

Gustave Whitehead and Plane No. 22, which he reportedly used to fly over Long Island Sound. *Library of Congress, Prints and Photographs Division, Miscellaneous Items in High Demand Collection.*

August 15

The Summer Outdoor Sojourn

At the start of the twentieth century, Connecticut governor Simeon Baldwin created the state's first parks commission. Charged with surveying and prioritizing lands for protection, the State Park Commission held its first meeting at the New Haven County Courthouse on September 29, 1913. General E.E. Bradley became the commission's first chairman.

The commission's first employee was Litchfield native Albert Turner, a Yale-educated engineer. Turner spent seven months traveling along the Connecticut coast identifying suitable locations for parks. Despite one acre of shoreline property costing about one-third of the commission's budget in its first two years, the state managed to purchase five acres of shoreline in Westport that became Sherwood Island State Park. The park opened to the public in 1931.

In its first one hundred years, the different iterations of the State Park Commission acquired land that became 107 state parks and 32 state forests. Now under the direction of the Department of Environmental Protection, Connecticut's state park system hosts approximately eight million visitors per year.

The summer of 2013 marked the 100th anniversary of the state park system in Connecticut. As part of the celebration, the state launched the Summer Outdoor Sojourn on August 15, 2013. The program consisted of 169 miles of biking, hiking, walking and kayaking (beginning at Quaddick State Park in Thomson and ending at Sherwood Island) meant to help Connecticut residents reconnect with their state's outdoor spaces.

August 16

A Legal Advocate for Women

Growing up on a farm in Marlborough, Connecticut, practicing law must have been the farthest thing from Mary Hall's mind. Born on August 16, 1843, Hall grew up in a time before women even had the right to vote. She graduated from Wesleyan Academy in Massachusetts and became a teacher.

A trip to Hartford to listen to social reformer John Hooker (husband of Isabella Beecher Hooker) give a talk on the property rights of married women, however, changed her career path.

Hall began studying the law under her brother Ezra, but Ezra's sudden passing looked to bring Mary Hall's new career to an abrupt end. That is when John Hooker decided to take Hall in as a student at his law office. Studying under Hooker, Hall applied for admittance to the Connecticut bar. She passed all of her exams in May 1882, but the Hartford County Bar Association deferred to the Connecticut courts to decide Hall's fate. In July 1882, the Connecticut Supreme Court agreed to allow Hall to practice law in the state, making her the first female attorney in Connecticut and only the second in the country.

Helping women handle wills and property became her specialty. In addition to providing legal services, Hall also helped start the Hartford Woman Suffrage Club in 1885 and founded the Goodwill Club to help disadvantaged and at-risk boys. She died in 1927 at the age of eighty-four.

August 17

Connecticut's Last Colonial Governor and First State Governor

A merchant by trade, a young Jonathan Trumbull began studying for the ministry at age thirteen. After briefly serving as a preacher, he returned to the family business in 1731 when he opened a trading business with his brother Joseph. The following year, Joseph disappeared while on a shipping voyage, and Jonathan took over the business himself.

While working in his hometown of Lebanon, Connecticut, as a merchant, Trumbull took to studying the law and entered a life of public service. After serving in various local political positions and in the General Assembly, he became deputy governor of the Connecticut Colony in 1766 and governor in 1769. He was the only governor to side with the colonies during the American Revolution and became the first governor of the *state* of Connecticut (after the General Assembly approved the Declaration of Independence). He then put his trading skills to good use, repeatedly coming to the aid of General George Washington during the Revolutionary War

whenever Continental army supplies were low. Serving in this capacity, he helped earn Connecticut the unofficial nickname of the "Provisions State."

After an unsuccessful attempt to expand Connecticut's territory into western Pennsylvania and the surfacing of rumors that Trumbull personally profited from illegal trade, Trumbull took the unprecedented step of resigning as governor. Offered back pay in depreciated currency for his service as governor during the war, Trumbull's transition from public life found him in dire financial circumstances. A little over a year later, on August 17, 1785, he died from a stroke at his home in Lebanon.

August 18

An Armed Man Strolls into Lincoln's White House

A man skilled in manufacturing machinery, and who obtained forty-two patents in his lifetime, Charles Miner Spencer was born in Manchester, Connecticut, in 1833. His most famous patent was for his breech-loading repeating rifle. It was the first patented repeating rifle to abandon the old-fashioned muzzle-loading system. In the 1860s, Spencer founded the Spencer Repeating Rifle Company in Boston and set about selling his rifle to the Union army. This required a trip to the White House.

On August 18, 1863, Charles Spencer strolled through the front door of the White House carrying his repeating rifle. A member of President Abraham Lincoln's staff escorted Spencer to a room where the president was waiting for him. The two men sat and talked about the merits of Spencer's design, and the inventor took the weapon apart at the president's request to demonstrate how it worked. Lincoln asked Spencer to return the following day and go shooting with him.

Around 2:00 p.m. on August 19, Spencer kept his appointment and he, Lincoln and Lincoln's son Robert headed for a cornfield (at the future sight of the Washington Monument), set up a board measuring three feet by six inches for a target and opened fire. Lincoln's first shot missed low, but he hit the target with his next five shots. At the end of the day, Lincoln recommended Spencer's rifle for testing and adoption by the military, and Spencer took home the wooden target board as a souvenir.

August 19

The Great Flood of '55

Connecticut survived the four to six inches of rain dumped on it by Hurricane Connie on August 13, 1955, with minimal flooding. When Hurricane Diane hit just five days later, however, the swollen rivers and saturated ground produced some of the worst floods in the state's history. Hurricane Diane dropped anywhere from fourteen to twenty additional inches of rain on the state. On August 19, 1955, the flooding began in earnest.

Major rivers across Connecticut, such as the Naugatuck, Farmington, Still and Quinebaug, overflowed their banks and sent water pouring through residential and commercial areas. The floods left nearly one hundred dead, destroyed over eleven hundred homes and damaged another twenty-three hundred and left eighty-six thousand people without jobs, causing President Dwight Eisenhower to declare Connecticut a disaster area.

August 20

The Man Who Took on the Confederate Army by Himself

Charles Lyman had very little training as a soldier as he stood on the battlefield at Fredericksburg, Virginia. Born in Bolton, Connecticut, in 1843, Lyman was a former schoolteacher who volunteered for the army at age nineteen and found himself called into active service on August 20, 1861.

On December 13, 1862, Lyman was part of a charge on the heights of a Confederate position at Fredericksburg. As Lyman charged ahead, withering Confederate fire convinced his comrades to retreat, and soon Lyman was all by himself, just two hundred yards from a Confederate command post. Standing behind only a narrow fence post, with bullets ricocheting off the post and his gun, Lyman made a mad dash for a nearby trench, and after having bullets pass through his haversack and his coat, Lyman leaped for the trench just as a bullet struck him in the back. He spent the rest of the day huddled in the trench before heading to a field hospital under the cover of darkness, carrying a wounded comrade on his back.

Later given command of an entire company, he made the mistake of writing out a physical description and list of clothing and money disbursed to a soldier killed under his command—thus allowing the boy's father to settle his son's accounts. Officers jealous of Lyman's rapid ascent to command reported it as a violation of secrecy orders, and Lyman received a dishonorable discharge from the army. Lyman, at twenty years old, went back to teaching. Ulysses S. Grant later awarded him an honorable discharge from the army.

August 21

The Fall of a Connecticut Icon

In 1662, King Charles II of England granted a charter to the colony of Connecticut, but just two decades later, King James II looked to revoke Connecticut's charter and sent an armed force under Sir Edmund Andros to retrieve it. Quick-thinking Connecticut politicians hid the document inside a large oak tree until the crisis passed. The tree, later named the Charter Oak, became a cherished part of Connecticut's identity.

On August 21, 1856, a strong summer storm snapped the giant tree—then several hundred years old—breaking it off approximately six feet from the ground. Connecticut residents did not take the loss of this beloved symbol of freedom easily. The state held a funeral for the tree, draping it in a flag as the Colt band played a solemn accompaniment. Church bells rang, and officials authorized a parade to honor the memory of the service the oak provided to the state.

The state continued to keep the memory of the Charter Oak alive long after the August storm, however. Artisans carved numerous ornamental pieces from the fallen tree, including a chess set and a chair for the state senate chamber. Officials authorized the planting of a seedling from the tree at the Connecticut building during the Louisiana Purchase Exposition in St. Louis in 1904, and Connecticut is still home to the Charter Oak Bridge and Charter Oak State College. The oak is also prominently featured on the back of the Connecticut state quarter issued by the U.S. Mint.

August 22

The First President to Ride in an Automobile

Theodore Roosevelt had numerous ties to Connecticut. His mother was born in Hartford, his second wife was a native of Norwich and his sister lived in Farmington. Both before and after his presidency, he made many celebrated trips to the state to see friends and family. While he was president, he made one particularly notable stop in Connecticut.

On August 22, 1902, as part of a trip through New England, Roosevelt took a train to Hartford and, from there, hopped into a car for a trip through the city. It was the first time a president of the United States ever publicly road in a car. The electric vehicle, powered by two four-hundred-pound batteries, topped out at thirteen miles per hour as it wound up Asylum Street, around the capitol and through Pope Park. Accompanied by security riding on horseback and bicycles, Roosevelt's joy ride lasted nearly three hours.

Teddy Roosevelt rides through Hartford, August 22, 1902. *Hartford History Center, Hartford Public Library.*

August 23

Around the World in Seven Days

It was at the 1913 county fair in his home state of Oklahoma that Wiley Post saw his first aircraft. Intent on avoiding the life of a cotton farmer, he enrolled in the Sweeney Automobile and Aviation School in Kansas City. He first gained national attention when he won an air race between Chicago and Los Angeles in 1930. The following year, he and navigator Harold Gatty flew Post's plane, the *Winnie Mae*, around the top of the globe, from New York to New York, in just under nine days. In the early summer of 1933, Post accomplished the feat solo, in a world-record time of seven days, eighteen hours and forty-nine minutes.

Post then embarked on a goodwill tour across America. On August 23, 1933, he arrived in Hartford. Unable to fly in the *Winnie Mae* because of bad weather, Post took a safer plane from Springfield to Hartford. Several hundred guests greeted his arrival around 3:10 p.m., and a twenty-one-piece band accompanied Post on a parade to the state capitol. Before heading off to a private dinner at the Farmington Country Club, Post thanked the Connecticut-based Pratt & Whitney company for helping build the engine used by the *Winnie Mae*.

Two years later, Post constructed a hybrid floating plane he wanted to test in Alaska and Siberia. Shortly after takeoff on August 15, 1935, Post lost control of the experimental plane and crashed near Point Barrow, Alaska. The crash claimed both Post's life and that of his passenger, actor Will Rogers.

August 24

Capturing the Amistad

In February 1839, Portuguese slave traders made captives of large numbers of Mende people on the continent of Africa and shipped them to Cuba for sale. Two Spanish planters purchased fifty-three of the captives, loaded them aboard the ship *Amistad* and sailed for plantations in the Caribbean. On July 1, 1839, the Mende captives seized the ship, killed the captain (and a cook) and ordered the remaining crew to sail back to Africa. The crew secretly

steered the ship northward, however, and on August 24, 1839, American authorities captured the ship off the coast of Long Island, New York.

Authorities imprisoned the Mende in New Haven, Connecticut, on charges of murder. The murder charges were later dropped and the captives transferred to a facility in Farmington, but a messy property rights battle ensued, with numerous entities, including the Spanish government, claiming ownership rights over the *Amistad* and its human cargo.

Despite President Martin Van Buren's intention to send the captives to Cuba, abolitionists in the North raised money to provide the Mende with legal counsel. The attorneys charged with obtaining freedom for the Mende were former U.S. president John Quincy Adams and Connecticut senator (and later governor) Roger Sherman Baldwin.

Local courts ordered the case tried at the federal level, and in 1841, the U.S. Supreme Court ruled in favor of the Mende, ordering their safe return to their homeland. By then, only thirty-five of the original fifty-three remained—the other eighteen having passed away in jail or during the voyage from Africa.

August 25

UHF Television

In 1948, television stations only broadcast on the limited number of wavelengths available in the VHF (Very High Frequency) spectrum. In order to keep broadcast channels from interfering with one another, the system required additional frequencies on which to operate. Until that technology evolved, the Federal Communications Commission (FCC) put a freeze on new television station applications—keeping late-comers to the television market, such as Denver, Colorado, and Portland, Oregon, from providing local programming to viewers.

The following year, the Radio Corporation of America (RCA) began experimenting with broadcasting in the UHF (Ultra High Frequency) range, potentially allowing for the broadcast of up to two thousand channels—a tremendous improvement on the twelve VHF channels available. Utilizing a two thousand mega-cycle beam transmitted from the Empire State Building, RCA began receiving transmissions at an experimental station

near Bridgeport, Connecticut. It then installed UHF converters and tuners in approximately one hundred homes in the Bridgeport area. That station, operated by NBC under the call letters KC2XAK, became the first UHF station in the country operating under a regular schedule. The success of the Bridgeport experiment persuaded the FCC to resume accepting new station applications in March 1951.

With the freeze now lifted, Herbert Mayer, president of the Empire Coil Company of New Rochelle, New York, saw an opportunity to operate the first UHF channel in Portland, Oregon. Mayer purchased the RCA station in Bridgeport and, on August 25, 1952, had it dismantled for transportation across the country. The first test pattern went live in Portland on September 18, and two days later, the city entered the age of UHF programming.

August 26

Camp Gertrude Bryant: A Community Affair

Gertrude Bryant, born in Avon, Connecticut, in 1917, was active in scouting by age seven and served as an Avon Girl Scout leader as a young adult. She trained to become a concert pianist at the Hartford School of Music before enlisting in the army in February 1943. Bryant became a part of the Women's Army Corp (given the nickname WACs) and served her country at Camp Patrick Henry in Newport News, Virginia, during World War II. Approximately a year and a half after enlisting, however, Bryant collapsed at her desk and later died at Walter Reed Army Hospital.

The military funeral for Bryant took place at the Avon Congregational Church. Attended by nearly seven hundred people, it was the largest funeral in the town's history and the first military funeral for a woman ever held in Avon.

Approximately three years after Bryant's death, on July 7, 1947, the Avon Girl Scout Day Camp opened on West Avon Road. For the first time, girls in town had a facility of their own, separate from the boys' camp they traditionally occupied whenever it was not in use. The camp thrived, thanks to the support of local residents who donated cooking utensils, sporting equipment, furniture, transportation, a flagpole, appliances and even access to a swimming pool. On August 26, 1947, the Avon Girl Scouts dedicated

the facility as Camp Gertrude Bryant. It operated as a day camp for nearly twenty years before the popularity of overnight camps led to declining attendance and the eventual closing of the camp in the 1960s.

August 27

The Sport of Kings

In spite of the Puritan values that played such a significant role in shaping Connecticut's identity through the centuries, gambling has seemingly always been deeply rooted in the state's culture. From betting on amusement park games to jai alai, dog racing and massive casino projects, Connecticut residents regularly succumb to the thrill of the wager. In the late nineteenth century, the sport of choice for the gambling crowd was horse racing.

One of the premier gathering places for gamblers, Charter Oak Park in West Hartford, first opened in 1873. The following year, on August 27, 1874, the park hosted a day of harness racing, the third in a four-day event. The event proved so popular that racing returned to Charter Oak Park annually for the next several decades.

The races grew in popularity, thanks to appearances by a number of famous horses now in the Harness Racing Hall of Fame, such as Little Brown Jug and John R. Gentry. On one July afternoon in 1897, nearly thirty thousand spectators turned out to see John R. Gentry make a failed attempt at breaking the two-minute mile. Among those in attendance was Thomas Edison, who captured a horse race on celluoid film for the first time ever.

Other locations throughout the state, such as Sage Park in Windsor and Crystal Lake in Middletown, capitalized on Charter Oak's success by offering their own races, but few matched the popularity of those found in West Hartford. Shortly after the turn of the century, however, Connecticut residents turned their focus to dog racing and other events. Charter Oak Park ultimately closed in the 1930s.

August 28

John Hancock Married

John Hancock was a wealthy merchant and an outspoken Patriot on the eve of the American Revolution when the British set out to arrest him (and John Adams) in Lexington, Massachusetts. Having narrowly escaped capture, he fled to Philadelphia, where he became president of the Continental Congress in May 1775. His fiancé, Dorothy Quincy, who witnessed the Battle of Lexington after arriving there to visit with Hancock, relocated to the home of Thaddeus Burr in Fairfield, Connecticut. Thaddeus Burr was a prominent local Patriot and the uncle of Aaron Burr (who famously killed Alexander Hamilton in a duel in 1804).

On August 28, 1775, having arrived in Fairfield during a break in his political duties, John Hancock married Dorothy Quincy at the Burr residence in Fairfield. Having little time for a honeymoon, the newlyweds headed to Philadelphia, where Hancock resumed his position in Congress and, later, became the first signer of the Declaration of Independence.

The Thaddeus Burr homestead in Fairfield. *Library of Congress, Prints and Photographs Division, Historic American Buildings Survey/Historic American Engineering Record/Historic American Landscapes Survey.*

August 29

Windmill Patent

Exploration into wind power was all the rage in the 1850s. Over the course of the decade, the U.S. Patent Office issued approximately fifty different windmill patents geared toward automating tasks traditionally reserved for more expensive sources of manpower. The major drawback to windmills was their tendency to tear apart during periods of extremely high winds. An inventor named Daniel Halladay came up with a solution to this problem.

Halladay was a native of Vermont (born in 1826) who moved to Massachusetts at nineteen before buying part of a machining operation in Ellington, Connecticut. There, John Burnham, an expert with hydraulic pumps, approached Halladay about designing a self-regulating windmill to pump water out of the ground.

Halladay's design (patented on August 29, 1854) became the first commercially successful self-governing windmill in the United States. Halladay designed a mechanism that turned the blades into the wind at low speeds (to capture as much wind as possible) but then changed the angle of the blades during strong winds (thus preventing centripetal force from tearing the windmill apart).

Shortly after receiving his patent, Halladay opened the windmill firm of Halladay, McCray and Company in Ellington before changing the name to the Halladay Wind Mill Company and moving it to South Coventry. Halladay's company produced windmills utilized by farmers for watering crops and by railroad companies for maintaining steady water supplies for steam engines. The industry and open fields of the Midwest, however, soon drew Halladay's operation away from Connecticut. A midwestern firm purchased his company and moved it to Illinois during the Civil War.

August 30

The Rent

Francis Pratt and Amos Whitney left their machinist positions at the Colt Manufacturing Company in 1860 to form their own tool company, but

when Frederick Rentschler came to them with a design for an air-cooled aircraft engine, the business quickly changed its focus. Rentschler's engine, the Wasp, became an overwhelming success, and the company expanded into East Hartford and opened an airstrip on which to test its aircraft. This testing operation resulted in the opening of a formal airfield—Rentschler Field—in 1931. When the airfield closed in the 1990s, the state began reviewing options for how best to utilize the land. Proposals included turning the area into a shopping mall, an amusement park or a racecar track.

In the late 1990s, the University of Connecticut, looking for a new home for its football team, became part of an ambitious plan to develop Hartford's waterfront. The Hartford Financial Group announced plans for Adrian's Landing, a business and recreation development project with a brand-new sports arena at its heart.

United Technologies donated seventy-five acres for the building of a stadium large enough to allow UConn's football program to move up to Division 1-A status. The company then donated an additional one hundred acres to allow for parking. The stadium opened in the summer of 2003, hosting the State Games of America and a USA Women's Soccer match. On August 30, 2003, the University of Connecticut football team played its first game at Rentschler Field, a 34–10 victory over the University of Indiana.

August 31

The First Lady of Golf

Known informally as the "First Lady of Golf," Glenna Collett Vare was a native of New Haven, Connecticut, born in 1903. As a child, she excelled in numerous sports, including swimming, diving and tennis, but developed a passion for golf and won her first match at the age of fourteen.

Vare dominated the women's game throughout the 1920s, thanks, in part, to her ability to drive the ball long distances. She won her first U.S. women's championship in 1922 and, in 1924, won fifty-nine of the sixty matches in which she competed—losing the other in a sudden-death playoff.

On August 31, 1935, five thousand spectators packed the Interlachen Country Club in Hopkins, Minnesota, to watch Vare play. With birdies on the last two holes, Vare won her record sixth national women's championship.

In addition to her six U.S. championships, Vare also won two Canadian Women's Amateur championships and one French. She became one of six women inducted into the inaugural class of the Women's Golf Hall of Fame in 1950 and became a member of the Connecticut Women's Hall of Fame in 1989. Today, the Ladies Professional Golf Association (LPGA) awards the Vare Trophy every year to the player with the lowest average on tour.

SEPTEMBER

September 1

Woodrow Wilson

Prior to becoming the president who led America through the First World War, Woodrow Wilson was a respected author, lecturer and university professor. Born in Virginia in 1856, he grew up in Georgia and then South Carolina and graduated from Princeton University. He then attended the University of Virginia Law School and earned a PhD from Johns Hopkins before settling into teaching.

His first job was at Bryn Mawr College, a liberal arts school for women, but Wilson did not care for teaching women. He wanted to teach men, and his opportunity arrived when he received an offer from Wesleyan University. Breaking his contract with Bryn Mawr, Wilson accepted an offer from Wesleyan to become chair of history and political economy, and on September 1, 1888, he moved his family to Middletown, Connecticut. While at Wesleyan, Wilson earned an annual salary of $2,500 and produced some of his finest work, including *The State*, a textbook that became a staple of political science scholarship.

In 1890, Wilson left Wesleyan for a chance to teach at his alma mater, Princeton. He became president of Princeton University in 1902 and served as governor of New Jersey in 1910. He defeated incumbent Republican William Howard Taft and the revitalized Bull Moose Party candidate Theodore Roosevelt to become president of the United States in 1912. He then won reelection in 1916 and guided the country through one of the most tumultuous periods in its history.

September 2

Up, Up and Away

The steamship *Parthenia* left Hartford on the morning of September 2, 1863, to take a group of excursionists on a daylong trip to Middletown, Connecticut. After picking up additional passengers in Wethersfield and Rocky Hill, the boat arrived at the wharf in Middletown around 1:00 p.m. for the day's main event—witnessing a balloon piloted by legendary aviation pioneer Silas Brooks lift off into the skies.

Silas Markham Brooks was every bit the showman. Born in 1824, the son of a clockmaker and farmer in Plymouth, Connecticut, he worked briefly for P.T. Barnum before moving to St. Louis, Missouri, and opening up a museum of oddities and attractions. He then formed a traveling circus and hired a hot-air balloonist to make ascensions meant to awe crowds believing they were witnessing the future of transportation. The ascensions proved so popular that Brooks began staging them fulltime.

Prior to a staged ascension in Memphis, Tennessee, in 1853, Brooks's balloonist became ill, and so Brooks decided to climb in and take the balloon up himself. It was the first of nearly two hundred such trips he undertook.

On September 2, 1863, Brooks began inflating his balloon along Main Street in Middletown around 2:00 p.m. At 4:00 p.m., he climbed into the balloon's basket and, twenty minutes later, rose straight up in the air for approximately a mile. He then crossed the Connecticut River, released a stack of merchant handbills into the air and safely parachuted a small dog down from the balloon before eventually landing around 5:00 p.m.

September 3

The Marquis de Lafayette

Marie Joseph Paul Yves Roche Gilbert du Motier, Marquis de Lafayette, was a fourteen-year-old boy of considerable wealth when he joined the French army in 1771. Just four years later, after hearing stories about the American colonies and their fight for independence, he and a few other French soldiers

he convinced to join him headed for America. Still a teenager, he became lifelong friends with George Washington, who viewed him as a son.

After the war, Lafayette returned to France, rescued the royal family from a mob attack during the French Revolution and served in the army until his capture by Austria and imprisonment by the Prussians in 1797. Napoleon Bonaparte negotiated his release, and Lafayette returned to France to find his financial fortune largely destroyed.

In 1824, while in his late sixties, he embarked on a final tour of America. Providing an atmosphere of tremendous fanfare at every stop, Americans celebrated the return of their French war hero. On September 3, 1824, Lafayette arrived in Connecticut, visiting Tolland and Stafford. The next day, it was on to Hartford, where an escort of troops led him to the statehouse for a reception by Governor Wolcott. After Lafayette's speech, General Wadsworth produced the well-preserved epaulettes and scarf Lafayette had worn at the Battle of Brandywine, still marked by the blood from the wounds the Frenchman received in battle. Lafayette then traveled flower-covered streets to visit children at the School for the Deaf before embarking on a boat down the Connecticut River to Middletown and on to New York.

September 4

The Everett Larson

Everett Larson was a Stamford-born marine serving on Guadalcanal in the fall of 1942. On October 8 of that year, Private First Class Larson, engaged in a firefight with the Japanese, dove into the Matankiau River to rescue a wounded comrade. The concentrated fire Larson's rescue attempt drew ultimately resulted in his death at the age of twenty-two. The military posthumously awarded Larson the Silver Star for his bravery, and his division earned a Presidential Unit Citation for its sacrifices on Guadalcanal.

On September 4, 1944, workers at the Bath Iron Works in Maine laid down the keel for what became the destroyer USS *Everett Larson*. Larson's mother helped christen the ship the following January, and the new destroyer entered service at the Boston Navy Yard on April 6, 1945.

The *Everett Larson* served in the Pacific, acting as an escort for aircraft carriers and the landing of U.S. marines in China in October 1945. Following Japan's surrender, the *Everett Larson* took part in the sinking of twenty-four captured Japanese submarines and went on to serve the navy until the ship's decommissioning in October 1972.

An agreement between the United States and South Korea gave new life to the *Everett Larson* when it became a part of the South Korean navy. South Korea renamed the ship the *Jeong Buk* and, after decommissioning it in 1999, turned it into a museum in Kangwando, Korea.

September 5

Celebrity Speed Trap

With its scenic landscapes and iconic architecture, the Merritt Parkway is a favorite thoroughfare of Connecticut residents traveling back and forth between central parts of the state and the New York border. The lack of commercial traffic, combined with its protection by the National Park Service, makes for more leisurely travel than commuters often find on the state's larger highways. This does not mean, however, that the scenic stretch of roadway has not seen its share of speeders—some of them famous.

Around 7:00 a.m. on September 5, 1955, police pulled over singer and actress Polly Bergen on the Merritt Parkway in Trumbull for driving over sixty-five miles per hour in a fifty-five-mile-per-hour zone. Famous for her roles alongside Dean Martin and Jerry Lewis, she was a Tennessee native who began singing on the radio at age fourteen. Bergen posted a forty-two-dollar bond for speeding and driving without a license to operate her friend's car.

Just three and a half hours later, police in Westport stopped entertainer Sammy Davis Jr. for driving seventy miles an hour on that town's stretch of the Parkway. Davis lacked the eighteen dollars in cash required for bail and needed to call his friend and legendary photographer Milton Greene in Weston to come bail him out.

September 6

The Return of Benedict Arnold

Before turning traitor, Benedict Arnold was one of the great heroes in American history. Born in Norwich, Connecticut, Arnold set up an apothecary shop in New Haven before the outbreak of the Revolutionary War propelled him to greatness. He played an instrumental role in capturing artillery at Fort Ticonderoga, nearly captured the city of Quebec and led a heroic charge that helped ensure victory at the Battle of Saratoga.

Hobbled by wounds received at Quebec and Saratoga and embittered by a lack of recognition for his sacrifices, Arnold saw a way to make money and rise through the ranks of the British army by secretly turning traitor and allowing the British to capture the fortifications at West Point—a plot uncovered by George Washington during an unannounced visit to upstate New York. With his plans foiled, Arnold fled and soon joined the British army.

Taking advantage of Arnold's knowledge of the area, the British sent him to raid the coastline of his old home state. On September 6, 1781, Arnold led 1,700 British, Hessian and Loyalist forces in a raid on southeastern Connecticut. Landing in New London, Arnold's men set fire to homes, businesses and warehouses in the busy port while British colonel Edmund Eyre took Fort Griswold from Colonel William Ledyard in Groton. The British destroyed both towns and slaughtered eighty-three colonial soldiers who surrendered to them, including Colonel Ledyard, who the British ran through with his own surrendered sword.

September 7

The Worldwide Leader in Sports

With cable television in its infancy back in the 1970s, former New England Whalers executive Bill Rasmussen put together his vision of a twenty-four-hour cable sports network. After acquiring funding from Anheuser-Busch and Getty Oil and a one-acre parcel of land in Bristol, Connecticut, Rasmussen prepared to launch the Entertainment and Sports Network (ESPN).

ESPN went on the air at 7:00 p.m. on September 7, 1979, and soon became, as its tagline indicates, the "Worldwide Leader in Sports." Starting out by broadcasting mostly collegiate and other amateur sports, the network eventually went on to sign deals with such powerful sports enterprises as the National Football League (NFL), Major League Baseball (MLB) and the National Association for Stock Car Auto Racing (NASCAR).

The network went international in 1983 and became a television staple in over two hundred countries. Acquired by the American Broadcasting Company (ABC), a part of the Disney Corporation, ESPN developed into a multimedia phenomenon, offering radio, television and Internet broadcasts; print media such as *ESPN the Magazine*; and even operating a chain of sports-themed restaurants.

September 8

Timothy Dwight IV

Timothy Dwight acquired an affinity for Yale College (later Yale University) passed down from generations of his family. A theologian and poet born in Northampton, Massachusetts, Dwight enrolled at Yale in 1765 and graduated four years later. He then obtained his license to preach and set about rendering service to residents throughout the state.

In 1783, he accepted a position as pastor of the Congregational Church at Greenfield Hill in the town of Fairfield. His compensation, which included a six-acre parish lot, 150 British pounds and twenty cords of wood annually, was the largest salary in Connecticut at that time. At Greenfield Hill, Dwight set up a very successful school for both boys and girls, one that drew over one thousand students in the next twelve years. Dwight spent six hours a day instructing students and the rest of his time writing and preaching. In 1785, he wrote "The Conquest of Canaan"—believed to be the first epic poem written in America.

It was on September 8, 1795, however, that Dwight returned to his beloved alma mater and became president of Yale. During twenty-two years as the school's president, Dwight received praise for both innovation and the modernization of the school's curriculum. It was a responsibility he undertook with great enthusiasm right up until his death in 1817.

September 9

Brother Governors

In far western Connecticut, two brothers from Ridgefield accomplished a rarely seen feat. Phineas Lounsbury, born in Ridgefield in 1841, shunned a formal education for work in the shoe industry. He partnered with his brothers and founded the Lounsbury Brothers, Inc., shoe factory. Success in business led him to enter politics, and he served in the Connecticut House of Representatives from 1874 to 1876. On September 9, 1886, Lounsbury received the Republican nomination for governor—the first such honor accorded a member of his family.

Phineas's brother George, three years his senior, was one of Phineas's business partners in the shoe factory. Unlike his brother, however, George graduated from Yale, as well as the Berkeley Divinity School. He also entered politics, albeit it twenty years after his brother. He served as a state senator from 1894 until 1898, when he, too, received the Republican nomination for governor.

Both men won their respective elections, with Phineas serving as Connecticut's governor from 1887 to 1889 and George from 1899 until 1901. Each retired from politics after their gubernatorial terms and returned to private enterprise. George passed away in 1904 and Phineas in 1935. Both men received burials at Ridgefield Cemetery.

September 10

The World's Most Popular Actress

Throughout the early half of the twentieth century, Hartford hosted a wildly popular theater scene. Establishments such as the Strand, the Colonial, the Lenox and the Poli Palace brought theatergoers to Hartford at the rate of over 150,000 per week. One of the capital city's most popular theaters was the State Theater. Built on Village Street in the 1920s, it underwent a $75,000 renovation in 1936 that made it one of Hartford's premier venues in the 1940s and '50s, drawing acts such as Peggy Lee, Frank Sinatra and Tony Bennett.

On September 10, 1954, the State Theater opened its season with a woman hailed as the "World's Most Popular Actress," Esther Williams. Raised in Southern California, Williams became a swimming champion in her late teens. When World War II canceled the 1940 Olympic Games, however, Williams turned to acting. MGM signed Williams, and she made her film debut alongside Mickey Rooney in 1942. Just two years later, her film *Bathing Beauty* became the most popular American film ever shown in Europe.

A smash success, Williams undertook a tour of the country's most popular theaters in 1954 and came to the State Theater in September of that year. Performing with her husband, Ben Gage, Williams treated audiences to stories and musical numbers performed in elaborate costumes, packing the theater's four thousand seats over the course of a three-day run.

September 11

Central Park

A member of the eighth generation of his family born in Hartford, Connecticut, Frederick Law Olmsted had a father who was a very successful merchant and often took his family on tours of picturesque locations throughout New England. Frederick, a newspaperman and farmer, began

An aerial view of Central Park. *Library of Congress, Prints and Photographs Division, Highsmith (Carol M.) Archive Collection.*

studying landscapes on his own and even went on a walking tour of Europe to study landscape design in the 1850s.

At this same time, the city of New York struggled to combat the ill effects of industrialization and urbanization by creating more natural open spaces. In 1853, the New York legislature approved a plan for the establishment of Central Park. On September 11, 1857, Olmsted became superintendent of the Central Park project. Ultimately, a plan submitted by Olmsted and Calvert Vaux, combining both formal and natural elements that separated pedestrians and carriage riders, became the winning design submission.

September 12

Martin Luther King Jr.'s Summer Job

With America's involvement in World War II creating labor shortages throughout the country, especially in the Northeast, farmers and business owners in New York and New England often imported seasonal help from the South. This proved true in the summer of 1944, when Cullman Brothers of Simsbury, Connecticut, hired students from Morehouse College in Atlanta to help with the shade tobacco harvest. Among these students was fifteen-year-old Martin Luther King Jr.

King and his classmates worked long hours in the hot sun during the week (earning four dollars per day toward their Morehouse tuition) but then often traveled into Hartford on weekends for entertainment or to attend church. His time in Connecticut made a lasting impact on King, who wrote home about the wonderful freedom he found sitting anywhere he wanted on trains and partaking of the finest restaurants and theaters in Hartford. On Sundays when the group stayed closer to home, they listened to sermons from their appointed religious leader, Martin Luther King Jr., who, on his way to becoming a lawyer, discovered an affinity for theology that summer in Simsbury.

It was September 12, 1944, when King left Simsbury, more resentful than ever of the segregation he faced in the South. He boarded a train headed for Washington, D.C., where he switched to a segregated line for the rest of the journey back to Atlanta.

September 13

The Highest-Ranking Union Officer Killed in the Civil War

One of the most influential commanders of the Civil War, Major General John Sedgwick, was born on September 13, 1813, in Cornwall Hollow, Connecticut. After attending the Sharon Academy, he enrolled at the U.S. Military Academy at West Point. He went on to fight in the Seminole War and served under future U.S. president Zachary Taylor in the war with Mexico.

Promoted to brigadier general in August 1861, he received a wound in the arm at the Battle of Glendale the following year and commanded a division of the Army of the Potomac during the Maryland Campaign. His most famous action came at the bloody Battle of Antietam, where, after having his horse shot out from under him, he received wounds in the wrist, shoulder and leg, requiring his men to carry him, unconscious, from the battlefield.

Sedgwick returned to action just ninety days later, however, at the Battle of Fredericksburg. On May 9, 1864, Sedgwick met his demise at Spotsylvania Courthouse, when, after announcing his position immune to enemy fire, a shot from a Confederate gunner took his life. Sedgwick became the highest-ranking Union officer killed in the war and received a burial near his home in Cornwall Hollow. Officials later erected monuments to Sedgwick at West Point, the Gettysburg Battlefield and the Connecticut State Capitol. The navy also christened a ship in his name during World War II.

September 14

The First Helicopter Flight

Aviation pioneer Igor Sikorsky, after fleeing unrest in his native Russia, brought with him design ideas for an aircraft capable of vertical takeoffs. Receiving a patent for his design in 1935, Sikorsky took the first modern helicopter into the sky on September 14, 1939. The aircraft flew for only a few seconds and remained tethered to the ground, but the single main rotor and tail rotor aircraft became the standard for helicopter design from that day forward.

Sikorsky's craft (known as the VS-300) used a single main lifting rotor to get the craft airborne, at which point the use of a "stick" to change the

angle of horizontal auxiliary rotors allowed the aircraft to move in different directions. Control of the rudder came from the use of foot pedals.

From March through October of the following year, the VS-300 made hundreds of test flights, allowing engineers to assess its performance. Then, in May 1941, Sikorsky piloted the VS-300 for a world-record 1 hour, thirty-two minutes and twenty-six seconds. As a prototype on which to base future, more sophisticated helicopter models, the VS-300 ultimately logged over 102 hours of flight time before outliving its usefulness. Sikorsky then donated the aircraft to Henry Ford's Museum in Dearborn, Michigan, on October 7, 1943.

September 15

Climax Fuse

Among the many hazards associated with mining in the early nineteenth century was the unpredictable nature of the fuses used to ignite black powder explosions. In 1831, an Englishman named William Bickford invented the "safety fuse"—a length of rope or yarn woven with a mix of black powder and varnish (for waterproofing) that burned at a steady, predictable rate. Bickford teamed up with Richard Bacon, a native of Simsbury, Connecticut, to make the fuse in America.

Bickford sent a representative named Joseph Toy to oversee the operation, and it was not long before Toy removed Bacon from the equation and formed Toy, Bickford and Company. Bacon's sons countered this move by starting a rival business, the Climax Fuse Company, in nearby Avon, Connecticut.

Staffed with large populations of eastern European immigrants, both companies operated under dangerous conditions that produced numerous fires, such as the ones experienced by Bickford's company in 1839 and 1851. One of the worst accidents occurred at the Climax Fuse Company, however, on September 15, 1905. The flammable combination of oil, yarn and black powder sparked a fire that resulted in fifteen deaths. Operations resumed the following January, thanks to replacement workers provided by, ironically, Ensign, Bickford and Company.

The two fuse companies actually merged two years later and became the Ensign-Bickford Company—operating out of Simsbury. The company met

with great success, thanks, in part, to the demand for explosives during World War I and World War II. But after the Second World War, Ensign-Bickford diversified its business interests and eventually stopped producing safety fuses.

September 16

Hannah Watson's *Courant* Events

When Ebenezer Watson died of smallpox on September 16, 1777, he left his twenty-seven-year-old wife, Hannah Bunce Watson, to care for their five children (all under the age of seven) and his newspaper, the largest circulated paper in North America. Despite possessing little knowledge of publishing, Hannah Watson took over the *Hartford Courant* (then known as the *Connecticut Courant*) and became one of the first female publishers in America.

Watson stepped into leadership at the *Courant* during a very volatile time, when British authorities shut down patriotic newspaper operations in both Boston and New York. Just four months into her new position, Tories set fire to the local paper mill, threatening to bring the newspaper's run to an end. Rather than close down, Watson teamed up with Sarah Ledyard (the widow of Watson's partner in the paper mill) and sought help from the Connecticut General Assembly, which agreed to finance the rebuilding of the mill the following spring.

Watson eventually remarried and handed off her publishing duties to her new husband, having never missed printing a single issue of the *Courant*. It was over two hundred years before another woman took charge of the *Hartford Courant*—when Marty Petty took the job in 1997.

September 17

The Soldiers and Sailors Arch

It was the fall of 1881 when the city of Hartford began to formally pursue the idea of a memorial to the four thousand citizens of the area who served in the Civil War—nearly four hundred of whom perished. After receiving between thirty and forty uninspiring designs, city officials invited

The Soldiers and Sailors Memorial Arch in Hartford (between 1900 and 1910). *Library of Congress, Prints and Photographs Division, Detroit Publishing Company.*

local architect George Keller to submit a design in January 1884. Keller's design met with unanimous approval and, two and half years later, reached completion (at a cost of $50,000).

On a rainy September 17 in 1886, trainloads of uniformed veterans arrived for the dedication of the Soldiers and Sailors Memorial Arch. Erected in Bushnell Park, the arch is a brownstone monument standing 116

feet high and features friezes of Civil War scenes, statues of angels Raphael and Gabriel and a staircase leading to panoramic views of Hartford and Bushnell Park.

September 18

Mark Twain Robbed

Author Samuel Langhorne Clemens (better known as Mark Twain) moved to the country in the summer of 1908. Wanting to remain near his New York City apartment, he hired architect John Mead Howells to build an Italian-style home in Redding, Connecticut. He moved into the estate, originally named Innocents at Home but later changed to Stormfield, and entertained such famous visitors as Thomas Edison. He charged male guests one dollar per visit as a contribution toward the construction of a town library.

Around midnight on September 18, 1908, Twain's secretary heard two burglars in the house making off with a number of valuables, primarily silverware. She called Deputy Sheriff Banks, who arrived immediately and

Stormfield in 1914. *National Archives and Records Administration, public domain image.*

traced the robbers' movements to the local train station. He boarded a train at the Redding station and confronted the robbers, one of whom produced a gun and shot Banks in the leg during a struggle. Authorities captured both perpetrators a short time later.

September 19

The Battle of the Books

After the founding of the Collegiate School in Saybrook in 1701, residents of Wethersfield, Hartford and New Haven objected to the school's location. A battle for control over the Collegiate School soon followed. In October 1716, trustees met in New Haven and determined it to be a more suitable location for the school. Elihu Yale, a prominent local merchant, donated goods sold to raise money for supplies, and the school honored him by eventually changing its name to Yale College.

Shortly after officials made the announcement regarding the move to New Haven, outraged citizens of Saybrook set about thwarting any attempt to remove the school from their town. After residents denied officials access to the school's books, Governor Saltonstall sent a sheriff to take them by force in December 1718. A scuffle ensued, and an angry mob damaged book carts, freed horses and tore down plank bridges along the route to New Haven.

Over 250 years later, on September 19, 1975, Saybrook first selectman Barbara Maynard officially apologized for the unruly behavior of the town's citizens during the "Battle of the Books." In the spirit of the nation's upcoming bicentennial celebration, Maynard officially put to rest any hostilities between the town and the now-prosperous Ivy League university.

September 20

The Big E

The Eastern States Exposition (known as "the Big E") located in West Springfield, Massachusetts, is the largest agricultural fair on the East Coast. States promote business, tourism and agriculture at the fair through

displays of their industrial and natural resources. Back in the 1930s, however, Connecticut residents railed at their state government for allowing Connecticut to be one of only two New England states (the other being Rhode Island) not represented by its own building at the fair.

Finally, in 1937, the Connecticut General Assembly approved the construction of a $35,000 Connecticut State Building for use at the Big E, provided residents raise $25,000 of that money privately. Thanks to the help of numerous organizations, such as the Connecticut State Grange, the Farm Bureau, the State Chamber of Commerce and the Connecticut Manufacturers Association, proponents of the building raised $38,000. Consequently, on September 20, 1938, Connecticut governor Wilbur Cross placed the cornerstone for the building at an elaborate ceremony on the fairgrounds.

Built in the style of the Old State House in Hartford, the Connecticut State Building officially opened in September 1939. Just two years later, however, the U.S. Army acquired the building from the state and used it as a kitchen for troops training nearby. The army gave the building back to the state in 1946 with the end of the war, and the renovated Connecticut State Building officially reopened for good the following year.

September 21

The Treaty of Hartford

After the English and their Native American allies slaughtered dozens of Pequot in Mystic, Connecticut, in the summer of 1637, the short-lived Pequot War came rapidly to an end. The remaining Pequot, under their leader, Sassacus, fled Connecticut. Awed at the power of the English and the ease with which they dispatched the Pequot, numerous tribes sought to get in the good graces of the English by hunting down the remaining Pequot people. The Mohawks eventually seized Sassacus and proceeded to chop off his head and hands, along with those of the forty Pequot warriors found with him.

The Pequot War officially came to an end with the signing of the Treaty of Hartford on September 21, 1638. The treaty required the seizure of all Pequot lands and the elimination of the name "Pequot" as a recognized Native American tribe. Officials ordered the remaining members of the Pequot sold into slavery or awarded to other tribes as spoils of war.

Just as significantly, the Treaty of Hartford allowed the English to annex a large portion of Pequot land and forbade English allies in the war, specifically the Mohegan and Narragansett tribes, from taking up arms against one another without English permission. In the end, the treaty symbolized a significant shift in the balance of power on the North American continent.

September 22

Nathan Hale Hanged

Nathan Hale was a schoolteacher at the outbreak of the Revolutionary War. Born in Coventry, Connecticut, in 1755, he graduated from Yale and taught school in East Haddam and New London before joining the Connecticut militia and then the Continental army. After the British forced George Washington's army out of New York, the commander in chief desperately sought ways to acquire information about upcoming British troop movements. Hale saw an opportunity to serve his country by volunteering to spy on the British.

Putting on civilian clothes, Hale took a boat from Norwalk, Connecticut, across the Long Island Sound to New York, where he slipped behind British lines. Lacking the necessary training for his new duty, Hale soon drew the attention of the British, who arrested him and sentenced him to death (as was the common fate of a captured spy). The British hanged Nathan Hale on September 22, 1776, in an area of modern-day Manhattan. Prior to his execution, a British soldier noted Hale's utterance of his famous line (possibly paraphrased), "I only regret that I have but one life to lose for my country."

Hale became the first American ever executed for spying. In recognition of his service, the Connecticut General Assembly voted to make Nathan Hale the official Connecticut State Hero in 1985.

September 23

The Great September Gale

The Great September Gale started in the Caribbean on September 21, 1815, and rapidly tracked northward. It slammed into Long Island and the southern coast of Connecticut on September 23 as the most significant natural disaster since the Great Colonial Hurricane of 1635 and proved the most destructive weather phenomenon experienced since Europeans settled the area.

The storm made landfall in southern Connecticut early in the morning, pushing the tides in Stonington seventeen feet higher than ever recorded and destroying a large portion of the town's coastal properties. Moving through the state at roughly fifty miles an hour, it uprooted crops, razed barns and killed livestock. With the storm still carrying salt from the ocean water, residents noted an odd salty taste to the rain and, upon the storm's exit, found crops ruined and buildings coated by a fine white layer of salt.

The storm did similar damage across Long Island and flooded much of Providence, Rhode Island, on its way up to central Massachusetts and New Hampshire. Despite the storm's ferocity, only two people lost their lives. The Great September Gale proved an eerie precursor to the Great New England Hurricane of 1938, which arrived during that same week of September and followed a nearly identical path, albeit accompanied by significantly higher damages and loss of life.

September 24

Connecticut's Last Whaling Voyage

In the middle of the nineteenth century, Connecticut boasted the third-largest whaling operation in the world, behind Nantucket and New Bedford, Massachusetts. The first recorded whaling voyage from Connecticut came on May 20, 1784, when the sloop *Rising Sun* headed for Brazilian waters and returned loaded with whale oil. After that, the shipbuilding areas around New London, Mystic and Stonington helped support a lucrative whaling industry. The town of New London alone,

operating as many as seventy-one ships during its history, harvested over $1 million worth of oil and whale bone.

By the early twentieth century, however, depleted whale populations and the discovery of alternative fuels (such as kerosene) had helped lessen the demand for whale oil and ultimately contributed to the demise of the industry. On September 24, 1908, New London captain James Buddington took the *Margarett* out on New London's last whaling voyage.

September 25

The Petersburg Express

In May 1864, with the Union army pressing its advantage in the Civil War, intense fighting erupted in northern Virginia. With a naval blockade on the vital Confederate port of Petersburg, eighteen thousand Union soldiers advanced on the city on May 9. Stopped just outside by a series of fortified positions, the Union army began what turned into a nine-and-a-half-month siege of Petersburg (not far from the Confederate capital of Richmond).

Among the units participating in the siege was the First Connecticut Heavy Artillery, which brought with it a seventeen-thousand-pound, thirteen-inch seacoast mortar later nicknamed the "Petersburg Express." Mounted on a flat railway car that moved the weapon from one firing position to the next, the mortar fired gigantic rounds into the enemy positions that helped destroy fortifications and force the Confederate army to evacuate the city.

Decades after the war, the Connecticut General Assembly appropriated $1,000 for the construction of a monument housing the Petersburg Express and honoring the First Connecticut Heavy Artillery. Though questions arose as to whether the gun placed on the grounds of the Connecticut State Capitol was actually the same mortar used by the First Connecticut (or just a similar model), the dedication of the Petersburg Express monument took place on September 25, 1902.

September 26

The Connecticut Colony

Groups of largely peaceful indigenous peoples living along the Connecticut River in the early seventeenth century enjoyed the rich hunting grounds and fertile agricultural lands the river basin provided but lived life under constant threat from more militant tribes, such as the Mohawk and Pequot, who regularly sought the payment of tributes in return for peace. In 1631, a delegation of Native Americans traveled to the Massachusetts Bay Colony and offered access to their land's abundant natural resources in return for protection, but the English settlers expressed little interest in relocating farther south.

This all changed, however, when news of a Dutch settlement near modern-day Hartford reached the English in 1633. English lieutenant William Holmes gathered men and all the supplies needed to start a trading post and sailed up the Connecticut River, past the Dutch, and arrived at the confluence of the Connecticut and Farmington Rivers on September 26, 1633. This settlement eventually became the town of Windsor.

In the years immediately following the establishment of the first English trading post in the area, new groups of Englishmen arrived, founding plantations that evolved into the town of Wethersfield and city of Hartford. In April 1636, the three settlements formed an alliance that later became the colony of Connecticut.

September 27

An Incredible Journey to Architectural Fame

Theodate Pope Riddle was born Effie Brooks Pope in Cleveland, Ohio, in 1867. Her parents sent her to the prestigious Miss Porter's School in Farmington, Connecticut, and then on a tour of Europe. Taking her grandmother's name of Theodate, Pope studied European architecture while battling sometimes crippling bouts of depression treated with electric shock therapy.

She returned to Cleveland but, shortly after, moved back to Farmington, where the self-taught architect went about restoring an eighteenth-century cottage and designing a retirement home for her parents. Over the next thirty years, she designed such projects as the Westover School in Middlebury, Connecticut, and the reconstruction of Theodore Roosevelt's birthplace in New York City.

In 1915, Pope was a passenger on the HMS *Lusitania* when a German U-boat torpedoed and sank it off the coast of Ireland. Among the 1,198 killed were all of Pope's companions. Rescuers thought Pope herself to be dead when they plucked her floating body from the icy water, but the flicker of an eyelid immediately set them about reviving her.

On September 27, 1927, the Avon Old Farms school in Connecticut opened—a project Pope involved herself in for the rest of her life. In addition to designing the building, she played a part in hiring the staff and developing the curriculum. She even briefly turned it into a veterans' hospital during World War II.

Theodate Pope Riddle died in 1946. Among the provisions contained in her will was the preservation of the retirement home she built for her parents. The home is now the Hill-Stead Museum in Farmington.

September 28

Free Education

The 1650 Connecticut Act for Educating Children (modeled after a similar act passed in Massachusetts just a few years earlier) required that the colony's children received enough education to read English and understand the laws under which they lived. An emphasis on literacy for the purposes of understanding the word of God and seeking salvation came with the 1798 act of the General Assembly that created school societies—church-based educational organizations.

With the coming of industrialization, however, attendance at Connecticut schools dropped precipitously. Children abandoned school for work in factories and various other jobs in order to supplement their family's income. A great deal of the debate around education became a matter of economics—jobs brought in money, while education cost money.

In 1868, with less than half the school-age children in Connecticut actually attending classes, Connecticut passed the Free School Law. On September 28, 1868, the *Harford Courant* detailed the plan, which called for the elimination of tuition at public schools and the redistribution of a school's operational costs to local taxpayers. The law required each town raise enough money through taxes to allow their local schools to operate for a minimum of six months every year. In addition, it called for each school to keep detailed records of student attendance and encouraged each town's residents to assist in wrangling up truant children.

September 29

Flagship of the Great White Fleet

Approved for construction on July 1, 1902; launched on September 29, 1904; and commissioned on September 29, 1906, the USS *Connecticut* was the lead ship in a new class of sixteen-thousand-ton battleships. In April 1907, the *Connecticut* became the flagship of the Atlantic Fleet and, six months later, led President Theodore Roosevelt's "Great White Fleet" of sixteen new

The USS *Connecticut* (circa 1907). *Library of Congress, Prints and Photographs Division, Detroit Publishing Company.*

battleships on a tour around the world as a demonstration of American naval power. The tour left Hampton Roads, Virginia, in December 1907 and visited places such as Trinidad, Brazil and Mexico before reaching San Francisco, California, in May 1908.

After its grand tour, the *Connecticut* served primarily as a training vessel throughout its service. In 1919, however, it made four transatlantic trips to bring U.S. servicemen home from the battlefields of World War I. The *Connecticut* met an undistinguished end in 1923 when the navy decommissioned the ship and sold it for scrap.

September 30

A Gem of a Hitter

In the early decades of the twentieth century, Bill Savitt built a successful jewelry business on Asylum Street in Hartford, Connecticut, by offering customers his famous POMG (Piece of Mind Guarantee). Savitt used money earned from his business to purchase Bulkeley Stadium in 1932. The only problem was that Savitt had no team to play in his stadium.

Savitt formed the Hartford Gems to play semipro baseball in the Hartford Twilight League. Savitt attracted fans through numerous promotions and charity events he held during games and by scheduling exhibitions against teams from all different leagues, including the professional major leagues and the Negro League. The Gems played against such legendary teams as the St. Louis Cardinals and Pittsburgh Pirates and battled Hall of Fame players such as Bob Gibson, Dizzy Dean, Lefty Grove and Satchel Paige.

On September 30, 1945, a fifty-one-year-old Babe Ruth joined the Gems for an exhibition game. With his professional career having ended ten years earlier, Ruth was a shadow of his former self. He thrilled the crowd with several home runs during batting practice but spent the majority of the day on the bench. When called on late in the game to be a pinch hitter, Ruth weakly grounded out to the pitcher.

OCTOBER

October 1

Civil Unions

Vermont became the first state to recognize civil unions when, in 2001, the Vermont Supreme Court ruled that excluding same-sex couples from marriage violated the state's constitution. Four years later, Connecticut became the second state to pass civil union legislation and the first state to do so without a direct order from the courts. The Connecticut legislature passed Senate Bill No. 963 in April 2005, allowing same-sex couples to enter into a legal union formally recognized by the state.

While the bill provided some legal benefits to same-sex couples, it did not provide all the same protections of legal marriage and did little to offer couples the social and cultural benefits traditionally associated with marriage. Governor Jodi Rell signed the bill on April 20, and the law took effect on October 1, 2005, but not without an amendment attached by the state House of Representatives that defined marriage as a union between a man and a woman.

This changed in 2010 following the legalization of same-sex marriage in Connecticut. This change in status brought about the repeal of SB-963 on October 1, 2010. The state mandated that all future same-sex unions be in the form of marriage and that any past civil unions be recognized as legal marriages.

October 2

The Governor's Foot Guard

In the second half of the eighteenth century, "Election Day" in Connecticut (as in many of the Americans colonies) was a day of boisterous celebration. Large crowds gathered around the polls, drank, fought and cheered at the prospect of partaking in the political process. As a consequence, military companies often escorted candidates and political dignitaries through the streets for protection, though military discipline did not exist to the degree it does today. In fact, during Connecticut's Election Day festivities in 1768, the Hartford guard accompanying the governor and his entourage became so inebriated and made such a spectacle of themselves that the governor had them disbanded and, for the next two years, sought the services of an East Hartford military company serving under George Pitkin.

After the guard offered their formal apologies and spent two years shamed by the hiring of their East Hartford counterparts, a group of forty-four Hartford men under Samuel Wyllys petitioned the General Assembly on October 2, 1771, asking for permission to restore honor to the Hartford guard. The assembly acquiesced, and the men formed the Governor's Guard (later known as the First Company Governor's Foot Guard), the state's oldest continually operating military organization.

Patterned after the First Regiment of Foot Guards in England, a second company (formed in New Haven and led by Benedict Arnold) joined the first and began a legacy of illustrious and unblemished service to the state. The years that followed witnessed the Foot Guard provide escorts to dignitaries ranging from George Washington, John Trumbull and John Adams to Queen Elizabeth II, Dwight Eisenhower and John F. Kennedy.

October 3

The Windsor Tornado

It was around three o'clock in the afternoon on October 3, 1979, when an unexpected storm brought high winds and heavy rains to the I-91 corridor near Hartford. As the skies continued to darken and the rain mixed with

hail, the storm moved into the Poquonock section of Windsor, and suddenly a funnel cloud touched down. An F-4 tornado with winds reaching 250 miles per hour tore through Poquonock, claiming three lives.

After destroying numerous homes and businesses, the tornado headed north to Bradley Airport. Though growing weaker, the storm tossed planes across the eastern portion of the airfield and destroyed the Air National Guard base in Windsor Locks. The tornado reached the New England Air Museum and, in five minutes, tore the roof off the building, sent a C-54 transport plane careening through the museum's ticket booth and destroyed much of the museum's collection. When the winds finally subsided, chunks of aluminum and fiberglass airplane pieces lay strewn about the surrounding area, while planes, tossed as high as 250 feet in the air, became little more than heaping piles of debris.

The Windsor tornado of 1979 was the strongest and most costly in Connecticut's history. With damages reaching $400 million, it also became the sixth most damaging tornado ever recorded in the United States.

October 4

The End of the Danbury Fair

The Danbury Fair was a staple of life in western Connecticut for 122 years. Initially held in 1821, Danbury began hosting the agricultural fair annually in 1869 when the Danbury Farmers and Manufacturers Society borrowed a tent and provided a venue for local residents to share practices and show off their agricultural prowess. The society eventually purchased one hundred acres of land on which to expand the fair which grew to offer everything from food, rides and Western-wear to horse and stock car racing.

By the latter half of the twentieth century, the fair regularly attracted hundreds of thousands of visitors from all over the Northeast—in part due to operators expanding the run of the fair from three days to ten. The Danbury Fair was the nation's oldest operating fair when it opened for the final time on October 4, 1981.

Located on a sought-after parcel of land along Route 7 and Interstate 84, the growth of Danbury's population and industrial base (including the recent completion of a corporate headquarters for the Union Carbide Corporation) drove up land prices in the area. Consequently, the Wilmorite

Corporation of Rochester, New York, made the land's owners (the Leahy family) an offer of $24 million for the property. The Leahys accepted, and the Wimorite Corporation began construction of a $75 million shopping complex that became the Danbury Fair Mall.

October 5

The First Woman Ordained in Connecticut

Celia Burleigh was a writer and activist born in Cazenovia, New York, in 1826. She lobbied for the rights of children—specifically their right to grow up free from abuse and to voice their opinions (albeit within the framework of attentive, obedient behavior). In addition, she worked diligently to promote her beliefs in equal rights and opportunities for women.

After marrying a New York City harbor master in 1865, she helped organize what became the Brooklyn Woman's Club in 1869 and became its first president. She also served as a secretary for the Equal Rights Association and, on November 29, 1870, stood on the platform at the Convention of the North-western Woman's Suffrage Association alongside such renowned figures as Susan B. Anthony and Lillie Peckham.

Burleigh's desire to spread her message to the largest possible audience fostered an interest in joining the ministry, a calling her husband encouraged her to follow. In July 1871, members of the Unitarian church in Brooklyn, Connecticut, invited her to be their summer minister. After developing a strong following in a very short period of time, Burleigh received an invitation to stay on as the church's permanent minister. On October 5, 1871, Burleigh became the first woman ever ordained in Connecticut, as well as the first woman ordained by the Unitarian Church.

October 6

Clinton versus Dole

The 1996 presidential election pitted President Bill Clinton against Republican senator Bob Dole. As election day neared, Clinton accumulated

a sizeable lead in the polls. With an eye on cutting into Clinton's lead, Bob Dole met the president in Hartford, Connecticut, on October 6, 1996, for the election's first televised debate.

Moderated by Jim Lehrer of PBS, the debate began with a focus on education, the economy and Medicare. Dole then attempted to undermine America's confidence in their president by attacking his approach to foreign affairs, crime prevention and spending. With the exception of a reference made to Clinton's admission of recreational marijuana use during his youth, what Dole failed to employ was a strategy attacking Clinton's personal character. Many Republican strategists later pointed to this missed opportunity as a turning point in the debate.

A Gallup poll taken after the debate showed that Dole's performance exceeded the public's expectations but did little to cut into Clinton's lead. The poll showed that 51 percent of viewers believed Clinton won the debate, compared to only 32 percent for Dole. With most Americans feeling they were better off financially than four years earlier, a second debate on October 16 did little to change their minds, and Clinton cruised to victory and a second term in office.

October 7

Danbury Baptists Write to Thomas Jefferson

The separation of church and state, while a fundamental part of American culture, was hardly an inevitability. While many of America's earliest settlers left their homelands in search of religious freedom and the country's founding fathers explicitly argued in favor of keeping the government out of religious matters, for a significant portion of America's history, there existed surprisingly few legal barriers to the development of state-mandated religion. This left followers of less-popular religions living in fear that the state might someday outlaw their beliefs.

One such group in the religious minority was a group of Baptists living in Danbury, Connecticut. Putting their concerns to paper, the group penned a letter to President Thomas Jefferson on October 7, 1801. In the letter, a Baptist committee consisting of Nehemiah Dodge, Ephraim Robbins and Stephen S. Nelson appealed to Jefferson's abhorrence for tyranny in asking that he maintain a policy of religious freedom for all.

Jefferson actually wrote the Danbury men back on January 1, 1802. He assured the Baptist committee that his duty to his constituents reinforced his belief in the separation of church and state. Though Jefferson's beliefs reflected those belonging to a significant portion of his constituents, it still took several twentieth-century battles in the United States Supreme Court to ultimately keep the government out of religious affairs.

October 8

The Bulkeley Bridge

A wooden bridge built over the Connecticut River in 1818 to connect Hartford and East Hartford burned to the ground on May 17, 1895. With Connecticut's capital now largely cut off from areas east of the river, officials authorized an expansion of ferry service and the construction of a number of temporary bridges to allow for easy transportation to and from Hartford. The General Assembly also passed the Bridge Act, authorizing the construction of a new permanent bridge.

The New York firm of McMullen, Weand & McDermott won the contract to build the bridge and began construction on the East Hartford side of the river. Masons laid the first stone for the bridge on April 16, 1904. Unfortunately, the project met with numerous delays caused by labor unrest from unpaid wages in 1904 and the breakup of a large ice flow that carried away a number of sand barges in the winter of 1907.

On October 6, 1908, a three-day celebration began as the bridge neared completion. Approximately seventy-five thousand participants took part in the festivities, which included the lighting of the bridge, a reenactment of the arrival of Thomas Hooker and a military pageant showing off hundreds of years of evolutionary weaponry. After the placing of the bridge's last stone, on October 8, nearly ten thousand masons joined a parade to celebrate the completion of the largest stone arch bridge in the world (at that time). Originally named the Hartford Bridge, officials later rededicated the structure as the Bulkeley Bridge, to honor the contributions of former governor, senator and bridge committee member Morgan Bulkeley.

October 9

The Connecticut College for Women

In 1911, at the end of a twenty-year period that saw a nearly 800 percent increase in the number of women enrolled in colleges in the United States, Wesleyan University announced its decision to become an all-male school. With women's colleges such as Vassar, Elmira and Oberlin providing successful models to follow, a committee of concerned citizens and educators began scouring Connecticut for a suitable location on which to establish a college for women.

A 340-acre hilltop bordered by the Thames River and Long Island Sound in New London became the committee's choice. The city of New London voted $50,000 toward the cost of building the school, and local residents donating amounts varying from $0.10 to $2,500 raised the remaining funds. A generous donation of $1 million came shortly after, and almost overnight, the Connecticut College for Women became one of the richest women's colleges in the country.

The Connecticut General Assembly granted the college its charter on April 4, 1911, and the school officially started classes four and a half years later. The college inaugurated its first president, Frederick H. Sykes, on October 9, 1915.

The first student body consisted of 151 women—many from New London and Norwich but some from as far away as Washington and Texas. In 1959, the college added the Connecticut College for Men (a graduate study program) and officially became a co-ed school in 1969.

October 10

Connecticut Approves the Declaration of Independence

In the summer of 1776, with the American colonies engaged in open war with Great Britain, the Continental Congress (charged with navigating the colonies' course through the American Revolution) recessed for three weeks. Prior to the recess, however, it elected a committee of five men to draw up a document articulately explaining to the world its case for independence

from Great Britain. These five men were Thomas Jefferson from Virginia, Benjamin Franklin from Pennsylvania, Roger Sherman from Connecticut, Robert Livingston from New York and John Adams from Massachusetts.

When Congress reconvened on July 1, it began consideration of the document (authored primarily by Thomas Jefferson) and adopted it on July 4, 1776. Church bells rang, and there were tremendous celebrations throughout the colonies, but there was still much work to accomplish surrounding the declaration. Only twelve of the thirteen colonies' representatives approved the document that day. The thirteenth colony, New York, did not accept the document until July 19, and the signing actually did not take place until August.

After a review of its own, the Connecticut General Assembly gave the Declaration of Independence its official approval on October 10, 1776. While a proud part of a new independent nation, the assembly also resolved to continue operating under the civil government established in its colonial charter.

October 11

Admiral Byrd

Richard Byrd's taste for adventure inspired him to become the first pilot to fly over the North Pole—a feat he accomplished in 1926. Byrd then set his sights on exploring Antarctica. Four ships carried Byrd, three planes, ninety-five dogs and 650 tons of supplies to Antarctica in 1928. Shortly after, Byrd became the first man to fly over the South Pole, and he returned to America a hero.

Byrd undertook a celebratory goodwill tour of the states in 1930. On October 11, he made his first public appearance in Connecticut since reaching the South Pole. He addressed a crowd of 2,600 in Waterbury before heading to Stamford the next day. A police escort then brought him to Bridgeport. By far the largest celebration took place on October 17 in Hartford, where, after arriving by train, Byrd received a forty-motorcycle police escort to two lectures before heading back down to Greenwich.

Admiral Byrd (second from left) receiving a gold medal from President Hoover weeks before arriving in Connecticut. *Library of Congress, Prints and Photographs Division, Harris and Ewing Collection.*

October 12

A New State Constitution

Shortly after the American colonies declared their independence from Great Britain, the vast majority of new states set about drafting a state constitution to provide citizens with a clearly defined system of government. In contrast to the growing enthusiasm for new state-specific legislation, Connecticut took little action. Living largely under the system defined in the 1630s, Connecticut residents did not see a reason to change (outside of removing references to royal rule found in their charter).

By the early 1800s, however, numerous debates surrounding representation, suffrage and religious freedom highlighted the need for a new governing document in Connecticut. A two-hundred-person convention (stocked by

both the Federalists and the Republicans with some of the greatest legal minds the state had to offer) voted to draft a new constitution in August 1818. The convention singled out twenty-four representatives to draft the document.

After only three weeks, the committee finished a draft ready for public consideration. Given an additional three weeks to review it, the public voted in favor of the new constitution by a margin of 13,918 to 12,364. On October 12, 1818, Governor Oliver Wolcott Jr. proclaimed the new constitution the supreme law of the state.

October 13

Lollipop or Lolly Pop

George P. Smith did not invent the lollipop, but he did help make it a household name. Having partnered with Andrew R. Bradley to form the Bradley Smith Company in New Haven back in 1883, Smith developed an affinity for a confectionary treat made by a nearby competitor consisting of chocolate caramel taffy served on a stick. He ordered his employees to begin hand-pegging sticks into his own company's hard candies. The product sold well but lacked a catchy name.

While attending a state fair, Smith encountered a racehorse named Lolly Pop, and he set about patenting the name for his popular candy. The U.S. Patent Office initially denied his application, citing the presence of the term "lollipop" in the English dictionary, but Smith successfully appealed the ruling by pointing out the uniqueness of his spelling variation. The government awarded Smith a trademark on the name "Lolly Pop" on October 13, 1931. It was not long, however, before the two spellings became interchangeable.

Under its new name, the Lolly Pop increased in popularity. Smith's automation of the stick-pegging process allowed for increased production, and he began shipping his product to locations as far away as China and South Africa.

The Bradley Smith Company actually stopped producing lollipops (along with other popular candies such as B'Gosh and Yale bars) just four years after receiving its trademark. The company, instead, became a very successful candy packaging and distribution enterprise.

October 14

Spanish Influenza

In 1918 and 1919, H1N1 influenza strains created a worldwide pandemic that took as many as 100 million lives. Potentially begun as an avian virus that spread to humans, "Spanish Influenza" proved fatal to victims of all ages but was especially prevalent among those in their twenties and thirties, as well as those closely confined in overcrowded cities or in the trenches of World War I battlefields.

The virus first appeared in Connecticut at the naval training station in New London. Within just three days, doctors reported several hundred cases, and the virus quickly spread to the areas around New Haven and Manchester. With an incubation period of only one or two days and the virus's unusual ability to compromise even the strongest of immune responses, quarantining all of those infected became impossible.

Citing a lack of confidence in the state's board of health, a council of Hartford citizens led by Alderman J. Humphrey Greene passed a resolution on October 14, 1918, asking the state to close all schools, theaters, churches and public events in hopes of limiting the spread of H1N1. Despite these efforts, the flood of patients overwhelmed hospitals, requiring the establishment of new emergency hospital facilities and even the acceptance of patients into private homes. The month of October alone witnessed five thousand influenza-related deaths in Connecticut.

The end of World War I helped bring an end to the worst of the pandemic. It did, however, linger into 1919 and, before it was over, take the lives of over nine thousand Connecticut residents.

October 15

A Connecticut Governor, a Russian Minister

Born in 1807 as the grandson of Hartford's first mayor, Thomas Seymour grew up in Hartford and graduated from Captain Alden Partridge's Military Institute in Middletown, Connecticut. A lawyer who never entered into practice, Seymour served as probate judge, newspaper editor

and commander of the Hartford Light Guard before winning election to Congress in 1843.

He declined to run for an additional term, however, and joined the army to fight in the newly opened war with Mexico as major of the Connecticut Infantry and the Ninth U.S. Infantry. He served with distinction in the war and returned to Connecticut a bona fide hero. Seymour capitalized on his newfound popularity by winning election to become the state's governor in 1850.

Seymour won reelection on numerous occasions and used his influence with Connecticut voters to throw support behind the presidential bid of Franklin Pierce. After assuming office, Pierce rewarded Seymour by offering him a position as U.S. minister to Russia. Seymour accepted, resigning as Connecticut's governor on October 15, 1853.

After four years in Russia, Seymour once again returned to Connecticut a hero. His unwillingness to support military action against the Confederacy at the outbreak of the Civil War, however, caused him to lose favor with Connecticut voters. After an unsuccessful run for governor in 1863, Seymour retired from political life and moved in with his sister in Hartford. He died there in 1868.

October 16

Yale's Charter

At the dawn of the eighteenth century, ten ministers gathered in Saybrook to address the need for more ministers in Connecticut churches. They agreed to petition the General Assembly for a school to train new ministers. Connecticut's governor and upper legislature, meeting at Captain Miles' Tavern, approved the charter and sent it to the legislature's lower house in New Haven for debate.

On the morning of October 16, 1701, a bell summoned legislators to the wooden meetinghouse in New Haven. There, the General Assembly debated the act throughout the morning. Approval for the school charter came just before the end of the session, and Connecticut had a new Collegiate School.

Thanks to the donation of a large one-story house and ten acres of property from a Saybrook resident, the ministers established the

Collegiate School in Saybrook. A change in location and even greater contributions coming in the form of supplies from a wealthy merchant named Elihu Yale ultimately led the school to change its name to Yale College.

October 17

Jupiter Hammon

October 17, 1711, was the birth date of Jupiter Hammon, born to slaves owned by Henry Lloyd and his family in Long Island, New York. Hammon lived in the Lloyd's manor house and actually attended school with the Lloyd children. Developing into a deeply religious man, Hammon used what education he acquired to write poetry. On Christmas Day in 1760, Hammon authored an eighty-eight-line poem entitled "An Evening Thought: Salvation by Christ with Penitential Cries." The following year, the poem appeared in Hartford, Connecticut, as a broadside, making Hammon America's first published African American poet.

With the death of Henry Lloyd in 1763, Hammon became the property of Lloyd's son, Joseph. A Patriot at heart, Joseph Lloyd moved his family to Connecticut when the British invaded New York during the American Revolution. While in Hartford, Hammon continued to write, publishing such works as 1778's "An Address to Miss Phillis Wheatly" and 1779's "An Essay on the Ten Virgins."

At the conclusion of the war, the Lloyd family returned to New York. Hammon, recognized for his ability with words, became a leader in the African American community. He gave an address to the African Society in New York City and became an influential contributor to the period's antislavery literature. Hammon died around 1806 and received a burial in an unmarked grave on the Lloyd property.

October 18

The Raid on Harpers Ferry

Connecticut abolitionist John Brown staged a raid on the federal armory in Harpers Ferry, West Virginia, in the fall of 1859. The raid was meant to seize weapons for the abolitionist cause and incite a slave insurrection in the South. After training twenty-two men on a nearby farm in Maryland, Brown launched his raid on October 16, 1859. He and his men captured several prisoners and briefly halted a Baltimore and Ohio train headed through Harpers Ferry, but the train went on to Washington, D.C., and alerted federal authorities to Brown's activities.

The slave insurrection Brown hoped to initiate never materialized, and soon a number of local militia companies surrounded Brown and his men in the armory building. The two sides exchanged sporadic fire until federal troops under Colonel Robert E. Lee arrived and stormed Brown's position in the facility's engine house on October 18, 1859. The army quickly captured Brown and sentenced him to hang on December 2.

The scene inside the engine house at Harpers Ferry. *Library of Congress, Prints and Photographs Division, Miscellaneous Items in High Demand Collection.*

October 19

The Connecticut Audubon Society

Mabel Osgood Wright was the daughter of prominent minister Samuel Osgood. Born in New York City in 1859, Mabel Osgood grew up in New York but spent summers at her family's eighteen-room retreat in Fairfield, Connecticut. There, surrounded by eight acres of gardens and woods, she developed a love for science and nature.

After marrying bookseller James Wright in 1884, she indulged a passion for writing by authoring numerous works on birds, landscapes and appreciating nature in one's own backyard. In 1898, she became president of the Audubon Society of Connecticut, an organization dedicated to preventing hunters and clothing manufacturers from killing birds in order to use their feathers for fashionable hats.

With the donation of ten acres of land in Fairfield from philanthropist Annie Burr Jennings, Mabel Osgod Wright established what became the oldest songbird sanctuary in the United States. In order to own real estate, Wright needed to reorganize the Audubon Society's legal structure. This revamped society, now in charge of Jennings's ten acres, met for the first time on October 19, 1914, in the Memorial Library in Fairfield.

Despite the death of her husband in 1920, Mabel Osgood Wright continued to author new works on nature and conservation, eventually completing twenty-five books. She died in 1934 at the age of seventy-five, and her bird sanctuary became a National Historic Landmark in 1993.

October 20

The Thomas Hooker Statue

At 3:00 p.m. on October 20, 1950, a crowd of several hundred gathered on the west lawn of Connecticut's Old State House in Hartford to witness the unveiling of a statue dedicated to Thomas Hooker—Hartford's founder and an early American proponent of democracy. On a spot not far from where Connecticut adopted its Fundamental Orders in 1639, the mayor of Hartford accepted the gift of the nearly eight-foot-tall bronze statue of

Hooker donated by the Society of Descendants and Founders of Hartford. The dedication ceremony lasted only thirty minutes, but a reception inside the Old State House followed, where attendees toasted the statue's creator, Frances Laughlin Wadsworth.

Wadsworth was a painter and sculptor born in Buffalo, New York, who attended St. Catherine's School in Virginia before receiving her formal training in art from some of the finest instructors in Europe. She moved to Hartford when she married insurance company executive Robert Wadsworth and began sculpting works found throughout the city. Included among her works is the memorial to children found at the West Hartford Methodist Church and *Safe Arrival*, a statue located in downtown Hartford.

The statue of Thomas Hooker was a work Wadsworth always considered among her most difficult projects, largely because no images or descriptions of Hooker's appearance existed. To compensate for this, Wadsworth studied the features of Hooker's descendants and tried to base her portrayal of him on what she read about his character.

October 21

Hayden Murder Trial

It was September 3, 1878, when the Reverend Herbert H. Hayden stopped by to see Mary Stannard of North Madison, Connecticut (an unwed mother of a two-year-old boy). Hayden asked Stannard to meet him later that day. When Stannard left her house, she told her father she intended to go out and pick berries, but she never returned. Locals discovered her lifeless body around 5:00 p.m. with a wound to the throat and a bruise to the head. On September 5, Reverend Hayden attended Stannard's funeral and helped her father carry her body home. The next day, authorities arrested Hayden for Stannard's murder.

Earlier that year, Mary Stannard had gone to the Hayden house to babysit while the reverend and his wife attended a dinner. Hayden, instead, decided to stay home that night and ultimately engaged in an adulterous relationship with Stannard. Shortly after, Stannard informed Hayden that she believed she was carrying his child.

The trial began the following fall, and on October 21, 1879, a packed courtroom heard the testimony of a local professor who produced numerous bottled samples of Stannard's stomach contents and organs—all showing signs of arsenic poisoning. Hayden admitted to purchasing arsenic but claimed he only used it to kill rats.

After the longest murder trial in the state's history (to that time), the jury found Hayden innocent. Part of the reason for its verdict, it later turned out, was the jurors' reluctance to put away a man married to such a beautiful young woman, Mrs. Hayden, who sat directly in front of the jury for most of the trial.

October 22

The Transcontinental Railroad

Apprenticed to a farmer at age fourteen and a grocer the following year, Collis Huntington was hardly on his way to being a construction, steamship and railroad tycoon as he grew up in Harwinton, Connecticut. Born on October 22, 1821, he finally left Connecticut at twenty-one to join his brother in a hardware store in Oneonta, New York. Seven years later, he headed to California to try his luck at selling hardware to the flood of prospectors digging up the West Coast in search of gold. Once there, he became one of the founders of California's Republican Party.

In 1861, he jumped on an opportunity he heard about to build the western leg of a transcontinental rail line connecting California to the East Coast. He became one of the founders of the Central Pacific Railroad Company and moved to New York to serve as the company's purchasing agent, legal adviser and political lobbyist. In May 1869, workers in Utah connected the lines of the Union Pacific and Central Pacific Railroads, completing the first transcontinental railroad line in the United States.

Huntington, recognizing railroads as the future of transportation, quickly bought up twenty-three different railroad companies in California. He then financed the formation of the Southern Pacific line, opening a transportation corridor between California and New Orleans in 1883. Huntington's land and transportation empire made him one of the most powerful men in America at the time of his death in 1900.

October 23

Sarah Pierce's Farewell

One of the most prestigious women's schools of the early nineteenth century started in the living room of Litchfield, Connecticut native Sarah Pierce in 1792. Pierce opened her home to a small group of students and, within a matter of years, received a schoolhouse donated by local residents interested in seeing her expand her enrollment. Together with Tapping Reeve's Litchfield Law School, the school Sarah Pierce later incorporated as the Litchfield Female Academy helped turn the little town of Litchfield into one of the leading educational centers in the country.

Pierce taught her students many subjects rarely offered to women, including math, chemistry, botany and geography. She supplemented this with instruction in needlework, painting and dance, sometimes combining subjects into one lesson as she did when she had her students paint geographic maps. In addition, Pierce made sure her students had opportunities for physical exercise and encouraged them to perform volunteer work.

In 1814, Pierce asked her nephew, John Brace, a graduate of Williams College, to assist her in teaching her growing number of students. Brace took over as principal of the school in 1825, allowing Pierce to slowly withdraw from the day-to-day responsibilities of operating the school.

Just seven years later, Pierce announced her retirement as the school's assistant principal. She delivered a farewell address to her students on October 23, 1832. The school, which instructed nearly three thousand women over its lifetime, closed shortly after.

October 24

The Goodspeed Opera House

Before becoming a successful merchant, banker, shipbuilder, hotel owner and railroad magnate, William Goodspeed joined his father's general store at Goodspeed's Landing along the Connecticut River in East Haddam. As his business ventures multiplied, however, Goodspeed required more

The Goodspeed Opera House in East Haddam. *Library of Congress, Prints and Photographs Division, Highsmith (Carol M.) Archive Collection.*

office space. In 1876, he built a larger multipurpose building, with offices on the main floor and a venue for live theater performances above. What became the Goodspeed Opera House held its first performance on October 24, 1877.

After Goodspeed's death in 1926, the building fell into disrepair, but in the late 1950s, a group of concerned residents began a campaign to revitalize the opera house. It officially reopened in 1963 and has since won more than a dozen Tony Awards for its original productions, many of which went on to great success on Broadway.

October 25

The Bounty

Waves three stories high, powered by one-hundred-mile-per-hour winds, battered the sailing vessel *Bounty* as it attempted to push through Hurricane Sandy off the coast of North Carolina in October 2012. The largely inexperienced crew battled fatigue, injury and illness from being tossed around the ship as they raced to keep the engines and bilge pumps running. Early on the morning of October 29, 2012, the *Bounty*, with ten feet of water in its hold, heeled hard to starboard and began to sink.

The fifty-two-year-old ship was a replica of the original eighteenth-century HMS *Bounty*. Built as a movie prop for the 1962 movie *Mutiny on the Bounty*, the rebuilt ship also served in the *Pirates of the Caribbean* films and in 2003's *Master and Commander: The Far Side of the World*.

The ship actually left on its fatal voyage from New London, Connecticut, under mostly clear skies on October 25, 2012. It headed for St. Petersburg, Florida, where its paying customers awaited the chance to take a tour of the 108-foot historical reproduction. Unfortunately for Captain Robin Walbridge, his decision to sail through the worst Hurricane Sandy had to offer came with dire consequences.

Crew members ranging in age from twenty to sixty-six anxiously awaited the arrival of three U.S. Coast Guard helicopters once their situation became untenable. Despite high winds and rough seas, the helicopters pulled sixteen crew members off the doomed vessel. Shortly after, however, an ocean search uncovered the body of forty-two-year-old crew member Claudene Christian. Authorities never found the body of Captain Robin Walbridge.

October 26

A Campaign Visit by Charles Evans Hughes

Charles Evans Hughes was one of the great legal minds of the early twentieth century. Graduating from Brown University at only nineteen, he went on to Columbia Law School and became a renowned anticorruption attorney in New York before becoming the state's governor in 1906. President William

Howard Taft appointed him to the Supreme Court shortly after, but Hughes resigned his position in 1916 to make a run for the presidency.

It was as a presidential hopeful that Charles Evans Hughes arrived in Connecticut on October 26, 1916. After boarding an 8:10 a.m. train in New York, between three and four hundred people greeted his arrival in New Haven with chants of "We want Hughes." Joined by Connecticut governor Marcus Holcomb and Senator Frank Brandegee, Hughes waved to enthusiastic crowds in Wallingford and Meriden before arriving at Union Station in Hartford.

From there, the Young Men's Republican Marching Club escorted Hughes to the Parsons Theater, where he addressed an audience of two thousand. Hughes railed against the era's system of class antagonism and told attendees he was neither for nor against joining the war in Europe but was instead a candidate who would do whatever was necessary to protect American rights.

Hughes ultimately lost the presidential election to Woodrow Wilson but became secretary of state under President Warren Harding. In 1930, Herbert Hoover appointed Hughes chief justice of the Supreme Court, a position he held until 1941.

October 27

Corporal Timothy Ahearn

New Haven's Timothy Ahearn received a promotion to corporal for the bravery he displayed at the Battle of Seicheprey in World War I. As the German army launched an early morning raid and gas attack on his position, Ahearn rallied his comrades by conspicuously standing and engaging the enemy in hand-to-hand combat.

After recovering from a wound, Ahearn was in action near Verdun, France, on October 27, 1918, when an enemy attack wiped out all of his superior officers. Corporal Ahearn took command of his company and, with just seventeen men, held his position throughout the day and night. Over the course of the battle, Ahearn even rushed out into heavy machine-gun fire to rescue a wounded comrade. For his actions on that October day, Ahearn earned the Distinguished Service Cross. Three days later, an enemy gas attack brought Ahearn's fighting days to an end.

After Ahearn returned home to New Haven, friends and family members noted that he had difficulty breathing and was prone to erratic behavior. He moved to New Jersey, where unsuccessful attempts at finding steady employment, according to one story, led him to the Midwest and then the West Coast, where he became an agricultural laborer. He died shortly after, at the age of twenty-five.

In 1937, the New Haven Chapter of the Yankee Division Veterans Association dedicated a statue honoring Ahearn in West River Memorial Park. For years afterward, Yankee Division veterans from World War I came to West River Memorial Park on the anniversary of the battle at Seicheprey to honor Ahearn's memory.

October 28

The Connecticut Woman Suffrage Association

Isabella Beecher Hooker (circa 1901). *Library of Congress, Prints and Photographs Division, Miscellaneous Items in High Demand Collection.*

Alongside her husband, John, Isabella Beecher Hooker helped form the Connecticut Woman Suffrage Association (CWSA) at Robert's Opera House in Hartford on October 28, 1869. The two-day meeting held there, and attended by such prominent leaders as William Lloyd Garrison, Elizabeth Cady Stanton, Frances Ellen Burr and Susan B. Anthony, helped organize a multifaceted campaign dedicated to winning women the right to vote.

Isabella Beecher Hooker served as president of the CWSA for thirty-six years. During this time, she organized demonstrations and conventions and lobbied Congress on behalf of her fellow suffragettes. She even introduced a

bill into the state legislature that recognized a married woman's right to own property. Hooker died in 1907, thirteen years before passage of the Nineteenth Amendment.

October 29

The Oldest Newspaper in Continuous Publication

Thomas Green set up shop in the Heart and Crown Tavern in Hartford on October 29, 1764, and began printing a weekly newspaper. Known as the *Connecticut Courant*, it was just the third newspaper published in the American colonies. The first issue consisted of just four pages, and future issues varied in length based on the availability of paper, but Green kept the *Courant* financially viable by selling clothing, hardware and spices out of the newspaper's front office.

The *Connecticut Courant* proved a vitally important source for news in the years leading up to the American Revolution. Providing coverage of such historic events as the Boston Tea Party and the signing of the Declaration of Independence, the *Courant* had the largest circulation of any newspaper during the Revolutionary War. Greene sold the paper to Ebenezer Watson, who added a paper mill to the *Courant*'s operations. When Watson died of smallpox in 1777, his widow, Hannah, became one of the first female publishers in America.

The *Courant* began producing a daily edition in 1837 (with the weekly edition continuing publication through 1896). In 1913, the paper (now known as the *Hartford Courant*) produced its first Sunday edition.

With a circulation in the hundreds of thousands, the *Hartford Courant* is the oldest newspaper in continuous publication in America. The winner of multiple Pulitzer Prizes, the *Courant* operates as a division of the Chicago-based Tribune Company, which purchased it from Times Mirror in 2000.

October 30

The Chinese Educational Mission

Yung Wing grew up in the Portuguese colony of Macao in modern-day China in the early 1800s. He attended missionary schools there and in British-held Hong Kong before the Reverend Samuel Robbins Brown, headmaster at Wing's school in Hong Kong, returned to America and brought Wing and some of his classmates with him. Wing became naturalized as an American citizen on October 30, 1852, and graduated from Yale two years later.

After graduation, Wing returned to China, where he successfully lobbied the government to allow Chinese students to receive a western education. The Chinese Educational Mission set up its headquarters in Hartford, Connecticut, in 1872. Shortly after, a group of thirty Chinese students (ranging in age from ten to fourteen) arrived in Hartford, settled in with their host families and began immersing themselves in western language and culture.

Over the next nine years, 120 Chinese students entered the program and temporarily relocated to areas throughout New England. Unfortunately, students tended to neglect their Chinese studies while in America, and the Chinese government, unhappy with the westernization of its students and the growing diplomatic tensions it faced with the United States, canceled the program in 1881. The following year, the U.S. government passed the Chinese Exclusion Act, limiting the ability of Chinese immigrants to legally enter the United States.

October 31

The Charter Oak Incident

A showdown of sorts took place at Sanford's Tavern in Hartford in October 1687. Although King Charles II of England granted Connecticut a colonial charter in 1662, his death in 1685 brought his brother, James II, to power. King James very much wanted to make Connecticut a part of New York, but Connecticut residents strongly opposed the idea. After Connecticut refused to voluntarily surrender its charter, the king sent an armed force under Sir Edmund Andros to take it.

On the night of October 31, 1687, Andros and his men squared off with Connecticut's political representatives at Sanford's Tavern. Andros read aloud the orders for Connecticut's annexation by New York and demanded Connecticut surrender its charter. With the document placed on the table between the two sides, a spirited discussion ensued. According to the cherished legend, as the debate reached a crescendo, all the candles in the room suddenly went out. After relighting the candles, the debate's participants found the charter had gone missing.

Accounts credit Captain Jeremiah Wadsworth with grabbing the charter in the darkness, running across the bridge over the Little River and depositing the document in a hollowed oak tree on the property of Samuel Wyllys. Connecticut residents named the tree the "Charter Oak," and it stood as a symbol of local pride and identity until a heavy storm on the night of August 21, 1856, snapped the tree in half.

NOVEMBER

November 1

The West Rock Tunnel

Work began on the Wilbur Cross Parkway (a section of Route 15 running from Milford to Meriden) in December 1939. The first section reached completion in 1940, the same day the last section of the Merritt Parkway opened. After completing a run from the Housatonic River to Derby Avenue in Orange, authorities placed the project on hold during World War II. It resumed with a link to Meriden finished in 1947 and subsequent sections completed in Wallingford, Hamden and then into New Haven.

The final stretch of the parkway ended with the completion of the $2 million West Rock Tunnel. Meant to eliminate travel through the streets of New Haven, the 1,200-foot tunnel ran 200 feet below the summit of West Rock, decreasing the time required to travel from Derby Avenue to Dixwell Avenue from twenty or thirty minutes down to eight or ten.

Acting as master of ceremonies, Lieutenant Governor William T. Carroll officially opened the West Rock Tunnel on November 1, 1949, allowing for a continuous stretch of highway to reach from New York to Vernon, Connecticut, near the Massachusetts border. In attendance at the ceremony were Connecticut governor Chester Bowles and the two sons of former governor Wilbur Cross. All took part in a ceremony held at Pond Lily Avenue, followed by a motorcade and a luncheon at the State Highway Department's nearby service garage.

George Robertson in his #16 Locomobile. *Library of Congress, Prints and Photographs Division, Bain Collection.*

November 2

The Locomobile

The Bridgeport-based Locomobile Company began producing steam-powered cars in 1899. The length of time required for the engine to create the required steam, along with the growing popularity of the internal combustion engine, soon brought about a change in the company's direction, however. In 1902, it hired engineer Andrew Riker to design a gas-powered Locomobile. Riker delivered the first one on November 2, 1902.

Locomobiles were a powerful and luxurious brand of car marketed to sportsmen and the wealthy. In 1908, a Locomobile (nicknamed "Old 16") driven by George Robertson became the first American car to win an international race. Unfortunately for the Locomobile Company, the growing popularity of cars made affordable to the general public, combined with the economic hardships of the Great Depression, brought an end to the company's financial viability in 1929, and it went out of business.

November 3

The Hempstead Diaries

Joshua Hempstead held many jobs over his lifetime. He worked as a farmer, carpenter, trader, surveyor, business agent, justice of the peace and representative to the General Assembly. Born in New London on September 1, 1768, he spent his entire life living in one house, first with his parents and seven sisters, then with his wife and nine children and, later, with an enslaved man named Adam Jackson and Jackson's two sons. None of this seemed a remarkable feat for its time. What proved so remarkable about Joshua Hempstead's life is that he documented nearly fifty years of it in his diary.

Hempstead made the first entry in his diary on September 8, 1711. The years that followed included observations on weather, town meetings, holiday celebrations, wars and legal proceedings. His many business ventures took him up and down the East Coast and out to the West Indies, all documented through diary entries. He even recorded births, deaths, baptisms and marriages in his town. In all, the diary covered forty-seven years of his life on more than seven hundred pages. His last entry came on November 3, 1758, just six weeks before his death.

The New London Historical Society published the first edition of Hempstead's diary in 1901. Since then, the diary has provided one of the most comprehensive first-person accounts of life in colonial New England.

November 4

The Arrival of John Winthrop Jr.

After studying at Trinity College in Ireland and traveling to France, Turkey and Holland, John Winthrop Jr. arrived back home in England in 1629 just as his father prepared to leave for North America. The following spring, John Winthrop Sr. became governor of the Massachusetts Bay Colony. Staying behind briefly to care for his father's business, John Winthrop Jr. boarded the ship *Lyon* and followed his father a year and a half later. He arrived in Boston on November 4, 1631.

While in Massachusetts, Winthrop Jr. established what became the town of Ipswich and started one of the first ironworks in Massachusetts. He returned to England in 1634 after the death of his wife and infant daughter and, the following year, accepted employment from Lord Brook and Lord Saye and Sele (along with a few others) to establish a colony at the mouth of the Connecticut River. After a return to Boston, twenty men under Winthrop's direction claimed the land and began building on it. Winthrop named the colony Saybrook after the men who hired him.

In May 1657, he became governor of the Connecticut Colony in Hartford. A 1659 change in the law that allowed for governors to serve consecutive terms then allowed Winthrop to serve as governor from 1659 until 1676. During the early part of his term, Winthrop recognized that Connecticut operated without a formal colonial charter. In 1661, he returned to England and procured Connecticut's formal charter from the king the following year.

November 5

Ella Giovanna Oliva Tambussi

On November 5, 1974, Ella Grasso (born Ella Giovanna Oliva Tambussi) became Connecticut's first female governor and the state's first governor of Italian descent. In addition, Grasso became the first woman in the nation to win a gubernatorial office without succeeding her husband.

The daughter of Italian immigrants who settled in Windsor, Ella Tambussi married school principal Thomas Grasso in 1942, the same year she served on Connecticut's War Manpower Commission and joined the League of Women Voters. She went to work as a speechwriter for the Connecticut Democratic Party the following year.

After serving in the General Assembly and then as Connecticut's secretary of state, she defeated U.S. Representative Robert Steele Jr. in the 1974 gubernatorial election. As governor, she inherited a $70 million debt and made numerous unpopular decisions to bring the state back to fiscal solvency. Her popularity soared, however, after a blizzard in February 1978, when Grasso conducted around-the-clock operations from the state armory to get Connecticut up and running again.

Grasso easily won reelection in 1978 but resigned just two years later after being diagnosed with ovarian cancer. She died in Hartford Hospital on February 5, 1981. Shortly after, President Ronald Reagan posthumously awarded her the Presidential Medal of Freedom.

November 6

The "Greatest Night" of JFK's Campaign

At 12:30 a.m. on November 6, 1960, Senator John Fitzgerald Kennedy touched down in Stratford, Connecticut. Just days before the presidential election, Kennedy returned to the state where he attended the Canterbury School and Choate (and where Mrs. Kennedy attended Miss Porter's School in Farmington) to capitalize on some late-campaign momentum.

In the pouring rain, a car drove Kennedy to the Roger Smith Hotel in Waterbury. Arriving around 3:00 a.m., a crowd of nearly forty thousand greeted him there. Kennedy came out on the hotel balcony and addressed his supporters. After a brief speech, he announced that he intended to go back inside and go to sleep, but the enthusiastic crowd cajoled him into staying out with them until nearly 4:00 a.m. Later, members of the Kennedy campaign referred to that night as the greatest night of their campaign.

The next day, a tired Kennedy completed his trip through Connecticut, which required stops in Waterbury, addressing a street rally in New Haven and talking to an assembly of nearly sixty thousand in Bridgeport. At 2:40 p.m., he boarded a plane in Stratford and headed to campaign stops in New York and New Jersey. He returned to Connecticut the next day, however, to give a speech in Hartford. By the end of the week, he had become the thirty-fifth president of the United States.

November 7

"Washington Slept Here"

In 1789 and 1791, President George Washington set out on trips to see the country. His travels throughout the colonies provided him both a measure of

escaping from the burdens of office and a chance to gauge the temperament of the nation's citizens. These were arduous journeys taken by the president, over primitive roads offering accommodations varying in cleanliness and quality (as Washington avoided staying at the homes of individuals for fear of appearing to favor one local political leader over another).

While many tourist destinations like to draw visitors by claiming, "George Washington slept here," in the case of one tavern in Ashford, Connecticut, the claim was true. In November 1789, on a leg of his journey that brought him from Boston to Hartford, Washington stopped in Pomfret in hopes of meeting with General Israel Putnam. Finding Putnam's residence too far away to visit and still remain on his schedule, Washington moved on to Ashford. There, on November 7, 1789, he spent the night at Perkins's Tavern.

The following day being Sunday, there was little fanfare around Washington's stay, and the president most likely spent the better part of the day in quiet solitude. He did take the time to note in his diary, however, that he did not find his accommodations to be among the better ones he encountered on his trip.

November 8

The Last Wooden Whale Ship

The American whaling fleet once numbered nearly three thousand ships. The oldest of these ships remaining afloat is the *Charles W. Morgan*. The *Morgan*, launched from New Bedford, Massachusetts, in 1841, undertook thirty-seven whaling voyages. A crew of just over thirty men typically manned the *Morgan* and embarked on voyages that often lasted for years at a time. One of the reasons the ship survived was the emphasis its builders placed on durability, allowing the boat to survive heavy storms and hull-crushing ice flows.

The *Charles W. Morgan* completed its last whaling voyage in 1921. Whaling Enshrined, Inc., then set about preserving the ship, which went on display in Dartmouth, Massachusetts. On November 8, 1941, however, the *Morgan* found a new home when a coast guard cutter towed the old whaler up the Mystic River to the Mystic Seaport. Since then, over twenty million visitors have climbed aboard the *Morgan* to explore. After a restoration effort begun

in 2008, Mystic Seaport relaunched the *Charles W. Morgan* for a tour of historic New England ports in 2013. The ship returned three months later and once again opened its decks to the public.

November 9

Grove Street Cemetery

An epidemic of yellow fever swept through New Haven in the mid-1790s. Manifesting itself in symptoms that included headaches, nausea and pain in the extremities, death came relatively quickly after the first signs appeared. Deaths from yellow fever reached into the thousands in New Haven, filling the cemetery on the New Haven Green.

In 1796, a group led by U.S. senator James Hillhouse planned for a new cemetery outside the center of New Haven. The state incorporated the new cemetery the following year (making it the first chartered burial ground in the United States), and on November 9, 1797, local resident Martha Townsend became the first person buried in "the New Burying Ground in New Haven."

Administrators divided the cemetery grounds into different sections, separating people in death by race and religion, as well as by their residential status (whether it be local resident, visitor or indigent traveler). The last burial took place there in 1812, and in the 1840s, residents raised money to erect the large sandstone walls around three sides to keep vandals away. By the 1870s, what had evolved into the "New Haven City Burial Ground" became known as Grove Street Cemetery.

Among those interred at the cemetery are such notable Americans as Roger Sherman, Eli Whitney and Noah Webster. The famous names found on Grove Street's headstones, combined with its unique Egyptian Revival architecture, eventually turned the cemetery into something of a tourist attraction. It became a National Landmark in 2000.

November 10

The Tong Wars Come to Manchester

The Tong Wars were a series of feuds in the late nineteenth and early twentieth centuries between rival gangs made up mostly of Chinese immigrants and their descendants. The term *tong* meant "hall" or "meeting place" in Chinese but, once Anglicized, became associated with these rival ethnic factions. Tongs began as benevolent societies offering protection to newly arriving immigrants, but competition between them facilitated their evolution into criminal organizations.

On the morning of March 24, 1927, Ching Lung, thirty-three, and Soo Hoo Wing, twenty-two, two members of the On Leong tong, arrived by rail in Hartford intent on murdering a member of the rival Hip Sing tong. The two men took a taxi to a Manchester laundry, where they shot their victim twice before reentering the same taxi and escaping to Meriden. From there, they took another cab to New Haven, where authorities quickly apprehended them.

Based on the testimony of several witnesses (including one of the cab drivers) and the presence of Soo Hoo Wing's fingerprints on the murder weapon, a jury sentenced the two men to death by hanging. The state carried out the sentence in November, executing both men in a chamber specially designed for hangings at the Wethersfield State Prison.

On November 10, 1927, the two criminals received an elaborate funeral in Hartford, financed largely from tong operations based out of New York City. Seventy tong men and a marching band accompanied the bodies on their way to interment at Zion Hill Cemetery.

November 11

The Windsor Locks Canal

In 1824, with work on the Farmington Canal already underway, commercial interests along the Connecticut River sought to keep pace by building a canal of their own. In order to open up river transportation between Hartford, Connecticut, and Springfield, Massachusetts, designers

The Main Street canal and rail crossing, Windsor Locks. *Archives and Special Collections of the University of Connecticut Libraries and AT&T.*

envisioned a canal system that navigated around Connecticut River rapids in Enfield.

Construction began in June 1827, and on November 11, 1829, residents celebrated the opening of what became the Windsor Locks Canal. For more than a decade, steamboats and scows brought people and goods back and forth between Connecticut and Massachusetts. The growth of railroad transportation, particularly the Hartford and Springfield Railroad, brought an end to much of the canal traffic, however. Though the canal still provided waterpower for several paper and rolling mills in the area, as the mills closed, nature slowly reclaimed much of the canal's infrastructure.

November 12

Town Meetings on the Constitution

After delegates to the 1787 Constitutional Convention agreed on a draft of the new American constitution, the ratification of the document fell to votes cast by individual states. The state votes, in turn, hinged on the votes cast by delegates elected from individual towns. Connecticut scheduled the town meetings for electing delegates to the state convention to take place on November 12, 1787.

While towns such as Danbury and Ridgefield elected delegates and instructed them to vote in favor of the Constitution, many towns needed more time to debate the issues. In fact, twenty-four of the seventy-nine towns in Connecticut voted to postpone their meetings until a later date while they grappled with the idea of conceding more power to a centralized government. Many town officials wanted more specific information regarding the proposed power of the federal government to levy taxes, the terms of federal judge appointments and the processes required for amending the Constitution.

In addition to debates over constitutional questions, some towns, such as Woodstock, dealt with instances of voter fraud in the election of their delegates, while Windham did not feel it proper to hold any vote at all. In the end, several towns, including Pomfret, Hebron and Mansfield, voted against the Constitution, but they proved to be in the minority. In January 1858, delegates to the Connecticut state convention voted to ratify the Constitution by a vote of more than three to one.

cNovember 13

The Birth of Suffragette Militancy

Emmeline Pankhurst was a British women's rights activist who used militant tactics in an attempt to win women the right to vote. In 1889, she founded the Women's Franchise League and, four years later, help found the more militant Women's Social and Political Union (WSPU). Members of the WSPU (the first activists labeled as "suffragettes") smashed windows, started fires and staged hunger strikes to further their cause.

In 1913, Pankhurst embarked on a tour of the United States to rally support for her cause. Upon her arrival in New York on October 18, however, authorities detained her at Ellis Island. Due to her inflammatory calls for "revolution" and militant actions, government authorities ordered her deported. Pankhurst appealed the decision, and ultimately President Woodrow Wilson ordered her release.

On November 13, 1913, Pankhurst addressed an assembly of suffragists in Hartford. In attendance was famous architect Theodate Pope, who encouraged Pankhurst to delve into stories of what life was like for women

in England. The evening included the passing of collection plates that accumulated $1,400 (approximately $30,000 in modern terms) in donations to further Pankhurst's cause.

Much of the militancy associated with Pankhurst's efforts dropped off the following year as Pankhurst leant her support to her country during World War I. In 1918, Britain passed the Representation of the People Act, which gave women over thirty the right to vote. The government lowered that age to twenty-one shortly before Pankhurst's death in 1928.

November 14

Boat Shoes

Paul Sperry was a Connecticut native who came from a nautical family. Sperry was an avid sailor and joined the navy during World War I. After returning to sailing at the war's end, Sperry experienced firsthand the potential hazards of slipping on a boat deck and searched in vain for a shoe capable of providing the traction he desired.

One winter day in 1935, he watched his cocker spaniel navigate across a patch of snow and ice without slipping, and this gave him an idea. He created a shoe with a herringbone pattern (similar to what he found on his dog's paws) cut into a white rubber sole. The pattern gave the shoe traction, and the white soles helped minimize scuff marks on a boat's deck. Sperry set up shop in New Haven and received a patent on his "Top-Sider" on November 14, 1939.

Impressed by its performance, the U.S. Navy utilized Sperry's design for use by servicemen during World War II. Fashion trends inspired by the Kennedys in the 1960s and "preppies" in the 1980s kept sales brisk. The popular shoe then went on to become the official shoe of the U.S. Sailing Team.

November 15

A "Rookie" Sings Opera at the Met

Rosa Ponselle was born in Meriden, Connecticut, in 1897 and pursued a career in entertainment from a young age. She traveled throughout the East Coast, appearing with her sister in numerous vaudeville acts, when, at the age of twenty-one, she signed a $150-per-week contract with opera manager Giulio Gatti-Casazza. Her first opera performance took place on November 15, 1918, in *La Forza del Destino* at the Metropolitan Opera. She became an instant success.

Over the next two decades, Ponselle became one of the signature voices of her generation. After leaving the Met in 1937, she made an unsuccessful attempt at transitioning into motion pictures. A failed return to the Met led to a series of concert tours, with Ponselle making her final regular appearances in 1939.

Rosa Ponselle (far left) and First Lady Eleanor Roosevelt (center) at the Jamboree for Prominent Women in Washington, D.C., March 9, 1940. *Library of Congress, Prints and Photographs Division, Harris and Ewing Collection.*

November 16

The First Connecticut Governor Actually Born in Connecticut

Joseph Talcott's grandfather John, after arriving from England around 1632, was one of the first settlers to buy land in what became Hartford. John became treasurer of the Connecticut Colony, as did his son. It was within this politically connected family that Joseph Talcott grew up with his eight siblings and five stepsiblings.

After becoming an officer in the local militia and inheriting property upon his father's death, Talcott rapidly transitioned through a series of civil and political offices. After several years of judicial appointments, he became deputy governor in 1723 after the death of Nathan Gold. The following year, Governor Saltonstall passed away, and legislators chose Talcott to take his place. Born in Hartford in 1669, Talcott became the first governor of the Connecticut Colony born in Connecticut.

Success in his new role as governor led to his reelection for a series of terms lasting seventeen years. During the course of his governorship, he used his legal background to help settle border disputes between Massachusetts and New Hampshire in 1730 and Maine and New Hampshire in 1731. He also thwarted numerous legal attempts by indigenous peoples living in the eastern part of the colony to regain stolen lands through appeals to the British government.

After seventeen years in office, Talcott died in 1741. Having acquired substantial wealth during his political career, his estate included land held in several different towns (including Middletown, Bolton and Coventry) and the ownership of five slaves.

November 17

The First Clock Patent in America

It was 1773 when English clockmaker Thomas Harland arrived in Norwich, Connecticut, and began making clock movements. He hired an apprentice named Daniel Burnap, who eventually found the need for his own apprentice. This apprentice was fourteen-year-old Eli Terry of East Windsor.

Terry went into business for himself in 1793, manufacturing wood and brass movements. On November 17, 1797, Terry received the first clock patent in America for his refined clock design. His success helped Connecticut grow into the leading clock manufacturer in the United States.

Terry continued to build on his achievements in the years that followed, acquiring ten clock patents over the course of his lifetime. In 1807, he helped revolutionize clock manufacturing after accepting an order for four thousand tall case movements from Edward and Levi Porter of Waterbury. In order to produce such a massive number, Terry devised a system of mass production harnessing waterpower to drive machines used to create large quantities of interchangeable parts. (Up until that time, most clock movements consisted of unique, handmade parts.) He filled the order in just three years.

In 1814, Terry made perhaps his last great contribution to clock manufacturing. Utilizing a design he patented two years later, Terry made a clock movement small enough to fit on a typical household shelf. These smaller wooden clocks proved popular for both their size and affordability, and their portability leant itself to sale by peddlers who traversed the countryside. The shelf clock's success helped cement Terry's legacy as the father of mass produced clocks in America.

November 18

Discovering Antarctica

Nathaniel Brown Palmer was a seaman from Stonington, Connecticut. Born in August 1799, he first set sail at just fourteen years old and served on a ship running British blockades during the War of 1812. After the war, he entered the sealing industry, exploring the South Sea looking for new seal rookeries. With seal populations in many parts of the southern hemisphere already depleted, sealers began traveling farther south in search of new hunting grounds.

In 1818, Palmer became the captain of the schooner *Galina* and began exploring areas south of Cape Horn. It was on November 18, 1820, however, while Palmer served as captain of the *Hero*, that he became the first captain to lay eyes on the continent of Antarctica. He took it upon himself to name it "Palmer Land."

In the years that followed, discrepancies emerged as to the exact date Palmer discovered Antarctica and even whether or not he was the first to find it. (Both Edward Bransfield of England and Fabien Gottlieb von Bellingshausen of Russia claimed to be the first to discover the new continent). Still, the Antarctic peninsula Palmer stumbled upon retained the name Palmer Land in his honor.

November 19

International Silver

As an entity covered under the laws of the state of New Jersey, the International Silver Company incorporated on November 19, 1898, and set up its headquarters in Meriden, Connecticut. The area in and around central Connecticut became a hub of the silver industry in the mid-nineteenth century, thanks, in part, to former peddlers Horace and Dennis Wilcox, who established the Meriden Britannia Company in 1852 and began coating their products in silver shortly after.

The first order of business for the International Silver Company was to buy up many of the silver businesses in the area and run them all as one giant corporation. International immediately purchased a long list of companies that included the Meriden Silver Plate Company, the Norwich Cutlery Company, the Wilcox Silver Plate Company of Wallingford, the Rogers & Hamilton Company of Waterbury, the Holmes & Edwards Silver Company in Bridgeport and the Barbour Silver Company and William Rogers Manufacturing Company in Hartford.

The revenues of the International Silver Company fluctuated in its formative years, but the company continued to grow and, by 1926, was grossing over $20 million per year. Meriden eventually became the major producer of silver products in the country, and in 1946, International Silver incorporated in Connecticut.

The middle of the twentieth century brought an era of corporate diversification, and the International Silver Company began branching out into electrical wiring, cosmetics and paper production. In the 1960s, it added office products and automotive parts. By 1984, silver production in Meriden had largely come to an end.

November 20

Guglielmo Papaleo Wins the Featherweight Title at Madison Square Garden

Willie Pep had a record of 53-0 as a professional boxer when he stepped into the ring against featherweight champion Chalky Wright at Madison Square Garden on November 20, 1942. In front of 19,521 fans, Pep fought a largely defensive battle, fending off a barrage by Wright in the middle rounds, and won eleven of the fifteen rounds on his way to becoming the youngest featherweight champion in professional boxing in forty years.

Pep was a Connecticut native, born in Middletown under the name Guglielmo Papaleo in 1922. After a childhood spent selling newspapers and shining shoes to help his family survive, he began boxing as an amateur in 1937 and then dropped out of high school to pursue a professional boxing career. Including his championship fight in 1942, Papaleo, whose Anglicized name was William and who fought under the name "Willie Pep," won his first sixty-three professional bouts before losing a non-title fight to Sammy Angott. Pep followed this loss by winning his next seventy-three fights.

Pep retired from boxing in 1966 with an unprecedented record of 230-11-1 after a career spanning twenty-six years. Retirement brought work as a referee and a sports columnist, as well as induction into the National Italian American Sports Hall of Fame in 1977 and the International Boxing Hall of Fame in 1990. Pep died in 2006 at a Rocky Hill nursing home after a five-year battle with Alzheimer's disease.

November 21

The New Britain Bakery Murders

As far as New Britain police ascertained, forty-nine-year-old Robert Kron stopped into the Donna Lee Bakery around 8:00 p.m. on October 19, 1974, to purchase some bread. He was followed by twenty-seven-year-old William Donahue Jr. of West Hartford, who was on his way to a dance for Northeast Utilities workers and needed directions to his date's house, and Thomas and Anne Dowling of New Britain, who stopped in for donuts after church.

Police found all four customers shot to death, along with bakery worker Helen Giansanti and owner John Salerni, just hours later.

Their killers were two New Britain men, Ronald Piskorski and Gary Schrager, both known as heavy drug and alcohol abusers. The two men, who had planned the robbery in advance, left a nearby party on the night of the nineteenth to rob the bakery but, finding Giansanti working alone and without much cash, waited for Salerni to return, which occurred after the unfortunate customers entered the building. In the end, the two crooks made off with only $300, leaving behind valuables and $1,350 Salerni had in his pocket.

After receiving a tip from Schrager's wife, police arrested Schrager and Piskorski and, on November 21, 1974, charged the two with murder. Piskorski ultimately received a sentence of 150 years to life in prison and Schrager, who disavowed any responsibility for the actual shootings, twenty years to life.

November 22

Colonial Dames

Elizabeth Colt (wife of deceased gun manufacturer Samuel Colt) hosted a meeting at her home (known as Armsmear) in Hartford on November 22, 1893. Colt, who also involved herself in the Hartford Decorative Arts Society, the Hartford Soldiers' Aid Society and the Women's Auxiliary to the Board of Missions of the Episcopal Church, looked to form a Connecticut chapter of the National Society of Colonial Dames of America. Though the national society had formed just one year earlier, Connecticut was already the last of the original thirteen states to form a local chapter.

The Colonial Dames was a genealogical society requiring members to trace their ancestry back to someone who had served the colonies in a military or civil capacity. Its initial goal was to protect and preserve the rapidly decaying manuscripts, documents and relics from the eighteenth century that provided detailed accounts of life in the times of their ancestors.

The Connecticut chapter chose Mrs. Nathaniel Shipman as its first president, but just one week later, Shipman stepped down, and the members chose Elizabeth Colt as her replacement. Colt also served as vice-president of the national organization from 1900 until her death in 1905.

In addition to preserving important documents and small artifacts from the colonial era, the Connecticut chapter expanded its efforts to include preserving historic buildings. In 1919, it purchased the Joseph Webb house in Wethersfield from photographer and antiquarian Wallace Nutting and eventually turned it into one of Connecticut's premier house museums.

November 23

The First African American Regiments

In the months following Abraham Lincoln's Emancipation Proclamation in 1863, the United States War Department created the Bureau of Colored Troops, meant to raise regiments of African American soldiers to fight in the Civil War. Though not as rapid to respond as other states, Connecticut held a heated debate

The Twenty-ninth Regiment at Beaufort, South Carolina (1864). *Library of Congress, Prints and Photographs Division, Civil War Glass Negatives and Related Prints.*

on the subject at a special session of the General Assembly on November 13. On November 23, 1863, Connecticut governor William Buckingham authorized a bill creating the Twenty-ninth Regiment Colored Volunteers.

By January, more than 1,200 volunteers had formed the Twenty-ninth—more than 500 more became parts of other regiments. After a parade through New Haven, the men set sail from Long Wharf in March 1864 to serve guard duty in Beaufort, South Carolina. Later, after fighting in several battles, including the Battle of Fair Oaks, two companies of the Twenty-ninth were among the first to enter the Confederate capital of Richmond after its fall in April 1865.

November 24

Taproom Politics

Bill O'Neill learned a great deal during his time working in the family business at O'Neill's Taproom, a small neighborhood tavern in East Hampton, Connecticut. A native of Hartford who grew up in East Hampton, O'Neill studied to be a teacher, worked at Pratt & Whitney Aircraft and sold life insurance before serving in the air force during the Korean War. After returning from the war, he settled into work at his father's tavern and found out a great deal about the needs of the community around him.

In 1954, O'Neill used this knowledge to become a member of the East Hampton Democratic Town Committee and sat on the Board of Finance and the town's Zoning Board of Appeals. From there, O'Neill won election to the state House of Representatives (on his third try). He then won reelection five times and, in 1975, became the House majority leader.

It was in 1978 that governor Ella Grasso left the choice of her running mate up to the state Democratic convention, and the convention chose Bill O'Neill to become Connecticut's lieutenant governor. When Grasso resigned in 1980, O'Neill became governor and served the state in that position for ten years. During his tenure, he helped raise teacher salaries, rebuild the state's transportation infrastructure and clean up Connecticut's water.

After retirement, O'Neill returned to East Hampton, where he passed away on November 24, 2007. The state buried him with military honors and even named a terminal at Bradley International Airport in his honor.

November 25

La Madrina

The death of Maria Sanchez (known around Hartford as La Madrina, "the godmother") on November 25, 1989, was a tremendous blow to the state's Puerto Rican and educational communities. With little more than an eighth-grade education, the twenty-eight-year-old Sanchez left Puerto Rico for Hartford in 1954. There, she set up a store, Maria's News Stand, on Albany Avenue and quickly became a fixture in the community.

Sanchez's business soon became a gathering place for Hartford's growing Puerto Rican population. Frustration at the lack of support and representation in state affairs inspired Sanchez to found the Puerto Rican Parade Committee in 1964 and, later, to form numerous associations aimed at providing legal, financial and community support to the state's Hispanic population.

In 1971, Sanchez began a campaign for mandatory bilingual education in Connecticut, and the following year she opened La Escuelita, the first bilingual school in the state. In order to expand on her efforts, Sanchez served on the Hartford Board of Education for sixteen years and, in 1988, became the first Hispanic woman elected to the Connecticut General Assembly.

To honor Sanchez's memory, the state dedicated the Maria C. Sanchez Elementary School in September 1991. Two years later, she earned a place in the Hartford Public Library's Plaza of Fame.

November 26

The Hartford City Guard

Fear of a Confederate attack on the prosperous city of Hartford in 1860 resulted in a meeting of twenty-two men in the office of General J.D. Williams in November 1860 to discuss forming a military company. Two months later, the Hartford City Guard mustered into service. Donning red pants and blue shirts, the company conspicuously paraded around the city, setting up camp near the state armory, and even sent a company to the front to fight in the Peninsular Campaign.

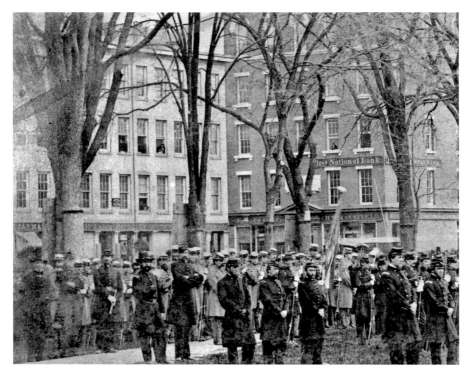

The Hartford City Guards and the New Haven Greys in New Haven (1864). *Library of Congress, Prints and Photographs Division, Historic American Buildings Survey/Historic American Engineering Record/Historic American Landscapes Survey.*

Six years later, on November 26, 1867, ex-guardsmen formed the Veteran Association of the Hartford City Guard. The organization consisted of members who had joined the guard prior to July 5, 1865. The Veteran Association held reunions every year on the second Wednesday in January, up until their fiftieth reunion in 1917, when those in attendance voted to make it their last.

November 27

The Connecticut Equal Rights Amendment

Despite Connecticut voting to ratify the federal Equal Rights Amendment in 1973, the legislation still required approval from additional states to become a federal law. Rather than waiting for that to occur, progressive elements

within Connecticut drafted their own amendments to the state's constitution to take effect immediately after a vote in November 1974. The amendment called for legal protection from discrimination based on a person's sex.

While women's groups and unions leant their support to passage of the amendment, numerous groups in the state debated the benefits of such legislation. One of these groups was the Citizens for the Preservation of Womanhood (based out of Monroe), which expressed concern that the passage of a state equal rights amendment destroyed protection for women in the workplace, lost a woman her right to financial support from her husband and opened the state up to the construction of unisex public restrooms.

On election day in 1974, proponents of equal rights for women overwhelmed the legislation's critics at the polls, however. With the state already providing protection from discrimination based on race, religion and national origin, on November 27, 1974, the General Assembly adopted the amendment to the state constitution that added "sex" to this list of protections.

November 28

The Green Bay Packers

Wartime restrictions on travel kept the Green Bay Packers from traveling home after a game in Brooklyn in late November 1943. Rather than traveling back to Green Bay and then to Philadelphia for their next game, the Packers stayed on the East Coast, at the Rye Country Club in New York. In order to pass the time and provide entertainment for workers laboring in local war industries, the Packers agreed to play an exhibition game at Muzzy Field in Bristol, Connecticut—in return for a payment of $3,000.

First dedicated in 1914, Muzzy Field hosted horse races, as well as football and baseball games. In fact, the first player ever to hit a home run at Muzzy Field was none other than Babe Ruth. Unfortunately, the stadium held only three thousand seats, so Bristol officials reached out to the nearby city of New Britain to acquire extra bleachers.

On November 28, 1943, ten thousand fans watched coach Curly Lambeau's Green Bay Packers play the New London Diesels—a semipro team. Green Bay's starters played only about five minutes and, after scoring a touchdown on their opening drive, were well on their way to a 62–14

victory. At halftime, local officials and the New Britain High School band honored Green Bay Packer Harry Jacunski, a native of New Britain, and his mother (who watched him play for the first time as a Packer that day) with a war bond and bouquet of flowers.

November 29

The Neptune's Voyage to Riches

Between 1796 and 1799, the 353-ton merchant ship *Neptune* completed one of the most successful trading voyages in early Connecticut history. Spanning the globe, wealthy New Haven ship owner Ebenezer Townsend hunted and bartered his way to a small fortune.

After traveling from New Haven to New York, the *Neptune* embarked on its epic journey on November 29, 1796, with forty-five Connecticut sailors, $500 in gold and a cache of tradable goods. A stop in the West Indies procured rum and sugar, and bartering in Brazil led to the acquisition of indigo and sandalwood. The ship stopped in the Falkland Islands and commenced lucrative operations hunting seals. After traveling around Cape Horn and arriving in China, Townsend traded sealskins and the remainder of his original cargo for silks, ivory and teas.

The *Neptune* returned to New Haven on July 11, 1799, having circumnavigated the globe. It returned with its $500 in gold still intact but now carried with it goods worth approximately a quarter of $1 million. After the federal government extracted a significant portion of the profits in the form of duties placed on the traded items, there still existed enough profit to make the voyage's investors extremely wealthy.

November 30

Lucy and Desi Get Married

Cuban-born bandleader Desi Arnaz first met Lucille Ball on the set of her 1940 film, *Too Many Girls*. The couple then began a courtship they kept secret from everyone, including their publicists. On November 30, 1940,

Arnaz called the Roxy nightclub in New York, where he was scheduled to perform in two shows that day, to say he was in Connecticut and would miss the first of the two shows because it was his wedding day.

Ball had flown in from a personal appearance in Milwaukee the previous Friday. The two came to Connecticut and obtained the required blood tests, but after applying for their marriage license, they found out that Connecticut law required a five-day waiting period before issuing any licenses, unless the parties involved found a judge willing to grant them a waiver. Arnaz and Ball went to probate court, and Judge Harold Knapp granted them the necessary waiver.

Ball, twenty-nine, and Arnaz, twenty-three, got married at the Byram River Beagle Club in Greenwich, Connecticut. Arnaz then made his way to the Roxy, and after his engagement at the club ended, the two headed to Havana for their honeymoon.

Eleven years later, their popular television show *I Love Lucy* hit the airwaves and became the number-one program in the country in less than a year. The show lasted nineteen years, despite numerous rumors of the rocky relationship between the two stars. Shortly after the last show aired, Arnaz and Ball divorced.

DECEMBER

December 1

Pfefferminz

In the 1920s, Austrian Edward Haas III made mints he marketed to adults to help them stop smoking. He opened a factory in Czechoslovakia and marketed the mints in dispensers shaped like cigarette lighters. The mints got their name, PEZ, from a shortened form of the German word *pfefferminz*.

In the 1950s, PEZ arrived in America. To increase marketing, the company made the mints in fruity flavors and placed them in toy dispensers baring likenesses to different superheroes, cartoon characters and movie stars. With a U.S. subsidiary located in New York City, the company began patenting its dispensers. It added feet to the dispensers (to make them easier to display) after relocating from New York to Orange, Connecticut, in the 1970s.

On December 1, 2011, PEZ opened a six-thousand-square-foot visitors' center in Orange. The center contained more than five thousand PEZ-themed displays, including a PEZ trivia game and a full-sized motorcycle made of PEZ. The center also contained glass walls, allowing visitors to watch the company produce over ten million candies every day.

December 2

The First Artificial Heart Surgery

Robert Jarvik grew up the son of a doctor in Stamford, Connecticut. After enrolling in Bologna's School of Medicine in Italy, he studied biomechanics at New York University. In 1976, he earned his medical degree from the University of Utah College of Medicine (a program known for conducting extensive research on the use of artificial organs). After losing his father to heart disease, Jarvik began researching artificial heart technology.

The device Jarvik invented was a $16,000 artificial heart named the Jarvik-7, made mostly of polyurethane. On December 2, 1982, doctors at the Utah Medical Center implanted Jarvik's invention into a living person, making it the first artificial heart operation in history.

The patient was a dentist from Seattle named Barney Clark, who was on the verge of death from heart failure. Following a seven-and-a-half-hour operation—extended by the replacement of a broken mechanical part on the Jarvik-7—doctors managed to control the rate of Clark's heartbeat through a large console that pumped air in and out of hoses attached to the heart. The sixty-one-year-old Clark lived another 112 days with his artificial heart before passing away at the University of Utah Medical Center in Salt Lake City in March 1983.

December 3

The First Continental Flag Ship

George Washington had the British pinned down in Boston in the fall of 1775, but his hold was tenuous at best. With British reinforcements on their way by sea, the Continental Congress decided it needed a navy. In October, Congress authorized the purchase and refitting of four ships for use in battle.

Among these ships was the three-hundred-ton merchant ship *Black Prince* (originally built in Philadelphia in the fall of 1774). Refitted in New London, Connecticut; armed with thirty cannon; and placed under the command of New London captain Dudley Saltonstall, the newly renamed *Alfred* became the first flag ship of the American colonies. On

The Grand Union flag raised on the *Alfred* at its commissioning on December 3, 1775, in Philadelphia. *U.S. Navy Art Collection, Washington, D.C., public domain image.*

December 3, 1775, Saltonstall became the first to unfurl the colonial flag on the high seas when he led the *Alfred* on a raid to capture Providence, Nassau, in the British West Indies.

December 4

The Only Four-Train Collision in American History

On the morning of December 4, 1891, with no traffic expected on the westbound track, workers at the railroad station in East Thompson, Connecticut, began using the track to couple cars for the Southbridge Freight. Little did they know that a train dispatcher in Putnam had transferred the eastbound 212 Freight temporarily onto the westbound track to allow two eastbound express trains headed for Boston to pass it. At 6:40 a.m., the 212 Freight roared out of the fog on the westbound track in East Thompson and barreled into the Southbridge Freight. The crash destroyed both locomotive engines and left a railcar jackknifed over the eastbound track.

As stunned workers came to terms with the crash, the first of the two express trains, the Long Island and Eastern States Express, came around

the corner at East Thompson traveling fifty miles an hour. It smashed into the jackknifed railcar on the eastbound track, sending the train over an embankment and into a telegraph pole—killing engineer Henry Tabor and fireman Jeremiah Fitzgerald.

Suddenly realizing that the Norwich Steamboat Express was only minutes behind the Long Island Express, a crewman ran up the line in an attempt to stop it but was too late. At 6:45 a.m., the Steamboat Express plowed into the back of the Long Island Express, setting it afire.

Despite the horrific nature of the crash, remarkably only Tabor and Fitzgerald lost their lives. The devastation near the wreck proved so extensive, however, that the rail line's operators opted to reroute trains around the site rather than rebuild the destroyed track.

December 5

Closing America's First Law School

In 1793, Tapping Reeve and his wife, Sally Burr Reeve, settled in Litchfield, Connecticut. The following year, Sally's brother, Aaron Burr (the future vice president of the United States who famously went on to kill Alexander Hamilton in a duel), came to live with them, and Tapping Reeve began instructing Burr on the law. Reeve earned a reputation as an effective and knowledgeable instructor, and it was not long before others placed themselves under his tutelage. His classes became so popular that Reeve eventually had to construct a schoolhouse on his property to accommodate the growing number of students. Reeve's Litchfield Law School became the first of its kind in the country.

In 1798, after receiving an appointment to the Connecticut Supreme Court, Reeve asked James Gould to join him as an instructor at the school. Born in Branford, Connecticut, on December 5, 1770, Gould attended Yale and worked as a schoolteacher before graduating from Litchfield Law School. Together with Reeve, Gould constructed an eighteen-month curriculum that challenged some of the most famous legal minds of the era.

Gould eventually built an additional school building on his own property to handle the overflow of students and, in 1820, began operating the school by himself. Unfortunately, just thirteen years later, Gould's failing

health forced him to close the school—but not before it graduated almost one thousand students, many of whom went on to become senators, congressmen, governors, state supreme court justices and even vice president of the United States.

December 6

Connecticut Yankee Nuclear Power

When the nuclear power plant operated by the Connecticut Yankee Atomic Power Company began operations in Haddam Neck, Connecticut, on January 1, 1968, it became the first commercial nuclear plant in the state and one of only two full-scale nuclear power operations in the country. The plant provided Connecticut residents with 490,000 kilowatts of electricity.

By the 1990s, however, nuclear energy proved expensive to produce compared to other available energy sources. This, combined with dangerous leaks at the Haddam Neck plant in 1978 and 1989, convinced its board of directors (on December 6, 1996) to close the plant.

The decommissioning of the plant began in 1998 and involved a painstakingly slow process of dismantling and removing radioactive components until radioactivity reached levels low enough to allow for reuse of the site. This process did not reach its conclusion until 2007. With portions of the site, including nearly one thousand nuclear fuel assemblies, remaining under the control of the Nuclear Regulatory Commission, the U.S. Fish and Wildlife Service eventually bought approximately fifteen hectares of the property and turned it into part of the Conte National Fish and Wildlife Refuge.

December 7

The Connecticut Governor Inducted into the Baseball Hall of Fame

Many Connecticut residents know Morgan Bulkeley for his organizing of the Connecticut Mutual and Aetna insurance companies, for the bridge connecting Hartford and East Hartford that bears his name or

for breaking into his locked governor's office and serving two more years after an election to find his replacement resulted in legislative gridlock. Prior to entering politics, however, Bulkeley was a Civil War veteran and baseball pioneer.

In 1861, Bulkeley joined the Union army and fought in the famous Peninsular Campaign during the Civil War. At the war's conclusion, he returned to Hartford and launched his career in insurance and finance. He also involved himself in baseball, investing in the National Association's Hartford Dark Blues. In 1876, when the newly formed National League replaced the National Association, the Hartford Dark Blues became one of the original members of the new league, and Bulkeley became its president. He resigned after only one year, however.

His post-baseball career saw him enter politics. In 1880, he became mayor of Hartford and, in 1889, began a fourteen-year run as Connecticut's governor. He then entered the U.S. Senate before returning to the insurance business and then passing away in 1922. In 1937, however, the National Baseball Hall of Fame inducted Bulkeley as one of the pioneers of the game. When the shrine officially opened in Cooperstown in 1939, visitors found Bulkeley's name listed alongside such iconic figures as Babe Ruth, Tris Speaker, Ty Cobb, Honus Wagner and Walter Johnson.

December 8

The Learned Blacksmith

At his birth on December 8, 1810, Elihu Burritt became the youngest of ten children born into a working-class family in New Britain. Largely self-educated, Burritt apprenticed himself to a blacksmith after the death of his father but found time at night to study languages (eventually teaching himself almost fifty). After walking from New Britain to Boston to study the collections of the American Antiquarian Society, Burritt ended up working at a forge in Worcester, Massachusetts, where his linguistic skills came to the attention of the governor, who dubbed him the "Learned Blacksmith."

Burritt then began speaking in public and, while researching materials for his lectures, became enamored of the concept of world peace. He developed into one of the most recognized and respected pacifists of his time.

In the 1840s, Burritt headed to Europe, where he helped form the pacifist League of Universal Brotherhood in England and, later, the Brussels Peace Congress. President Lincoln then appointed him U.S. consul to England during the 1860s.

After returning from England, Burritt retired to his hometown of New Britain. He suffered a stroke a few years later and eventually passed away in 1897.

December 9

Jim Morrison Arrested in New Haven

Backstage before a concert by the legendary rock group the Doors at the New Haven Coliseum, on December 9, 1967, lead singer Jim Morrison made out with a female fan in a dressing room shower. As accounts of the story reported, a police officer, not recognizing Morrison, told the couple to stop. Morrison then allegedly cursed at the officer and pushed him, causing the officer to spray Morrison with Mace.

Once on stage, Morrison, still angry about the backstage altercation, launched into a tirade of obscenities directed at the police or, as he referred to them, the "little blue men." Officers then came out on the stage, arrested Morrison and charged him with obscene behavior and inciting a riot. Authorities released Morrison after he paid a twenty-five-dollar fine. Morrison later immortalized the event in the 1970 song "Peace Frog."

While awaiting trial for allegedly exposing himself at a concert in Miami in 1969, Morrison collapsed and died in a hotel room in Paris, France, in July 1971. He was twenty-seven years old. The state of Florida later posthumously pardoned Morrison, but Connecticut never did. Connecticut typically requires a request for pardon come from the person actually convicted of the crime.

December 10

"Inventing" Anesthesia

Horace Wells was a Hartford dentist who, on the night of December 10, 1844, attended a nitrous oxide demonstration put on by the famous showman Gardner Colton. During the course of the demonstration, one of the volunteers to whom Colton administered the gas injured his leg but reported feeling no pain. Wells decided the gas might work to lessen pain during tooth extractions.

The day after the demonstration, Colton came to Wells's office and administered nitrous oxide to Wells while the dentist had one of his own teeth extracted. Declaring the test a success, Wells began administering the gas to his patients. The following February, Wells's former apprentice and partner William Morton arranged for Wells to give a demonstration of his technique at the Massachusetts General Hospital, but the improper administration of the gas nullified much of its effect, and the crowd turned on Wells, accusing him of being a fraud.

In 1848, Wells temporarily left his family behind to set up a practice in New York City and gain greater exposure for his experiments. Away from his home and family, Wells became depressed and started treating himself with ether and chloroform. On the night Wells turned thirty-three, he hurled acid at two women in the street, and police promptly arrested him. While behind bars, Wells committed suicide by inhaling chloroform and then cutting the main artery in his leg.

December 11

The Gas Turbine Helicopter

A colleague of helicopter pioneer Igor Sikorsky, Charles Kaman, at age twenty-six, used $2,000 invested by two friends to found what became the Kaman Corporation in West Hartford. Four years later, in 1949, he built the Kaman K-225 helicopter but soon replaced the aircraft's engine with a light, powerful Boeing gas turbine engine, known more commonly as a "jet" engine. On December 11, 1951, the K-225 took to the skies as the first helicopter to fly utilizing a gas-powered turbine engine.

The Kaman K-225. *Smithsonian National Air and Space Museum (NASM 2007-01799).*

Kaman also developed the first twin-turbine helicopter and the first remote control helicopter. Basing his aviation research on the study of vibrations, he later utilized this knowledge to found the popular Ovation brand of guitars. Kaman also established the Fidelco Guide Dog Foundation in the 1960s to provide service dogs to the blind.

December 12

Milford Jai Alai

Jai alai, a sport compared to cricket, squash and lacrosse, evolved from the game of handball in northern Spain in the nineteenth century. It came to Cuba in 1889 and debuted in America at the 1904 World's Fair in St. Louis. In 1972, in an effort to increase revenues, state legislators approved the creation of jai alai frontons in Connecticut. With little legalized gambling existing outside Las Vegas, the sport caught on very quickly.

The first Connecticut frontons opened in Hartford and Bridgeport in 1976. The following May, an arena offering 4,800 seats opened in Milford

and met with immediate success. An opening night crowd of seven thousand surrendered over $470,000 — more than Bridgeport and Hartford took in on their respective opening nights combined.

The fronton in Milford survived the arrival of casinos on the Atlantic City boardwalk in 1978 and having players regularly accused or convicted of throwing games because state residents had limited nearby options for gambling. In the early 1990s, however, the arrival of the Foxwoods and Mohegan Sun casinos put too much pressure on the jai alai industry. Hartford and Bridgeport closed their doors in 1995, but Milford held on until 5:00 p.m. on December 12, 2001. At that point, a nearly quarter-century run of jai alai in Connecticut came to a close, having generated over $76 million in revenue for the state.

December 13

The Shubert

The Shubert brothers opened a series of theaters in the early 1900s that hosted some of the most iconic shows and performers of the century. In December 1914, just two years after opening their first theater in New York City, Lee and J.J. Shubert opened the Shubert Theatre in New Haven and named it after their brother Sam. Opening night, December 11, 1914, witnessed a performance of *The Belle of Bond Street*, with seats sold for anywhere from $0.25 to $1.50.

In 1916, the Shubert in New Haven hosted the world premiere of *Robinson Crusoe, Jr.* starring Al Jolson. The show set a precedent of huge stars and important world premiers arriving in New Haven. In the years that followed, Lionel Barrymore, W.C. Fields and Will Rogers all graced the stage in New Haven, while the theater hosted premieres for such famous musicals as *South Pacific*, *The Sound of Music*, *Carousel* and *The King and I*. In 1943, audiences packed the New Haven Shubert to see *Away We Go*, a musical comedy that eventually went on to create theater history in New York under the name *Oklahoma!*.

It was 1976, after sixty years of memorable performances, when the Shubert closed. With New Haven in the midst of an extensive urban renewal program, authorities targeted the theater for demolition. Over

the next seven years, however, a fight to restore the theater ended up saving the Shubert, and it officially reopened for business on December 13, 1983.

December 14

Nazis Invade Southbury

In the late 1930s, with American politicians looking to appease German expansionists in hopes of avoiding another world war, the United States allowed the American wing of the Nazi Party (the German-American Bund) to set up camps across the country. On October 1, 1937, Stamford resident Wolfgang Jung purchased a 178-acre plot in Southbury, Connecticut, to set up Camp General von Steuben. Jung hoped to turn a nearby access road into a rail line bringing in Bund Youth Movement members from all over New York and Connecticut to a facility capable of accommodating over one thousand people.

Once the story of Jung's purchase made the newspapers, local residents rallied to subvert Jung's plans. The town called a meeting for November 23 to address the problem. In the meantime, a mass mailing went out to town residents, warning them of the danger of the Bund. In order to slow construction at the camp, police arrested workers clearing brush on a Sunday for violating Connecticut blue laws that prohibited work on Sundays.

On December 14, 1937, the town approved new zoning laws that allowed for agricultural use of the area in and around the camp but forbade paramilitary activity in the town unless conducted by the United States government. While many saw the town's strategy as a violation of the American Constitution, the measure still passed by a vote of 142 to 91. After the new law took effect, the Bund sold the property but threatened to set up camps elsewhere in Connecticut. None of those camps ever materialized.

December 15

The Hartford Convention

The War of 1812 hit New England's interests hard. While most of the country opposed British trade restrictions, Britain's checking of America's expansion westward and its impressing of American merchant sailors into the British navy, the economic wellbeing of the New England states depended largely on their ability to trade with Europe. A war with Great Britain took away America's greatest trading partner.

The most vocal opposition to the war came from the Federalist Party. On December 15, 1814, Federalist delegates from Connecticut, Rhode Island, Massachusetts, Vermont and New Hampshire met in Hartford to draft a formal protest of federal policies. The Hartford Convention called for an end to the disastrous trade policies introduced by presidents Jefferson and Madison, for economic support to bolster the struggling New England economy and for greater restrictions on presidential power.

The Hartford Convention lasted until January 5, 1815. What delegates did not know was that less than two weeks into their convention, on December 24, 1814, U.S. delegates in Europe had signed the Treaty of Ghent, ending hostilities with Great Britain. After word of the convention got out, Federalist opponents accused the convention's attendees of seditious acts and of attempting to convince the New England states to secede from the Union. The stigma attached to the Federalist Party after the convention helped to slowly bring about its demise.

December 16

The Yankee Expressway

In addition to the national security concerns that prompted numerous federal interstate highway projects in the middle of the twentieth century, a number of other factors prompted state and federal governments to fund the construction of larger, more direct transportation routes. Among these were America's growing love affair with the automobile, a postwar economic boom that required the transportation of ever-greater quantities

of raw materials and consumer goods to sprawling suburban areas and the need to alleviate congestion in well-traveled towns and cities by providing alternate routes around them.

In Connecticut, the outdated and overburdened Route 6 bore the brunt of the east–west travel in the state. In order to attract industry and relieve traffic congestion in populated areas such Danbury, Waterbury and Hartford, Connecticut began construction of a highway stretching from the New York border to Hartford. Governor Abraham Ribicoff suggested naming the road the "Yankee Expressway" (a suggestion adopted by the General Assembly in 1959)—to the rest of the nation, the new east–west highway was Interstate 84.

Construction on I-84 began in October 1958, and on December 16, 1961, the first major section of the highway opened (traveling from New York through Danbury, Bethel, Brookfield and Newtown). Simultaneous projects also brought about construction in Waterbury, Cheshire, Southington and Hartford that year. By the end of 1961, workers had completed seventy-four miles of I-84 at a cost of $61 million. Once in Hartford, designers planned to run the highway east to Providence, Rhode Island, but a debate in 1972 ultimately brought the decision to redirect its path up to the Massachusetts Turnpike.

December 17

Jimmy Carter and the Navy

Georgia-born Jimmy Carter graduated from the U.S. Naval Academy in 1946, having completed an accelerated program used in wartime. He went on to serve as a radar officer and a training and education officer before deciding to enter the submarine service. He completed his rigorous training at U.S. Navy Submarine School in New London, Connecticut, on December 17, 1948.

After receiving an honorable discharge in 1953, Carter entered politics. He won election to the Georgia senate in 1962 and, upon his second attempt, became Georgia's governor in 1971. Carter announced a run for the U.S. presidency three years later and won his party's nomination on the first ballot at the 1976 Democratic National Convention. He became the

nation's thirty-ninth president in November of that year and served in the Oval Office from 1977 until 1981.

A little more than a decade after Carter's loss to Ronald Reagan, the U.S. Navy ordered the construction of a new special mission submarine from shipbuilders at Electric Boat in Groton, Connecticut. When completed, SSN-23, the USS *Jimmy Carter*, was just the third sub built as part of the new Seawolf class and became the largest submarine in the United States Navy.

December 18

The Demonic Possession Trial

In February 1981, nineteen-year-old Arne Johnson; his twenty-six-year-old girlfriend, Debbie Glatzel; and Johnson's friend and landlord, forty-year-old Alan Bono, took in a meal together at the Mug 'N' Munch café in Brookfield. After consuming three carafes of wine, the group returned to Johnson's apartment on the grounds of Bono's dog kennel. There, Johnson and Bono got in a fight over Debbie Glatzel, and Johnson took out a knife and stabbed Bono in the abdomen five times before running off into the woods. Police arrested him later that day and charged him with Bono's murder.

While prosecutors contended Johnson had killed Bono in a drunken rage, Johnson's attorney, Martin Minella, claimed the murder was the result of demonic possession. Minella argued that Johnson became possessed by demons after witnessing an exorcism on Debbie Glatzel's twelve-year-old brother. Minella planned to call on Ed and Lorraine Warren of Monroe, paranormal investigators, to testify that forty-three demons possessed Glatzel's brother and that, during the exorcism, Johnson challenged the demons to possess him.

A Danbury judge ultimately threw out Minella's defense in the so-called Brookfield Demons case. A jury later convicted Johnson of manslaughter and, on December 18, 1981, sentenced him to ten to twenty years in prison.

December 19

A Stitch in Time

Watertown native Nathaniel Wheeler entered into the machinery business in the middle of the nineteenth century. As part of the firm of Warren, Wheeler & Woodruff, he traveled in 1851 to New York, where he met Allen Wilson. Wilson was a blacksmith and cabinetmaker who had a new design for a sewing machine. Wheeler agreed to oversee the production of five hundred of Wilson's machines, and finding them a success, the two launched the Wheeler & Wilson Manufacturing Company in Watertown in 1853.

Just over a year later, on December 19, 1854, Wilson received a patent, his fourth, for the four-motion cloth-feeding sewing machine. The method for automatically feeding cloth through a sewing machine became the new standard in the industry, remaining largely unchanged in present-day machines. Wheeler and Wilson became leaders in the industry. In 1856, with revenues pouring in, the company moved from Waterford to larger facilities in Bridgeport, Connecticut. The company won numerous international awards for its design and, by the time of its sale in 1905, had grossed millions of dollars for its owners.

December 20

Connecticut Executes a Twelve-Year-Old Girl

On the morning of July 21, 1786, six-year-old Eunice Bolles, daughter of a prominent New London family, began walking to school. On her way, she encountered Hannah Occuish, a girl she knew well. Occuish lured Bolles into the woods with the offer of a piece of calico, and once out of sight, she severely beat Bolles with a rock before strangling her. Occuish then placed Bolles's body next to a stone wall and covered it in rocks to make it appear as if the wall had given way and crushed her six-year-old companion.

Upon discovery of the body, town residents immediately set to finding Bolles's killer. They questioned Hannah Occuish, who told them she saw four boys near the crime scene on the day of the murder. Finding no sign

of the boys, they then brought Occuish to the Bolles's home. Once shown Eunice's body, Occuish broke down and confessed to the murder.

Hannah Occuish was a twelve-year-old mentally disabled girl who spent her life shuttled between foster homes after her mother abandoned her. Eunice Bolles caught Occuish stealing strawberries while working a summer harvest and told on her, prompting Occuish's vicious retribution later that year. A local court sentenced Occuish to hang for her crime. While many residents voiced concern at sentencing a young girl with limited mental faculties to death, a New London judge proved determined to send a message to the local community about New London's tolerance for crime. Noticeably afraid and looking to the crowd for help, Occuish climbed upon the gallows on December 20, 1786, where the state carried out her sentence.

December 21

A Parched Capital City

In 1927, years before applying to the legislature for approval, the Metropolitan District Commission (MDC) began acquiring lands to build what became the Barkhamsted Reservoir. With the city of Hartford's rapid growth, the nine-billion-gallon Nepaug Reservoir no longer had the ability to keep up with the city's demand for water. The MDC envisioned the construction of a new thirty-billion-gallon reservoir to meet the city's needs but first needed to acquire the land on which to construct it. This meant displacing up to one thousand people.

The MDC began purchasing farms in Barkhamsted and Hartland Hollow. It applied for approval for its plan in 1929 and received it in 1933. As neighbors and customers sold their properties to the water company, it only got harder on those left behind to scratch out an existence. In all, the MDC acquired eighty properties, relocated twenty miles of highway and moved four cemeteries containing 1,300 bodies. After bringing in the S.J. Groves company of Ridgefield to strip the land, workers set all the remaining brush and demolition debris ablaze.

Authorities then began diverting water from the Farmington River into the new reservoir. On December 21, 1944, water flowed directly from the Barkhamsted Reservoir into Hartford. While the new water

source provided much relief for the overburdened Nepaug Reservoir, it actually took eight years to finally fill the new nine-mile-long reservoir to capacity.

December 22

New-Gate's First Prisoner Escapes After Just Eighteen Days

The notorious New-Gate prison in East Granby (formerly a part of Simsbury) started as a copper mine in 1705. After mining ceased, officials saw the deep underground caverns as an ideal place to house prisoners. With just two narrow shafts reaching to the surface, officials saw no need to staff the site around the clock. Consequently, the prison's first inmate, John Hinson, who arrived on December 22, 1773, escaped up a sixty-seven-foot shaft just eighteen days later, most likely with the help of a rope lowered to him by a female acquaintance.

Heightened security measures turned the mines into a military prison during the Revolutionary War and then a state prison shortly afterward. Prisoners worked above ground during the day but returned to the dark,

Old New-Gate Prison in East Granby. *Library of Congress, Prints and Photographs Division, Highsmith (Carol M.) Archive Collection.*

slimy, vermin-ridden caverns at night until the construction of a new four-story aboveground cellblock in 1824. The prison closed three years later with the opening of a new prison facility in Wethersfield.

December 23

Beardsley Park's Founder Attacked in His Home

James Walker Beardsley was a native of Monroe, Connecticut, born in 1812. Descended from William Beardsley, one of the first settlers of Stratford, Beardsley made his fortune as a cattle broker and farmer. He followed up his successful business career with a foray into politics as a member of the state General Assembly.

In 1878, a retired Beardsley decided to donate more than one hundred acres of his land in the north end of Bridgeport to create a public park. In 1884, Frederick Law Olmsted, the Connecticut landscape architect who designed New York City's Central Park, agreed to work on what became Beardsley Park.

Prior to the park's completion, however, on December 23, 1892, thieves broke into Beardsley's Bridgeport home. Beardsley's reported wealth attracted the two criminals to his house, but upon arriving, they found little worth stealing. With most of Beardsley's money tied up in the construction of the park, the thieves managed to acquire only sixty dollars and a gold watch. Irate, the thieves became violent. The seventy-seven-year-old Beardsley confronted them, but the thieves overpowered him, and during the course of the altercation, one actually stood on Beardsley's stomach, damaging a number of his internal organs. Beardsley died from his injuries on New Year's Day, 1893.

December 24

Wall Street's Most Influential Insider

After the death of his father and two elder brothers, Charles Dow spent the remainder of his childhood helping his mother operate the family farm

in Sterling, Connecticut. Dow always wanted to be a news correspondent, however, and despite lacking a college education, he got a job at the *Springfield Republican* newspaper in 1869. After five years there apprenticed under Samuel Bowles, Dow went to work at the *Providence Star*, where he became friends with *Providence Evening Press* reporter Edward Jones.

In 1879, Dow covered a mining strike in Colorado for the *Providence Journal* and returned to the East Coast looking for work in New York City as a reporter on mining stocks. The Kiernan News Agency hired him as a financial correspondent, and shortly after, Dow convinced his new employer to hire Edward Jones as well. In 1882, the two friends formed their own news agency.

Dow and Jones started their business with a single typewriter, writing up summaries on stock trends and handing them off to a runner to distribute on Wall Street. On July 3, 1884, the company's afternoon letter contained an eleven-stock index Dow felt reflected the movements of the most widely traded stocks on the market. This was the first-ever Dow Jones Industrial Index.

Recognized as an important financial insider, Dow became a member of the New York Stock Exchange on December 24, 1885. Just four years later, he put out a new four-page newsletter with an annual subscription rate of five dollars per year and named the paper the *Wall Street Journal*.

December 25

Florence Griswold

At her birth on Christmas Day in 1850, Florence Griswold became a member of one of Old Lyme's wealthiest families. Her mother turned their home into a finishing school for young women in 1878, and Florence eventually became a teacher there. By the late 1890s, however, Florence was the only family member left at the residence, and she turned it into a boardinghouse to help herself survive. In 1899, painter Henry Ward Ranger, fresh from a stay in Europe, moved into Griswold's home after deciding to establish a center for American art in Old Lyme.

The Old Lyme Art Colony attracted numerous influential artists to Griswold's home, making it the epicenter of the nation's Impressionist

movement. In the 1930s, with Griswold near death and deeply in debt, a number of successful artists formed the Florence Griswold Association and purchased her property to keep it away from her creditors. In 1947, the building opened as a public museum.

Trees Along a Pool, by Henry Ward Ranger (1906). Bonhams San Francisco, public domain image.

December 26

A Half-Hearted Attempt at Spying

Growing up in Niantic, Connecticut, as the grandson of German immigrants, William Colepaugh developed a fascination for all things German. He attended a military prep school in New Jersey, and at the outbreak of World War II, Colepaugh, then in his early twenties, began expressing an interest in moving to Germany.

In January 1944, he took a job as a messboy aboard a Swedish relief vessel; jumped ship in Lisbon, Portugal; and offered his services as a spy to the German consulate. The German military sent him to a spy school in the Netherlands, where he learned various methods of sabotage. On November 29, 1944, the German submarine *U-1230* landed Colepaugh and a German-born radio technician named Erich Gimpel on the coast of Maine. Loaded with guns, a fake social security card, cash and jewels, Colepaugh and Gimpel traveled down through Boston to New York City to begin their mission—spying on American war material production.

Once in New York, Colepaugh seemed to lose enthusiasm for his mission. He spent the money the Germans gave him on alcohol and women, and then, on December 26, 1945, with the money largely gone, he turned himself in to the FBI. Four days later, authorities arrested Gimpel.

Both men received death sentences, but three days before their executions, President Franklin Roosevelt passed away, and his successor, Harry Truman,

commuted their sentences to life in prison and, later, down to thirty years. After his release, Colepaugh married and opened a small business in King of Prussia, Pennsylvania. He died in 2005.

December 27

Hartford's Prostitution Scandal

In the early twentieth century, the east side of Hartford hosted a thriving prostitution trade. Local "bawdy houses" gained support through the proliferation of bars and hotels that prospered nearby. In addition, Hartford police took a seemingly relaxed attitude toward prostitution, rarely ever arresting customers and usually only charging prostitutes a fine before allowing them to return to their business. A 1911 criminal trial, however, eventually revealed the depths of the scandal, disclosing that local law enforcement officers often worked on behalf of prostitution houses, accepting payments to ignore criminal violations.

Local reformers, clergy members and women's rights activists refused to tolerate the corruption and licentious behavior and called on Hartford's mayor, Edward Smith, to close down the city's prostitution industry. In addition, the Central Labor Union in Hartford passed a resolution on December 27, 1911, demanding the city's police commissioners crack down on the illicit trade. Two days later, Smith ordered police chief Eilliam Gunn to close down the city's brothels.

In 1912, the city council passed a resolution creating the Hartford Vice Commission, but the city provided little funding for its efforts. A large portion of the money used to tackle prostitution in Hartford ended up coming from private donations.

December 28

Connecticut Takes Up Arms Against Pennsylvania

In July 1753, the Susquehanna Company formed in Windham, Connecticut. Its goal was to settle lands in the Wyoming Valley (of what today is

western Pennsylvania) granted by King Charles II of England in the 1662 Connecticut Charter. After receiving approval from the General Assembly and surveying the land, the first attempts to actually settle the land came in 1762 and 1763. Unfortunately, when the settlers arrived, they found the area occupied by Pennsylvania settlers who, thanks to the king's poor knowledge of North American geography, had received the land in a grant as well. At a meeting in Hartford on December 28, 1768, the Susquehanna Company decided to continue settling the land anyway.

The following year, hostilities erupted between the factions of settlers, culminating in the First Pennamite War. The American Revolution brought a particularly viscous attack by a group of Tories under commander John Butler that resulted in the deaths of 150 Connecticut settlers and sent many more fleeing from the Wyoming Valley. They soon regrouped, however, and returned to western Pennsylvania—resulting in even more fighting.

In the early 1780s, a Continental Congress court ultimately decided the land belonged to Pennsylvania, but Connecticut settlers refused to leave, resulting in the Second Pennamite War. After several more years of conflict, Connecticut finally conceded and accepted lands later known as the Western Reserve (in modern-day Ohio) as compensation for its losses. In return, Pennsylvania agreed to recognize land titles held by Connecticut settlers who stayed, on the condition that they become residents of Pennsylvania.

December 29

Mystic Seaport

Mystic, Connecticut, has a shipbuilding tradition that dates back to the area's earliest European settlements. Up until the early twentieth century, mariners constructed hundreds of ships along the Mystic River, providing the area with a thriving maritime trade. The arrival of iron ships in the middle of the nineteenth century, however, commenced a steady decline in wooden shipbuilding that all but brought an end to the practice. To keep the area's traditions alive, three men—Edward Bradley, Carl Cutler and Charles Stillman—incorporated the Marine Historical Association, known today as Mystic Seaport, on December 29, 1929.

The *Charles W. Morgan* at Mystic Seaport. *Library of Congress, Prints and Photographs Division, Highsmith (Carol M.) Archive Collection.*

Starting out as a one-building museum, Mystic Seaport eventually acquired a number of historic buildings used to re-create a small coastal settlement from the town's shipbuilding past. In addition, it grew into one of the nation's leading maritime museums through the acquisition of millions of artifacts and the world's largest collection of boats and maritime photographs.

December 30

Connecticut's Valley Forge

In the winter of 1778–79, just one year after enduring the hardships of Valley Forge, Continental troops faced an equally bleak, if not worse, winter at their encampment in Redding, Connecticut. Several snowstorms throughout December made travel extremely difficult, keeping food stores stockpiled in nearby Danbury—tantalizingly close but still out of reach. In addition to the deprivation of food and the brutally cold temperatures, soldiers also faced the increasingly frustrating problem of delayed payment

for their services. With continental currency in free fall, any delay in payment significantly decreased the purchasing power of army wages.

Fed up with their circumstances, a group of disgruntled soldiers organized on December 30, 1778, for a march on the legislature in Hartford. With a potential mutiny on his hands, General Israel Putnam raced from his headquarters on Umpawaug Hill over to the encampment. Upon his arrival, he addressed the mutineers, calmly advising them regarding the dire consequences of such a march. The soldiers soon dispersed.

Putnam then set about punishing those responsible for the uprising, leading to multiple arrests. The leader of the group later attempted to escape, but a guard shot and killed him, and the remaining jailed mutineers appealed to Putnam for a pardon. While Putnam agonized over deciding their punishment, his scouts captured a spy, a Tory from Ridgefield named Edward Jones. Rather than punish the mutineers, Putnam chose to send a message to his troops by executing Jones, along with a teenage deserter named John Smith. He carried out the executions on Gallows Hill in February 1779.

December 31

A One-Man Arsenal

A major in the Continental army, Middletown's Nathan Starr set about forging and repairing weapons at the end of the Revolutionary War. In 1798, the United States government, fearing an impending war with France, asked Starr to produce

An unidentified Union soldier holding an 1818 Nathan Starr cavalry saber. *Library of Congress, Prints and Photographs Division, Liljenquist Family Collection of Civil War Photographs.*

two thousand cavalry swords, complete with scabbards and belts. Receiving the nation's first military contract for swords, Starr delivered the weapons by the end of the year, receiving a $2,000 payment for his services on December 31, 1798.

As additional orders poured in, Starr eventually opened up a factory on the Coginchaug River in 1813. There, three generations of his family made over twenty-two thousand sabers, five thousand swords and nineteen thousand muskets between 1813 and 1845, but federal armories opened in Springfield, Massachusetts, and Harpers Ferry, Virginia, helped bring an end to the Starr family's once-prosperous business.

BIBLIOGRAPHY

Air Mobility Command Museum. "Airman 1st Class John L. Levitow." http:// amcmuseum.org/history/medal_of_honor/a1c_levitow.php.

Alden, John D. "The Ups and Downs of Electric Boat." United States Naval Institute. http://www.usni.org/magazines/proceedings/1999-07/ups-and-downs-electric-boat.

Americaslibrary.gov.

Ammidown, Holmes. *Historical Collections: Sturbridge. Charlton. Southbridge*. vol. 2. New York: Holmes Ammidown, 1874.

Arnold, Chris. "Wiffle Ball: Born and Still Made in the USA." National Public Radio. http://www.npr.org/2011/09/05/140145711/wiffle-ball-born-and-still-made-in-the-usa.

Atlantic Reporter: With Key-Number Annotations, vol. 79. St. Paul, MN: West Publishing Co., 1911.

Austen, Barbara. "Saving the Scattered Remnants: Samson Occom and the Brotherton Indians." WNPR News, November 1, 2013. http://wnpr.org/post/saving-scattered-remnants-samson-occom-and-brotherton-indians.

———. "Yung Wing's Dream: The Chinese Educational Mission, 1872–1881." WNPR News, September 27, 2013. http://wnpr.org/post/yung-wings-dream-chinese-educational-mission-1872-1881.

Avery, Kevin J. "John Frederick Kensett (1816–1872)." Metropolitan Museum of Art, Heilbrunn Timeline of Art History. http://www.metmuseum.org/toah/hd/kens/hd_kens.htm.

Bailer, Darice. *Connecticut: The Constitution State*. Milwaukee, WI: World Almanac Library, 2002.

Baker, T. Lindsay. *A Field Guide to American Windmills*. Norman: University of Oklahoma Press, 1985.

Barkhamsted Historical Society. "Historical Tour." http://barkhamstedhistory.org/content/historicaltour.aspx.

Barlow, Susan. "The Cheney Silk Mills." Manchester Historical Society. http://www.manchesterhistory.org/reprints/MHS3_CheneySilkMills.html.

Barnard, F.A. *American Biographical History of Eminent and Self-Made Men with Portraits and Illustrations on Steel, Michigan Volume*. Cincinnati, OH: Western Biographical Publishing Co., 1878.

Barnum, Phineas Taylor. *The Life of P.T. Barnum: Written by Himself, Including His Golden Rules for Money-Making. Brought up to 1888*. Buffalo, NY: The Courier Company, 1888.

Battle of Britain London Monument. "P/O A. Mamedoff." http://www.bbm.org.uk/Mamedoff.htm.

Bayles, Richard, ed. *History of Windham County, Connecticut*. New York: W.W. Preston & Company, 1889.

Beach, Joseph. *History of Cheshire, Connecticut, from 1694–1840, Including Prospect, Which, as Columbia Parish, Was a Part of Cheshire Until 1829*. Cheshire, CT: Lady Fenwick Chapter, DAR, 1912.

Bernstein, Arnie. *Swastika Nation: Fritz Kuhn and the Rise and Fall of the German-American Bund*. New York: St. Martin's Press, 2013.

Besso, Michael. "Thomas Hooker and His May 1638 Sermon." *Early American Studies* (Winter 2012): 194–225.

Bill of Rights Institute. "Virginia Plan." Americapedia. http://billofrightsinstitute.org/resources/educator-resources/americapedia/americapedia-constitution/virginia-plan/.

Bolton Historical Society. "Charles Lyman: Bolton Civil War Hero." http://www.boltoncthistory.org/charleslyman.html.

Bowen, Charles. *The American Almanac and Repository of Useful Knowledge for the Year 1830, Comprising a Calendar for the Year; Astronomical Information; Miscellaneous Directions, Hints, and Remarks; and Statistical and Other Particulars Respecting Foreign Countries and the United States*. 2nd ed. vol. 1. Boston: Collins and Hannay, and G. and C. and H. Carvill, 1833.

Boyd, Deanna, and Kendra Chen. "The History and Experience of African Americans in America's Postal Service." Smithsonian National Postal Museum. http://postalmuseum.si.edu/AfricanAmericanHistory/p1.html.

Boynton, Cynthia Wolfe. *Remarkable Women of Hartford*. Charleston, SC: The History Press, 2014.

Bradsby, Henry C., ed. *History of Luzerne County, Pennsylvania*. vol. 1. Chicago: S.B. Nelson & Co., 1893.

Brawley, Benjamin Griffith. *The Negro Genius: A New Appraisal of the Achievement of the American Negro in Literature and the Fine Arts*. New York: Bilbio & Tannen Publishers, 1966.

British Broadcasting Company (BBC). "Emmeline Pankhurst (1858–1928)." http://www.bbc.co.uk/history/historic_figures/pankhurst_emmeline.shtml.

———. "John Lennon Remembered: Bigger Than Jesus." BBC Radio. http://www.bbc.co.uk/radio2/events/lennon/jesus.shtml.

Brittin, Frank L. "Ultra-High Frequency TV Stations." *Popular Mechanics*, October 1951.

Brown University. "New England Hurricanes." http://www.geo.brown.edu/georesearch/esh/QE/Research/CoastStd/NEHurric.htm.

Bryant University. "Mamedoff, Andrew 'Andy.'" *Bryant College Goes to War.* http://digitalcommons.bryant.edu/mamedoff_war/.

Burlington Library. "Flood Friday, August 19, 1955." http://www.burlingtonctlibrary.info/flood.htm.

Burritt, Elihu, and Charles Northend. *Elihu Burritt: A Memorial Volume Containing a Sketch of His Life and Labors, with Selections from His Writings and Lectures, and Extracts from His Private Journals in Europe and America.* New York: D. Appleton & Company, 1879.

Bushnell Theater. "Bushnell History." http://www.bushnell.org/content/history-archives-landmark-building.

Carlton, Lawrence S. "The Rise and Fall of Silas Brooks, Balloonist." *Hog River Journal.* http://www.hogriver.org/issues/v06n02/silasbrook.html.

Casey, Wilson. *Firsts: Origins of Everyday Things That Changed the World.* New York: Penguin Group, 2009.

Cash, Leon Eugene. "Elementary Education in Connecticut Under the School Society: An Historical Study of Elementary Education During the Period 1799–1856." PhD dissertation, Yale University, 1940.

Cassidy, Martin B. "Lessons of Mianus River Bridge Collapse Not Yet Learned." *Stamford Advocate,* June 27, 2013. http://www.stamfordadvocate.com/local/article/Lessons-of-Mianus-River-Bridge-collapse-not-yet-4628743.php.

CBS News. "Activists Protest Outside AIG Execs' Homes." March 21, 2009. http://www.cbsnews.com/news/activists-protest-outside-aig-execs-homes/.

CBS New York. "Young King Inspired by Time on Conn. Farm." http://newyork.cbslocal.com/2011/01/17/young-king-inspired-by-time-on-conn-farm/.

Chicago-Kent College of Law. "Griswold v. Connecticut." U.S. Supreme Court Media. http://www.oyez.org/cases/1960-1969/1964/1964_496.

Chicago Tribune.

Child, Frank S. *An Historic Mansion: Being an Account of the Thaddeus Burr Homestead, Fairfield, CT, 1654–1915.* Internet Archive. https://archive.org/details/historicmansionb00chil.

Chisolm, Hugh, ed. *The Encyclopedia Britannica: A Dictionary of Arts, Sciences, Literature and General Information.* 11th ed. New York: The Encyclopedia Britannica Company, 1911.

Choate Rosemary Hall. "A History of the School." http://www.choate.edu/page.cfm?p=509.

City of New Haven. *City Year Book of the City of New Haven: Containing Lists of the Officers of City and Town Governments, Messages of the Mayor, Reports of Heads of Departments, Public Documents, and Miscellaneous Papers for 1872–3.* New Haven, CT: Press Tuttle, Morehouse & Taylor, 1873.

City of Waterbury. "Interesting Facts about Waterbury." http://www.waterburyct.org/content/9586/9599/9604.aspx.

Clark, Clifford Edward. *Henry Ward Beecher: Spokesman for a Middle-Class America.* Champaign: University of Illinois Press, 1978.

CNN.com.

Colby, Barnard L. *New London Whaling Captains.* Mystic, CT: Marine Historical Association, 1936.

Connecticut Audubon Society. "The History of the Connecticut Audubon Society." http://www.ctaudubon.org/our-history/#sthash.hMzVIsgh.dpbs.

Connecticut College. "The History of Connecticut College." History and Traditions. https://www.conncoll.edu/at-a-glance/history-traditions/.

———. "A History of Connecticut College: Opening Day, 1915." http://www.conncoll.edu/news/news-archive/2011/a-history-of-connecticut-college-opening-day-1915.htm#.VFZdF8np_bx.

Connecticut General Assembly online. cga.ct.gov.

Connecticut Historical Society. "Finding Aids." http://www.chs.org.

ConnecticutHistory.org.

Connecticut History Online. "War on the Homefront: Connecticut Goes to War, 1860–1945." http://www.cthistoryonline.org/cho/journeys/j_infra_war_ww1.html.

Connecticut Judicial Branch Law Libraries online. "History." http://www.jud.ct.gov/lawlib/history/.

Connecticut Landmarks. "Hempsted Houses." http://www.ctlandmarks.org/content/hempsted-houses.

Connecticut Mirror.

Connecticut Motor Coach Museum. *Waterbury Trolleys.* Charleston, SC: Arcadia Publishing, 2005.

Connecticut Post.

Connecticut Society of Professional Journalists. "CT Journalism Hall of Fame: Hannah Bunce Watson." http://connecticutspj.org/ct-journalism-hall-of-fame-hannah-bunce-watson/.

Connecticut Society of the Sons of the American Revolution. "About." http://connecticutsar.org/about/.

Connecticut's Old State House. "History Timeline." http://www.ctosh.org/timeline.asp.

Connecticut State Grange. "History of the Connecticut State Grange." http://www.ctstategrange.org/csghistory.asp.

Connecticut State Library online. http://www.ctstatelibrary.org/.

Connecticut State Police Museum and Educational Center. "Abbreviated History." http://www.cspmuseum.org/CMSLite/default.asp?CMSLite_Page=7&Info=Abbreviated+History.

Connecticut Women's Hall of Fame. "The Inductees." http://www.cwhf.org/inductees.

Cooper, Grace Rogers. *The Invention of the Sewing Machine.* Washington, D.C.: Smithsonian Institution, 1968.

Cronise, Titus Fey. *The Natural Wealth of California.* San Francisco: H.H. Bancroft & Company, 1868.

Crouch, Tim. "The Flight Claims of Gustave Whitehead." Smithsonian's National Air and Space Museum, March 15, 2013. http://newsdesk.si.edu/sites/default/files/2013-Whitehead-Statement.pdf.

Daily Voice (Stamford, CT).

Dana, Gorham. *Automatic Sprinkler Protection.* 2nd ed. New York: John Wiley & Sons, 1919.

Darien (CT) Times.

Daughters of the American Revolution. "DAR History." http://www.dar.org/national-society/about-dar/dar-history.

Day (New London, CT).

de Castella, Tom. "What Caused the Mystery of the Dark Day?" *BBC News Magazine*, May 18, 2012. http://www.bbc.com/news/magazine-18097177.

Depauw, Karen. "Frances Laughlin Wadworth: Sculpting the Past." WNPR News, March 7, 2014. http://wnpr.org/post/frances-laughlin-wadworth-sculpting-past.

Derby Historical Society. *Ansonia*. Charleston, SC: Arcadia Publishing, 1999.

Dock, Julie Bates. *Charlotte Perkins Gilman's "The Yellow Wall-Paper" and the History of Its Publication and Reception: A Critical Edition and Documentary Casebook*. University Park: Pennsylvania State University Press, 1998.

Dommermuth-Costa, Carol. *Woodrow Wilson*. Minneapolis, MN: Lerner Publications, 2003.

Duyckinck, Evert A., and George L. Duyckinck. *Cyclopaedia of American Literature: Embracing Personal and Critical Notices of Authors, and Selections from Their Writings, from the Earliest Period to the Present Day; with Portraits, Autographs, and Other Illustrations*. vol. 1. New York: Charles Scribner, 1856.

Dwight, Benjamin Woodbridge. *The History of the Descendants of John Dwight, of Dedham, Mass*. vol. 1. New York: John F. Trow & Son, 1874.

Economist. "Who Flew First?" July 3, 2013. http://www.economist.com/blogs/democracyinamerica/2013/07/aviation-history.

Elihu Burritt Library. "Elihu Burritt 1810–1879." http://library.ccsu.edu/help/spcoll/burritt/biography.php.

"Eli Whitney." *Encyclopedia of World Biography*, 2nd ed. vol. 16. Detroit: Gale, 2004.

Eli Whitney Museum and Workshop. "Inventing Change: The Whitney Legacy." https://www.eliwhitney.org/museum/about-eli-whitney/inventing-change.

Encyclopedia Britannica online. http://www.britannica.com/.

Enfield Historical Society. "The Hazard Powder Company and the Hazardville Gunpowder Industry (1836–1913)." http://www.enfieldhistoricalsociety.org/EHSpowder.html.

Episcopal Church. "Samuel Seabury, First American Bishop." http://www.episcopalchurch.org/sites/default/files/downloads/bi111112half.pdf.

ESPN online. http://espn.go.com/.

Evensen, Bruce J. "Dow, Charles Henry." American National Biography Online. http://www.anb.org/articles/16/16-03537.html.

Farley, William P. "Jonathan Edwards and the Great Awakening." *Enrichment Journal* (Winter 2002). http://enrichmentjournal.ag.org/200201/200201_104_johnathan.cfm.

Faude, Wilson H. *Connecticut Miscellany: ESPN, the Age of Reptiles, CowParade and More*. Charleston, SC: The History Press, 2013.

Federal Writers Project. *Connecticut: A Guide to Its Roads, Lore and People*. Boston: Houghton Mifflin Company, 1938.

Filler, Jonathan. "Arguing in an Age of Unreason: Elias Boudinot, Cherokee Factionalism, and the Treaty of New Echota." Master's thesis, Bowling Green State University, 2010.

Finkelman, Paul, ed. *Encyclopedia of African American History: 1896 to the Present; from the Age of Segregation to the Twenty-First Century*. New York: Oxford University Press, 2009.

Fippinger, Richard. "A History of the Wethersfield Fire Department." Wethersfield Volunteer Fire Department. http://www.wvfd.org/History/history.htm.

Foord, John. *The Life and Public Services of Andrew Haswell Green*. New York: Doubleday, Page and Company, 1913.

Ford, Jo-Ann. "Candlewood Lake: A View of Its Future Based on Its History and Development." Unpublished manuscript. Town of New Fairfield. http://www. newfairfield.org/filestorage/80/540/ford.htm.

Fort Wayne (IN) News.

Fought, Leigh. *A History of Mystic, Connecticut: From Pequot Village to Tourist Town*. Charleston, SC: The History Press, 2007.

Fox News. "History of the Hamburger: From Immigrant Fare to Fast Food Favorite." September 3, 2012. http://www.foxnews.com/leisure/2012/09/03/ history-hamburger-from-immigrant-fare-to-fast-food-favorite/.

Gallaudet, Edward Miner. *Life of Thomas Hopkins Gallaudet*. New York: Henry Holt and Company, 1888.

George Mason University, Roy Rosenzweig Center for History and New Media. "The Tom Thumb Archive." http://chnm.gmu.edu/lostmuseum/searchlm. php?function=find&exhibit=thumb&browse=thumb.

Georgia Writers Hall of Fame. "Elias Boudinot." Hall of Fame Honorees. http:// www.georgiawritershalloffame.org/honorees/biography.php?authorID=5.

Giannuzzi, Maria. *Windsor Locks Canal*. Charleston, SC: Arcadia Publishing, 2007.

Gladwell, Malcolm. *Personality, Character, and Intelligence: Part Three from What the Dog Saw and Other Adventures*. New York: Little, Brown and Company, 2009.

Gleason, Carrie. *The Biography of Rubber*. New York: Crabtree Publishing, 2006.

Glenday, Craig, ed. *Guinness World Records 2013: Discover a World of New Records*. Bantam Books Mass Market ed. New York: Random House, 2013.

Goddard, Stephen B. *Colonel Albert Pope and His American Dream Machines*. Jefferson, NC: McFarland and Company, 2000.

Google Patent Search. www.google.com/patents.

Greene, George. "Origin of the Wiffle Ball." *Examiner,* June 22, 2009.

Greenwich Library. "The Mianus River Bridge Collapse." http://www. greenwichlibrary.org/blog/historically_speaking/2011/03/the-mianus-river-bridge-collapse.html.

Grigg, Bob. "1816—The Year Without a Summer." Colebrook Historical Society. http://www.colebrookhistoricalsociety.org/1816%20-%20The%20Year%20 Without%20Summer.htm.

Grinspan, Jon. "'Young Men for War': The Wide Awakes and Lincoln's 1860 Presidential Campaign." *Journal of American History* 96 (September 2009): 357–78.

Gronbeck, Bruce. "The Gallup Poll." University of Iowa. http://www.uiowa.edu/ policult/politick/smithson/961012.htm.

Gross, Linda P., and Theresa R. Snyder. *Philadelphia's 1876 Centennial Exhibition*. Charleston, SC: Arcadia Publishing, 2005.

Grove Street Cemetery. "The Grove Street Cemetery." http://www.grovestreetcemetery.org/.

Guevin, John R. *View from the Top: The Story of Prospect, Connecticut.* Prospect, CT: Biographical Publishing Company, 1995.

Gunn, Angus M. *Encyclopedia of Disasters: Environmental Catastrophes and Human Tragedies.* Westport, CT: Greenwood Press, 2008.

Hall, David D. *Witch-Hunting in Seventeenth-Century New England: A Documentary History, 1638–1693.* Boston: Northeastern University Press, 1999.

Halttunen, Karen. *Murder Most Foul: The Killer and the American Gothic Imagination.* Cambridge, MA: Harvard University Press, 1998.

Hamm, Diane L. *Military Intelligence: Its Heroes and Legends.* Honolulu: University Press of the Pacific, 2001

Hanrahan, Ryan. "Remembering Windsor, Windsor Locks Tornado: 30 Years Later." NBC Connecticut News. http://www.nbcconnecticut.com/news/local/Remembering-The-Windsor-and-Windsor-Locks-Tornado-30-Years-Later-62410147.html.

————. "Uh, Toto, We're Still in Connecticut: A Series of Tornadoes Devastated Parts of the State on July 10, 1989." NBC Connecticut News. http://www.nbcconnecticut.com/news/local/Looking-Back-at-Connecticuts-Most-Violent-Tornado-Outbreak.html.

Harper, Kimberly, and Garrett Walker. "Nathaniel Lyon (1818–1861)." *Historic Missourians.* The State Historical Society of Missouri. http://shs.umsystem.edu/historicmissourians/name/l/lyon/index.html.

Harriet Beecher Stowe Center. "*Uncle Tom's Cabin*." http://www.harrietbeecherstowecenter.org/utc/.

Harris, Neil. *Humbug: The Art of P.T. Barnum.* Chicago: Chicago University Press, 1975.

Hartford (CT) Courant.

Harvard Business School. "The International Silver Company." Lehman Brothers Collection. Baker Library. http://www.library.hbs.edu/hc/lehman/company.html?company=the_international_silver_company.

Harvard Square Library. "Jared Sparks (1849–1853)." http://www.harvardsquarelibrary.org/biographies/jared-sparks/.

Harvard University. "Jared Sparks." *History of the Presidency.* http://www.harvard.edu/history/presidents/sparks.

Harvard University Library. "James, Anna Louise, 1886–1977. Papers, 1874–1991: A Finding Aid." http://oasis.lib.harvard.edu/oasis/deliver/~sch00656.

Hazelton, John H. "The Historical Value of Trumbull's 'Declaration of Independence.'" *The Pennsylvania Magazine of History and Biography* 31, no. 121 (January 1907): 30–42.

Henshaw, Thomas. *The History of Winchester Firearms, 1866–1992.* Winchester, ON: Winchester Press, 1993.

Hereditary Societies in Connecticut. "Connecticut Society of the Daughters of the American Revolution." http://societyct.org/connecticut-society-of-the-daughters-of-the-american-revolution/.

Hibben, Paxton. *Henry Ward Beecher: An American Portrait*. New York: George Doran Company, 1927.

Hildreth, Richard. *A Report of the Trial of the Rev. Ephraim K. Avery, Before the Supreme Judicial Court of Rhode Island, on an Indictment for the Murder of Sarah Maria Cornell; Containing a Full Statement of the Testimony, Together with the Arguments of Counsel, and the Charge to the Jury*. 2nd ed. Boston: Russell, Odiorne and Co., 1833.

History Channel. "Oct 6, 1996: Bill Clinton Debates Bob Dole." *This Day in History*. http://www.history.com/this-day-in-history/bill-clinton-debates-bob-dole.

Homan, Tom. "The Day I Owned the King Tut Exhibit." Chapel Hill, NC: American Diplomacy Publishers, 2012. http://www.unc.edu/depts/diplomat/item/2011/0104/fsl/fsl_homan_tut.html.

Horton, Wesley W. *The Connecticut State Constitution*. 2nd ed. New York: Oxford University Press, 2012.

Hour (Norwalk, CT).

Housatonic Valley Council of Elected Officials. "Regional Transportation Plan, Part 3A: Interstate 84 Improvement Policy." http://www.hvceo.org/transport/transport_plan3_majorcorridori84.php.

Houze, Herb. *Winchester Repeating Arms Company: Its History & Development from 1865 to 1981*. Iola, WI: Krause Publications, 2004.

Howard, Nora. *Avon*. Charleston, SC: Arcadia Publishing, 2000.

Howe, Henry. *An Outline History of New Haven: (Interspersed with Reminiscences)*. New Haven, CT: O.A. Dorman, 1884.

Huffington Post.

Humphreys, Frank Landon. *Life and Times of David Humphreys: Soldier—Statesmen—Poet*. New York: G.P. Putnam's Sons, 1917.

Hurd, Duane Hamilton. *History of New London County, Connecticut: With Biographical Sketches of Many of Its Pioneers and Prominent Men*. Philadelphia: J.W. Lewis and Co., 1882.

H.Z. Williams and Bro. *History of Trumbull and Mahoning Counties: With Illustrations and Biographical Sketches*. vol. 2. Cleveland, OH: H.Z. Williams and Bro., 1882.

Igor Sikorsky Historical Archives. "VS-300 Helicopter." http://www.sikorskyarchives.com/VS-300_Helicopter.php.

Independent (London, UK).

Indiana University. "Politics & Peace." War of 1812 Collection. Lilly Library. http://collections.libraries.iub.edu/warof1812/exhibits/show/warof1812/the-war-1814/politics---peace.

Institute for Justice. "*Kelo v. New London*: Lawsuit Challenging Eminent Domain Abuse in New London, Connecticut." http://www.ij.org/kelo.

Jefferson, Oshawn. "John Levitow's Legacy Will Live Forever." United States Department of Defense. http://www.defense.gov/news/newsarticle.aspx?id=45571.

Jensen, Laura. "Helen Keller in Connecticut." WNPR News, October 22, 2011. http://wnpr.org/post/helen-keller-connecticut.

Jewish Historical Society of Greater Hartford. "Fox Family and G. Fox & Co." http://www.jhsgh.org/template/findingaid.php?src=Fox%20Family_GFox.xml.

John F. Kennedy to Helen Keller, June 20, 1963, Transcription. American Foundation for the Blind. http://www.afb.org/info/about-us/helen-keller/letters/john-f-kennedy/letter-to-miss-keller-from-john-f-kennedy-june-20-1963/12345.

Johnson, James M., Christopher Pryslopski and Andrew Villani, eds. *Key to the Northern Country: The Hudson River Valley in the American Revolution*. Albany: State University of New York Press, 2013.

Jones, Mark H. "Audacious Alliances." *Hog River Journal*. http://www.hogriver.org/issues/v01n04/audacious_alliances.htm.

Journal Inquirer (Manchester, CT).

Kageleiry, Jamie, and Christine Schultz. "The Bayonet-Sickle-Style Can Opener." *Yankee* 58, no. 6 (June 1994): 18–37.

"Kellogg, Stephen Wright, (1822–1904)." *Biographical Dictionary of the United States Congress*. http://bioguide.congress.gov/scripts/biodisplay.pl?index=K000067.

Kennedy, Ross A., ed. *A Companion to Woodrow Wilson*. Hoboken, NJ: Wiley-Blackwell, 2013.

Killingly Historical Society. "Mary (Dixon) Kies, America's First Female Patent Holder." *Killingly Historical Society Online Journal* 7 (2005). http://www.killinglyhistory.org/online-journals/online-journal-vol-7-2005/23-mary-dixon-kies-americas-first-female-patent-holder-.html.

Klingman, William K., and Nicholas P. Klingman. *The Year without Summer: 1816 and the Volcano That Darkened the World and Changed History*. New York: St. Martin's Press, 2013.

Law Notes. New York: E. Thompson Company, 1921.

Lehman, Eric. "The Locomobile Company of America." Bridgeport Library. http://bportlibrary.org/hc/north-end/the-locomobile-company-of-america/.

Lepore, Jill. *The Story of America: Essays on Origins*. Princeton, NJ: Princeton University Press, 2012.

Library of Congress. "Jefferson's Letter to Danbury Baptists." *Information Bulletin* 57, no. 6 (June 1998). http://www.loc.gov/loc/lcib/9806/danpre.html.

Library of Congress, Science, Technology & Business Division. "The Winchester Rifle: 'The Gun That Won the West.'" http://www.loc.gov/rr/scitech/SciRefGuides/winchester-rifle.html.

Litchfield County (CT) Times.

LitchfieldHistoricalSociety.org.

Lloyd Harbor Historical Society. "Jupiter Hammon: America's First Colonial Afro-American Published Poet." http://lloydharborhistoricalsociety.org/jupiter.html.

Longshore, David. *Encyclopedia of Hurricanes, Typhoons, and Cyclones, New Edition*. New York: Facts on File, 2008.

Los Angeles Times.

Lossing, Benjamin J. *Lossing's Pictorial Field Book of the War of 1812*. vol. 1. Gretna, LA: Pelican Publishing, n.d.

Louis' Lunch. "History." http://www.louislunch.com/history.php.

Maher, Kathleen. "P.T. Barnum, (1810–1891)—The Man, the Myth, the Legend." The Barnum Museum. http://www.barnum-museum.org/manmythlegend.htm.

Malan, Douglas S. *Muzzy Field: Tales from a Forgotten Ballpark*. Bloomington, IN: iUniverse, 2008.

Malley, Richard C. "Tragedy at Tariffville: The Railroad Wreck of 1878." WNPR News, January 10, 2014. http://wnpr.org/post/tragedy-tariffville-railroad-wreck-1878.

Mangan, Gregg. "Newgate in 1825: A Nursery of Crime." *Connecticut History* 47, no. 1 (Spring 2008): 1–37.

Mank, Gregory William. *The Very Witching Time of Night: Dark Alleys of Classic Horror Cinema*. Jefferson, NC: McFarland & Company, 2014.

Marc, David. "Schick, Jacob." American National Biography Online. http://www.anb.org/articles/10/10-02294.html.

Mark Twain Library. "The History of Stormfield." http://www.marktwainlibrary.org/PDF-Files/HistoryOfStormfield.pdf.

Masonic Voice Review. vol. 13. Masonic Publishing Company, 1911.

McCusker, John J. *The First Continental Flagship, 1775–1779*. Washington, D.C.: Smithsonian Institute Press, 1973.

Menschel, David. "Abolition without Deliverance: The Law of Connecticut Slavery, 1784–1848." *Yale Law Journal* 111, no. 1 (October 2001). http://www.yalelawjournal.org/note/abolition-without-deliverance-the-law-of-connecticut-slavery-1784-1848.

Mercer, David. *The Telephone: The Life Story of a Technology*. Westport, CT: Greenwood Press, 2006.

Metropolitan Opera Archives. "Rosa Ponselle, 1897–1981." http://archives.metoperafamily.org/Imgs/Ponselle.htm.

Mielach, David. "The Entrepreneurist." *Business News Daily*, April 28, 2010. http://www.businessnewsdaily.com/2430-wiffle-ball-maker-story.html.

Milford Historical Society online. http://www.milfordhistoricalsociety.org/.

Miller, Robert A. *A True Story of An American Nazi Spy: William Curtis Colepaugh*. Victoria, BC: Trafford, 2013.

Miner, Marcia. "The Burning of Fairfield." *Fairfield Online*, August 1, 2008. http://www.fairfieldonline.net/fm/articles/?id=4719&c=23.

Mock, Gary N. "Cheney Brothers Silk, South Manchester, Connecticut." Textile Industry History. http://www.textilehistory.org/CheneyBrothersSilk.html.

Mohegan Nation of Connecticut Land Claims Settlement Act of 1994. H.R. 4653. 103rd Congress. 1994.

Montagna, Joseph A. "History of Connecticut Through 1690." Yale-New Haven Teachers Institute. http://www.yale.edu/ynhti/curriculum/units/1978/4/78.04.02.x.html.

Monticello.org. "Embargo of 1807." http://www.monticello.org/site/research-and-collections/embargo-1807.

Montreal Gazette.

Morens, David M., and Anthony S. Fauci. "The 1918 Influenza Pandemic: Insights for the 21st Century." *Journal of Infectious Diseases* 195, no. 7 (2007): 1,018–28.

Murphy, Kevin. "A Valley Flooded to Slake the Capital Region's Thirst." *Hog River Journal*. http://www.hogriver.org/issues/v04n01/flooded.htm.

Mystic Seaport. "*Charles W. Morgan*: The Last Wooden Whaleship in the World." http://www.mysticseaport.org/visit/explore/morgan/.

———. "History of Mystic Seaport." http://www.mysticseaport.org/about/history/.

Nader.org. "Biography." https://nader.org/biography/.

National Archives online. http://www.archives.gov/.

National Baseball Hall of Fame and Museum. "Morgan Bulkeley." http://baseballhall.org/hof/bulkeley-morgan.

National Conference of State Legislatures. "Civil Unions & Domestic Partnership Statutes." http://www.ncsl.org/research/human-services/civil-unions-and-domestic-partnership-statutes.aspx.

National Governor's Association. "Connecticut Governor George Edward Lounsbury." http://www.nga.org/cms/home/governors/past-governors-bios/page_connecticut/col2-content/main-content-list/title_lounsbury_george.html.

———. "Connecticut Governor Phineas Chapman Lounsbury." http://www.nga.org/cms/home/governors/past-governors-bios/page_connecticut/col2-content/main-content-list/title_lounsbury_phineas.html.

National Institute of Standards and Technology. "L'Ambiance Plaza Building Collapse, Connecticut, 1987." Disaster and Failure Studies. http://www.nist.gov/el/disasterstudies/construction/lambiance_plaza_1987.cfm.

National Oceanic and Atmospheric Administration, Fisheries Service. "Milford Laboratory." http://nefsc.noaa.gov/nefsc/Milford/.

National Park Service online. www.nps.gov.

National Transportation Safety Board. "Captain's Decision to Sail into the Path of a Hurricane Caused the Tall Ship *Bounty* to Sink off Atlantic Coast," Press Release. https://www.ntsb.gov/news/2014/140210.html.

National Women's History Museum. "Hellen Keller." http://www.nwhm.org/education-resources/biography/biographies/helen-keller/.

———. "Sybil Ludington (1761–1839)." *Young and Brave: Girls Changing History*. https://www.nwhm.org/html/exhibits/youngandbrave/ludington.html.

Naval Submarine Base New London. "History." http://www.cnic.navy.mil/regions/cnrma/installations/navsubbase_new_london/about/history.html.

NavSource.org. "USS Everett F. Larson (DD-830/DDR-830)." http://www.navsource.org/archives/05/830.htm.

NBC News. "Embattled Conn. Governor Resigns: John Rowland May Have Faced Impeachment over Corruption Allegations." http://www.nbcnews.com/id/5241442/#.VFTRqsnp_bx.

NBC Connecticut News. "Obama at CCSU: 'Time to Give America a Raise.'" http://www.nbcconnecticut.com/news/local/President-Obama-to-Speak-at-Central-Conn-State-University-Today-248529171.html.

Neff, Liz. "Camp Gertrude Bryant." Avon Historical Society. http://www.avonhistoricalsociety.org/HistoricalAvon.htm.

New England Historical Society. "Mabel Osgood Wright: The Bird Woman of Fairfield, Connecticut." http://www.newenglandhistoricalsociety.com/mabel-osgood-wright-bird-woman-fairfield-connecticut/.

New Haven Colony Historical Society. *Papers of the New Haven Colony Historical Society.* vol. 4. New Haven, CT: New Haven Colony Historical Society, 1888.

New Haven (CT) Independent.

New Haven (CT) Register.

New London County Historical Society online. http://nlhistory.org/.

News Times (Danbury, CT).

New York City Department of Parks and Recreation. "Olmsted-Designed New York City Parks." http://www.nycgovparks.org/about/history/olmsted-parks.

New York Daily News.

New York State Stenographers' Association. *Proceedings of the New York State Stenographers' Association, Volumes 28–33: Including Papers Read, Discussions, Etc., at the Twenty-eighth Annual Meeting Held at Convention Hall, Alexandria Bay, August 27 and 28, 1903.* Albany: Argus Company, 1903.

New York Times.

Noah Webster House and West Harford Historical Society. "Noah Webster History." http://www.noahwebsterhouse.org/discover/noah-webster-history.htm.

Nolan, Christian. "Connecticut Yankee Nuclear Plant Awarded $39.7 Million." *Connecticut Law Tribune,* February 15, 2013. http://www.ctlawtribune.com/id=1202588481580.

Norcross, T.W. "Flood on Pequonnock River, Connecticut." In *Water-Supply and Irrigation Papers of the United States Geological Survey,* edited by the United States Geological Survey. Washington, D.C.: U.S. Government Printing Office, 1906, 157–64.

Normen, Elizabeth J., ed., with Stacey K. Close, Katherine J. Harris and Wm. Frank Mitchell. *African American Connecticut Explored.* Middletown, CT: Wesleyan University Press, 2013.

NutmegStateGames.org.

Ohio History Central. "Elijah Wadsworth." http://www.ohiohistorycentral.org/w/Elijah_Wadsworth.

Oklahoma Historical Society. *Encyclopedia of Oklahoma History & Culture* online. http://digital.library.okstate.edu/encyclopedia.

Orcutt, Samuel, and Ambrose Beardsley. *The History of the Old Town of Derby, Connecticut, 1642–1880: With Biographies and Genealogies.* Springfield, MA: Press of Springfield Printing Company, 1880.

Oviatt, Edwin. *The Beginnings of Yale, 1701–1726.* New Haven, CT: Yale University Press, 1916.

Pagliuco, Christopher. *The Great Escape of Edward Whalle and William Goffe: Smuggled Through Connecticut.* Charleston, SC: The History Press, 2012.

Patch Media online. http://patch.com/.

PBS.org.

Perrin, John William. "The History of Compulsory Education in New England." PhD dissertation, University of Chicago, 1896.

Pevar, Stephen. *The Rights of Indians and Tribes.* New York: Oxford University Press, 2011.

Polmar, Norman. *The Naval Institute Guide to the Ships and Aircraft of the U.S. Fleet.* 18th ed. Annapolis, MD: U.S. Naval Institute, 2005.

Prichard, Sarah Johnson. *The Town and City of Waterbury, Connecticut.* Edited by Joseph Anderson, with the assistance of Anna L. Ward. New Haven, CT: The Price and Lee Company, 1896.

Princeton University. *The Papers of Thomas Jefferson.* Princeton, NJ: Princeton University Press, 2008.

PR Newswire. "Gary Franks Denounces Joe Biden's 'Back in Chains' Metaphor." August 28, 2012. http://www.prnewswire.com/news-releases/gary-franks-denounces-joe-bidens-back-in-chains-metaphor-167657175.html.

Providence (RI) Journal.

Pulitzer.org. "Wall Street Journal Staff." 1997 Pulitzer Prize Winners. http://www.pulitzer.org/biography/1997-National-Reporting.

Report of the Commissioner of Patents for the Year 1854: Arts and Manufactures, vol. 1, 33rd Congress. Washington: A.O.P. Nicholson, 1855.

Reuben, Paul P. "Charlotte Perkins Gilman 1860–1935." California State University–Stanislaus. *Perspectives in American Literature.* http://archive.csustan.edu/english/reuben/pal/chap6/gilman.html.

Reynolds, David S. *John Brown, Abolitionist: The Man Who Killed Slavery, Sparked the Civil War, and Seeded Civil Rights.* New York: Vintage Books, 2006.

Rhoads, Edward J. "In the Shadow of Yung Wing." *Pacific Historical Review* 74, no.1 (February 2005): 19–58.

Richmond Memorial Library. "Mary Hall." http://www.richmondlibrary.info/blog/2007/04/mary_hall.html.

RiversideCemeteryCT.org.

Robinson, Kathleen. "Henry & Fredrick: The Road to Automatic Fire Sprinkler Systems." *National Fire Protection Association Journal* (November/December 2011). http://www.nfpa.org/newsandpublications/nfpa-journal/2011/november-december-2011/news-and-analysis/looking-back/?p=1.

Rockey, John L., ed. *History of New Haven County, Connecticut.* vol. 1. New York: W.W. Preston and Co., 1892.

Rolling Stone. "The Carpenters." *Rolling Stone* online. http://www.rollingstone.com/music/artists/the-carpenters.

Rosen, Fred. *The Historical Atlas of American Crime.* New York: Facts on File, 2005.

Roth, David M. *Connecticut: A History.* New York: W.W. Norton and Company, 1979.

Rutkowski, Stephanie. "Jan. 23: First 'Frisbee' Toys 1957." ABC News. January 23, 2012. http://abcnews.go.com/blogs/extras/2012/01/23/jan-23-first-frisbee-toys-1957/.

Sacramento (CA) Daily Union.

Samberg, Joel. "Remembering Karen Carpenter, 30 Years Later." National Public Radio. http://www.npr.org/2013/02/04/171080334/remembering-karen-carpenter-30-years-later.

San Francisco Call.

Scotti, R.A. *Sudden Sea: The Great Hurricane of 1938.* New York: Little Brown and Company, 2003.

Scott, Otto. *The Secret Six: John Brown and the Abolitionist Movement.* New York: New York Times Books Co., 1979.

Selleck, Charles Melbourne. *Norwalk*. Norwalk, CT: self-published, 1896.

Shoreline Times (New Haven, CT).

Shore Line Trolley Museum. "Local History." http://shorelinetrolley.org/about/local-history/.

Shubert New Haven. "Shubert Theatre History." http://shubert.com/shubert-theater/the-history.

Sikorsky Aircraft Corporation. "About Sikorsky." http://www.sikorsky.com/About+Sikorsky.

Simsbury Historical Society. "Martin Luther King: His Time in Simsbury, Connecticut." http://www.simsburyhistory.org/SimsHistory/mlking.html.

Smithsonian National Museum of American History. "Stubby." The Price of Freedom: Americans at War Collection. http://amhistory.si.edu/militaryhistory/collection/object.asp?ID=15.

Smithsonian National Postal Museum. "Crossing the Atlantic by Steamship." Arago: People, Postage, & the Post. http://arago.si.edu/index.asp?con=4&cmd=2&eid=481&slide=20.

Society of Colonial Wars in the State of Connecticut. "1769—The Pennamite Wars." http://colonialwarsct.org/1769.htm.

———. "1637—The Pequot War." http://www.colonialwarsct.org/1637.htm.

Spalding, J.A., ed. *Illustrated Popular Biography of Connecticut*. Hartford, CT: Press of the Case, Lockwood and Brainard Company, 1891.

Sperry Top Sider. "Our Story." http://www.sperrytopsider.com/en/content?caid=our-story.

Stafford Motor Speedway. "History of Stafford Motor Speedway." http://staffordmotorspeedway.com/sms-track-history/.

State of Connecticut online. http://www.ct.gov/.

StatueofLiberty.org. "Statue History." http://www.statueofliberty.org/Statue_History.html.

Stiles, Henry. *The History and Genealogies of Ancient Windsor, Connecticut; Including East Windsor, South Windsor, Bloomfield, Windsor Locks, and Ellington. 1635–1891. Genealogies and Biographies*. vol. 2. Hartford, CT: Case, Lockwood and Brainard Company, 1891.

Submarine Force Museum. "History of USS *Nautilus* (SSN 571)." http://www.ussnautilus.org/nautilus/index.shtml.

Supreme Court Historical Society. "Oliver Ellsworth (1796–1800)." http://www.supremecourthistory.org/history-of-the-court/chief-justices/oliver-ellsworth-1796-1800/.

Swarthmore College. "Historical Background." Peace Collection, Elihu Burritt Papers, 1840–1965. http://www.swarthmore.edu/library/peace/DG051-099/dg096Burritt/dg096burritt.htm.

Syracuse University Libraries. "Collis Potter Huntington Papers." Finding Aids. http://library.syr.edu/digital/guides/h/huntington_cp.htm.

Tambling, Richard. "The Day Spencer Shot Holes in Criticisms of His Rifle." Manchester Historical Society. http://www.manchesterhistory.org/reprints/MHS3_Spencer_Lincoln.html.

Tateosian, Nicole. "Hartford, Connecticut: Discrimination, Separation, and Urban Riots." *Hartford Studies Collection: Papers by Students and Faculty. Paper 24.* Hartford: Trinity College Digital Repository, 1998. http://digitalrepository.trincoll.edu/cgi/viewcontent.cgi?article=1023&context=hartford_papers.

TeachingAmericanHistory.org.

Telegraph (Nashua, NH).

Temple, Robert. *The History of Harness Racing in New England.* Bloomington, IN: Xlibris, 2010.

Textor, Katy. "History Lesson: Past Debates." ABC News. http://abcnews.go.com/Politics/story?id=120209.

Thayer, George B. *History of Company K: First Connecticut Volunteer Infantry During the Spanish-American War.* Hartford: R.S. Peck and Co., 1899.

Thomas J. Dodd Research Center. Archives and Special Collections online. http://doddcenter.uconn.edu.

Time. "Leona Helmsley." http://content.time.com/time/specials/packages/article/0,28804,1891335_1891333_1891317,00.html.

TodayinGeorgiaHistory.org.

Todd, Charles Burr. *In Olde Connecticut: Being a Record of Quaint, Curious and Romantic.* Edited by Henry R. Stiles. New York: Grafton Press, 1906.

Town of Bethlehem, Connecticut. "Brief History of the Bellamy-Ferriday House & Garden." http://www.ci.bethlehem.ct.us/bellamy_ferriday.htm.

Town of Branford, Connecticut. "Brief History of Stony Creek Quarries." http://www.branford-ct.gov/content/149/243/687/default.aspx.

Town of Derby. "Rev. Richard Mansfield." http://www.electronicvalley.org/derby/quiz/Pages/mansfield,richard.htm.

Town of Fairfield. "The Burning of Fairfield during the American Revolution." http://www.fairfieldct.org/content/10724/12146/12165.aspx.

Town of Lebanon. "Revolutionary War Office." http://www.lebanontownhall.org/war-office.htm.

Treaty of Hartford. September 21, 1638. Yale Indian Papers Project. Yale University Library.

Trinity on the Green. "Ithiel Town." Trinity Parish online. http://www.trinitynewhaven.org/Home/History/IthielTown/tabid/119/Default.aspx.

Trumbull, James Hammond, ed. *The Memorial History of Connecticut, 1633–1884.* vol. 1. Boston: Edward L. Osgood, 1886.

Tucker, Abigail. "The Great New England Vampire Panic." *Smithsonian,* October 2012. http://www.smithsonianmag.com/history/the-great-new-england-vampire-panic-36482878/?page=2&no-ist.

United States Congress online. www.house.gov.

United States Department of Energy online. http://www.energy.gov/.

United States Department of State, Office of the Historian online. http://history.state.gov/.

United States Figure Skating Association. "History." http://www.usfsa.org/About.asp?id=508.

United States Geological Survey. "Connecticut: Earthquake History." Earthquake Hazards Program. http://earthquake.usgs.gov/earthquakes/states/connecticut/history.php.

United States National Library of Medicine. "Most Horrible and Shocking Murders." http://www.nlm.nih.gov/exhibition/murderpamphlets/pamphlets5.html.

United States Naval Academy. "James Earl 'Jimmy' Carter." Presidents of the United States. http://www.usna.edu/Notables/featured/bios/01carter.htm.

United States Navy Department, Bureau of Construction and Repair. *Annual Report of the Chief of the Bureau of Construction and Repair to the Secretary of the Navy for the Fiscal Year Ending June 30, 1903*. Washington, D.C.: Government Printing Office, 1903.

————. Naval Historical Center. "USS *Connecticut* (Battleship #18, later BB-18), 1906–1923." http://www.history.navy.mil/photos/sh-usn/usnsh-c/bb18.htm.

————. Naval History & Heritage Command online. http://www.history.navy.mil/.

United States Senate online. http://www.senate.gov/.

United States Statues At Large, vol. 108. 103rd Congress. Washington, D.C.: U.S. Government Printing Office, 1994.

University of Connecticut. "History." http://www.uconn.edu/history/.

University of Connecticut Health Center. "Hartford Firsts and Other Interesting Facts." http://www.uchc.edu/md/pediatrics/Historical%20Facts.pdf.

University of Virginia, Miller Center. "Gideon Granter (1801–1809): Postmaster General." *American President: A Reference Guide*. http://millercenter.org/president/jefferson/essays/cabinet/125.

USA Today.

USHistory.org.

USS *Constitution* Museum. "Papers of Isaac Hull." http://www.ussconstitutionmuseum.org/proddir/prod/496/57/.

Vaill, Dudley Landon. *The County Regiment: A Sketch of the Second Regiment of Connecticut Volunteer Heavy Artillery, Originally the Nineteenth Volunteer Infantry, in the Civil War*. Winsted, CT: Litchfield County University Club, 1908.

Vanderpoel, Emily Noyes. *Chronicles of a Pioneer School from 1792 to 1833: Being a History of Miss Sarah Pierce and Her Litchfield School*. Cambridge, MA: Harvard University Press, 1903.

Vaughan, Alden T. *New England Frontier: Puritans and Indians, 1620–1675*. 3rd ed. Norman: University of Oklahoma Press, 1995.

Vermont Merino Sheep Breeders' Association. *Spanish Merino Sheep: Their Importation from Spain, Introduction into Vermont and Improvement Since Introduced. A List of Stock Rams with Their Pedigrees and a Register of Pure Bred Flocks of Improved Spanish Merino Sheep*. vol. 1. Burlington, VT: Vermont Merino Sheep Breeders' Association, 1879.

Verrill, A. Hyatt. *Along New England Shores*. New York: G.P. Putnam's Sons, 1936.

Wadsworth Atheneum. "A Brief History of the Wadsworth Atheneum." http://www.thewadsworth.org/about/history/.

Wahba, Phil. "AIG Protestors Take Connecticut Bus Tour." Reuters, March 21, 2009. http://www.reuters.com/article/2009/03/21/us-aig-connecticut-tour-new-idUSTRE52K23220090321.

Wallace, Irving. *The Fabulous Showman: The Life and Times of P.T. Barnum*. New York: Alfred A. Knopf, 1959.

Warner, William B. *Protocols of Liberty: Communication, Innovation & the American Revolution*. Chicago: University of Chicago Press, 2013.

Waterbury (CT) Republican-American.

Webb-Deane-Stevens Museum. "The Wethersfield Conference." http://www. webb-deane-stevens.org/pdf/ConfAtWeth-Final05.pdf.

Western Reserve Historical Society. "Abstract." Elijah Wadsworth Family Papers, Series II. http://catalog.wrhs.org/collections/search?keyword=wadsworth&titl e=&creator=&identifier=&subject=&year=&year-max=&smode=advanced.

West Virginia Division of Culture and History. "John Brown and the Harpers Ferry Raid." West Virginia Archives and and History Collection. http://www. wvculture.org/history/jnobrown.html.

WFSB News. "1983 Wells Fargo Robbery 'Alleged Mastermind' Sentenced." November 14, 2012. http://www.wfsb.com/story/20097847/1983-wells-fargo-robbery-alleged-mastermind-sentenced.

Wilkins, William Clyde. *Charles Dickens in America*. London: Chapman and Hall, 1911.

Williams, Catherine Read. *Fall River: An Authentic Narrative*. Boston: Lilly, Wait and Company, 1834.

Windsor Historical Society. Christopher Miner Spencer Collection. http:// windsorhistoricalsociety.org/fa_spencer.html.

———. "Windsor History." http://www.windsorhistoricalsociety.org/windsor_history.html.

Wolcott Historical Society. "History." http://www.wolcotthistory.org/.

Woodrow Wilson Presidential Library and Museum. "Biography." http://www. woodrowwilson.org/about/biography.

Woods Jr., Thomas E. *Summary of Nullification: How to Resist Federal Tyranny in the 21st Century*. Brussels, Belgium: Primento, 2013.

Wooley, John, and Gerhard Peters. "Harry S. Truman." The American Presidency Project. University of California–Santa Barbara. http://www.presidency.ucsb. edu/ws/?pid=12688.

———. "Lyndon B. Johnson." The American Presidency Project. University of California Santa Barbara. http://www.presidency.ucsb.edu/ws/?pid=26290.

Worcester, Wayne. "Connecticut Tornado of 1989." *Yankee Magazine*. July 1990.

World Nuclear News. "Wildlife Refuge Buys Connecticut Yankee Land." January 10, 2013. http://www.world-nuclear-news.org/WR-Wildlife_refuge_buys_Connecticut_Yankee_land-1001135.html.

Yale University, Jonathan Edwards Center. "Sinners in the Hands of an Angry God (1741)." http://edwards.yale.edu/research/major-works/sinners-in-the-hands-of-an-angry-god/.

Zielinski, Gregory A., and Barry D. Keim. *New England Weather, New England Climate*. Lebanon, NH: University Press of New England, 2003.

ABOUT THE AUTHOR

Gregg Mangan currently holds a master's degree in public history from Central Connecticut State University and a doctorate in public history from Arizona State University. He worked for seven years as a freelance historian, writer and editor, writing pieces for such publications as *Connecticut History*, *Connecticut Explored* and ConnecticutHistory.org and editing manuscripts for such books as Linda Buzogany's *The Superman Years* and Briann Greenfield's *Out of the Attic: Inventing Antiques in Twentieth-Century New England*. He served as an intern at the Connecticut Department of Culture and Tourism (now the Department of Economic and Community Development) and currently works for the Connecticut Humanities at Wesleyan University as the manager of the ConnecticutHistory.org digital history project.